Judy Goldhill

About the Author

VIRGINIA NICHOLSON was born in Newcastle-upon-Tyne. After studying at Cambridge University she lived in France and Italy, and then worked as a documentary researcher for the BBC. Her first book, *Charleston: A Bloomsbury House and Garden*—written in collaboration with her father, Quentin Bell—was an account of the Sussex home of her grandmother, the painter Vanessa Bell—Virginia Woolf's sister. She is married, has three children, and lives in Sussex, England.

About the Author

Vivian Meik ... was born in Newcastle upon Tyne. After studying at Cambridge University, she lived in France and then ...

Among the Bohemians

Experiments in Living

1900–1939

VIRGINIA NICHOLSON

Perennial

An Imprint of HarperCollinsPublishers

This book was originally published in Great Britain in 2002 by
Viking, an imprint of Penguin Books.

The first U.S. hardcover edition of this book was published in 2004 by William
Morrow, an imprint of HarperCollins Publishers.

HarperCollins books may be purchased for educational, business, or sales
promotional use. For information, please e-mail the Special Markets Department
at SPsales@harpercollins.com.

FIRST PERENNIAL EDITION PUBLISHED 2005.

The Library of Congress has catalogued the hardcover edition as follows:

Nicholson, Virginia.
 Among the bohemians : Experiments in living 1900–1939
 / Virginia Nicholson.—1st ed.
 p. cm.
 "Originally published in Great Britain in 2002 by Viking"—T.p. verso.
 Includes bibliographical references and index.
 ISBN 0-06-054845-2
 1. England—Social life and customs—20th century. 2. Bohemianism—
England—History—20th century. 3. Bell, Vanessa, 1879–1961. 4. Thomas,
Dylan, 1914–1953. 5. Carrington, Dora de Houghton, 1893–1932.
6. Artists—Great Britain—Biography. 7. Poets, Welsh—20th century—
Biography. I. Title.

DA566.4.N53 2003
942.082'3'0887—dc21

 2003056231

ISBN 0-06-054846-0 (pbk.)

22 LSC 10 9

For Bill

Contents

List of Illustrations

Section 1

Augustus John, Norfolk, 1909 (photograph National Portrait Gallery, London; copyright reserved)

Café scene from H. Murger, *Scènes de la Vie de Bohème*, 1845 (British Library, London, Tab. 501.a.6)

'An Unfinished Masterpiece' by Philip Burne-Jones, *c*. 1900 (Rochdale Art Gallery, Lancashire/Bridgeman Art Library)

Robert Graves in his kitchen, photograph by Douglas Glass (© J. C. C. Glass, photograph National Portrait Gallery, London)

Kathleen Hale and her boyfriend, possibly Frank Potter, on holiday in Italy, 1926 (Courtesy of Peregrine McClean)

Rosalind Thornycroft and her children in Italy, 1920s (Courtesy of Chloë Green)

Quentin and Julian Bell, Asheham, *c*. 1914 (Tate Gallery Archive, London)

John Hope-Johnstone, portrait by Augustus John, *c*. 1911 (Glynn Vivian Art Gallery, Swansea/© courtesy of the artist's estate/Bridgeman Art Library)

Bedales pupils wheeling barrows (Courtesy of Bedales School)

Romilly John, bronze by Jacob Epstein, 1907 (© estate of Jacob Epstein/Tate Gallery, London/photograph Conway Library, Courtauld Institute of Art, London)

By the Avon, 1930. Poppet John, Jean – a friend, Nicolette Macnamara, Vivien John and Caitlin Macnamara (Courtesy of Prosper Devas)

Vaslav Nijinsky dancing in *Le Dieu Bleu*, 1912 (AKG, London)

The cast of *A Midsummer Night's Dream*, Charleston, 1925 (Tate Gallery Archive, London)

The hall in Ethel Sands's house from D. Todd and R. Mortimer, *The New Interior Decoration*, 1929

Section 2

Line Drawing Acknowledgements

p. 15, 'Immortal Augustus' by Dorothea St John George from K. Hare: *London's Latin Quarter*, 1926; p. 19, 'Most wondrous and valiant Brett'; p. 140, p. 214, by Carrington, courtesy Frances Partridge; p. 32 from George du Maurier, *Trilby*; p. 37, Isadora Duncan by Abraham Walkowitz, courtesy of Zabriskie Gallery, New York; p. 52, 'Earth Receiving' by Eric Gill from *Procreant Hymn* and p. 140, *Clothes*, © courtesy the artist's estate/Bridgeman Art Gallery; p. 69, 'Pyramus sleeping' by Augustus John (private collection/ © courtesy of the artist's estate/Bridgeman Art Library); p. 97, 'My parents have a theory . . .' by Pont (Graham Laidler), from *Pont* by Bernard Hollowood, © Miss Kathleen M. Laidler and the Proprietors of *Punch*; p. 98, 'Children' by Gwen Raverat, © estate of Gwen Raverat 2002, all rights reserved DACS; p. 108, 'First Russian Ballet Period' by Osbert Lancaster from *Homes Sweet Homes*, courtesy Anne Scott James; p. 119, 'Mrs John's Window Sill' and p. 156, 'Images of Dorelia', from *The Glass of Fashion*, © courtesy estate of the late Sir Cecil Beaton; p. 184, 'Eiffel Tower' and p. 256, 'Armistice Day' by Nina Hamnett from *The Silent Queen*, 1927, private collection/© courtesy of the artist's estate/Bridgeman Art Library; p. 148, 'Poetry' by Fred Adlington from St John Adcock, *A Book of Bohemians*, 1925; p. 195, 'Ukanusa Drudgee' by Christine Bell from Mrs J. G. Frazer, *First Aid to the Servantless*, 1913; p. 241, 'Paul Nash and Bunty Walking' by Paul Nash, © estate Paul Nash/Tate Gallery, London; p. 247, woodcut by Ray Garnett from David Garnett, *The Grasshoppers Come*, courtesy Richard Garnett; p. 258, 'The Can Can' by Ethelbert White in *La Boutique Fantasque*, in 'The Dancing Times', 1919; p. 290, 'Betty May in the Fitzroy Tavern' by Nina Hamnett from *Betty May, Tiger-Woman – my story*, 1929, private collection/© courtesy of the artist's estate/Bridgeman Art Library

Introduction

I know that I am not alone in my partiality for trivia. Nowadays, thousands of people flock to see the kitchens in stately homes when they could be admiring the portraits on the walls. Tourists visiting an ancient Roman site are delighted to turn a corner and discover a row of holes side by side along a stone bench – communal lavatories. Hugely successful museums like Plymouth Plantation in Massachusetts now feed this public taste by employing actors to play out the homely everyday lives of the Pilgrim Fathers – gardening, washing and preparing meals.

Too much reverence can estrange us from the object of our worship. I for one, love to be brought up close – to touch, to taste, if possible to smell the lives of people from the past. I want to know how they coped. I want to compare my life with theirs. I want to feel I could have known them. This appetite for identification with history is important. A sense of contact brings with it a sympathy which helps us to understand our own links with the past.

But it can be hard. A visit to Mozart's birthplace in Salzburg demands strenuous efforts of the imagination to overcome the distancing effects of glass cases and trooping tourists with 'Audiokaisers' jammed to their ears. One retreats into the seething Getreidegasse with all sorts of burning questions still hanging: what was the life of this child genius really like? How did the young Mozarts get fed, washed, educated? How did Anna Mozart run the house, do the washing, clean the sheets? Too many centuries have passed since Wolfgang was born there in 1756 for the best efforts of museum curators to succeed in providing satisfying answers to such questions.

The recent past is another story. So much still survives, in the form of tangible ephemera, photographs, writings, and the living memory of grandparents and survivors, that one has only to reach out and grasp it – furniture, food, bedrooms, bathrooms and all. Here where I live in the south of England the small museum of Charleston (home of my grandmother the painter Vanessa Bell) still survives as it was when she lived there, down to the smallest detail. The homes of other famous names from the last century or so – Freud, Proust, G. B. Shaw, Kipling, Monet, Cocteau – are still furnished with the possessions of their occupants, making it possible to fantasise that they have merely stepped out for a brief stroll and will shortly return.

"WHAT A LOVELY HOBBY YOUR HUSBAND HAS!"

Bohemia provided inexhaustible material for
the irreverent cartoonists of *Punch* (18 January
1933).

The sense of contact with artists and thinkers of the last hundred and fifty
years brings with it an awareness of the momentous times through which
they were living. Prompted by inquisitiveness, I started on an exploration
of what was to become this book: a close-up examination of the daily life
of 'Bohemia' in Britain in the first half of the twentieth century, signalling
its relevance to life today.

I soon discovered what an ever-expanding project I had embarked upon.
I reread memoirs and biographies, talked to 'survivors', and sought out
novels of the period which commented on or illustrated their own times. I
read about my great-aunt Noel Olivier, with whom Rupert Brooke was in
love. There were riches too in my aunt Chloë Baynes's memoir of her
mother, Rosalind Thornycroft, who had an affair with D. H. Lawrence. I
drew on my own memories of my uncle David Garnett, and I corresponded
with my aunt Angelica Garnett. I spent hours chatting with our old family
friend Frances Partridge.

Soon it became obvious that I had to spread the net much wider, and
here I owe a special acknowledgement to Michael Holroyd and to his

magisterial biography of Augustus John. After a total immersion course in Augustus and Dorelia, the material came thick and fast. I found out about all their friends and rivals, from Kathleen Hale to Nina Hamnett, Jacob Epstein to Betty May, Edna Clarke Hall to Wyndham Lewis. Augustus was like a seductive spider to whose huge web every butterfly or beetle seemed to cling. Just beyond its snare hovered yet more exotic winged creatures: the Garman sisters, Theodora Fitzgibbon, Gwen Otter, Alan Odle, Tristram Hillier, Allanah Harper, Philip O'Connor and many, many more.

I held a magnifying glass over the habits and domestic lives of artists and writers in this country for the forty-odd years before the Second World War, and it revealed tendencies, overlaps, above all, aspirations in common among an entire subsection of society, that set them apart from the vast mass of conventional British people. This tiny, avant-garde minority possessed a special cohesiveness that went beyond movements and styles in art. Their daily lives seemed touched with an artistic consciousness that bore vivid witness to an ideal about how one should live.

We have become wary of ideologies today, but there was a heroic, starry-eyed quality to much of their stance towards life which I found immensely engaging. I found I admired these people for their enviable commitment and courage in challenging the conformity of their age. They were idealists, romantics, libertarians and sensualists, contemptuous of material wealth and conventional propriety. They espoused freedom in sexual relationships, they emphasised friends above family, they believed in 'true' living and 'true' loving, and worshipped nature. They had an adventurous spirit, and adopted an extravagant visual style, in their clothes and their surroundings. These principles were all latent in the writings and memories of my grandmother's generation and the one that followed it. Sometimes just a couple of these 'signature' characteristics were enough to identify their affiliation to the group as a whole. In other cases one recognised and applauded the fully paid-up card-carrying disciple. As one decoded the audacious messages communicated via emerald corduroy and hand-crafted sandals, pink distemper and blue china, *daube de boeuf* and *vin de table*, the character of this tribe became implicit and familiar – and yet its disparateness made it curiously hard to identify. It seemed best to adopt the label used so loosely and extensively by the chroniclers and autobiographers themselves: Bohemian.

Bohemia is a hard country to place, and yet it was utterly familiar to the people who inhabited it from the turn of the century until the outbreak of the Second World War, a place where to be different was to be accepted. Here they felt at home and among friends: an incongruous, eccentric club

of artists, some rich, some poor, talented and untalented, who believed in friendship more than family and who by their very differences proclaimed themselves to be part of a confederacy.

The curious slippery adjective 'Bohemian' goes back to ancient times. We now translate the French word 'Bohémien' as 'Gypsy', but the original *Boii* were refugees from the area known until recently as Czechoslovakia. From the early days of the Roman Empire until the Middle Ages waves of these displaced persons fled into Western Europe. Many of them, it appears, threw in their lot with disreputable groups of wandering minstrels, mostly unfrocked priests and monks; and from that time the term 'Bohemian' seems to have attached itself to nomadic groups of like appearance. When the first genuine Romanies appeared in France from central Europe with their vagabond habits and colourful array, they were identified with the previous arrivals, and by the late sixteenth century all gypsies were indiscriminately labelled Bohemian, regardless of their exact origin. Right from the start, the country of Bohemia was located wherever its inhabitants were to be found.

The idea of *Bohemia* is immensely powerful. It has attached itself to individuals as disparate as Jesus Christ, Shakespeare and Sherlock Holmes, and everybody has a mental pigeonhole into which the imaginary Bohemian more or less fits. For many this takes shape as a garret, the refuge of the lonely genius. For others it is a tavern where gypsy-clad people drink and dance. Some conjure up with distaste the Parisian zinc cluttered with untalented phoneys – dirty, poor and smelly. A closer look reveals that the natives of Bohemia are not just painters and poets, but must also include vegetarian nature-lovers living in caravans, poseurs in velvet jackets drinking absinthe in the Café Royal, earnest lesbians in men's suits and monocles, kohl-eyed beauties in chiffon and emeralds. If there is a definition of Bohemia it has, somehow, to accommodate all these, for all have travelled in their minds to that notional country; each has made some corner of it their own, each has found in that varied terrain some special attribute that makes of them, too, Bohemians.

And so I made my own voyage into Bohemia. I am not an academic, but a researcher. I make no apology for my fascination with the laundry-list view of history. Knowing that Roy Campbell had a recipe for bouillabaisse or that Dorothy Brett bobbed her hair is the kind of detail I find not only revealing but indispensable to understanding their lives. Gradually, as the fuller picture emerged, I began to realise how in advance of their times many of these lives seemed. And without being an historian, I felt instinctively that Bohemia had, over those four decades from the death of Queen Victoria

until the outbreak of the Second World War, changed the way we live now. The more I found out about the period, and the ways in which it contrasted with the preceding century, the more this instinct was validated.

Though the social edifice of the nineteenth century could be tyrannous, the Victorian age was also one of great upheavals and profound questionings. Religion, romantic love, psychology, science, political structures, were all dissected by the great thinkers of the nineteenth century, found wanting, and turned on their heads. The last bastion to crumble was the family. By the 1890s even this revered institution was coming under attack and ridicule. Some Victorian attitudes proved hard to eradicate. However, as the twentieth century dawned the romanticism of the nineteenth century was evolving into a fundamental challenging of the bases of society, above all the role of women and the foundation of the family.

Buoyed up by the radicalism of the great, late Victorians, the Bloomsbury Group was merely among the first to ride the crest of a wave which was gathering force at that time, a wave which swelled with ideas of suffrage, feminism, pacifism, vegetarianism, spiritualism, independence and free thought of all kinds. Artists and writers of all colours were rebelling against their precursors, staking out a new territory where honesty and experimentation in intellectual, artistic and sexual matters became the priorities.

The early decades of the twentieth century were an exciting time to be an artist, for modernism was on the rampage. Ezra Pound coined their artistic war-cry, 'Make it new . . .' The traditional novel was under attack; the Ballets Russes changed everything they touched; Post-Impressionism convulsed the bourgeoisie. The artistic community in England and elsewhere was embarked upon an imaginative attempt to dismantle society as they knew it, and remake it in a new image. In their daily lives as in their art, these people lived experimentally, in what amounted to a domestic revolution.

As the new ideas gained ground, a growing number of fugitives from conventionality sought refuge in Bohemia. In this country of the mind, such artistic refugees found acceptance, absolved by their 'genius' from the rules of normal behaviour. There these outlaws might remain for life or, as their fortunes changed – as success, marriage or conformity claimed them – they might return to the world outside. There were those who, though not indigenous, formed alliances with this country; others came as tourists, to gasp and wonder at its excesses. Like all territories, it had a changeable climate, a varied landscape.

Bohemia was a hospitable country, and a new sense of kinship grew up amongst those people who felt themselves, as artists, to be on the margins

of repressive, post-imperialist society. As social sub-groups go, it was small, and a remarkable number of such people all knew each other and interwove their lives in the four decades before the Second World War.

They came mostly, but not all, from the educated middle-classes. There were some eminent names among them. But it seemed one didn't have to achieve immortality as an artist for Bohemian aspirations to express themselves, and in many cases there seemed little to remember these figures by other than perhaps their outré conversation, their wayward lifestyle or exotic appearance. Few people today have any perception of, for example, Viva King, Stuart Gray or Jacob Kramer. Who were Godwin Baynes, Christabel Dennison and Mary Butts? They don't appear in the standard companions and dictionaries cataloguing the achievements of the twentieth century. Yet though their contribution to history may appear insignificant, cumulatively their humble domestic breakthroughs amount to victory.

We have a tendency to judge artists by the durability of their creations. My approach is to judge them by the quality of their daily lives. Many of the names that appear in this book are those of second-rank painters and inferior writers, artists' models and hangers-on. Some of them had affairs with or married into Bohemia. Others remain enigmatic footnotes in the memoirs of their more illustrious contemporaries. But nearly all of them were in some respect idealists and rebels, pioneers of the everyday. These Bohemians not only revered Cézanne and worshipped Diaghilev, they sent their children to co-educational schools, ate garlic and didn't always bathe. They went hatless and shoeless, painted their front doors red, slept on divans. They became tramps or took off in caravans. Flamboyant and subversive, they read Edward Carpenter, Havelock Ellis and *Ann Veronica*. They were trying out contraception, imagism and Post-Impressionism. They were often drunk and broke, sometimes hungry, but they were of a rebellious spirit. Inhabiting the same England as colonials, Etonians, peers and puritans was a parallel minority of moral pioneers, travelling third class and coping with faulty fireplaces. Often their idealistic experiments went disastrously wrong, and sometimes they felt cast adrift on the sea of new freedoms. And yet gradually, imperceptibly, they changed society. This book testifies to that quiet revolution.

Thus the choices made by Bohemians are its subject, not their achievements. I have not attempted to examine the period chronologically; partly because the rich seam of material I discovered defied historical analysis, and partly because a thematic approach seemed to me altogether more revealing. Thus the ensuing chapters set out to describe in some detail the essence of their domestic innovations, examining the facts of living in poverty, the

breakdown of sexual and emotional barriers, Bohemia's radical approach to the upbringing of children, self-expression in the home, in clothes and in food, the realities of housework and hygiene, the romance of travel, and last but not least the spirit of celebration that has always animated Bohemia at its best. Brief biographical details of the extensive cast list of characters appear in Appendix B on page 292.

Seventy years on we may well look back upon our grandparents' generation as naive, selfish, sexist and politically incorrect. However a little historical perspective easily puts these misassumptions right: in the context of the times, and of the challenges they were taking on, these people were a sincere and courageous minority.

Unfortunately the avant-garde has always had to live with the awkward fact that, sooner or later, it creates a following, and that its lonely journey into the unknown can start to seem a little well-trodden after the passage of a few years. Bohemia's greatest achievement may well have been the complete assimilation by today's society of its victories against the establishment.

There is a paradoxical consensus that the function of art is to challenge. We look to artists to break new ground and attack the status quo, but over time they themselves become the objects of society's admiration – fashion leaders, celebrities, originals. The aristocrats of talent – albeit in soap opera and sport – have come to replace the aristocrats of birth in our allegedly class-free society. Where they lead, we will follow. Like the Bohemians, we now condemn puritanism, segregation, sexism, intolerance of minorities. We are no longer inhibited by rigid etiquette. Today, the Bohemians' emphasis on a new, informal way of living, with friendship for its own sake, the right to personal liberty, sexual freedom, feminism, deviations in dress and manners, foreign food, experimentation with interior decoration are all taken for granted. They have, in their battle with the establishment, created the norms of a new establishment.

1 · Paying the Price

Why is poverty so romantic? – Why do artists despise money?
– How does one survive while producing something that no one
will buy? – What does an artist do who runs out of money? – Does
being rich disqualify one from Bohemia? – If being Bohemian
means being poor, is the gain worth the pain?

A couple of years after their marriage in 1918, the writer Robert Graves and his painter wife Nancy found themselves unable to make ends meet. They were living on the outskirts of Oxford at Boars Hill, and had two small children; Graves had sworn, after the war experiences described later in his famous book *Goodbye to All That* (1929), never to be under anyone's orders again. He was determined to live by his pen – an inadequate resource with which to pay for the needs of his household. It was Nancy's idea to start a shop.

At first 'The Poets' Store' seemed too good to be true; a carpenter erected a charming hut to Nancy's design and outside it they hung an attractive Celtic sign. The shop was to be a general store, and they stocked it with all the necessities from washing powder to tea leaves. The community in which they lived brought them some valuable publicity, for their closest neighbour – and landlord – was the poet John Masefield, then at the height of his fame, and Mrs Masefield could buy her soapflakes from them. Another poet, John Nichols, also lived nearby; and there was a sprinkling of Oxford writers and academics in the village, all of whom could be supplied with back bacon, pipe tobacco and cheese. The *Daily Mirror* duly carried a headline 'Shop-Keeping on Parnassus', which Graves hoped would encourage custom.

It soon proved to be a disastrous enterprise. Robert had to abandon his writing in order to serve behind the counter. Nancy quarrelled with the nursemaid and sacked her, so she had both to look after the children and bicycle round the area taking and delivering orders. The Graveses' humanitarian instincts were bad for business – they undercharged their poorer customers and allowed them to run up debts. The book-keeping was hopelessly mishandled, and Robert went down with influenza. 'We decided to cut our losses.' They tried to sell the whole business to a local firm of grocers. However, here Mrs Masefield proved intransigent. The

shop was on her land, and although she had been sympathetic to Robert and Nancy as struggling artists, she appeared reluctant to allow her neighbourhood to become tainted by vulgar commerce. The shop's depreciating stock was sold off at bankruptcy prices to wholesalers, and the charming hut was taken apart and sold for timber at a loss of £180. After a lawyer had worked to mediate their debts, they were left owing £300*. The family were now faced with homelessness and destitution. Graves's father-in-law helped as best as he could with a gift of £100. The remainder came to them from the extraordinary generosity of Graves's friend T. E. Lawrence. He gave them the first four chapters of his great account of the Arab Revolt, *The Seven Pillars of Wisdom*, and the sale of these for serial publication in America fetched the final £200. They were out of debt, but penniless, and the whole episode had proved an unmitigated calamity.

Optimism, impracticality, and in the end, terrifying dependency all feature in this cautionary tale of a pair of artists utterly unsuited for a commercial venture. The Graves's salvation came not from social security or unemployment benefit, but from helpful friends and relatives; in the 1920s the Poor Law provided assistance only for those who could not support themselves by any other means, including friends, family and charity. Robert and Nancy's improvident behaviour had brought them to the brink of starvation.

There is something improbable about the story of the Poets' Store which tempts one to laugh. But beneath the absurdity lies a simple fact of life for those who wanted to live and work as artists before the Second World War: it took courage to make such a choice, and sacrifices had to be made. When the artists and would-be artists who are the subject of this book set out on their chosen career, none of them knew whether those sacrifices would prove to be justified in terms of their work. Fifty years on we may judge that Dylan Thomas's poverty was noble, while Nina Hamnett's was senseless. But a minor artist with no money goes as hungry as a genius. What drove them to do it?

I believe that such people were not only choosing art, they were choosing the life of the artist. Art offered them a different way of living, one that they believed more than compensated for the loss of comfort and respectability. They reinvented daily life, and brought about changes that are with us to this day.

<p style="text-align:center">*</p>

* Worth around £7,000 today; however, rather than indicate modern values for every sum mentioned in this book, I recommend the reader to refer to Appendix A on page 291 for an easy conversion table.

The image of the starving Bohemian artist did not originate in the twentieth century. The prototype had been laid down in Paris in the 1840s, in Henri Murger's hugely successful book, *Scènes de la Vie de Bohème*.

Scènes de la Vie de Bohème was autobiographical. Born in Paris in 1822 of humble origins, Murger struggled to turn himself into a writer. He shared rooms with three artist friends in the rue des Canettes. They lived in unutterable poverty: 'We are aching with hunger,' he wrote in 1843. 'We are at the end of our tether. We must find ourselves a niche, or blow our brains out.' When they could scrape together twenty sous the group would gather at the Café Momus, which soon became the centre for a group of Bohemians attracted by cheap coffee and stimulating conversation.

In 1845 Murger drew on his experiences with the Café Momus crowd to produce a series of short articles for the magazine *Le Corsaire*. Over the next four years his own life and that of his friends – including his liaison with a factory girl called Lucile, who was probably the inspiration for Mimi – provided the copy for his only claim to immortality, the *Scènes de la Vie de Bohème*. This tells the story of the romance of Rodolphe and Mimi, ending with her melodramatic death. It paints a heart-warming picture of garret life with their Bohemian friends that still has power to captivate. The work went through various incarnations – articles, a stage play and a book – but was immortalised in 1896 as Puccini's opera *La Bohème*.

Because Murger's book was drawn from life, we should trust his account of the rigours of Bohemia. In its preface he wrote:

Bohemia bristles with . . . poverty and doubt . . . [Bohemians are] incessantly at war with necessity . . . they know how to practise abstinence with all the virtue of an anchorite, but if a slice of fortune falls into their hands you will see them at once mounted on the most ruinous fancies, loving the youngest and prettiest, drinking the oldest and best, and never finding sufficient windows to throw their money out of. Then when their last crown is dead and buried, they begin to dine again at that table spread by chance, at which their place is always laid, and, preceded by a pack of tricks, go poaching on all the callings that have any connection with art, hunting from morn till night that wild beast called a five-franc piece.

In other words, it was a recklessly hand-to-mouth existence. And yet as the book demonstrates, this existence had a kind of gay romantic irresponsibility that made it intensely powerful as a role model. Romanticism propagated Bohemianism, and Bohemians and Romantics have much in common; both were driven by headlong intemperance and a desire to live for the moment. But for both there was a price to pay.

> We poets in our youth begin in gladness;
> But thereof comes in the end despondency and madness.

William Wordsworth's lines in 'Resolution and Independence' probably allude to the poisoning by arsenic of the boy poet Thomas Chatterton, who was reduced to despair by poverty. The image of garret life still exerts a powerful hold on many of us, but it is blurred by that very romanticism, while the sheer beauty of some of the poetry and music that has come out of that period beguiles us into a comforting sense that it was not real. When today's opera audiences applaud as Mimi gasps her last in Rodolfo's arms, it may be hard for them to appreciate that Mimi and Rodolfo, Schaunard and Marcello had many real counterparts in nineteenth-century France, real Bohemians in real garrets who genuinely had not enough to eat, whose health was destroyed by poverty and despair. Murger's preface again:

[The Bohemians] die for the most part, decimated by that disease to which science does not dare give its real name, want . . .

The Bohemians of early nineteenth-century Paris, as Murger knew only too well, died younger than any other sector of society at that time, their ranks depleted by insanity, typhoid, tuberculosis and sheer starvation. In his own case, despite his success with the publication of *Scènes de la Vie de Bohème*, the years of poverty undermined his health, and he died at the age of thirty-eight.

Poverty in England could be even worse. A visiting nineteenth-century Frenchman, Francis Wey, recorded with horror the condition of the truly destitute in London, who, little better than gutter-dwellers, lay 'higgledy-piggledy in the mud, hollow eyed and purple cheeked, their ragged clothing plastered with muck'. Actual starvation was not unknown, and in 1900 a fifth of the population of this country ended their days in the workhouse. Even in 1937 George Orwell was to write angrily of the vile and undignified squalor, the subsistence diet and the infested dwellings of the working classes in Wigan and elsewhere. This then was the prospect in life for anyone who had no means of support. The message was there for anyone to read – forsake money at your peril.

Thus, to the outside world, artists seemed set on an unthinkable course towards self-destruction. In his thinly disguised autobiographical novel *Of Human Bondage* (1915) W. Somerset Maugham dramatises the experience of making that leap. After an alienated childhood, his young hero Philip Carey reaches a point where he feels he can only find self-expression as an artist.

Like so many others, Philip had fallen under the spell of Murger's *Vie de Bohème*. 'His soul danced with joy at that picture of starvation which is so good-humoured . . . squalor which is so picturesque . . .' With little money, and to the appalled disapproval of his stern uncle – a vicar for whom painting is a disreputable and immoral activity – Philip decides to risk a spell in Paris as an art student. Turn-of-the-century Paris, with its studios, cafés and general Bohemian élan, served for the majority of English artists of that period as an indispensable rite of passage on their route to artistic maturity.

Once enrolled in art school, Philip sets out to experience Bohemian Paris to the full. Early on, he meets a dejected young woman who, like him, has come to the city to seek her artistic fortune. Fanny battens on Philip. She is unattractive, untalented, ungracious; she possesses a single hideous and tattered brown garment. At a brasserie together one evening Philip is disgusted by Fanny's repellent table manners – she eats like an animal. Nevertheless their relationship progresses falteringly, as much from Philip's embarrassed pity for Fanny as because she seems to have no other friends. Then for a while they lose touch. One day Philip receives a message to come to Fanny's garret studio; he makes his way up to the tiny attic, and there finds her body, emaciated, hanging from a nail in the ceiling. She has been dead for some days. Horrified, he pieces together the story:

She had been oppressed by dire poverty. He remembered the luncheon they had eaten together when first he came to Paris and the ghoulish appetite which had disgusted him: he realised now that she ate in that manner because she was ravenous . . . She had never given anyone to understand that she was poorer than the rest, but it was clear that her money had been coming to an end, and at last she could not afford to come any more to the studio . . . She had died of starvation.

Did the prototype Philip Carey have this experience? It is hard to tell; biographies of Somerset Maugham do not shed light on this episode in his novel, with one possible exception. On 27 July 1904 Willie Maugham's brother Harry, an aspiring writer and Bohemian, was found lying on his bed, fully dressed, writhing in agony: he had swallowed nitric acid, and had been there for three days while the corrosive chemical gradually killed him. Harry Maugham's dreadful death, reminiscent of Chatterton's, is echoed in the novel – the despair of the embittered artist whose hopes will never be realised, the impoverished Bohemian who can see no future in his art, yet no reason for existence in any other of life's paths.

For as Philip Carey now discovered, poverty was not romantic. Again and again in the annals of Bohemia the pain of penury is expressed with

anguish and bitterness. 'The poverty among my contemporaries was terrible' recalled the painter C. R. W. Nevinson of his pre-First World War student days, and this is borne out by countless examples of artists reduced to the bare necessities – sleeping under newspapers for warmth, freezing in chilly studios with broken windows, eating packet soup day after day or subsisting on crusts and tea, walking to save twopenny fares, owing rent.

ALTHOUGH IN THE MEANTIME HE FEELS THE DRAUGHT A BIT, THE STRUGGLING ARTIST WHO HAS SUBMITTED HIS OUTSIDE MASTERPIECE TO THE ACADEMY THINKS IT UNWISE TO BEGIN REPAIRS UNTIL HE KNOWS THE VERDICT OF THE SELECTION COMMITTEE.

Punch, 13 April 1932.

With such tangible examples of the results of trying to live from art, it was not surprising that the majority of the bien-pensant middle classes took a dim view of art as a profession, seeing Bohemian poverty as at best self-indulgent folly, at worst criminal recklessness. The disgust felt by Philip Carey's uncle at his nephew's indigence betrays a profound defensiveness and self-righteous indignation. For the likes of the Rev. Carey, his nephew's rejection of the conventional, salaried world represented much more than just light-hearted unworldliness. This was an affront to his entire way of life.

For by the beginning of the twentieth century society had become an unwieldy but also extremely expensive edifice to maintain. High society

under Edward VII was a tottering display of extravagant magnificence –
huge meals, huge houses, huge balls. Lower down the scale the middle
classes went as far as they could in emulating their betters. Social presentation
was considered vitally important; the bourgeoisie was not prepared to stint
on housemaids and laundered tray-cloths, embossed calling-cards and kid
gloves. The conventionally minded felt snubbed, indeed shocked to the
core, by those who turned their backs on money. It was not nice, it was not
respectable, it was dangerously improvident.

The result for many young artists was a head-on collision of values with
the older generation. For the young, opting for painting and poetry meant
salvation. For the old, such a choice was equivalent to cheating on the Stock
Exchange or some such almost unmentionable behaviour. There was no
money to be made out of poetry. The poet Stephen Spender's relatives saw
his choice of career as 'perverse, obscene, blasphemous . . . depraved . . .'
But the tenacious ones held on to their vocation, for rejection of the
conventional moneyed world was what gave them their very identity.
Bohemians felt that they were inheritors of a kingdom where the rich man
cannot penetrate. Being penniless qualified one for a higher form of life than
that offered by Victorian society. It is arguable that the very label Bohemian,
with its romantic echoes of far-off lands, was adopted to give status to the
poor who might otherwise have sunk without trace into the gutter. And
the direr their Bohemian distress, the more it sanctified the conviction that
art was worth making sacrifices for.

Contempt for money was the extension of this position. If poverty is an
imperative for an artist – as many believed it to be – then wealth was to be
derided, regarded as sordid and corrupting to the integrity of the artist.
Bohemia on the whole felt a psychic distaste for Mammon. Of course that
attitude was in no way exclusive to Bohemia; it has a long Christian tradition,
and by the end of the nineteenth century writers like Dickens had done
much to elevate the status of the poor while condemning the cruelty and
avarice of the Gradgrinds of this world. Many thoughtful and high-minded
people were also struggling to come to terms with their instinctive aversion
to the materialism and excess of the Victorian and Edwardian age – like the
founding fathers of Fabianism and socialism whose tenets of redistribution
led to the formation of the Labour Party. But this particular Bohemian
attitude was an extreme position.

Under the pseudonym George Beaton the writer Gerald Brenan published
Jack Robinson: A Picaresque Novel in 1933. In it, he wrestles with the question
of whether one can renounce material things, and exist 'like the lilies of the
field', trusting to fortune and inspiration. As a young man Brenan – who

came from a well-to-do upper-class family – was intensely attracted by the idea of poverty:

The life of the poor, I held, had necessarily a greater reality than that of the rich because it was more exposed to fate and chance. It had also a greater blessedness if it was accepted voluntarily.

Like his hero – with whom he manifestly identifies – Brenan himself had run away from home in his teens and taken to the road as a tramp, travelling a pilgrim's path to self-discovery. In the novel Jack encounters a succession of colourful characters who flesh out his theories and influence his progress. One of these is the vagabond Irish philosopher Kelly whom he runs into singing his way down a hillside track:

'You see myself,' he went on. 'Would you call me a rich or successful man? I don't mind – speak plainly.'

I looked at the stained clothes drawn round his little body, at the long patched boots and haggard face, and answered:

'No, I can't say I should.'

'Now that is because you judge by material judgements. Seen in the spirit I am happy and successful, brilliant and free and want for nothing . . . I sing without ceasing from morning till night. Didn't you hear me?'

'Yes, I did.'

'Do the rich sing? No. Do they live in the open air under the beautiful trees? No, they do not. Do they love Nature? Do they delight in poetry? Not one. Oh, I pity the rich, I pity all men and women who are rich with all my heart.'

Thus Brenan/Beaton expresses the quintessential Bohemian attitude to money, though Jack Robinson's subsequent progress does much to dispel this outlook on life. But many Bohemians eagerly espoused it, and found in it a sense of validity and incorruptibility that nothing could take away. Believing that money was sordid and vile, that it cut you off from the raw material of life so essential to the artist, that it was repellent to place filthy lucre in proximity to art, did much to take the sting out of hunger and cold.

Dylan Thomas and his wife, Caitlin, took the attitude to its logical extension and vaunted their poverty as an indispensable ingredient in their art. Thomas's biographer and close friend, Constantine Fitzgibbon, who joined him on many a pub crawl, described Dylan's attitude best:

Just as at school he had to be thirty-third in trigonometry, just as in America he had to be the drunkest man in the world, so in London in 1937 he could not simply be a poor poet: he had to be the most penniless of them all, ever. Therefore such money as he might make or be given had to be spent, given away, even lost immediately. Money had become only another skin to be removed as quickly as possible in his revelation of the absolute Dylan. Like so many, perhaps like all, his attitudes, this one never really changed. It was one of the causes of his ruin.

Caitlin found herself almost dazzled by 'the romance of poverty . . . the inspiring squalor of the artistic world' in which the two of them lived. Yet after his death she bitterly recalled how Dylan's renunciation of money entailed an enthusiastic advocacy of the Chatterton model: 'Poverty and, preferably for the perfectionist, an early agonising death thrown in too. Dylan scrupulously fulfilled both these romantic conditions.'

Bohemians like Dylan and Caitlin Thomas were proud to place art before bourgeois comforts; managing to stay alive on very little money was cause for self-congratulation. No-frills self-sufficiency seemed a laudable and entirely achievable aim; and who needs parlourmaids and table-napkins anyway?

Yet it can be hard to appreciate that, for a large proportion of the middle classes, keeping up to the mark was already a struggle, and to opt out of that world was to descend from what was de facto a low level of provision and comfort. The parlourmaids and calling-cards were paid for out of tight incomes, nor did families like Ursula Bloom's have any of the expectations that we have today. The daughter of a country clergyman, she gives us a picture of her family's life both before and after the First World War. They lived an impeccably respectable life in a country vicarage on three hundred pounds a year: 'Few people realise today how careful the whole of England was about the spending of money, and all families saved a little for the rainy day . . .' remembered Ursula.

Servants' wages had to come out of the budget, because the middle classes took a certain retinue of staff for granted, but the family made economies on every front. They never bought expensive joints; clothes and furniture had to last; rooms were rarely redecorated, and nobody bought manufactured toilet paper because it was too expensive. Socks were always darned; middle-class formalities like the tipping of servants could leave one disastrously short of cash. With careful penny-pinching, nobody went hungry, but no housewife worth her salt omitted to keep scrupulous accounts, or to pay the butcher's bill on the nail.

What is striking about such examples as the Blooms is that one would expect such families to have more spending power today. Undoubtedly at

the beginning of the twenty-first century we are accustomed to spending a
far higher proportion of our available income on what would, just fifty years
ago, have been seen as impossible luxuries. Today a country vicar would
automatically expect to own a car, a refrigerator and a telephone, to travel
and have holidays, to purchase ready-made clothes at regular intervals, eat
convenience foods and occasionally eat out, buy cheap medicines and afford
a television and radio. Not one of these things was generally affordable by
the Blooms, never mind taken for granted. Before 1945 this was the general
state of affairs. The only thing that our generation no longer expects, which
our grandparents counted upon, was servants. At the beginning of the
twentieth century the labour market was such that every middle-class
household could afford servants, and it was not until the Second World War
that even people on moderate incomes found it hard to afford the minimum
of one maid and a charwoman.

Returning to the Bohemian artists of this period, we have to adjust our
own expectations in order to understand what living on a low income meant
in England in the first half of the twentieth century. The middle classes
already lived frugally enough; they had no modern-day superfluities. Cutting
loose from cramped conventional middle-class society and from regular
sources of income didn't mean renouncing luxuries, it meant renouncing
necessities. It meant going without regular meals, economising on heat and
clothing, reducing one's living to the essentials. The fact is that by opting
for a life independent of the rat race, many artists were forced to become
déclassé, and this was a genuine sacrifice, albeit a willing one. It took real
courage to opt for the life of a 'struggling artist'.

Remember too that for self-employed people before the Second World
War there was no automatic benefit system, as there is today. Skilled
artisans or their widows might claim from the Friendly Benefit Societies;
ex-employees could draw the dole in times of hardship, and low earners
who had paid their compulsory contributions were also entitled to free
medical treatment by the 'panel', otherwise the doctor expected prompt
settlement. The prospect for an unsalaried freelance artist who could not sell
his or her work, or survive by other means, was starvation.

* * *

These realities give a context to the evidence gleaned from artists' memoirs,
letters and biographies of the period.

Turn-of-the-century London: the impoverished Arthur Ransome finds
himself unable to earn, and is compelled for a week to live off apples and
cheese which cost 2d a pound. Slade student Edna Waugh stands her friend

Gwen John a boiled egg and coffee because she is too poor to buy herself a midday meal. Jacob Epstein earns one shilling an hour as an artists' model. His trousers are torn, he cannot afford a haircut, and he sleeps under newspapers.

The early 1920s, and the aspiring artist Kathleen Hale's luck has run out; she is only able to save herself from starvation by selling her hair. Sophie Fedorovitch, an exiled Polish painter, is living in one room on the Embankment, with no bed, only a chair to sleep on, and a broken window pane which she cannot afford to have mended. The newly married artists John and Christine Nash are struggling to feed themselves on the proceeds from John's wood engravings. If he makes three guineas Christine reckons they can eat for a month.

Constantine Fitzgibbon was convinced that by the 1930s conditions for artists had deteriorated yet further – 'There was suddenly much less money about.' The Depression meant that parents were even more unwilling to subsidise the younger generation in feckless activities like painting or writing poetry. Compared with what he saw as the irresponsible freedom of art students in the 1890s, Fitzgibbon insisted that his contemporaries had no room for manoeuvre: 'What the young men of the thirties could afford was a bedsitter and beer and sometimes Bertorelli's.'

Bertorelli's could do a half-portion of spaghetti in those days for fivepence, while a bedsit might cost about twelve shillings a week; (in Dylan Thomas's case the rent was extracted from him by his flatmates who held him upside down and shook the shillings from his pockets). Two pounds a week would keep the wolf from the door, just.

I don't know what I lived on during this period

recalled the writer Philip O'Connor of that time . . .

. . . on sixpences, half-crowns . . . friends, my sister; I painted water-colours for our local art-dealer and junkman, who paid me 1½d each for them, and up to five shillings for oils . . . when [I was] very short, I would raid my sister's flat, mostly for pots of jam.

But it all depended on what you expected of life, and a cheerful Micawber-like optimism can be discerned among some very poor artists who found to their joy that they could live within their income. Augustus John's wife, Ida, wrote to a friend describing the family's life in Paris in 1905. They had almost no furniture, only one bed between the three adults and five babies,

and bare boards on the floor. But Ida was content: 'I think we must be rich, because though there is such a lot of us, we live very comfortably and are out of debt.'

Such happy situations were rarely the result of financial competence. Detached from their class, many artists abandoned hope of ever acquiring middle-class virtues like how to handle money. The careful keeping of accounts, an activity so dear to the heart of the bourgeois chatelaine, was in any case dismissed in most artistic households as petty, materialistic and irrelevant to art.

The themes of unworldliness and poverty run throughout Arthur Ransome's *Bohemia in London* (1907), an autobiographical account of a youthful sub-culture. This engaging book is a companion guide for the novice traveller in Bohemia, with lively descriptions of the terrain, the natives and their habits, diet, language and customs, by a resident; it was written when Ransome was only twenty-two, twenty-five years before he wrote the first of his classic children's books, *Swallows and Amazons* (1930). An odd, subjective ramble, its very naiveté is persuasive. For Ransome, you could only qualify as a Bohemian by being poor, but in Bohemia, discomfort was immaterial, and hunger insignificant compared to the bliss of living there. His descriptions of his garret existence in Chelsea – the Bohemian heartland in those days – are full of nostalgia for a penurious but happy existence. 'Those were wonderful days in that winter of 1904,' he later wrote in his autobiography, and in the next sentence: 'I never starved but I was always hungry.'

In the following decades, Arthur Ransome's Bohemia was unconsciously replicated by a generation of hard-up artists in the basements and studios of Chelsea, Fitzrovia, Camden Town and Bloomsbury. Their priorities, like his, were not financial:

The men who really care for their art, who wish above all things to do the best that is in them, do not take the way of the world and the regular salaries of the newspaper offices. They stay outside, reading, writing, painting for themselves, and snatching such golden crumbs as fall within their reach from the tables of publishers, editors and picture-buyers. They make a living as it were by accident. It is a hard life and a risky . . .

Literature was Ransome's passion. Rather than lose the chance of buying two leather-bound volumes of *The Anatomy of Melancholy* for seven-and-sixpence, he preferred to go without dinner and walk home to Chelsea.

One can't help sympathising with this kind of spontaneous improvidence, uncalculating and naive as it is, just as it's hard to resist, against one's better judgement, applauding Augustus John for crazily investing £300 in the construction of primitive aeroplanes by a French crank called Bazin. There is no evidence that anything became airborne as a result. John's friend and rival Jacob Epstein – who never learnt how to sign a cheque – used to arrive at his mistress Kathleen Garman's house once a week laden with apricots in brandy, exotic flowers and fruit. 'I wish he could have given us something for the housekeeping,' recalled Kathleen's daughter sadly. The actress Brenda Dean Paul and her mother never failed to deck their studio with gardenias and tuberoses, even when all they could afford to eat was a boiled egg. Such grand gestures would furnish further proof to the bourgeoisie of artistic foolhardiness.

<p style="text-align:center">*</p>

'Not taking the way of the world' often meant serious hardship; clearly Bohemia's poor had to find other sources of income than painting, poetry and prose. All too often, they were dealing in unsaleable commodities. Luckily, their powers of invention were not wasted in coming up with ideas for keeping themselves afloat. A well-disposed dentist appears to have accepted paintings in return for dentures in St Ives. Nina Hamnett kept herself in drinks outside pub hours by painting murals on the walls of the Jubilee Club.* Lilian Bomberg started a greengrocer's shop which foundered through lack of custom: the strait-laced locals were deterred by the sight of Bomberg's Bohemian garb as he perched on a ladder painting the sign to hang above it. And the poet Liam O'Flaherty took up catering:

[We're] setting up 'tea-rooms' in this house, giving teas to tourists. Crowds of people come up to see the mountains in summer, so they will probably make the thing pay. Margaret will cook, Adelaide will serve, and I will be on the premises armed with a monstrous axe to club the bourgeoisie if they become impertinent or fail to pay their bills. I hope we make some money in the business because it seems there is very little hope of making money any other way.

And in a lucid moment between drugs, apache lovers and absinthe, Epstein's luscious model Betty May decided to start a sweetshop in the country, making all the confectionery herself. Rather to her surprise it was a success, but she was forced to give it up by her current husband and his disapproving

* Myth has it that one of Nina's few properly paid jobs was as art critic of the *Licensed Victualler* journal.

family who thought 'Miss Betty' should not be engaging in retail trade. Mortified, she was on the next train back to the Café Royal. There was always a familiar face there who would stand her a drink.

The Café Royal was a good place for a spot of wheeler-dealing too. When times were hard Betty or her fellow Bohemians might make the price of a glass of absinthe by supplying gossip or copy for an exhibition critique to the Fleet Street hacks who flocked around its tacky but opulent interior hoping for morsels from the art world. If this failed they could always borrow from a friend.

<p style="text-align:center">*</p>

Bohemia's position on borrowing money was startlingly distinct from that of conventional society, and it still is. Most people in the early twentieth century subsisted on cash; bank accounts were only for the better-off. Lady Troubridge, author of *The Book of Etiquette* (1931), categorised 'borrow[ing] even the smallest sum of money' alongside unpunctuality, putting one's feet on the chairs or sneezing in public. This was, indisputably, 'Conduct which is incorrect.' To offend against Polonius's famous injunction 'Neither a borrower nor a lender be' had been regarded for centuries as taking the slippery slope to perdition. The easy-come easy-go, sometime-never attitude to borrowing which existed in Bohemia was worlds away from the condemnatory stand of Lady Troubridge and her ilk, and yet the anecdotal evidence is that hardly anyone was hurt by it.

This was because in Bohemia you didn't borrow ten pounds to last you the month, you borrowed your twopenny bus fare home. You hung around Augustus John till he stood you a drink. On the whole the borrower was straight: 'I am asking you to send me fifty pounds,' wrote the South African poet Roy Campbell to a friend, C. J. Sibbett. He was in dire need. 'I shall never be able to repay it. I am asking it as a gift.' Sibbett sent twenty-five pounds straight away, and another twenty-five soon after. No doubt there were scroungers and spongers, but it was a two-way process, and the Bohemian community took a different attitude to helping out needy comrades. Viva King, for example:

[My mother] thought [Francis Macnamara] a sponger . . .

she wrote in her piquant autobiography, *The Weeping and the Laughter* (1976), recalling her curious platonic relationship with one of Augustus John's closest friends:

'If you want to see English people at their most English, go to the Café Royal where they are trying their hardest to be French,' wrote Beerbohm Tree. Augustus John was the Café's acknowledged king.

Perhaps because I have always been a rock for spongers to cling to, I have never understood why scorn is heaped upon those who are often clever enough to take with grace what is usually freely given.

Viva, a Bohemian celebrity in her own right (though never an artist) had experienced poverty but married wealth; her sympathies, however, remained with the poor and she strongly appreciated Francis Macnamara's Irish gaiety and wit. Viva generously forgave his sponging habits in return for the pleasure they had together – trips to the zoo and strolls round antique shops in the Brompton Road – while taking the view that artists are exempt from the rules; you lent money to them out of the goodness of your heart, understanding and forgiving them whether they were geniuses or not. Above all, there was a tacit understanding that you didn't expect to be repaid.

For Francis Macnamara the word 'lender' was synonymous with 'giver', and his children were brought up with this assumption. His daughter Nicolette grew up between her own family and the Johns (Augustus was a second father to her). It was they who influenced her belief that money represented only one thing – freedom of action – while entailing no

responsibilities. Neither she nor anyone she knew had ever 'earned' money. Francis wrote; Augustus painted. This they did from innate talent. 'Money was a secondary consideration.' When needed it would appear as if by magic from some patron or rich relation. Failing this, borrowing was the obvious solution. When Nicolette married the painter Anthony Devas she discovered to her astonishment that his family did not see things in the same light – 'With the Devases, borrowing was to be avoided except in an emergency.' It took Nicolette much painful adjustment to come to terms with the conventional Devas approach to money, where borrowing and not returning money was seen as bordering on theft.

For some Bohemians, the distinction between borrowing and downright dishonesty became blurred. Cheques were bounced, shops lifted, hotel bills left unpaid by fleeing guests. Constantine Fitzgibbon expended considerable ingenuity in cheating the gas company. He inserted twenty-five centime pieces into the meter, which worked if you gave it a sharp tap at the same time. He also discovered to his joy that if he placed a sixpence on the railway line which ran a few hundred yards from his tumbledown cottage near Buntingford, the train would squash it to the size of a shilling, and the gas meter would not differentiate.

There were those who took the view that possessions were bad, so it was all right to take them off people. Philip O'Connor broke open his sister's gas meter and went off with the proceeds without any compunction. In the thirties, the critic Geoffrey Grigson and his wife took pity on the indigent Fitzrovian poet Ruthven Todd, 'an unhealthy-looking grey oddity'. Grigson had often wondered how this Bohemian kept alive – he seemed to have no visible means of support. Eventually he fathomed that Ruthven supported himself by stealing.

[He was] a thief, an innocent, honest literary thief. He wouldn't have picked your pocket or burgled. Books and manuscripts were his game, not from shops, but from friends or those who befriended him.

Unaware, the Grigsons let Ruthven a room in their house for ten shillings a week in the belief that a job he then had reviewing books would cover this paltry sum.

One day Grigson was chatting to a bookseller acquaintance in his shop off the Charing Cross Road. The bookseller mentioned that he had bought for ten shillings a batch of second-hand books, one of which happened to contain a letter to Grigson. A few weeks later, the bookseller pointed out another strangely familiar batch of books which he had bought from the

same seller. It was Ruthven Todd. Grigson paid ten shillings and bought them back. This arrangement persisted for some time; Todd filching his landlord's books from the top shelf where he was least likely to notice their absence, selling them and paying his rent back out of the proceeds; Grigson then retrieving his possessions for payment of the same sum.

We never taxed the Innocent Thief with his theft, this generous creature who seldom came to see us without some present, paid for God knows how, for the children.

Thus by shifts and expedients and the generosity of friends the Bohemian ekes out a dependent survival; Grigson's patient collusion in what the bourgeois world would undoubtedly see as a reprehensible offence, his warm-hearted appreciation of Ruthven's essential honesty and niceness, leaves one feeling the world to be a better place.

<p style="text-align:center">*</p>

One of the most noticeable and cheering things of all as one delves into accounts of Bohemia is the ready assumption among the better-off that if you had money you were honour-bound to help those who had none. And even if you had no money at all – like Dylan and Caitlin Thomas – you despised bourgeois tight-fistedness:

Avarice, meanness, stinginess were the worst of all crimes for us . . . We ourselves were never mean. We bought drinks liberally round the house, on tick . . . It is easy not to be mean when there is nothing in the kitty to be mean with. The more that is in the kitty, the more difficult it is, apparently, not to be mean.

It was of course an attitude that reduced them speedily to a state of utter dependency.

Friends' open-handedness must have saved many an impoverished artist from despair. Take Augustus John; it was he who spotted Kathleen Hale's talent and gave her the post as his secretary, at two pounds a week, so that she could give up scratching a living doing odd jobs and find more time for her own work. Or take Maynard Keynes, who tactfully subsidised two of his best friends, both in money difficulties, the painter Duncan Grant and the writer David Garnett. Keynes insisted that a deed of covenant made out to Grant should be dependent on an equivalent deed made out to Garnett, thereby ensuring that each felt impelled to accept the money, because refusing it would jeopardise the offer to the other. Keynes also contributed

heavily towards the cost of running the Bell country house, Charleston. Roger Fry was another philanthropic friend to penniless artists: it was partly their plight that persuaded him to start the Omega Workshop in 1913, as a way of providing hard-up artists with a minimal income. A similar enlightened attitude prevailed when Helen Anrep, Fry's mistress, was left after his death in reduced circumstances – an unmarried 'widow'; Vanessa Bell and others clubbed together to buy her a reconditioned refrigerator.

The story is well known of how Virginia Woolf and Ottoline Morrell – deeply impressed by reading *The Waste Land* – set up a fund to release T. S. Eliot from the necessity of working in a bank (help which he rejected as insufficient). It is only one among many heartening examples of altruism in the artistic community. Long before he was famous, Lytton Strachey was supported financially by his friend Harry Norton. The painter Dorothy Brett regularly paid Mark Gertler's rent for him. The editor Edward Garnett, having located a cheap cottage for W. H. Davies to live and write in, paid for the poet's fuel and light out of his own pocket. Numbers of young artists – Gertler, Nash, Meninsky, the poets Rupert Brooke and Isaac Rosenberg – had reason to be grateful to the patron Eddie Marsh, who bought their work, had them to stay and helped them out in innumerable ways. Edward Wadsworth was a painter who had inherited a fortune, and he and his wife Fanny entirely supported the Vorticist leader Wyndham Lewis during his most impoverished period. But Lewis found it hard being an object of charity. Regrettably, one week the expected sum of money failed to materialise, whereupon Lewis scrawled an ungracious postcard to his benefactors bearing the words:

Where's the fucking stipend?
Lewis

Lewis later became dependent on the reluctant charity of Dick Wyndham (no relation), an aspiring artist of substantial independent means, who felt exploited by Lewis's rapacity. The writer took revenge on his patron, portraying him in *The Apes of God* (1930) as a vile charlatan with deviant sexual tastes, and that was the end of that friendship.

Patronage took many forms. Dick Wyndham's cousin David Tennant, a cultured socialite, made life easier for artists in the way he knew best, by starting the Gargoyle Club, which he specifically aimed at a Bohemian clientèle, keeping the prices deliberately low. Rudolf Stulik, the Austrian *patron* of the famous Eiffel Tower restaurant, applied a Robin Hood principle, charging people what he thought they could afford. The tactic eventu-

Illustration from "The Most Wondrous and Valiant Brett" – Dora Carrington.

Carrington pays homage to her friend Brett, at work in her sparse studio. The
gas ring at floor level was a common feature of rented rooms.

ally bankrupted him, and though the artists set up a fund to bale him out,
he was forced to leave his restaurant.

Established writers like Edmund Gosse, George Bernard Shaw and John
Galsworthy were notably generous to younger authors in distress, producing
loans and handouts. They were also luminaries of the Royal Literary Fund,
which gave grants to writers in desperate straits: in 1910 £1,650 was raised
to help authors who had 'turned their back on the prospect of pecuniary
gain'. There was of course no certainty of subsidy for all; in 1925 Liam
O'Flaherty was rescued from the brink by a cheque for £200, but in 1938
Dylan Thomas was turned down.

Unfortunately there was no equivalent fund for artists, and with no
state-funded safety-net, the Bohemian social network could be a lifeline for
those who were desperate. Somebody usually knew somebody who could
help, rally others, organise a temporary whip-round – even if they themselves
were little better-off. It was the compassionate Viva King who set up an
appeal to rescue her old friend Nina Hamnett from utter destitution.

Nina Hamnett had spent a lifetime only just keeping her head above

water – or perhaps, in her case, whisky. A splendidly buoyant and sociable character, she appears in innumerable memoirs of the period; she was the Ur-Bohemian, uncrowned 'Queen of Bohemia', first lady of Fitzrovia. In 1911 she rebelled against her middle-class background, and scraping by on the fifty pounds advance on a legacy from her uncle, plus two shillings and sixpence a week donated by some kindly aunts, she launched into the London art world with a vengeance. Her exuberance and spontaneity won her a wide circle of friends at the Café Royal, including Augustus John, Walter Sickert, Roger Fry and Henri Gaudier-Brzeska, and she soon conquered Paris, where she became an habituée of the left bank cafés, a friend of Modigliani, Picasso and Cocteau. She was an admired painter, but her real gift was for living life to the full. By the thirties Nina, a fixture in the Fitzroy Tavern, was virtually a tourist attraction in her own right. Yet she was always penniless. There are endless stories of her getting stranded in Paris unable to pay for her hotel, sitting in bars waiting for acquaintances to turn up to pay her mounting drink bill – though often she would have preferred a square meal. Ruthven Todd helped out when she couldn't afford clothes by printing a circular for her which read WHAT DO YOU DO WITH YOUR OLD CLOTHES? Do you give them to the SALVATION ARMY or the poor? If so, DO NOT, REMEMBER NINA. But as her youthful resilience waned, the issue of her poverty began to get more serious.

Her talent had degenerated but she never lost her good spirits

wrote Viva King.

The smallest happening in her life was enlarged to happy proportions. About 1937 I heard she was living in extreme poverty and a friend and I started a fund to help her . . .

They sent a circular to all Nina's friends suggesting that everyone should contribute half a crown a week to keep her going. The fund got off to a good start, but after a while the goodwill started to wear thin as it became clear that there was no other remedy for Nina's poverty. Eventually only Viva herself and one or two others were still loyally keeping the bailiffs at bay. Viva acknowledged that Nina, despite her dissolute ways, was capable of giving great joy, and saw no reason why she should be abandoned by the old friends who had had such good times in her company over the years.

For Nina, despite having to live in bug-infested rooms with at times only

boiled bones and porridge to keep her from starvation, was munificent when she had money. As a true Murger-style Bohemian, Nina would blow any money that came her way on 'ruinous fancies'. Her name had become well known in the newspapers after she had been sued for libel by the notorious diabolist Aleister Crowley in 1934.* One day after this when Nina was sitting in the Fitzroy Tavern, Ruthven Todd walked in with a copy of a popular paper, and pointed out to her a photograph captioned 'Miss Nina Hamnett, artist and author . . . takes a walk in the Park with a gentleman friend'. The caption was inaccurate, for the lady with the unnamed male friend was in fact Betty May. Nina jumped up, borrowed the newspaper and half a crown for a taxi, and dashed to Fleet Street where she demanded settlement for libel; to avoid trouble the paper promptly gave her twenty-five pounds. Before long she was back at the Fitzroy Tavern where she opened a tab for all comers. When Betty May walked in Nina instantly plied her with whisky; the astonished Betty wondered where all the largesse was coming from, and as soon as she found out she too was on her way to Fleet Street threatening writs. The paper obliged, forced to admit that their photograph of her was wrongly captioned, and she was soon back at the party with another twenty-five pounds. The celebrations went on well into the evening, by which time both women were back to their usual penniless state.

In her autobiography Nina rather wistfully reflected that her reckless attitude to money came about from her middle-class upbringing – 'being brought up as a lady and taught never to mention money'. Unfortunately, such artlessness had dire consequences. Poverty is bad enough, borrowing could suffice as a means of struggling by, but serious grown-up debt was no laughing matter.

For one proud spirit debt was a way of life. When he was at Oxford the young writer Arthur Calder-Marshall became friends with an eccentric spinster known to him and his fellow undergraduates as 'Auntie Helen'; they attended her tea parties and sat at her feet while she expounded to them on poetry and philosophy. In due course it dawned on Calder-Marshall that Auntie Helen was practically starving. He gently offered to give her some money. The old lady was indignant; she had learnt over a lifetime how to survive on nothing, and she was not going to start compromising now:

* Crowley, who claimed to be the Beast from the Book of Revelation, had set up a community in Sicily where abominable practices were carried out. Cats' blood was alleged to have been drunk. One member of the community – Raoul Loveday, third husband of Epstein's model Betty May – died. Nina had referred to this in print, and Crowley sued alleging defamation. However Crowley lost his case, and both Nina and Betty became household names overnight.

'. . . I don't want your money and I'll tell you why. As an Artist who will have to fight the Philistines all your life, the sooner you learn this the better. Remember: PROVIDED YOU ORDER THE BEST, THERE'S NO NEED TO PAY FOR IT.'

'I don't understand,' I said.

'Shopkeepers,' she said, 'are parasites on society. The important thing to know is that they are snobs. Never be mean. If you want a small bottle of eau-de-cologne, you can't put it on the bill. Buy a pint of Chanel. Don't drink beer. Order champagne; by the dozen at least. We Artists are the aristocrats of the world. But we must behave like aristocrats.'

Auntie Helen's extravagant philosophy didn't survive the Wall Street Crash. Those who, like her, lived on credit, were the first casualties. Calder-Marshall got an urgent message one morning to call at her house with the biggest suitcase he could carry. He managed to get there before the bailiffs, and carried away with him her best books, her precious candlesticks and her incense burner before the Philistines could get their hands on her 'lovely things'. Auntie Helen fled with what she stood up in.

*

And yet, despite a general ineptitude with money, some Bohemians renounced Chanel and champagne, while still managing to survive on very little indeed, and sometimes on almost nothing. Economies could be made, changes to one's way of life; one could retreat to less expensive locations, or even emigrate. Living experimentally was all too often a by-product of being forced to live economically.

When Mary Garman (sister to Kathleen, Epstein's mistress) married the poet Roy Campbell, she was making ends meet by driving a bread-delivery van. Roy's father cut off his allowance for marrying without his consent, and the couple were living in rags. In the early days of their marriage they survived as artists' models and for a while Roy was able to make a living as an acrobat for two pounds a day. But being shot backwards out of a gun and chewing glass in front of an audience couldn't last, and Roy and Mary were sick of city life. They moved to deepest Wales where Roy set out to demonstrate that you *could* live on poetry and nothing else. This was in 1921. The stable they rented cost £1 16s a year. Five pounds a month paid for everything else, though books accounted for half of this budget. That left about 12s 6d a week for all their bodily needs – in other words, next to nothing. They had no earnings at all. The very small sums they now required for the rent were provided by an anonymous well-wisher; this proved to be Roy's father, who had relented and reinstated Roy's allowance at a minimal

level. The couple settled down in their mud-floored stable to read Dante, Rabelais, Milton and the Elizabethans – 'living on the continual intoxication of poetry for two years'. Roy, who had tremendous caveman instincts, went trapping for rabbits and game for the pot, and they collected gulls' eggs from the cliff face. He poached and scavenged, and sometimes the locals would bring them gifts of potatoes or fuel. It was a heady life, and cheap.

Soon after Roy and Mary's two daughters were born the family moved to France, lured by the romance of Provence, bullfights and troubadours, but also by the favourable exchange rate then prevailing. In 1925 you could get over a hundred francs to the pound; in the late twenties George Orwell rented a room in Paris for two hundred francs a month, and found he could live – just – on six francs a day. It was this fact as much as the inspiring quality of the Mediterranean light, the intoxicating conversation of the Montparnasse cafés, or even the wonder of seeing Florence or Rome, that led many artists like Roy Campbell to forsake England and find a place where it was, quite simply, cheaper to live. Fact and fiction tell us how, with the post-war exchange rate at its most favourable for years, the exodus to the Mediterranean was irresistible, because you could live in the sunshine for half what it cost to live in England. Even after the crash, one could still get over eighty francs to the pound, and a prix fixe menu cost six francs; while in Italy in the 1930s for example, the exchange rate was nearly sixty lire to the pound. Aldous Huxley found that he could live 'in comfort' there on £300 a year. 'The worst is however that I haven't got £300 a year . . .'

In her novel *Ragged Banners* (1931) Ethel Mannin's hero the young poet Starridge shakes the gloomy poverty of London from off his feet and, with an artist friend, heads for the Riviera. After paying for third-class travel to Italy they have £12 left between two: 'We can live on that for six weeks at least . . . We've really nothing to worry about. The gods, anyhow, will take care of their own . . .'

This deeply held assumption that one would never really have to go hungry died hard. The Campbells, Huxley, and the fictional Starridge all came from educated middle-class backgrounds, and adapting to poverty was hard for them. Such people, brought up to expect a certain level of comfort, might well be loath to scrounge drinks and borrow money because they were too broke to stand a round. Their asceticism was often nominal, and having to be stingy went against the grain. Recalling his youth in the 1920s, the writer Douglas Goldring summed it up:

No one who has not actually been through the experience of dropping suddenly from middle-class comfort to the income level of a farm labourer, can understand

its effect on men old enough to have acquired certain regular habits, such, for example, as changing occasionally into evening clothes, taking cabs . . . In 1919 I used to be genially mocked by Alec Waugh: . . . 'Look at Douglas! If he's only got half-a-crown in his pocket, he hails a taxi.' . . . Going abroad broke the shock. Cheap hotel accommodation, cheap – and delicious – food and even cheaper drinks also made it possible for the depressed *intelligentsia* to enjoy for a while the indulgences and *menus plaisirs* to which, in pre-war days, they had been accustomed.

For despite the strong imperatives that kept Bohemians poor – idealism, artistic status, rejection of materialism, contempt for wealth – Bohemia often proved in the end a dispiritingly necessitous place in which to live. For a group of people who to some extent defined themselves by their denial of the moneyed world, they were indeed noticeably obsessed with it. It could be very hard, if you were a painfully impecunious artist, not to feel that the rich world was undeserving. Living with the consequences of a difficult choice can strain one's powers of endurance. Indeed, a sense of monstrous injustice that 'they' should have all the money and none of the capacity truly to feel or appreciate the finer things, burned in many breasts. It was quite simply unfair that the rich should be so rich, when there was no money left in the kitty, and one's tiny hand was frozen, and one was burning one's poems to keep warm . . . The artist Dora Carrington (who chose to be known by her surname) had been painfully poor in her time, living off soup and unable to afford tram fares; still in financial difficulties after her marriage to Ralph Partridge, she longed for her parents-in-law to die and solve their problems: 'It makes one's blood boil that R's parents should be such shits and such rich shits . . .' she moaned, but when 'old Perdrix' finally did die they weren't much better off:

At the most we shall gain £60 by old Perdrix's death . . . I wish some malignant disease only to be contracted by middle aged – middle class parents would sweep through England, . . . and swallow them all up.

Uncharitable emotions perhaps, but understandable. Meanwhile, she and Ralph continued to be dependent on the better-off Lytton Strachey, who was unfailingly generous in subsidising those who were dear to him. Even before he had much money himself, Strachey was supportive to needy artists, like Carrington's ex-lover, the painter Mark Gertler.

Mark Gertler was the son of an impoverished immigrant Jew; for a while his father supported the family of seven on 12s 6d a week earned by smoothing walking-sticks with sandpaper. They lived in one room in

Whitechapel. Stubborn and obsessive, Gertler grew up with a powerful sense of the injustice of their lot. Vital, mercurial and determined to become a painter, he overcame his father's reservations and gained assistance to attend the Slade School of Art. It was there that he fell passionately in love with the elusive Carrington, and it was also at the Slade that this almost uneducated prodigy crossed a class barrier into a world of incongruous, exciting new values. But his lack of money caused him deep frustration:

No one loves comfort more than I do . . . [but] I am continually struggling against being overcome by the sordidness of my surroundings and family and by poverty. How I loathe poverty!

Gertler had no desire to live out a fantasy, and by 1916 was totally disillusioned. He wrote to Strachey:

Yesterday I drew my last £2; in about a week I shall be penniless . . . To be a good artist one must have an income. Believe me that is true. The starving artist in the garret is a thing of the past. To paint good pictures one must have a comfortable studio and *good* food – a garret and crust of bread isn't good enough. Let no person come and tell me that poverty is good for an artist!

Strachey did his best to rally friends around, encouraging them to make contributions or buy Mark's pictures, and many helped where they could. But all his life Gertler never really escaped from the scourge of money worries, not helped by the black depressions to which he was prey. He contracted tuberculosis, partly brought on by poor diet and living conditions. Later, marriage and a child increased his sense of responsibility. Through the thirties Gertler kept anxious accounts of income and expenditure in which the settlement of hospital fees, and doctor's and whisky merchants' bills feature alongside laundry, rates and electrical repairs. In 1939, aged forty-eight, worn out by the years of unequal struggle, he turned on the gas tap and lay down to die.

<center>*</center>

Inevitably, perhaps, the Bohemian artists' attitude to wealth and poverty led them into a perplexing maze. 'I am an artist, therefore I despise wealth,' runs the argument. 'Though I cannot earn money by my art, I need money to live, but I hate materialism because materialism destroys art. Art can only flourish where material things are absent. The seriousness of my artistic purpose is thus defined by my poverty. But I am sick of living off hard-boiled

eggs, and freezing, and it is making me ill, and if I don't have food and clothing and medicine I will die . . . and if only I had five shillings, or five pounds, or five hundred pounds a year and a room of my own . . .' Poor Caitlin Thomas did her best to be penniless and proud of it in her artistic life with Dylan, but every so often her resolve broke down when she thought of how things might have been if Dylan had capitalised on his fame instead of squandering every penny on booze: 'Just think of the money: wads of lovely crackling cracklers to do with just as one pleases . . .' It's a *cri de coeur*, from one who has never had enough.

In his search for the meaning of life, Gerald Brenan's fictional hero Jack Robinson is less emotional, more analytical, in reaching the same conclusion: money is indispensable. It has taken him an investigative odyssey via the vagabond Kelly, the world of gypsies and vagrants, sleeping rough and scraping coppers from the gutter, to discover that life in the abyss is base and barbaric:

I had looked poverty in the face; those features, if touching and tragic to a cursory glance, were on a more lengthy inspection merely stinted and meagre . . . Off then with these rags! I must henceforth make it my aim to acquire money.

In parallel with his character, Gerald Brenan himself also suddenly found himself possessed of a grown-up income – unearned in his case. He was briefly overwhelmed with conflicting feelings of gratitude and guilt at the betrayal of his early ideals, but self-interest emerged the winner and he hurried out to purchase a fast car.

<p style="text-align:center">*</p>

Does being rich disqualify one from Bohemia? Obviously, poverty is not the sole qualification for joining the club – love of art and scorn of convention can also arise in the rich man's breast. In fact some artists and *soi-disant* Bohemians were quite well-off with private incomes, while retaining their anti-materialist ethic intact. Frances Partridge, a committed art-lover with Bohemian allegiances, has always maintained that 'money is the most ghastly form of snobbery'. She had married Ralph Partridge after Carrington's death, and he now kept the couple comfortably off through his money market speculations. The phenomenon of the rich Bohemian has arisen since Henri Murger's time – to him it would have been antithetical – but it nevertheless demonstrates that the notion of Bohemia is more than the sum of its parts as portrayed in the *Vie de Bohème* model.

Even in the late nineteenth century, when awareness of garret-Bohemia was at its highest, a parallel Bohemia existed of comfortable, clubbable old

roués in soft collars with their actressy female companions, keen to spend an evening knocking back claret and admiring each other's pen portraits. Such far from penurious art- and literature-loving chattering classes of the day had their own publication, *The Bohemian* (founded 1893) – 'An Unconventional Magazine' – which regaled them with reviews, music-hall gossip and risqué fiction. They disported themselves at the Bohemian clubs, the Sketch or the Savage. A typical habitué of such clubs is described in H. G. Wells's 'succès de scandale' *Ann Veronica* (1909): the heroine is courted by an eminently 'suitable' young man, Hubert Manning, for whom she feels friendship but no passion. Mr Manning writes her a most reasoned and persuasive proposal of marriage, laying before her his prospects and advantages, these being of such transparent merit that the pompous young man has little doubt of being accepted:

I come to you a pure and unencumbered man. I love you. In addition to my public salary I have a certain private property and further expectations through my aunt, so that I can offer you a life of wide and generous refinement . . . I have a certain standing not only as a singer but as a critic, and I belong to one of the most brilliant causerie dinner clubs of the day, in which successful Bohemianism, politicians, men of affairs, and cultivated noblemen generally, mingle together in the easiest and most delightful intercourse. That is my real milieu, and one that I am convinced you would not only adorn but delight in . . .

Any heroine worth her salt would refuse such a complacent stuffed shirt, and of course Ann Veronica does. But the interesting thing about this is that even some wealthy asses like Hubert Manning felt that Bohemia gave them a certain creditable standing, so long as it was of the 'successful' sort. One didn't want to come into too close proximity with the garret. That was for fiction, or for failures.

Ruin lurked around every corner, and a fellow-traveller like Mr Manning preferred to take no risks with his public salary or expectations, since even for a successful writer there were no guarantees of security. The name of Stephen Phillips is virtually forgotten today, and yet in his day the young poet made a small fortune by his writings, which were compared favourably by critics with those of Sophocles, Shakespeare and Milton. More than 21,000 copies of his verse drama *Paolo and Francesca* were printed and sold, and for some time Phillips was receiving about £500 *a week*. Phillips was tall and well-built, and women idolised him, but he loved and married a lowly actress whose father was a builder. While May was pregnant she had a riding accident; the baby was born prematurely and died young. Phillips took the

blame on himself. That was the end of his happiness; he became bitter and started to drink heavily. The money slipped through his fingers; he lived out the Bohemian myth *à la* Murger, spending it on 'ruinous fancies . . . drinking the oldest and best . . .' – which he believed would inspire him, but as his life collapsed, so did his reputation. Nevertheless he continued to throw money away in munificent gestures. Once in freezing weather he bought a fur coat for a hundred and fifty guineas, and the very next day gave it away to a tramp. (The tramp, afraid to be accused of theft, returned it.) Recklessly generous, Phillips gave his last five pounds to an old actor friend who was out of work. At last even May left him, hastening his disintegration. He died at fifty-one.

Safer far to look after the investments while enjoying the social laxity that Bohemia seemed to offer. One well-heeled example is Sir Herbert Beerbohm Tree, who used the substantial profits from his production of George du Maurier's *Trilby* (another Bohemian garret love story) to build Her Majesty's Theatre in the Haymarket; high up in an inner sanctum of the theatre's dome he and his wife Maud gave opulent first night supper parties to the élite of 'High Bohemia'. This artistic milieu was the natural territory of their daughter Iris, a socialite art student whose original appearance and gregariousness brought her a wide circle of friends and admirers, many of them from the upper echelons of society. With Lady Diana Manners and Nancy Cunard, Iris formed a kind of 'Mayfair troika', the centre of 'Haut Bohemia' in the twenties. A swarm of moneyed acolytes gathered at their table at the Eiffel Tower – here were to be seen the likes of ex-debutante turned small publisher Allanah Harper, society photographer Cecil Beaton, chronicler of the inter-war period (and, probably, one-time lover of Nina Hamnett) Anthony Powell, soldier and landowner turned writer and painter Dick Wyndham, or the sapphist descendant of the Duchess of Westminster, Olivia Wyndham. These 'Bohemians' were a far cry from Mimi and Rodolphe, or the ravenously hungry Arthur Ransome, or the desperately dependent Mark Gertler, but despite their financial means, they still fall within the definition. It expands to encompass them.

Or take Bloomsbury – most of its members were comfortably middle class, with private incomes and support systems which – compared to the garret dwellers – placed them well outside the confines of famine-and-feast Bohemia. Clive Bell was a bon viveur with extensive financial resources from his parents' coal-mining interests. His wealth supported Vanessa Bell's ménage, paying for the upbringing not only of his own children but also of Vanessa's daughter by Duncan Grant, Angelica. They had servants and were able to maintain rented establishments in London, Sussex and the south of

France. Yet Virginia Woolf asserted in her diary in 1930 that Vanessa and Duncan based their relationship on Bohemianism, and that this was what gave it its indestructibility. Angelica too regarded her mother as being an instinctive Bohemian, despite her upper-middle-class upbringing, which from time to time reasserted itself. Vanessa's Sussex home, Charleston, has today come to epitomise the Bohemian lifestyle. Or take Augustus John, who by the 1920s was one of the highest-paid living artists in Britain, painting millionaires; one such portrait sold in 1923 for three thousand guineas. Yet still Augustus encapsulated the very image of the Bohemian in his manners and appearance.

The existence of a rich Bohemia presented artists with a difficult problem. The invasion of their inviolate territory by the moneyed world was in some respects welcome, providing as it did a market for creativity, and yet it was also deeply distasteful. It distorted artistic values. By the twenties rents in Chelsea had been driven so high by invading dilettanti that Ransome's hard-up painters and poets had all been forced out. 'Art has now become a business, like the selling of stocks and shares or jam or motor-cars . . .' lamented the cultured social commentator Patrick Balfour in 1933. The artist's challenge to society was devalued by its reduction to the status of commodity; this was, and still is, a bitter pill to swallow. Yet there have always been some, like Philip Carey in *Of Human Bondage*, Mark Gertler, Arthur Ransome, Nina Hamnett, Kathleen Hale, Dylan Thomas and many others, who refused the palliative, remaining uncompromising in their choice of a way of life.

★

Was it worth it? What if Nina Hamnett had settled for a safe life: the marriage market, babies, the conventional life of a middle-class 'lady'? What if Mark Gertler had decided to join the family firm in the East End and become a furrier? Or if Kathleen Hale had done a secretarial course like her sister instead of going to art school? Would their lives have been more fulfilled? The answer is inevitably a mixed one. When Arthur Ransome, by then an elderly successful writer, looked back on his Bohemian days, his main emotion was one of nostalgia for his romantic youth:

It was certainly the unhealthy, irregular meals I ate, my steady buying of books instead of food, that brought about the internal troubles that have been a nuisance through most of my life. At the same time I doubt if any young man . . . can ever know the happiness that was mine at nineteen, dependent solely on what I was able to earn and living in a room of my own with the books I had myself collected.

One morning, six months before her death at the age of a hundred and two, I met Kathleen Hale, the author and illustrator of some of my favourite children's books, about Orlando the Marmalade Cat. Her memoir *A Slender Reputation* (1994) had proved a rich resource in researching this book. I found Kathleen living in a small basement room in an old people's home on the outskirts of Bristol. The walls of her room were adorned with her own drawings, lino cuts and metal compositions. Though rather deaf, she was vigorous and somewhat formidable. Her springy iron-grey hair was cropped short, and she wore a blue caftan top with a silver necklace. She talked about the past, but also about the present, and her relationships with the other 'greyheads' in the home, who to her surprise had turned out to be fascinating individuals. Halfway through our interview she mischievously produced an illicit bottle of gin which we drank from plastic cups. Encouraged, I said I thought that despite the extreme hardships of her early life, I was under the impression that she had enjoyed it:

'Oh yes, it was absolutely wonderful, and not hard all the time by any means, and the difficult parts like having to stay indoors because you couldn't face going past a bun shop, well, that was all part of it, all part of the general plan I had of how to live. But oh, my dear, it was freedom, it really was, it was bliss.'

2. All for Love

What is wrong with talking about sex? — What is wrong with sex outside marriage? — Why shouldn't self-expression extend to the bedroom? — Is homosexuality wrong? — Must relationships be confined to members of the opposite sex, and the same class and colour? — Is marriage a meaningful institution? — Is there such a thing as free love?

In a desert of Victorian values, Bohemia was an oasis where anti-permissive rules had no force. Sexual licence in an artistic environment was a powerful combination, both threatening and alluring, and part of the irresistible fascination for the general public of *la vie de Bohème* was the passionate abandon represented by Murger in his portrayal of that life, by Puccini in his opera of the book, and by George du Maurier in his best-selling love story *Trilby* (1894).

In *Trilby* three young Englishmen (fairly well-heeled) go to Paris to play at being Bohemian. They adopt suitable camouflage — artistic berets and blouses — go in for interesting salad dressings, and generally disport themselves in the city of sin. The handsome one (rather disconcertingly named Little Billee) falls madly in love with a charming Irish laundry-maid, formerly an artists' model, named Trilby, and is overjoyed when she agrees to enter an engagement. This 'entente' causes mayhem when Little Billee's mother, Mrs Bagot, finds out. Mrs Grundy incarnate, she storms across the Channel, and when she discovers Trilby's former profession, promptly intervenes and breaks up the relationship. Little Billee is grief-stricken:

I want — *her* — *her* — *her*, I tell you — I must have her *back* . . . do you hear? . . . *Damn* social position . . . Love comes before all — love and art . . . and beauty . . . Good God! I'll never paint another stroke till I've got her back . . . never, never, never I tell you — I can't and I won't! . . .

But Trilby is cast out, and takes up with Svengali, whose name has entered popular phraseology as the hypnotic magus with sinister powers. Trilby falls under his spell and takes the world by storm as a singer. She returns to Little Billee at the end when it is too late, and dies — but not before Mrs Bagot has had time to repent of her harsh words.

This novel, which became a huge popular success, had all the elements most calculated to titillate an appreciative British readership. There was the ingénue heroine whose sexual downfall makes her a victim, dying a 'tragic' operatic death. There was the romance of the mysterious seducer, irresistibly 'mad, bad and dangerous to know' – Lord Byron, Casanova, Don Juan and the Marquis de Sade rolled into one. There was also studio life: '. . . happy days and happy nights, sacred to art and friendship . . . Oh, happy times of careless impecuniosity!' This beguiling melodrama was to become a romantic prototype for a thousand aspirant Bohemians, appearing again and again in nostalgic memories of youth, like those of Viva King:

I had long yearned for the sort of studio life described in *Trilby*. Walking alone in Chelsea, I would gaze up at the large windows and see myself among crowds of artists and musicians. There was little work going on in the studio of my imagination. It was mostly fun and conversation, with me a listener to all the intellectual talk, a spiritual helpmeet or Egeria of some great man. But I was Martha as well as Mary, ready in a day-dream to work myself to the bone to further the genius of the man I loved. I was a little dashed when Father described *Trilby* as 'a boring book about three English prigs', even though by now I had moved on to Murger's *Vie de Bohème* . . .

Trilby: the romantic prototype.

In 1900s Bohemia we are in a time of wide-eyed romanticism. Little
Billee, Viva King and their contemporaries now seem appealingly innocent,
unworldly and unmaterialistic, but 'Love comes before All – Love and Art'
and 'Free Love' were mantras for their time. The new generation was
sloughing off the dead casings of the nineteenth century, emerging in a fresh
skin, to rediscover Love and rediscover Sex.

It was probably in 1908 that Virginia Woolf, her sister Vanessa, and Lytton
Strachey found they could talk about sex. The story has been often repeated,
but it still stands as a mythic moment in the history of twentieth-century
liberation:

... the long and sinister figure of Mr Lytton Strachey stood on the threshold. He
pointed his finger at a stain on Vanessa's white dress.

'Semen?' he said.

Can one really say it? I thought & we burst out laughing. With that one word all
barriers of reticence and reserve went down. A flood of the sacred fluid seemed to
overwhelm us. Sex permeated our conversation. The word bugger was never far
from our lips. We discussed copulation with the same excitement and openness that
we had discussed the nature of good. It is strange to think how reticent, how
reserved we had been and for how long.

That celebratory sense of liberty, the feeling of bursting from bonds, was
almost tangible at times: 'I want to kiss people, copulate with them, dance,
drink, ride in racing motor cars, climb trees, camp out . . .' confided the
young David Garnett to his diary.

Divesting oneself of virginity without more ado was the first thing to do
– like the young Enid Bagnold, who left her stuffy parental home in the
suburbs, went to live in Chelsea, and in very little time had taken the
irrevocable step with literary Lothario Frank Harris:

'Sex,' said Frank Harris, 'is the gateway to life.' So I went through the gateway
in an upper room in the Café Royal . . .

As I sat at dinner with Aunt Clara and Uncle Lexy I couldn't believe that my
skull wasn't chanting aloud: 'I'm not a virgin! I'm not a virgin!'

They were drunk on new delights, this unrepressed band of New Women,
and they felt no shame, no need to conceal their liberation. They wanted to
cry it from the rooftops. Nina Hamnett wanted a plaque on the house where
she had been deflowered. There was a sense of fun about the new-found
freedom. Sex was natural, loving, an expression of spontaneous lusts,

preordained for human ecstasy. What was to stop one making love on a clifftop in broad daylight? Why resist, why hold back?

Kathleen Hale in her old age was indignant at the suggestion that she and her friends were dissolute or promiscuous. She regarded herself as deeply in love, committed, and quite open in her affairs. It was all-important to her that she had profound feelings about her lovers, and it was this that gave her and Bohemians like her their moral validity.

For the pioneers of free love had more than their natural inclinations and lusts to support their cause. The Bohemian romantics were steeped in the ideal of truthful living and truthful loving. They were passionately certain in their belief that sex should be seen as a mystic state released from the prison of social expectations. Today such beliefs may appear naive, but the ideal of free love was revered with almost spiritual fervour by a generation of Bohemians. This idealism was fuelled by an equal sense of the profanity and barbarism of contemporary society, which not only condemned women and many men to a life sentence of never-to-be-realised longings, but prostituted women in a degraded transaction called marriage. When the author Grant Allen wrote his novel *The Woman Who Did* (1895) it was a best-seller. Although its language and sentiment read somewhat mawkishly today, the heroine would find many latter-day sympathisers in her single-minded determination not to marry cynically.

The beautiful Herminia Grey wears simple Pre-Raphaelite-style clothes and white roses in her hair – she is clearly all soul. To her rather more conventionally minded suitor Alan Merrick this virginal goddess is irresistible. Their conversation is on a higher plane, their hearts unite, and Alan asks Herminia to be his wife. But his plane is not as high as hers, for Herminia has made up her mind never to marry. Instead she proposes that they should be 'very dear, dear friends, with the only kind of friendship that nature makes possible between men and women'.

I know what marriage is – from what vile slavery it has sprung; on what unseen horrors for my sister women it is reared and buttressed; by what unholy sacrifices it is sustained and made possible . . . I can't be untrue to my most sacred beliefs.

Alan takes some persuading, but at Herminia's insistence eventually agrees to live unmarried for the sake of her principles. A dramatic confrontation ensues when Merrick senior, Alan's wealthy father, finds out. Spluttering with revulsion at his son's disgusting defiance of decency, he promptly disinherits him. Soon after, Herminia becomes pregnant. Rather shamefully, they go to Italy to have the baby in Perugia, and there Alan regrettably dies

of typhoid contracted from bad drains. Herminia is left a penniless unmarried mother. She returns to England and, as a fallen woman no longer acceptable to society, is faced with a struggle for survival. In her hour of need a kind editor gives her a small sum for some journalism; with hard work and a few friends she manages to scrape a living for herself and her child. Déclassée, bereft of respectability, soiled goods, yet still refusing to compromise those 'sacred beliefs', Herminia finds a natural home in the only community tolerant enough to give her refuge – Bohemia. A hospitable country, it had long permitted freedom of choice in sexual matters. Its doors had always been open to sexual transgressors, to unmarried mothers, to the unrespectable, the unfortunate or the plain immoral – all the casualties of bourgeois censoriousness. Although Herminia is a victim, ostracised and outlawed, by giving her unshakeable convictions Allen claims moral pre-eminence for his heroine.

The Woman Who Did made an eloquent if rather over-effusive plea for the values of tolerance and freedom in love, but perhaps their most sensational manifesto came with H. G. Wells's *Ann Veronica* (1909). It is hard now to understand quite how affronted polite society was by this novel, but the reaction was one of implacable hostility to the book's liberal message, and Wells had to endure humiliating persecution from public and critics alike. The book tells the simple story of its eponymous heroine, a 'new' woman (largely based on Amber Reeves, H. G. Wells's mistress at the time). As the daughter of a dull suburban business-man, Ann Veronica is impatient with the dreariness of her safe, sheltered middle-class life. Her aspirations of independence – ('I want to be a human being; I want to learn about things and know about things . . .') – become reality when she runs away to London. There she experiments with various emancipated movements – Fabianism, the suffragettes – but discovers true freedom only in the arms of her college tutor, Capes. Together they flee to Switzerland. Despite, or because of, the hostile reaction to the book, thousands of readers were mesmerised by Wells's daring in depicting this love affair, in which the hero and heroine seemed to breathe the purer air of a parallel morality:

'If individuality means anything it means breaking bounds – adventure. Will you be moral and your species, or immoral and yourself? We've decided to be immoral.' . . .

'Look at our affair,' he went on . . . 'No power on earth will persuade me we're not two rather disreputable persons. You desert your home: I throw up useful teaching, risk every hope in your career . . . all our principles abandoned . . . Out of all this we have struck a sort of harmony . . . and it's gorgeous!'

'Glorious!' said Ann Veronica . . .

Later they loitered along a winding path above the inn and made love to one another . . .

For a time they walked in silence.

'I wonder,' she began presently, 'why I love you – and love you so much? I know now what it is to be an abandoned female. I *am* an abandoned female. I'm not ashamed – of the things I'm doing.' . . .

In their Alpine sanctuary the lovers feel invulnerable from the condemning, conventional world, able to celebrate their new-found liberty beyond the reach of 'the established prohibitions of society', the tattling busybodies; 'We're the rarest of mortals . . .'

This sense of superiority to common humanity is most exaltedly expressed by the dancer Isadora Duncan, describing her first meeting with the actor and theatre designer Gordon Craig:

Here stood before me brilliant youth, beauty, genius; and, all inflamed with sudden love, I flew into his arms with all the magnetic willingness of a temperament which had for two years lain dormant, but waiting to spring forth. Here I found an answering temperament, worthy of my metal. In him I had found the flesh of my flesh, the blood of my blood . . .

. . . Hardly were my eyes ravished by his beauty than I was drawn towards him, entwined, melted. As flame meets flame, we burned in one bright fire. Here, at last, was my mate; my love; my self – for we were not two, but one, that one amazing being of whom Plato tells in the Phaedrus, two halves of the same soul.

This was not a young man making love to a girl. This was the meeting of twin souls . . .

Despite the Mills & Boon flavour of this encounter, in the context of pre-permissive society there is something courageous about Isadora's certainty and idealism, her radiant belief in complete emotional, spiritual and sexual fulfilment.

Rosalind Thornycroft was born in 1891. Her father, Sir Hamo, was an eminent sculptor many of whose busts and figures still stand to commemorate the great and the good of past centuries. The Thornycroft family lived comfortably in Hampstead; Sir Hamo and his wife, Agatha, were involved in the various liberal movements of the day – Fabianism, positivism, co-education. They were 'arty', despised Philistines, and brought their children

Isadora Duncan: 'When she appeared we all had the feeling that God was present.'

up in an 'advanced' way. When Rosalind – a fresh-faced 'stunner' of sixteen – met the magnificent Godwin Baynes at a Wagnerian singing party, she was bowled over by his Siegmund; soon afterwards there was a great snowstorm and Godwin took Rosalind tobogganing on Hampstead Heath. How could she resist when he picked her up in his strong arms and carried her over a snowdrift?

Love flowered. There were trips to the Russian ballet, a holiday with Arnold Bax soaking up the Irish twilight in the mountains of County Kerry, and happy Sunday afternoons with their Bohemian friends, laughing and singing – 'everyone was either musical or literary or an art student'. Then they became engaged. Rosalind felt their love to be transcendent, and her faith in this was so powerful that she was able to persuade her parents to allow the pair to go – unmarried – to Paris together in the summer of 1912:

I think [my parents'] 'free' attitude was based on an absolute belief in the pure and innocent behaviour of anyone brought up in the way I had been by them. I agreed with this view, but, convinced that we were a special case by virtue of our perfect love on the lines of German romanticism – (Wagner's Ewig Einig Ohne Ende) – we felt we were justified in becoming complete lovers. I did not, however, confess this 'marriage' to Mother, although it was a way of life that was lived by many of our contemporaries of advanced people among Fabians and students.

Back in England the pair set up home in Bethnal Green, where Godwin practised as a doctor, with his sister Ruth as 'chaperone'. They were not legally married for another year.

<p style="text-align:center">*</p>

The romanticism of Herminia Grey and Ann Veronica in fiction, or of Isadora Duncan and Rosalind Thornycroft in real life, runs like a seam of gold through Bohemia's attitude to love, just as the same romantic idealism informs their attitude to money and poverty. Bohemia had its libertines, undoubtedly, but on the whole their motives were coloured by a kind of uncynical naiveté.

Augustus John, as so often in Bohemian circles, set the pace. He was promiscuous, but not afflicted by guilt; his promiscuity had a happy-go-lucky quality, a well-meaning delight in the newness of fresh sex. Though he strayed, he always returned to his chief love Dorelia, and he never meant anyone to get hurt. Augustus's entire personality exuded an irresistible aura of sex, like a force of nature. Women found him magnetically virile in his youth, swaggering, long-haired, earringed, talented, the male sex symbol of his day. Michael Holroyd, his biographer, roughly classified John's conquests into 'occasional models', 'chief mistress', and 'grand lady', but did not attempt a complete tally of Augustus's groupies. When Viva King went to stay at Alderney Manor, the Johns' home in Dorset, Edie (Dorelia's sister) recommended her to shove a chest-of-drawers against her bedroom door. Not that it would have prevented him if he had tried, according to her. Viva claimed to have been one of the few who managed to repel him. One day, reading aloud to him from the works of sexologist Havelock Ellis, Viva became aware that Augustus, excited by the passage, was starting to emit strange sounds – 'like a sea elephant coming up for air' . . .

[I] realised it was Augustus starting some 'funny business'; but when told to, he returned quietly to his chair. When I was married he would whisper that he would like to give me a child. I am told he proposed this to many women.

Augustus's secretary Kathleen Hale was less resistant to his powerful mascu-
linity:

I felt a frisson whenever he came into the room. Sometimes there would be mock
battles between us, when he would try to 'rape' me, scuffles that always began and
ended in laughter – hardly the atmosphere for passion. I have always found laughter
as good as a chastity belt. Once, though, out of curiosity, I allowed him to seduce me.
The sex barrier down, this aberration only added a certain warmth to our friendship.

There was something almost endearing, if preposterous, about Augustus
John's determination to 'have a go' whatever the circumstances, and few
could resist.

Dylan Thomas fell into much the same category as Augustus John, though
most accounts agree that physically he was unattractive. But according to
Constantine Fitzgibbon Dylan's sexual susceptibility was disarming to the
strings of women he slept with: 'His interest in women was normal, and he
satisfied it in a manner that was quite accepted and acceptable in the Soho
of his youth . . . he just liked girls, and he told them so.' There was at least
no hypocrisy about it.

Here too, Bohemians felt themselves to be standing on the moral high
ground in relation to society in general. They were revolted by humbug
and pusillanimity, by prudery combined with furtive promiscuity. The
'illicit' nature of sexual liaisons during that period both made a statement
and added hugely to the excitement. The sense that the terrain on which
they were so joyously cavorting was really a public lawn sternly labelled
KEEP OFF, made the Bohemian sex pioneers almost inebriated with their
own wickedness. For Vanessa Bell, mentioning the word semen was only a
start. Painting 'really indecent subjects' was another way to get Mrs Grundy
running for her policeman's helmet.

I suggest a series of copulations in strange attitudes and have offered to pose [she
wrote to Roger Fry in 1911]. Will you join? I mean in the painting. We think there
ought to be more indecent pictures painted . . .

Bawdy was fun; Nina Hamnett would regale a pub full of regulars with
smutty jokes and limericks:

> I sometimes wish when I am tight
> That I were an hermaphrodite
> And then, united to a black

> Deep-bosomed nymphomaniac
> We'd be wafted up to heaven
> In position forty-seven.

Being shocked was for prudes and old maids. Where was the kick in being genteel?

By the time Marie Stopes's book *Married Love* was published in 1918, there was no stopping the onward rush of what Douglas Goldring called the New Morality. For in it Stopes pointed out – to married and unmarried alike – the importance of mutual orgasm, and directed her readers to a little-known part of the female anatomy, the clitoris. This, she explained in the most tactful language, could, by arousal, consummate a woman's desires. She also advocated such consummation as beneficial and valuable quite apart from the useful, procreative function of sex. In order to achieve this desirable result, it was permissible to have sex without having children, and Stopes explained how to do it. Her book came, as Goldring said, like the answer to a prayer. Equally liberating were the newly published writings of Freud. The literate and semi-literate eagerly pounced on his psychoanalytical theories, which, with their new-found vocabulary of 'repressions', 'complexes', 'release of inhibitions' and 'unconscious desires', provided a persuasive rationale for more or less doing what you wanted to do. And now the plaguey Puritans could protest in vain, for the gateway was flung wide, and the way was paved for an adventure of the senses, a voyage of experimentation with Bohemia off to a flying start and free-thinkers of all colours tagging along behind.

<center>*</center>

Now it no longer seemed to matter if you branched out into unconventional permutations; for artists, self-expression was all, and as in art the spirit of modernism was blowing away the shreds and tatters of conventional representation, so in love and sex the rules were toppling, giving way to imaginative refractions and reinterpretations of the norm. For example, was the conventional couple mandatory? What law proscribed living with more than one woman, or more than one man, or a man and a woman? As it happened bigamy had been illegal in Britain since 1603 and homosexuality was only legalised between consenting adults in private in 1967, but Bohemia is a country with a more relaxed attitude to these transgressions, and its inhabitants were undeterred by laws beyond their frontiers. The *ménage à trois*, or occasionally *à quatre*, was not uncommon. Not that these relationships would have constituted an offence against the law, for in most cases the

individuals were only married to one of the partners in the household, the other being brought in as an accessory live-in mistress. The complexities of these households could become labyrinthine. The Bloomsbury Group was once described as 'a circle of people who lived in squares and loved in triangles'. But the phenomenon was by no means confined to Bloomsbury, which for all its infamous reputation was restrained compared to some set-ups.

The young Helen Maitland came to Europe from the west coast of America in 1909; in Paris she fell in with the artistic community that revolved around Augustus John, who had been living there since 1905. Helen became mistress to Augustus's friend Henry Lamb, who had recently parted from his wife, Euphemia. When that affair turned nasty she re-attached herself to the talented and dashing Russian mosaicist, Boris Anrep.

She started living with my father Boris in about 1910 [recalled their son, Igor] . . . and they were very happy in Paris together – but, he had a wife. He always had two wives, all his life, which of course made for difficulties. He had married Yunia in Russia – she was a young lady of a respectable family and he was caught in bed with her, and he was made to marry her . . . and she was living in the house when my father took on my mother, and they lived in a *ménage à trois* in Paris for quite some time.

Then at the beginning of the War I was born, and my mother thought it better to go back to England. They took a cottage in Gloucestershire, and Yunia came too – in fact she helped my mother with the children.

With Boris away in Russia, there was little reason for Yunia to remain, and she went back to Poland. When Boris eventually returned in 1917 he brought with him a substitute, his brother's sister-in-law, a beautiful seventeen-year-old called Maroussia, who moved in with the family, by then living in Hampstead:

One tended to go round a corner and find my mother in floods of tears, not because she was jealous of Maroussia, but because Boris and Maroussia had been having a terrific row – Russians are given to shouting at one another – and they shouted their heads off such a lot that it upset my mother, who really didn't like high emotions . . . Boris was pretty unfaithful, not only with Maroussia but with numerous other people, and my mother got a bit tired of it. She left him for Roger Fry. My father cut up terribly rough, and he threatened to tar and feather Roger Fry, and Roger took this terribly seriously and went out and bought himself a pistol, but the pistol was not to shoot Boris, it was to shoot himself if he was tarred and feathered!

Helen duly settled down with Roger Fry as his wife in all but name (for he had a living wife, tragically certified insane), while Boris and Maroussia continued their tempestuous relationship.

But this was nothing compared to the tortuous intricacies that played havoc with the marriage of Robert Graves and Nancy Nicholson. The American poetess Laura Riding had entered the Graves's lives in 1926; her advent precipitated upheavals in the marriage, which was already showing signs of strain. The couple's financial situation was perilous, Graves was shell-shocked, and Nancy was struggling to keep the family afloat. However Laura's powerful personality acted like a rudder on the ménage, and by 1929 comparative peace reigned in the Graves/Nicholson/Riding household at 'Free Love Corner' in Hammersmith. For Laura they were a wonderful 'Trinity', invested with a mystical aura. It was the arrival of number four, an obscure poet and entomologist named Geoffrey Phibbs who wrote under the pseudonym Geoffrey Taylor, that tipped the balance into anarchy and farce. Phibbs was in thrall to Laura's eccentric theories of 'The Four', but Laura's mystic creed was impenetrably confusing . . .

$$R = L \quad >N \quad >R$$
$$L = G \quad >R \quad >N \quad >L$$
$$L = N \quad >G$$
$$N = G \quad >L \quad >R$$

. . . and he found himself struggling to make sense of his own position in this convolute quadratic equation. Laura had taken charge; she was the crazed vivisectionist of his destiny. It is hard to imagine today how potent and overwhelming the experience of sex must have been in those early decades of the twentieth century, when orgasm seemed an experience like the discovery of radium. Its impact was incalculable, dizzying; no wonder it drove people like Laura Riding over the edge.

Years later, David Garnett described the ensuing melodrama in a paper given to Bloomsbury's Memoir Club; his own incidental involvement came about because he had had a passionate affair with Phibbs's wife Norah – but she is peripheral to the story:

Geoffrey was tall, dark, immature, adventurous and very nice. Like Shelley he believed in Love and Freedom and Free Love and hated his conventional Anglo-Irish fishing and shooting family . . .

Robert Graves and Laura Riding formed a group . . . they welcomed Geoffrey Phibbs with delight. He made them into a real group of poets. They were engaged

in publishing their works, thoughts and pronunciamientos under the name Seisin . . . Becoming one of a group with Robert Graves and Laura Riding . . . was all rather terrific and a change for Geoffrey after living alone with Norah in a cabin in the Wicklow Mountains.

And it was still more terrific when Laura Riding took him as her lover and drove him all the way from Hammersmith to the Burlington Arcade in a taxi where she bought him an immensely expensive pair of black silk pyjamas for him to wear in bed with her. She had the bill sent to Robert Graves, explaining to Geoffrey that [T. E. Lawrence] would provide the money . . . He had been sent providentially to help in the great work. Laura Riding had everything planned out. And her plan was to shake the Universe itself.

. . . One day, quite unexpectedly, Geoffrey Phibbs sent me a telegram saying that he was coming to stay with Ray [Garnett's wife] and me at Hilton Hall. He wanted advice . . .

I spent almost all the time of his visit discussing the predicament in which he found himself and his future and giving him advice. The trouble was that he was scared of Laura Riding. She had told him, as a great secret, that she was going to stop TIME, and that his help was necessary for this operation. Stopping time was carried out in bed. Robert was all right in bed and she loved him and admired him – but he had proved no good as a time-stopper. [Geoffrey] discovered that she really believed that with the assistance of this vigorous new young lover she was going to break the frame of the universe. What was more, she was dead nuts on doing it.

'Time has been going on long enough,' she would say earnestly. 'We can break through and stop it. Not just move about in it as Donne has shown is possible, but smash it up altogether.' She expected him to do his share of the work. No shirking was allowed. She had a timetable.

. . . Geoffrey had decided that on no account would he go back to live with Laura. It was not that he was afraid that she would prove right and that he would suddenly find himself an Immortal . . . suspended in a timeless universe. No. It was not the *consequences* that scared him but the *process* designed to bring it about. He could not and would not face it any longer . . .

Meanwhile Graves and Laura had tracked Geoffrey down to the Garnetts' home in Huntingdonshire. There were flurries of telegrams:

'Will never return to Laura.'

'Laura cannot live without you. Robert.'

'Absolutely refuse to return to Laura. Geoffrey.'

'Am coming to fetch you. Matter of life and death. Robert.'

A desperate Robert Graves then hired a car and drove to Hilton to fetch Geoffrey back; Graves issued threats. Compromises were negotiated. Geoffrey departed; but within twenty-four hours he was back again, wild eyed and on the verge of an emotional collapse. Laura had threatened suicide; but still Geoffrey refused to live with her. She argued and implored. Laura had then hurled herself from the fourth-storey window fracturing her spine. By a miracle she survived and was able to walk again. Geoffrey squared the circle by soon after taking up with Nancy, who by this time was feeling a bit left out, and went off with her to look after the Graves children. Laura and Robert left the country.

<p style="text-align:center">★</p>

Assuredly, the nuclear family was not the only way; in Bohemia one could, and did, live differently. To dismiss this as self-indulgence is to miss the ideological rationale, the belief that sexual freedom was on a higher plane that guided much of their behaviour, bungled and flawed though it probably was. Maybe it is our loss. Certainly that behaviour appears to have been fired by hope and by a belief that one can conduct one's relationships in a truly unpossessive and co-operative manner.

Henry Lamb tentatively suggested a commune to include Dorelia John (with whom he had also been conducting a passionate affair) and Augustus, Ottoline and Philip Morrell, Helen Maitland and himself; the proposal was not adopted, probably because Augustus was unlikely ever to agree to any formal arrangement. His own ménage at the time, consisting of himself, his wife Ida and his mistress Dorelia, achieved a precarious stability because the two women were devoted to one another, and because Ida was reluctant to play the jealous wife role. 'I shall never consider myself a wife – it is a mockery,' she wrote to Dorelia.

David Garnett, aggressively heterosexual by temperament, nonetheless succumbed to the dangerous allure of a three-way ménage at Charleston during the First World War, consisting of himself, Duncan Grant and Vanessa Bell. The household at Ham Spray – Lytton Strachey, Carrington and Ralph Partridge – has inspired several books, and a notable film; but not so much is known about Carrington's friend Christine Kühlenthal, wife of the painter John Nash, herself a talented ex-Slade student. Christine adopted the Bohemian posture towards life – her cropped hair and Dorelia-style dresses identifying her firmly with the younger generation of free-thinkers and breakaways. Growing up in Gerrards Cross, Christine's bosom

companion was another artistic 'crophead', Norah; together they communed with nature in the wooded glades of suburbia, dressed in corduroy breeches and floppy blouses. They were flatmates until 1917, but a source of local gossip ended when Norah left to become a landgirl. Missing her, Christine became engaged to John Nash, who was sent to the trenches as a war artist. Meanwhile Norah married her boyfriend Charlie. Christine visited them frequently and wrote to John of their happy new state of affairs:

Charlie and I take it in turns to sleep with Norah, which again I think is very kind of him. The charwoman thinks it the most extraordinary thing she has ever heard of. I forget how she found out . . . I think their married life is most successful.

★

Christine and Norah were behaving adulterously, but they had done nothing illegal. Homosexual men ran more of a risk – but run it they did, with enthusiasm and conviction. Far from discouraging homosexuality, the trauma of the Oscar Wilde trial in 1895 unleashed a gay stampede.

The seer Edward Carpenter was one who was undeterred by the fall-out from the trial, and his passionate advocacy of what he called 'Uranian' love brought him an equally fervent flock of followers, swayed by his idyllic vision of how mankind could live:

Once more in sacred groves will he reunite the passion and the delight of human love with his deepest feelings of the sanctity and beauty of Nature; or in the open, standing uncovered to the Sun, will adore the emblem of the everlasting splendour which shines within.

Above all, Carpenter believed that men and women could attain fulfilment through their sexual relationships. In *The Intermediate Sex* (1908) he claimed that homosexuality was not a vicious warp of nature, but innate; it was, moreover, superior to heterosexual love, and we should all applaud its value to society, since according to him many artists – including Tennyson – were homosexual. Carpenter practised what he preached. He set up home with a charming working-class Derbyshire man called George Merrill, and together they tilled the soil, lived off fruit and nuts, and made their own sandals. When not wearing them they allowed their feet to 'press bare the magnetic earth', living 'the life of the open air, [in] familiarity with the wind and waves . . .'

Other feet meanwhile were pressing the stage of London's Covent Garden, with equally liberating effect. In 1911 Diaghilev's Ballets Russes arrived in London after their *succès fou* in Paris of the preceding years. The effect of Stravinsky's music, Braque's decors, Bakst's costumes, Fokine's choreography, and above all, Nijinsky's dancing on the London art scene was incalculable. Until Diaghilev ballet had been an entertainment largely aimed at the heterosexual male, who came for a titillating evening looking up the dancers' skirts at the Alhambra. Now ballet came out of the closet. The new idiom presented androgynous creatures like Nijinsky's '*faune*' or '*spectre de la rose*' with breathtakingly frank eroticism. Male sexuality was dramatised to its utmost. Ballet was never the same again, but neither were homosexuals. Here at last, for many artists, was a medium which permitted them to experience prohibited emotions, and to exult in them as never before. *Vive* the spirit of Oscar Wilde – aestheticism was back with a vengeance.

Illegal it may have been, but the forbidden fruits were succulent. Vanessa Bell took vicarious relish in dreamily conjuring up a vision of her old friend Maynard Keynes's tasty indulgences, and warned him as she wrote that she intended to make her letter so pornographic that he would have to destroy it in case the servant saw it. He didn't.

Did you have a pleasant afternoon buggering one or more of the young men we left for you? It must have been delicious out on the downs in the afternoon sun, a thing I have often wanted to do . . . I imagine you, however, with your bare limbs intertwined with him and all the ecstatic preliminaries of Sucking Sodomy – it sounds like the name of a station . . . How divine it must have been . . .

What *would* the parlourmaid have thought?

Today we are worlds away from the atmosphere of restriction and taboo which both ghettoised and intensified the sexual leanings of Bohemia's homosexuals in those days. Secrecy and stealth attended their movements. Public toilets and the ever-available Guards' barracks were known meeting-places; more aspirant types might attend the meetings of the Fitzrovian 'Psychological Society' that doubled as a pick-up joint for homosexual aesthetes. The painter Robert Medley, born in 1904, grew up in a society where it was still deeply difficult to admit to being gay. His entrée into Bohemia enabled him to recognise and accept his own sexuality. Bit by bit, via Bloomsbury (he was kissed by Lytton Strachey), via evenings at the Ballets Russes, via an uncertain relationship with the young W. H. Auden, and eventually via Elsa Lanchester's Cave of Harmony – a nightclub in

Gower Street — his initiation was complete. It was there that he met the love of his life, the dancer Rupert Doone:

One or two couples took the floor. I was a good dancer and I decided to show off with Elsa in a tango. I had obviously gone too far in my apache role for, holding me at arm's length, she suddenly announced in her clear voice. 'The trouble with you, Robert, is that you don't know what sex you are!' As everybody had been looking on, the only reply to this deadly shaft was to take off all my clothes and demonstrate the facts. This unpremeditated exhibition was greeted with a round of applause. It was evidently what was needed to get the party going and I was not allowed to get dressed again . . .

Among the spectators a blond young man with an unmissable air of self-possession caught Robert's eye. The circumstances were propitious, and Robert had nothing left to conceal. The couple went soon after this to Paris, where 'under French law nobody had the right to interfere with our relationship', but returned in due course to London, founded the Group Theatre, and settled into cosy domesticity in Hammersmith. Robert was unswervingly loyal to Rupert for the rest of their lives together.

Only in Bohemia could their relationship be acknowledged and accepted. The shock-absorbing effect of such latitude made homosexuality into something blithe, camp, and often comic. Racy stories did the rounds, like the one about choreographer Frederick Ashton's intense sexual experience with an eviscerated melon, later apparently served up by his mother as a delightful treat for supper. Naomi Mitchison's friend was given a guardsman for his birthday. Evelyn Waugh told a risqué tale of a judge trying a sodomy case who went to consult an eminent colleague on his sentencing policy: 'Excuse me, my lord, but could you tell me — what do you think one ought to give a man who allows himself to be buggered?' 'Oh, 30s or £2 — anything you happen to have on you.'

The unmasking of homosexuality demanded a new slang. Viva King and her circle bluntly referred to the homosexuals amongst their friends as 'so', short for sodomites. 'Fairies' was American, and 'pansy' was just for the ladylike. By the thirties words like 'queer', 'pouffe', 'tapette' or 'he-vamp' were also prevalent, while the extremely manly Roy Campbell was revolted by what he referred to as 'Peters'.

It takes some perspective to place this homosexual current in the context of its time. The Oscar Wilde trial had left British society reeling and divided by the 'disgusting' revelations which had brought him to his knees. In its aftermath you could not sit on the fence. Oscar was too much of a celebrity,

his nemesis too violent, to permit any equivocation. From the moment his sentence was pronounced, aestheticism was a dirty word. Experimenters with absinthe and dabblers in Swinburnian verse burned their green carnations and dived for cover. The First World War brought the nation's puritanical homophobia even more to the fore; a fear of 'unclean acts' went alongside a hatred for the effete and decadent art by then inescapably associated with them. Homosexuality was seen as an infection, sapping the nation's manly strength that was needed to kill Germans in the trenches; by the same token, modern art turned men into perverts, cowards and traitors. We still live with the vestiges of this anti-art homophobia, but in those days it took unusual courage to challenge it.

The pursuit of love was less risky for lesbians, for lesbianism was not illegal. When the law was amended in 1885 to clamp down more firmly against male homosexuality, those seeking royal assent for the statute were thwarted by the prospect of having to explain to Queen Victoria *how* women could have sex together. But that was not to say it was sanctioned either. For the writer Sylvia Townsend Warner it felt good to live dangerously. 'Feeling safe and respectable is much more of a strain . . .' she sighed, after a blissful morning lying in her lover Valentine's arms, '. . . listening to the wind blow over our happiness.' For Sylvia, here was fulfilment beyond her wildest dreams. Like Robert Medley, she too remained faithful until Valentine died, and mourned away her final years aching for her lost love.

Then in 1928 Radclyffe Hall's book *The Well of Loneliness* was banned for obscenity. This brought the issue of lesbianism to public notice. Instantly identifiable from the trial pictures, there was now no mistaking the Radclyffe Hall lookalikes in manly tailored suits and shingled hair who frequented Chelsea and St John's Wood. Roy Campbell was as dismissive of these degenerates as he had been of the 'Peters': 'I . . . object to the dismalness of the English Lesbian, her grey, frowsy outlook, her grim puritanical dress, and her atmosphere of a psychoanalysis class.'

One presumes that Roy did not include his own wife Mary in this category; he was probably referring to her lover Vita Sackville-West, more recognizable in the 'frowsy puritanical' portrait he sketches. Mary was beautiful and glamorous, but her marriage to Roy nearly broke up when she embarked on a passionate affair with Vita, who had lent the pair a cottage on her Kent estate. Vita appears to have exercised *droit de seigneur* over her tenant's lovely wife – Mary, however, being more than willing to be swept off her feet by the enchanting aristocrat. Her landlady was also her goddess, her mother-figure; they made love, read sonnets together, and sent each other passionate billets-doux:

Is the night never coming again when I can spend hours in your arms, when I can realise your big sort of protectiveness all round me, and be quite naked except for a covering of your rose-leaf kisses?

wrote Mary to Vita. Roy was furious, and took savage revenge on Vita in his long poem *The Georgiad* (1931):

> Her gruff moustaches dropping from her mouth,
> One to the North, the other to the South,
> Seemed more the whiskers of some brine-wet seal
> Than of a priestess of the High Ideal –

Vita always did her best to keep any whiff of scandal under wraps; she was far too lofty an aristocrat to enjoy the feeling of openly shocking the bourgeoisie.

But for Bohemians sexual and emotional intensity could be heightened by a feeling that one was breaking class taboos as well as gender ones, and there were utopian ideals at stake as they hurled themselves over social barriers with kamikaze recklessness. Drearily conventional concepts like suitability, rank, and caste were thrown overboard in the dizzy descent. D. H. Lawrence introduced the 'gamekeeper-fucks-Lady' element into British literature with *Lady Chatterley's Lover* (1928) (another notorious banning), but one senses that Lawrence was cranking up his own erotic sensations in writing about Constance's secret slumming with Mellors, as much as those of the characters. Lady Chatterley may have been drawn from life. Ottoline Morrell's biographer Miranda Seymour hazards that Lawrence was portraying her subject's real-life affair with a young gardener called Lionel Gomme ('Tiger') who was working at Garsington in 1920. Ottoline's lover brought her 'simple love', 'across the great gulf of the world, conventions and positions . . .'; the fact that 'Tiger' was mainly interested in football and cars did nothing to lessen his attractions. Sleeping with members of the working class offended every convention of the time; Nina Hamnett made no secret of how turned on she was by boxers, building labourers and sailors.

Even more defiant in their breach of accepted behaviour were the women who, like Nancy Cunard, had sex with black men. According to Douglas Goldring the daring jazz-obsessed female acolytes of 'Haut Bohemia' were notorious for 'their attacks on the virtue of [the] Negro artists' who danced and sang in London's revue shows. There were some narrowly averted public scandals, but the participants were, it seems, getting their kicks by deliberately tempting fate. Nancy was a class rebel who delighted in pushing

out the boundaries. This included having a long-term sexual relationship with a black man named Henry Crowder, to the predictable outrage of her mother, Lady Cunard, and her upper-class cultured friends. One day Lady Asquith dropped in to luncheon with Lady Cunard, and making small talk over the meal chanced to refer in a rather barbed manner to her friend's errant daughter. How is Nancy? she asked '. . . what is it now – drink, drugs or niggers?' Lady Cunard found herself utterly embarrassed; advisers rallied round, Sir Thomas Beecham was enlisted to pen an admonitory letter to Nancy, detectives and policemen were put on the case. Nancy meanwhile wallowed in the notoriety which attached itself to her, and retaliated by publishing a lengthy open letter to her mother entitled 'Black Man and White Ladyship', in which she sounded off over pages on colour prejudice and class, and revelled in the unconscious double entendres into which her White Ladyship had floundered:

With you it is the other old trouble – class.

Negroes, besides being black (that is, from jet to as white as yourself but not so pink), have not yet 'penetrated into London Society's consciousness'. You exclaim: they are not 'received!' (You would be surprised to know just how much they are 'received'.)

But the episode was not just a peccadillo; Nancy Cunard's relationship with Henry endured. She also dedicated herself for years to compiling an exhaustive 'Negro Anthology'.

Men 'stooping to conquer' was nothing new, indeed it was almost regarded as an obligatory rite of passage for young eighteenth- and nineteenth-century blades to test their prowess on available girls of the lower class; but Bohemia brought a new twist to the tradition. Carrington's capriciousness caused her lover Gerald Brenan endless heartache and loneliness, which he assuaged by the obsessive picking-up of shopgirls or homeless teenagers from off the London streets. They would go for long mournful walks together, eat fried eggs in workmen's cafés, and stagger back to Brenan's flat in the early hours for stimulating proletarian sex sessions. Later, when Carrington married Ralph Partridge, one aspect of the *ménage à trois* – consisting of Lytton Strachey and the Partridges – was that Ralph liked heterosexual sex and Carrington didn't. However, it was important for Carrington to keep Ralph within the ring-fence in order to secure Lytton's all-important happiness – for he was in love with Ralph. Carrington thought Ralph would stray if his lusts were unrequited, so, according to Frances Partridge, she colluded in providing him with a spot of extra sex:

When they were living in Tidmarsh there was a very juicy girl called Annie who worked for them, blonde . . . and Carrington was quite capable of egging Ralph on to make up to Annie in order to get something done, or to soothe her down after she'd had too much to do, or too many people's sheets to change . . . and he would certainly give her a kiss . . . Carrington loved secrets, and I think the situation of the mistress of the house egging him on tickled them both. I don't think he minded at all; she was always encouraging him to have affairs, because the worry was that otherwise he would leave Lytton . . .

Laclos's *Les Liaisons Dangereuses* (1782) was a favourite Bloomsbury text; its depiction of a sexual laboratory where dilettante scientists carried out combustible experiments on unsuspecting victims exactly suited the Bloomsbury spirit of mischief. They loved the intrigue and gossip which made an aphrodisiac of daily life. 'What a pity one can't now and then change sexes!' lamented Lytton Strachey. 'I should love to be a dowager Countess.' 'You should make a point of trying every experience once, excepting incest and folk-dancing' (quoted by Arnold Bax in his memoirs) could have been a Bohemian motto, were it not that even those taboo activities were tried by some of the freer-spirited among their number. The conventional world was full of confining prohibitions, unmentionable acts, undoable deeds, but Bohemia was emancipated from limitations; yet even in this there was a kind of morality, almost a political correctness. The matter-of-fact Naomi Mitchison took the line that it was wrong to condemn; she was way ahead of her time in this. What married middle-class lady writer would be as relaxed as she was when asked by a friend to tie him up and beat him . . . '. . . which I did, making fierce faces and quite enjoying it myself but not, I expect, hurting him as much as he might have preferred. Why should we insist on certain patterns of conduct?'

Ethel Mannin's broadmindedness was stretched to its limits however when the obese and repellent Dr Norman Haire, who had made a fortune from fitting intrauterine devices and was secretary of something called the 'World League for Sexual Reform', asked her whether she had ever tried bestiality: 'In response to my reaction of horror [he] asked calmly, "Why not?" and added, with an unusual smile, "They say you can train a peke to do anything!" '

The sculptor and typographer Eric Gill is now known to have had incestuous relationships with all three of his daughters, and yet, as his biographer has demonstrated, there was almost a spirit of innocent experimentation at work in him. The Gill daughters appear to have been psychologically undamaged, and perhaps this was owing to their father's

unexploitative, unthreatening approach. He wanted to know, to prove, to explore, to celebrate; he saw no moral contradictions in marital infidelity, in being a Catholic who disapproved of birth control and of homosexuality, yet indulged in incest, troilism – and bestiality. His capacity for egocentric delusion on the grand scale was quite extraordinary, and yet relatively harmless. Gill's erotic art speaks of a man guiltlessly in love with the sheer wonder and beauty of sex and the human body.

To have got away with such preposterous behaviour for as long as Gill did and remain married – which he did – indicates an unusual degree of compliance on the part of Mary his wife. But Mary was more than just tolerant; she believed herself blessed with incredible fortune in being married to a man of such talent, and even after nearly twenty-five years of putting up with Gill was able to write devotedly to him, 'I am simply bubbling all over with pride at the thought of being your wife.' For her, geniuses were absolved from the normal rules of behaviour.

'Earth Receiving'. A wood engraving for
Procreant Hymn, 1926, by Eric Gill.

*

The ideal of truthful living and truthful loving was a potent one. The old-fashioned institution of marriage stood little chance against it, and yet it could not be jettisoned overnight. Edwardian society was gripped by 'the

marriage question'; it was a burning issue that touched on women's rights
and on the entire basis of society itself. The public debate was constantly
aired in the correspondence columns of daily papers, while intellectuals,
playwrights, novelists and politicians all made exhaustive mileage out of it.
Thus any free-thinking Bohemian worth the name who was considering
plighting their troth to their beloved found themselves at the cutting edge
of public controversy. If you were a feminist, marriage seemed like a legalistic
concession to the tyranny of patriarchy. If you were an artist, were you to
regard conventional marriage as incompatible with your way of life, or as
simply irrelevant? Did you try what became known as 'the modern experi-
ment' or 'companionate marriage', and go 'Lawrencing off together' into
the sunset? You were forced to take a stand on the matter.

Arthur Ransome was unequivocal: 'The door into the registrar's office is
the door out of Bohemia.' But others saw matrimony as a great excuse for
an unconventional party *à la Bohème*, like that of Roy Campbell and Mary
Garman in 1922. The bride wore a long black dress and a long golden veil;
the groom managed to borrow a frock-coat from a waiter at the Eiffel
Tower, but his shoes were full of holes. Wyndham Lewis was one of the
guests at the Harlequin nightclub in Beak Street, Soho:

The marriage-feast was a distinguished gathering, if you are prepared to admit
distinction to the Bohemian, for it was almost gypsy in its freedom from the
conventional restraints. It occurred in a room upstairs. In the middle of it Campbell
and his bride retired. The guests then became quarrelsome . . .

The Ukrainian Jewish artist Jacob Kramer appears to have picked a fight
with Augustus John over the size of his biceps, at which point Roy Campbell,
disturbed by the fracas, abandoned his nuptial bed, re-entered the room in
pyjamas and threatened to throw Kramer out of the upper-floor window:
'You let my guests alone, Jacob. Don't let me hear you've interfered with
John again. Mind I'm only just upstairs, Jacob. I'll come down to you!' He
then went back to bed. 'This was a typical "post-war" scene,' claimed
Wyndham Lewis. 'This is how, in the "post-war", you were married and
were given in marriage . . .'

For the Campbells, matrimony was to be a rocky ride, a test of endurance
by poverty, alcoholism and infidelity. It was in the hope of finding creative
stability that some couples resolved to run their relationships along rational
lines. The idea of the open marriage or partnership appealed strongly to
those high-minded individuals who saw themselves as logical yet instinctive,
egalitarian yet passionate. In Bohemia one lived for higher things – art,

music, poetry; one ought to be able to conduct one's relationships, too, on elevated principles. People like Naomi Mitchison imagined themselves living a free artistic life unhampered by petty possessiveness, infidelity and accusations. And she and her husband, Dick, were scrupulous in examining their motivations in agreeing to be unfaithful to one another. Having consented to that principle, they worked hard to stick to their self-imposed rules. There was to be no jealousy, no casual promiscuity, no hurtful comments. Affection and respect were to remain the bedrock of their marriage, which expanded to permit new channels of communication. It wasn't always easy to cut loose from their guilt-laden upbringing, but Naomi believed powerfully in the need to do so: 'I sometimes hoped I was fighting for more freedom, for a whole generation of women. My daughters perhaps?' They were high hopes indeed, and Naomi Mitchison felt buoyed up by the sense of a turning tide. She envisaged a happy future when her grandchildren might be the offspring of several fathers, 'uncensured', when the defences built by a doomed patriarchy might be smashed by the unstoppable flood of true sexual liberty.

Her dream has of course come true – we are surrounded today by the lapping waters of the permissive society – but it is surely not the one she hoped for. Naomi Mitchison was aware that feelings of occasional guilt or jealousy tainted her ideology; considering the world in which she and her generation had been brought up, how could it be otherwise? Their dreams of free love were on a collision course with bourgeois ethics, with repression, ignorance and unthinking tradition. These were the 'false' lives and 'false' loves that Bohemia turned its back on, and it is not hard to see why.

<p style="text-align:center">*</p>

It is worth reminding ourselves of the fact that Victorian society prohibited unmarried men and women from meeting alone, a rule that was upheld by the strait-laced until well into the twentieth century. Chaperones were there to enforce these rules. At balls, a girl might not dance more than three dances with any one partner. On the face of it, there is something preposterous indeed about the notion that two young people of the opposite sex will instantly commence sexual gropings unless accompanied by a married gentlewoman or a servant. But chaperones were seen as necessary for vetting the social suitability of potential suitors, as much as for preventing illicit fumbling. Seen anthropologically, chaperones were not so much the Mrs Whitehouses of their day, prudes shocked into fainting fits by the thought of sex, as society's watchdogs, constantly on the alert for class transgressions. Their golden rule was avoidance of scandal. For adventurous spirits it felt

stifling to be so constantly nannied and scrutinised, with things you mustn't do, mustn't be, mustn't express. And it was the bourgeoisie that mutinied, for the propriety ethic was overwhelmingly middle class. Artists felt indignant that licentious behaviour should be the preserve of the aristocracy, as it had been hitherto. If toffs with handles to their names could behave permissively, then so could artists, who felt themselves to be equally far above the common herd.

Aristocratic circles had always regarded themselves as exempt from pettifogging ordinances – the seventh commandment for example. It was understood amongst the élite – without having to be spelt out – that the hostess of an Edwardian house-party would, with the utmost tact, so dispose the guests' bedrooms as to accommodate 'recognised' lovers within easy reach of each other. One's strait-laced housekeeper would disapprove, but duchesses were above censure. In Vita Sackville-West's novel *The Edwardians* (1930), based on her own memories of an upper-class upbringing, the nineteen-year-old hero, Sebastian, has an adulterous liaison with Sylvia, the wife of Lord Roehampton; all is well until scandal threatens, then the affair breaks up. Vita herself became passionately involved with the tempestuous Violet Trefusis, who was the daughter of Edward VII's mistress. Although 'everybody' knew about these illicit entanglements, nobody spoke about them in public. As Mrs Patrick Campbell once famously said, 'I don't mind where people make love, so long as they don't do it in the street and frighten the horses.' Meanwhile the rules had to be seen to be observed – and there were so many of them:

I was still forbidden to be alone with a man except by chance in the country. A married woman must bring me home from a ball. For walking and shopping and even driving in a taxi, a sister or a girl was enough protection. I could go to the Ritz but to no other London hotel. But generally there was more freedom . . .

remembered Diana Cooper of her upper-class upbringing just before the First World War. Nice girls were also banned by their mothers from large areas of London, Belgravia being regarded as the only completely safe neighbourhood. In the 1930s writers on social etiquette were still counselling against the sharing of taxis, the expression of affection in public places, and unmarried women living on their own.

With these acknowledged rules, there went an unwritten codification of conduct and customs associated with 'loose living'; the smallest sign could spell volumes to the vulgarity vigilantes. Coloured notepaper, especially mauve, was 'fast', thin stockings a sign of lax morals, dyed fur, scent or –

God forbid – make-up was damning. A kiss – even to a friend – was in questionable taste.

Sexual appetites were seen as disagreeable and destabilising, therefore they ceased to exist. The Victorian denial of desire was above all made plain in its imposition of ignorance. There was the curious fact, for example, that girls knew *nothing* about the facts of life and must remain virginally innocent until their wedding day, whereat, from the moment they left the church, they were omniscient. Boys were barely more informed:

Sexually my education had been of the usual sort . . .

recalled the painter Adrian Daintrey in later life . . .

. . . a hair-raising 'warning' at Temple Grove of the results of masturbation, and a very shy, formal talk by my father. Gentlemen, I learnt, 'went straight' until at some time in the very remote future they were in a position to marry. The state of chastity, so difficult to maintain, carried with some people a fantastic importance: I once heard it said of some young man who had been killed in World War I, 'He has been spared further temptation.'

With ignorance and propriety went puritanism. Armies of rigid do-gooders formed committees with names like the Society for the Suppression of Vice, the Friends' Purity Committee, the National Social Purity Crusade, and many more, united by a common cause in favour of cold baths, healthy minds in healthy bodies, gentlemanly exercise, and ladylike restraint. And not surprisingly, when nice, respectable, decent people like this ran up against Bohemians they regarded them with deep denial and suspicion.

During the First World War Lady Ottoline Morrell housed an assortment of artists and writers and conscientious objectors – Clive Bell, Mark Gertler, Carrington, Aldous Huxley and Lytton Strachey among them – at Garsington Manor. During that time the painter Dorothy Brett brought her prim sister Sylvia to stay there for a weekend. Whether the natives cranked the conversation up a notch or two to shock her is pure speculation, but if they did it certainly worked:

The C.O.'s are so awful – flabby cowards – over-sexed – undersexed – never normal – The conversation consists of depraved and curious conditions in life so that you long for an ordinary couple to come in and say 'Well, we live an ordinary life, do ordinary things in the ordinary way and have ordinary children.'

At breakfast with your bacon and eggs you get a minute and detailed description of life *à la* Oscar Wilde . . . Oh it made me feel very sick inside . . . I tell you I had to have a mental bath when I got home, as well as a bodily one.

And the feeling of antipathy was mutual. The advanced author Ethel Mannin declared that the 'plague of puritans' – the book-banners, the censors, the bishops and right-wing politicians, and even the BBC – were 'rapidly making this country no fit place for a decent, intelligent person to live in . . .'

*

The Victorian fetish of purity was to some extent a protective stance against the burden on society inflicted by unwanted babies. Some of the horror felt by respectable matrons and patriarchs at the new permissiveness was dismay at the thought of a generation who were having their pleasures and 'getting away with it'. Contraception, moreover, was a thwarting of God's plan, and thus wrong. But wrong or not, the new generation was leaping in with enthusiasm: 'An army of girl-graduates descended on London, each with her contraceptives in her handbag and a grim determination to rid herself as soon as possible of her repressions . . .' wrote Douglas Goldring in his book *The Nineteen Twenties* (1945).

The contents of those handbags were – by the time of which he was writing – varied and available to anyone who persisted. Rubber condoms (made possible by the invention of vulcanization – a process which improves the elasticity and strength of rubber) were probably first available in the 1870s. They were washable and you cleaned them up afterwards with carbolic soap. Soluble pessaries came on the market in the 1880s. Information about the use of contraceptives began to be widely disseminated. The quaintly named *Wife's Handbook* (1887) by Dr H. A. Allbutt was in print for several decades and, despite attempts to prosecute its author for obscenity, reached its forty-first edition by 1910. It was full of useful information about preventative measures in the form of sheaths, Dutch caps, sponges, tampons, and the like. Imperfect though these methods were, they allowed a latitude of choice hitherto denied. If the wages of sin were no longer necessarily a baby, it ceased to be a question of whether, but when, to launch into an active sex life.

Carrington finally ran out of excuses not to go to bed with Mark Gertler when he acquired a contraceptive device for her. But she squirmed over the nastiness of trying to use it: 'Really I did try that thing. Only it was much too big, and wouldn't go inside no matter what way I used it! But I won't be so childish any longer . . .'

'That thing' was probably a Dutch cap, used in combination with a

'Volpar gel'; she might have had less of an excuse if she had used a Gräfenberg intrauterine ring, a device which had to be specially fitted and which Ethel Mannin described as being 'to the Twenties what the Pill is to the Seventies'. Though scrupulous doctors still interrogated those who came to them for contraception, it was now all the rage. Marie Stopes opened the first birth control clinic in London in 1921, and a throng of reformists attended the Hammersmith Palais de Danse in 1924 for the Birth Control Ball. The conservatives – like the pious Margaret Fletcher – could only look on and lament the onward rush of permissiveness:

Halls were engaged in London and public meetings held which were open to both sexes and all ages. At these, preventive appliances were sold – ostensibly to the married – but in practice to anyone who described themselves as being so, without the smallest evidence . . . [There was] a new uncertainty in matters of right and wrong. Times were changed . . .

Inevitably the 'things' went wrong however, or one couldn't bear the mess, or one forgot. Sex has consequences, even for romantic idealists, and not surprisingly there were casualties.

When Constantine Fitzgibbon's girlfriend 'Giselle' became pregnant, he stood by her while they went through the nightmare of trying to procure an illegal operation abroad. A friend lent them money and they visited a suave Parisian doctor who patronised them, refused to help, and charged them a large sum. A friend in Montparnasse knew of an abortionist some-where in the suburbs. They found their way out there but quailed when they were admitted to a dingy drawing room; Constantine noticed a dirty teaspoon, and thought he heard groans coming from the next room. A repellent crone drying her hands on a grubby towel agreed to do the operation immediately for cash. They made their excuses and left – 'Giselle cried all the long way back in the Métro.' Constantine's mother came to the rescue with money to support them, and they enthusiastically turned their attention to becoming parents, but at seven months Giselle miscarried, and the baby died.

When Dorothy Brett, Carrington's contemporary from Slade School days, suspected herself to be pregnant by the writer John Middleton Murry, he was less supportive. Brett found the implications terrifying:

I am afraid. I have struggled through a terrible time of depression . . . The worry, the fear exhausts me . . . I feel, as I suppose every woman feels, that the burden is all left to me. Murry can turn from one woman to another while I have to face the

beastliness of an illegal operation = or the long strain of carrying a child and perhaps death = not that I mind the last = it might be the best way out if I am not strong enough to stand alone.

Brett (who like Carrington had chosen to be known by her surname) confessed her fear to Murry, who reacted brusquely; an abortion was the only solution he could contemplate.

Such operations were not an easy option, being not only illegal, but expensive. In the 1930s they cost about £100. They were also hazardous, and Brett may justifiably have feared death. Murry was only prepared to help Brett make arrangements, while she waited powerlessly, agonised at the thought of what this would do to their relationship. Doctors were put in train, pills were prescribed and a physician friend of Murry's was prepared to persuade a colleague to carry out the operation, which, in the event, and to everyone's great relief, turned out to be unnecessary. Either the pills had worked or it had all been a scare; but during a time of intense anxiety Brett felt fearful, alone and betrayed.

★

In so many ways the reality didn't live up to expectations, and going on living for art, being a twin soul, and fighting for the freedoms of the next generation was tough faced with the hard-to-eradicate sexism of the Bohemian male. Although women in the first decades of the twentieth century were making inroads into traditionally male domains – universities, politics, professions – though they gained the vote in 1928 and were embattled upon the marriage question, they still had much to contend with in the form of unreconstructed male attitudes. The largely unchallenged image still tended to be that of the masterful male artist, while 'Egeria' played the subservient role, yielding pride of place to the genius, and often trading her own talent for a life as housekeeper, brushwasher, model or muse. Her reward was in the reflection of her master's glory. How blissfully contented Trilby was to spend a day sewing buttons on shirts, washing linen, and looking after the comforts of Little Billee and his male friends. How cosily Katherine Mansfield and her friend Beatrice Campbell sat chatting by the fire, darning their menfolk's socks. And how wistfully the wayward Betty May admired Epstein's redoubtable wife, Peggy, regarding her as the epitome of a superb domestic helpmeet – 'What a pity every man of genius cannot have such a wife!' Unfortunately some 'men of genius' seem to have regarded their phenomenal prowess as being an excuse for bizarre acts of sexism, Roy Campbell being one:

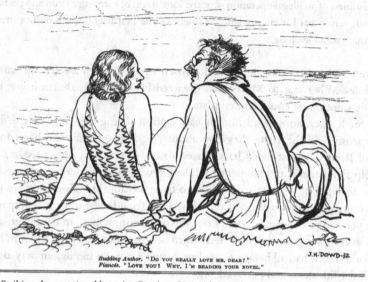

Budding Author. "Do you really love me, dear!"
Fiancée. "Love you? Why, I'm reading your novel."

J.H.Dowd.32

Striking the emotional bargain, *Punch* 14 September 1932.

Though we were very happy, my wife and I had some quarrels since my ideas of marriage are old-fashioned about wifely obedience . . . To shake up her illusions I hung her out of the fourth-floor window of our room so that she should get some respect for me . . .

This was probably fantasy, but nonetheless illustrates Campbell's attitude. He claimed she liked it, just as he claimed that women expected to be beaten by their husbands for insubordination.

Mary Campbell, like Mary Gill, Peggy Epstein and others tended to take the line of least resistance, finding a certain satisfaction in subservience to the artistic ego of their husbands. For others the sacrifice was greater, for it meant having their own artistic personality squashed by their husbands' selfish attitudinising. In some cases this was an irreparable loss in terms of the art they might have produced.

Edna Waugh, one of the most promising and beautiful students at the Slade School of Art in the late 1890s, appeared to have a brilliant career ahead of her. When the barrister Willie Clarke Hall proposed to her, she anticipated their marriage as 'the sweet interchange of mind, of spirit, of body', and on their engagement Willie made her a promise that, as a painter, she need have no concern about domestic affairs – 'I want you to consider Art your profession . . . We must have a housekeeper to do all that sort of

thing.' But their marriage in 1898 nipped all her romantic and artistic hopes in the bud. Willie was cold; he refused to discuss his life or thoughts with her, and his domestic expectations amounted to tyranny. His promise broken, she was expected to be wife, mother, hostess and housekeeper – but artist, no.

Hilda Carline was another painter, bold, experimental, but patchy, an artist who might have achieved status in her lifetime – had she not been married to Stanley Spencer. His genius dominated their lives together. Although she appears not to have resented his success, domesticity left Hilda with no space for her own painting. And marriage didn't just stifle artistic creativity; the end of singledom meant the end of the exhilarating, liberating life of the unfettered Bohemian. When Kathleen Hale exchanged poverty, ill-health and insecurity for marriage with a man who could give her comforts and a family, she also put behind her the good times. Douglas McClean was literal-minded, humourless, controlling. When he read her first *Orlando* book he reacted, 'But Kathleen, cats don't *do* those things.' 'When you married, your light went out,' her old friend Viva King told her.

For some Bohemian women who knew what was good for them, marriage just meant giving up too much. The painter Tristram Hillier's girlfriend, Georgiana, got pregnant by him, but dug her ideological heels firmly into the ground when he suggested they get married:

'Why are you . . . so insistent upon conforming to this archaic survival? Marriage can make no difference to people's relationship unless they are the slaves either of superstition or some stupid social code.'

Tristram finally prevailed upon Georgiana for the sake of the baby, but she had to be dragged to the altar, eight months pregnant.

*

All too often those who tried to bypass the stupid codes were thwarted not so much by social opposition as by their own insecurities and insurmountable feelings of jealousy. Attempts to make the open marriage work were seldom successful. Dick and Naomi Mitchison were sadly a rare case. That theirs survived was thanks to qualities of remarkable tact and also to their mutual fortune in finding equally compliant and tactful lovers. When two people decide to have extramarital affairs their position is dangerously inflammable, and the possibility of a conflagration is compounded by the number of participants, each one of them a smouldering ember of live emotions.

The great sex guru himself, Havelock Ellis, made superhuman efforts to come to terms with his wife Edith's lesbian infidelities. He professed not to grudge her happiness with Claire, the third party in the triangle, and claimed that he did not feel the slightest jealousy, but Ellis's claims started to ring hollow when he admitted that he could no longer endure Edith's coldness to him, and her extensive absences. He owned up to an 'obscure restless discontent and unhappiness'; 'I was suffering, and Edith could not fail to detect the cause.'

When John Nash first made love to Christine Kühlenthal they made a 'freedom pact'; they would be 'as one, yet free'. It was under the terms of this pact that Christine had confidently resumed her lesbian affair with Norah during John's absence in the trenches of France. But after their marriage the situation was less satisfactory; John was gloomily preoccupied by his old passion for Carrington, and this so undermined their relationship that it came close to fragmenting.

The poet Stephen Spender struggled to suppress his anguish at his first wife's infidelity. He and Inez were in love, and their marriage seemed strong enough to withstand a little buffeting; he felt unthreatened at first by her bantering 'I love you and shall love you always, but I might leave you . . .' which didn't at the time seem worth taking too seriously. In any case he felt it beneath him to make possessive demands on her:

I was jealous and I made scenes, but I did not demand that she should act against her inclination . . . [our love] would go on existing beyond the vows which we had made so unreflectingly in the Register Office . . .

As Inez was frightened, she did not behave in a way which would strengthen my confidence, and there were hours when I simply became a prey to the most stupefying anger and jealousy . . .

We separated in the early summer of 1939.

Idealism combined with artistic temperament put Bohemian relationships under intolerable pressure at times. Artists are both the most fascinating and the most unstable individuals, but they are also sensitive plants, easily battered. When Viva King met Philip Heseltine (the composer, whose pseudonym was Peter Warlock) it was love at first sight. Though he was married to the model Bobby Channing ('Puma'), this was irrelevant to Viva, who was mesmerised by his fascinating pallor, his black clothes and air of aloofness. After their initial encounter at the Café Royal they staggered home, Viva very drunk, accompanied by a sculptress friend, Jackie:

[I] had almost to be carried up the stairs.

Jackie found a bed to get into, and Philip and I sat together by the piano, on which he played now and again as we talked through the night to morning. Jackie kept an inquisitive ear to the wall, and when she heard me cry 'No! no!' she thought the worst. In fact it was my natural response to Philip's nihilism. On and on he talked of the futility of life – nothing mattered and he (and all of us, I gathered) would be better dead. But who, I thought, was better equipped than myself to pull him out of his slough of despond with my love? This was a mission that I had been waiting for all my life . . .

We did not go to bed together – our love was on a higher plane; so high in fact, that there was only one way it could go, and that was down!

For the next few months the pair were on an emotional roller-coaster. They would part, then accidentally meet, when a moment of passionate eye-contact would send their hearts racing again. Heseltine followed Viva to Paris where they celebrated Bastille Day for three days and nights without sleeping, after which they finally fell into a passionate embrace. Then Heseltine left without a word. Viva was again in shock. They met again, once, after she had married; the old electricity kindled, and then died. But no love of Viva's could have helped Heseltine; a few weeks later she read of his suicide in the newspaper: 'He gave his cat to the landlady, shut the doors and windows of his basement room and turned on the gas, which put him to sleep for ever. He was thirty-six.'

Certainly, Heseltine was unbalanced, his capacity for happiness distorted by depression. He was a victim; his own inspiration and passions were forces beyond his control, and they finally derailed him.

*

The nineteenth century made strenuous efforts to keep the cauldron of emotion, sex, desire and art from boiling over. Suppression took different forms – in vain the guardians of society sweetened the brew with sentimental sugariness, clamped on the lid with puritanical measures, denounced and denied; but illicit loves and lusts spilled forth from a vessel that could no longer hold them; it has never been closed again. We can still hear the echoes of that torrent – the clamour of spurned and exploited women, the shouting matches, the smashing of crockery thrown by Tristram Hillier's lover, the shots that rang out when Peggy Epstein took an antique pistol and shot her husband's mistress in the arm.

And yet still palpable beneath all these turbulent emotions is that profound idealism about love which Isadora Duncan expressed so passionately in her

paean to Gordon Craig. Viva King's love was 'on a higher plane'; Stephen Spender's faith in love outweighed in the end his disillusionment. Remember that the contemporary climate of bigotry and puritanism made Bohemia a ghetto. Embattled Bohemians clung all the more tenaciously to their ideals, and in that sour, repressive age only love and art seemed capable of expressing the highest human aspirations. The plunge when it came was all the more dire.

<center>★</center>

By 1918 Rosalind Thornycroft's Bohemian idyll lay in ruins. When the euphoria passed she discovered that Godwin was a philanderer, and succumbed to uncontrollable feelings of jealousy. They had two small children; with Godwin away at the war Rosalind fell into the arms of a former admirer, Kenneth Hooper, and was soon pregnant by him. Rosalind's idealism brought her now to the brink of an irrevocable step – divorce. She could not contemplate continuing to live in a loveless marriage with Godwin, who seemed fatally susceptible to other women, despite his protestations that these were trivial flirtations. Rosalind's father-in-law, a pious non-conformist, lamented the bitter blow: 'The H. G. Wells atmosphere has vitiated their home life; if it had been based on loyalty and love to Christ; shown in work for others, this might not have happened.' He probably had *Ann Veronica* in mind. But although Rosalind, like Wells's heroine, was an abandoned woman, nevertheless she behaved with extraordinary courage in agreeing to have her lover, Kenneth Hooper, cited in their divorce case as co-respondent.

In 1921 when Rosalind's divorce case came before the aptly named Justice Horridge, the divorce laws were still Victorian. Only one ground was acceptable for divorce, and that was the biblical one: adultery. The disgrace that attached to public accusations of adultery was extremely damaging. If Rosalind had sued Godwin for divorce, the scandal might have wrecked his chances of pursuing a successful career as a doctor; yet she must have agonised over the decision which she eventually made, in agreeing to be the guilty party. For the daughter of an eminent Royal Academician to run the gauntlet of the press with such an admission caused her to quail within. Rosalind decided to leave the country. The Thornycrofts, left behind to face the music, were traumatised by the lubricious coverage of their daughter's case, in which her love letters to Kenneth Hooper were extensively quoted, and headlines reading 'Feminist Divorced' strapped across the columns of the *Daily Mirror*. Sir Hamo Thornycroft's brother's family refused ever to speak to their niece again after her vulgar divorce. Rosalind, with

little Bridget, Chloë and the baby, Nan, lived in Italy for the next four years, and did not return until the scandal had died down.

Between 1900 and 1930 the divorce rate rose more than six-fold. The avant-garde had raised the stakes very high in pursuit of personal fulfilment and individualism, and there had to be a reckoning. The composer Constant Lambert, inquisitive, libidinous and insatiable, committed adultery once too often. There was a series of terrible rows, and Flo Lambert finished by throwing her wedding ring into a lake.

But Bohemia could also be a sanctuary for the abandoned. Returning to find an empty flat after his wife had packed her bags, the writer Peter Quennell contemplated the reduction of his domestic existence to a bed, a chair, a table and a candle in a bottle philosophically: 'Indeed, I rather enjoyed my odd bohemian existence, and certainly did not regret the neat and elegant setting that had vanished never to return . . .' And like the good new Bohemian that he had become, he wasted no time in finding a replacement: 'My new friend willingly joined me; she was a true bohemian herself, and our love affair seemed all the more enjoyable because it flourished in such sparse surroundings.'

For Quennell the wilderness was 'Paradise enow' – for a space, while the affair lasted. For many Bohemians there were moments of bliss, moments when the Isadora vision became a reality in those garrets and studios and basements, when, entwined in one's lover's arms, with the smell of paint and turpentine to send the soul eddying off into the heights, a composition or a verse could inspire transports of passion all the more intense because one was hungry and poor and defiant . . . And when the moment passed, there remained the thrill of fighting the battle for emotional and sexual liberty that raged in this country from the late nineteenth century onwards. It was an exhilarating time to be alive. Though they were often beaten back, it was a fight in which the Bohemians were on the winning side. Their romantic ideology was stronger than that of their opponents.

*

Perhaps, after all, happiness wasn't the point. In 1907, in a scene straight out of Puccini, Augustus John's young wife, Ida, lay dying of puerperal fever in the boulevard Arago after the birth of her fifth child, Henry. Augustus's mistress Dorelia was looking after the other children not far away. There was a tremendous thunderstorm as Augustus sat by Ida's bedside, and towards the end she was feverish but out of pain. As day broke over the rain-washed city of Paris, Ida was sufficiently conscious to drink a toast with her husband – 'to Love!' The end was close now. As the hours passed she subsided again

into delirium, unconsciousness, then death. As soon as it was over Augustus
ran out of the hospital in a fever of excitement; he was almost high on relief.
'I could have embraced any passer-by. I had escaped the dominion of death
at last and was free.' The city was intensely beautiful; he felt almost as if he
was hallucinating: 'unbelievable – fantastic – like a Chinese painting . . .'
Then with a sense of triumph the bereaved husband proceeded to go out
and celebrate; Augustus spent the next three days drunk. Perhaps it was the
only possible reaction for someone who so powerfully wanted life for the
living, who wanted to believe more than anything in art and beauty, and
refused to be vanquished by death's inevitability. He knew he had worn
Ida out with his infidelities, she was drained and weakened by repeated
pregnancies, deprivation and emotional exhaustion – but faced by her death,
and his complicity in it, Augustus set out to live life to the full.

3. Children of Light

*What is it like to be brought up in Bohemia? – Should children be kept
clean and tidy? – Should children be given rules and punishments? –
How do you bring up a creative child? – Should children be
educated, and if so, how?*

Ida John's death left five children motherless. In the six years of her marriage
to Augustus, life had been tough for this once promising art student. There
was very little money, and one after another the babies kept appearing:
David first, then Caspar, Robin, Edwin, and Henry.

Like many other women, Ida discovered that after the comparative
serenity of bringing up one baby, the contrast when a second arrives can be
shocking. After Caspar's birth the Johns could no longer afford a nurse, and
Ida now found herself submerged in the babies' needs. The day began at
five-thirty or six in the morning, and she was unceasingly on the go from
that time until the infants could be put to bed at seven-thirty in the evening.
She then had 'a delightful island' of three hours before the night session
began, for Caspar was a wakeful baby. Ida was dropping with exhaustion
after several months of this. Her friend Mary Dowdall's letter to her husband
describing the chaos of the Johns' life at their home at Matching Green in
Essex makes it seem all too present:

Mrs John is beating the baby to sleep which always amuses me and appears to
succeed very well – she is so earnest over it that the baby seems to gather that she
means business . . . The baby is simply roaring its head off and no one paying any
attention – it is in another room . . . You would hate to be here. Mr Augustus looks
sometimes at the baby and says 'Well darling love – dirty little beast' at the same
time . . . I think [Ida] must have sat on the baby – it has suddenly stopped crying.

After the family moved to Paris in 1905 the only thing that kept Ida sane
was the presence of Augustus's mistress, the divinely calm Dorelia, who
soon had two babies of her own – Pyramus and Romilly – and more than
shared the burden of bringing up six little boys under the age of five. Dorelia
took outbreaks of measles in her stride; she wheeled the pram, and helped
feed, bath and dress the multitude. It was no small task. There was one living

room and one bed for the whole family, who were otherwise accommodated between an assortment of boxes and baskets. Quiet lasted at best for ten minutes; then the whining, grumbling, howling, or all-out yelling would begin again. When Augustus was away the children were particularly unruly. One day David took a pair of scissors to his own and Caspar's hair, turning them into cropped convicts. Ida referred to her offspring as 'the acrobats'; they roared, rolled, tumbled and somersaulted. Eventually the neighbours could stand the racket no longer and had them evicted. When John's friend and patron Will Rothenstein visited the family he was appalled: 'I felt terribly sad when I saw how the kiddies were brought up, though anyone may be considered richly endowed who has such a mother as Ida. Ours seem so clean and bright compared with them just now . . .' he wrote to his wife Alice.

Ida contemplated the birth of a fifth child with glum dread. She feared her confinement, and confessed, 'I am dreadfully off babies just now . . . in a fortnight or so the silent weight I now carry will be yelling its head off out in the cold.' These forebodings were tragically justified. It was Henry's birth in March 1907 that brought on the puerperal fever that killed her.

Even with all her characteristic serenity and goodwill, Dorelia could not be expected to look after the entire lot. Ida's formidable middle-class mother, Ada Nettleship, immediately offered to take in her three eldest grand-children. At this point it was not in Augustus's power to refuse, but he made it clear that he intended to get his children back. Soon the boys were the victims in a tug-of-war between Augustus, who wished them to return to Dorelia's care, and their conventional grandmother. By Summer 1907 Augustus managed to reassemble his family at Equihen, a village near Boulogne, but Mrs Nettleship firmly insisted on coming too. There, she was horrified by what she saw as Dorelia's incompetence: the children were dressed like gypsies, their bedrooms were full of uncontrolled frogs and grasshoppers, and on one occasion they only escaped drowning en masse because they were rescued by a local fisherman. Then all the children caught eye infections. That was the last straw. Mrs Nettleship scooped up three of her grandsons and transported them back to Wigmore Street to be cured, shampooed, and fumigated. Augustus was dismayed at the thought of their beautiful locks being shorn and their lovely tattered, colourful clothes being replaced with constricting shoes and tight collars; he ranted at the thought of them being turned into 'little early Victorian bourgeois prigs'. But Mrs Nettleship was no less appalled at the prospect of her daughter's children being reared by their father's mistress, and got up like ragamuffins. The denouement came with a heated chase around London Zoo, where Augustus

finally succeeded in cornering two of his boys behind the pelican house and carrying them off as hostages. Despite Mrs Nettleship's protests, all but Henry were eventually brought up by Dorelia.

<p style="text-align:center">★</p>

Augustus John sincerely believed he had his children's best interests at heart. His view was that Dorelia was a rare genius, who would bring them up to be brave and beautiful and free. Restraint and discipline were not words in John's vocabulary. He loved babies; he loved them physically, loved to see them crawling about, loved gently to bathe their soft naked bodies; and he loved to make as many of them as he could. There were seven by the time Ida died. Dorelia's two girls Poppet and Vivien came next. Nine recognised children. Then Zoe, Amaryllis and Tristan to miscellaneous mothers, and who knows how many more, unrecognised?★ The John household was overflowing with progeny; the visible and audible expression of the great man's potency, they peopled his world.

Augustus John's sketch of his baby son Pyramus, 'the most adorable of children', who died of meningitis aged six.

Augustus John set off in the spring of 1909 with two gypsy caravans, six horses, Dorelia, her sister Edie and seven assorted children to camp in fields outside Cambridge. Rupert Brooke visited them there and was completely entranced:

The children are lovely brown wild bare people dressed, if at all, in lovely yellow, red or brown tattered garments of John's own choosing . . . They talked to us of an

★ Max Beerbohm estimated over ninety-nine. Even the children themselves got bewildered. Romilly, the sixth child to be born to Augustus, wrote an autobiography entitled *The Seventh Child* (1975) on the grounds that he was the seventh 'officially'; (although Henry, born 1907, was born after Romilly, he was legitimate while Romilly was not). He was apparently much teased about this.

imaginary world of theirs, where the river was milk, the mud honey, the reeds and trees green sugar, the earth cake, the leaves of the trees (that was odd) ladies' hats, and the sky Robin's blue pinafore . . . To live with five wild children in a caravan would really be a very good life. I shall take to it one day.

Romilly John, who must have been three at the time of the Grantchester camp, left his own memoir of the John upbringing. In 1911 the extended family moved to Alderney Manor near Parkstone in Dorset, where he and his brothers were allowed to live a primitive, amphibious life, in and out of the garden pond, or running around naked to get dry and warm up. Callers such as the vicar were startled to see a horde of children in a state of nature blocking his entrance to the front door – 'he retreated instantly'. At intervals the troupe appeared, clothed or otherwise, for meals, then returned to their games in a nearby brickyard or sand quarry. The human occupants of Alderney shared their existence with a farmyard full of cows, donkeys, hens, cats and ponies; there were two tame saddleback pigs on which Poppet and Vivien used to ride around the house and garden. The children were greatly occupied in rounding up cattle, making butter, collecting eggs and firewood. From 1917 the four children of Augustus's friend Francis Macnamara swelled the ranks at Alderney. According to Kathleen Hale this crowd was quite without the need for adult intervention to provide them with amusement. They had no toys, but were utterly absorbed in their own private pursuits.

*

The John household was depicted, travestied perhaps, but not without a grain of truth, by Margaret Kennedy in *The Constant Nymph*, her best-selling novel of 1924, a work of romantic fiction which descends from *Scènes de la Vie de Bohème* and *Trilby*. Kennedy chose the Austrian Tyrol rather than the Dorset heathland for the opening scenes of her novel, but apart from this Augustus's ménage at Alderney is not so far removed from the composer Albert Sanger's extended family living in the Karindehütte – an overflowing chalet full of children and guests:

Few people could recollect quite how many children Sanger was supposed to have got, but there always seemed to be a good many, and they were most shockingly brought up. They were, in their own orbit, known collectively as 'Sanger's Circus', a nickname earned for them by their wandering existence, their vulgarity, their conspicuous brilliance, the noise they made, and the kind of naphtha-flare genius which illuminated everything they said or did. Their father had given them a good, sound musical education and nothing else. They had received no sort of regular

education, but in the course of their travels had picked up a good deal of mental furniture, and could abuse each other most profanely in the *argot* of four languages.

The story that follows is the stirring romance of the elfin Tessa Sanger, whose untamed nature stays constant to her twin soul, the young Bohemian musician Lewis Dodd, to whom she has been devoted since childhood. Lewis is captivated by the 'wild, imaginative solitude of her spirit'; while for Tessa 'her love was as natural and necessary to her as the breath she drew'. She is fourteen when the novel opens, quick-witted, unstable, ragged, barefoot and unkempt; she personifies the free spirit, the child of nature. She, like her brothers and sisters, has no discipline in any field except music. When Albert Sanger dies, well-meaning relatives send her to England to be tamed in the boarding-school system, but she escapes. Though Lewis marries and years pass, Tessa remains true to her childhood attachment, and eventually they run away together; but it is too late. Tessa is too frail and evanescent a spirit for this world, and she must die.

The Constant Nymph is a romantic glorification of a state of grace, of the ideal of Jean-Jacques Rousseau's innocent, experience-taught child, uncorrupted by 'civilised' values. This child was possessed of innate worth, instinctive intelligence and knowledge of its own interests. According to Rousseau, most teaching distorted and denatured the child's inner sense of what was good:

I contemplate the child, and he pleases me. I imagine him as a man, and he pleases me more. His ardent blood seems to reheat mine . . . his vivacity rejuvenates me.

The hour sounds. What a change! Instantly his eyes cloud over; his gaiety is effaced. Goodbye, joy! Goodbye, frolicsome games! A severe and angry man takes him by the hand, says to him gravely, 'Let us go, sir,' and takes him away. In the room into which they go I catch a glimpse of books. Books! What sad furnishings for his age! . . .

Leave him alone at liberty. Watch him act without saying anything to him. Consider what he will do and how he will go about it. Having no need to prove to himself that he is free, he never does anything from giddiness and solely to perform an act of power over himself. Does he not know that he is always master of himself? . . . He is always ready for anything.

In other words, trust the child to know what is good for him. In *Emile* (1762), Rousseau advocated that the child should be allowed to run barefoot, that it should be hardened by cold baths and outdoor exercise, that its immunities should be permitted to develop by resisting interference when

a child is ill. 'The farther we are removed from the state of nature,' he wrote, 'the more we lose our natural tastes.'

Rousseau's model of the naturally brought-up child became the foundation for an alternative way of thinking about the raising of children. It has pervaded educational discourse ever since. In the late nineteenth century the eagerness to embrace Rousseau's precepts was more urgent than ever, as liberals sought new ways to free themselves from the stranglehold of Victorian orthodoxy. Vanessa Bell may never have read Rousseau, but his influence can be felt in her determination to prevent the stunting of her own children by over-protective parenting. At Charleston the Bell children grew up in an almost prelapsarian world, a kind of Eden. Following her children around the walled garden with her Box Brownie camera, she captured their cherubic nakedness, or their intent absorption in the mud of the cattle pond, or a burgeoning soap-bubble, or a flower. Julian, Quentin and Angelica grew up barefoot and naked; children of nature, unruly, subject to every danger and subjects in every painting:

In the eyes of the grown-ups we had one virtue [remembered Quentin]: we did not need to be amused. We could be trusted to amuse ourselves with games of our own invention. When I was about eleven or twelve I used to bicycle into Lewes (the roads in those days were very safe) and purchase gunpowder from a shop which still had a few customers who used the old muzzle-loaders. The grown-ups must have noticed the occasional explosions which startled the birds in the garden and were sometimes accompanied by fragments of flying metal, but I can remember no enquiry, and certainly no reprimand. All this enabled us to enjoy Charleston to the full, and I am still grateful for the policy of wise neglect which made it for us so happy a place.

In this world the child's own sense of what was right for him or her – in this case, gunpowder – sufficed in identifying material for joy and frolicsome games. Vanessa did not interfere with the boys' amusements beyond providing pencil and paper and a few books, or '. . . any small objects they can pretend are armies, such as peas or beans, or cards, [which] will keep them happy for hours . . .'

Indeed, like the John children, the Bell children appear to have been content with few toys and distractions. Although a wide range of toys was available to children of that era, few childhood memoirs of artists dwell on them; long hours were spent absorbed with simple playthings. The more 'enlightened' the parent, the fewer the toys provided; and on the whole such children seem not to have felt deprived. Rosalind Thornycroft, it is true, couldn't help longing for a beautiful porcelain doll '. . . with eyes that

opened and closed . . . long lashes and ringlets . . .' Her progressive parents despised dolls on aesthetic and rational grounds: 'Fringes, ringlets and dolls were all taboo and beneath contempt.' Rosalind and her two sisters Joan and Elfrida had to be content with a set of wooden nine-pins, which they adorned with calico and ribbons to become exemplary dolls. Their brother Oliver branded poker-work faces on to the skittle-heads, which gave them all unique characters, and they were put to bed in grocery boxes. Children like this were expected to use their time creatively, and they did.

Apart from their more combustible and explosive obsessions, which were mostly confined to Charleston, Quentin and Julian Bell had one special London game that titillated them more than all the others, and which gave them early lessons in human psychology. They would manufacture a small tightly wrapped parcel, and drop it on to the Gordon Square pavement below; from their upper-floor window they would then watch with fascination the reactions of passers-by to the potential 'treasure'. Would they ignore it? Would they immediately pick it up and pocket it? Or would they edge it into the gutter with their foot before sidling across to 'accidentally' appropriate it? A very few might even seize the package and rip it open, only to find that it contained – nothing. Yet again, nobody intervened or rebuked the boys for this heartless hoax.

Iris Tree was equally set upon a course of benign non-interference:

If by the grace of heaven I ever have children I shall send them for about a year at the age of 10 to some farm, alone with healthy brown peasants, where they can be in the mud and steal pears and get killed as much as they want to.

Edward and Constance Garnett, though they did not abandon their only child David ('Bunny') to the care of healthy brown peasants, were also Rousseauesque in his upbringing. In their remote Arts and Crafts house in the Surrey woods, his parents left Bunny very much to his own devices from an early age. He was shy and wild, antisocial and with an innate contempt for ritual; but he was also self-sufficient:

I [acquired] independence of character and thought, a readiness to do things for myself and a love of nature, an ability to handle an axe, light a fire of wet sticks, sleep out of doors in comfort, even in wet weather, and so on.

He poached rabbits with his dog Nietzsche, played truant in the woods, eating the bark of trees mixed with digestive biscuits for his lunch, and on summer mornings crept out of the house before sunrise to explore the

Surrey Weald with his closest friend, Noel Olivier. Bunny was also brought up to think for himself, which instilled in him a stubborn streak that remained all his life. At the age of four he critically dismissed the well-meaning uncle who told him that it was unmanly for a boy to sit on a potty: '[I] secretly thought him a fool . . .' At five years old Bunny was sufficiently sceptical to enter into philosophical discussions with George, the odd-job boy, who told him that he and his family would burn in hell because they did not go to church. Bunny smugly rebutted him with: 'You only say that because you're the boy who cleans the knives.'

Like his contemporaries, Bunny was encouraged by his parents to call them by their Christian names: Edward and Constance. The culture of deference had no place in Bohemian families. For Romilly John, Dorelia was 'Dodo'; for Julian, Quentin and Angelica Bell their mother was 'Nessa'. Igor Anrep knew his mother, Helen, as 'Doey', and felt no compunction about calling her 'a bloody fool', because at times she appeared to him to be exactly that.

<p style="text-align:center">*</p>

Such attitudes stood out in sharp contrast to their time: for the old cliché of the nineteenth-century family – 'Children should be seen but not heard' – still held sway. Victorian and Edwardian children often inhabited an entirely different floor of the house from their parents, meeting them only at stipulated times. When they did meet, they were expected to display model behaviour. Childhood was not supposed to be fun. Enforcement of hated disciplines – such as churchgoing – was justified on almost homeopathic grounds: 'The more you hate it . . . the more good it does you' the young Margaret Haig was told when she complained. Life was full of pressures and prohibitions:

Never take a second mouthful before you have finished the first. Do not finish to the last crumb or spoonful, or scrape your plate. When finished do not clutch your knees.

General remarks. Do not read much. Do not eat too much butter or jam. Say your prayers. Keep your hair in order.

<p style="text-align:right">(Rules drawn up by her sisters for Margaret Gladstone, 1882)</p>

Ursula Bloom, an austerely brought-up child of the middle classes, remembered how children's bedtimes before the First World War observed a hierarchy as strict as holy writ, according to age. Babies were put to bed prompt at five-thirty, and small children at six. From the age of nine bedtime

was raised to seven o'clock; at twelve to seven-thirty. A fifteen-year-old was sent upstairs at eight. The formality of family life could be suffocating. Lesley Lewis, who chronicled her own upbringing in this era, remembered how after nursery tea schoolroom-age children were garbed in layers of elaborate, prickly underwear, fastened at the back with complicated buttons, surmounted by heavily starched pinafores or shirts, and led down to the drawing room for an appointment with their parents. Mealtime discipline was rigid; finger-marks or smears on the table or silverware were frowned upon, 'indeed breathing was very much discouraged in the dining-room'.

Part of the horror of the Victorian era felt by 'enlightened' people came from the sheer hardship that children were made to endure. To spare the rod was to spoil the child, and physical comfort was seen as little short of sinful. In the 1860s doctors wrote books – echoing Rousseau perhaps, but without his emphasis on the individual – extolling methods of 'hardening' children. They must not sit by the fire, nor lounge on cushions in easy chairs, nor sleep on soft mattresses with warm blankets. Cold baths were obligatory. Sweets were banned; a plain bun without currants might be permitted for special occasions. Jam was a luxury. All food provided must be eaten; nothing was to be left on the plate. Even on the wettest, coldest days of winter an afternoon walk was obligatory, no matter if the raw weather brought tears to one's eyes, and chilblains were endemic. 'They', the authorities, had ordained that children must be, like Pip in *Great Expectations*, brought up 'by hand'. So rigorously was this rule of terror imposed, that when the writer Ford Madox Ford grew up he still had difficulty persuading himself that he was an autonomous adult, who could do what he liked:

Lurking at the back of my head, I have always the feeling that I am a little boy who will be either 'spoken to' or spanked by a mysterious *They*. In my childhood *They* represented a host of clearly perceived persons: my parents, my nurse, the housemaid, the hardly ever visible cook, a day-school master, several awful entities in blue who hung about in the streets and diminished seriously the enjoyment of life, and a large host of un-named adults who possessed apparently remarkable and terrorising powers. Now-a-days, as far as I know, I have no restraints . . .

The adult Ford made a bid for liberty one day when he took a piece of uneaten fish and hurled it out of the window at the helmet of the policeman standing in the street below, but guilty feelings prevailed when he later felt tempted to lob a large bag of mouldy flour at the same 'awful entity in blue'.

He resisted, inhibited by the unseen *They* of his childhood. Ford recognised that the emotions and anarchic impulses of his childhood were ever-present within him, and that he, like many others of his generation if only they would admit it, had never really grown up.

<center>*</center>

Ford felt that staying in touch with this essential childishness was what made him a free and creative individual. One can only imagine how *They* might have reacted to the twelve-year-old Julian Bell letting off a loaded airgun under the dining-room table at Charleston. And what on earth would *They* have made of the disorderly upbringing of the John babies?

The haute bourgeoisie had its position to keep up; if one let things slide, if one's children didn't conform, or mixed with dirty lower-class children, one could be stigmatised and lose caste. Bohemia was happily *hors de combat* in the competition for social position; these were people who had long relinquished any such claim, so why not allow their children to hurl fish and let off explosions?

Many parents saw the provision of liberty for their children as a prior condition of creativity, both their own and their children's. But at times one feels that this neglect was as much expedient as ideological. Bringing up children is very hard work. For parents with not much money, teams of nursemaids boiling nappies, starching frills and enforcing table manners were beyond their reach. Leaving children alone to get on with their lives was a great deal simpler and cheaper than keeping them up to the mark. And choices had to be made. You could maintain cleanliness and order, or spend the time on creative activities – but not both.

Robert Graves insisted to his friend the writer Peter Quennell that it was not impossible; the child could be minded, the soup kept from boiling over, and a stanza composed simultaneously. But Quennell noted that Graves's look of severe strain told a different story. The family finances did not run to childcare, and anyway Nancy was determined to look after the four children under six years old herself. She did her best to sew their clothes, feed and clean them, at the same time as attempting to draw and paint. She had high standards, and instituted punctual bedtimes and rest-times; the children were not allowed to eat meat or drink tea, but might have as much fruit as they wanted. Otherwise they ran wild and free in the fields near their home village of Islip, in contact with farm animals, enjoying their frolicsome games in the riverside mud. Nevertheless the strain of childcare began to tell on Nancy, and her health broke down.

When Robert Graves started to make a little more money from his

writing, Nancy capitulated and they took on a nanny. This was in the 1920s, when domestic help was expected as a right by everyone except those actually surviving on the breadline. It may seem surprising that servants and Bohemians coexisted. In fact a nanny was paid around twenty pounds a year plus her keep; this could not be regarded as an extravagance. In proportion to their annual income, the cost of childcare might amount to what a household today would spend on running a small car – which they would no doubt regard as indispensable. Vanessa Bell did not have a car, but for her a nursemaid was a necessity. It would not have occurred to her to undertake the arduous side of childcare herself.

But of course nurses and nannies were a mixed blessing, and it took a rare one to cope with the delinquency of some of their little Bohemian charges. It was not what they were used to. In the bourgeois home, Nanny ruled supreme, while parents were remote and godlike beings. Angelica Garnett's memoir *Deceived with Kindness* (1985) paints quite a different picture. Her mother Vanessa Bell experienced anguish at Angelica's tantrums when the nurse Nellie came to bear her off to bed, breaking into the idyll of their most intimate fireside moments. The conflict hurt both of them. Vanessa's freedom to paint, or to leave the house, was bought at the price of guilt-ridden relationships with the lower-class women to whom she entrusted her children, while Angelica suffered from the suffocating, compensatory love lavished on her by her mother during their times together. Vanessa's permissive views necessarily clashed with those of nurses like Nellie who forced cold plates of uneaten porridge on the children at successive mealtimes, while Angelica uneasily transferred her love from one to another.

But Angelica would never have traded her ambiguous upbringing for the persecution, the all-out neglect, the sheer cruelty endured by some of her contemporaries. Evidently, the severity of childhood oppression was in itself instrumental in driving misfits and free spirits out of captivity, to become refugees in Bohemia.

That hunger they felt for life beyond the prison bars can hardly be overestimated. Take the case of Dorothy Brett, whose father, Reginald, was a Liberal MP and also a member of the inner circle surrounding Queen Victoria. The Brett children's father was almost a stranger to them, and in adulthood Dorothy would recount a family story about how she and her sister Sylvia were taken by their nursemaid for an airing in their pram in Hyde Park. The nursemaid spotted Reginald across the way strolling with a friend and told the children to wave to their papa. Reginald was baffled; why were those two little girls waving at him and who could they possibly belong to? 'Perhaps they are yours,' hazarded the friend.

The Brett children were subjected to neglect bordering on abuse. When their mother discovered that the nanny she had employed to care for them was habitually drunk, she did not dismiss her, but simply forbade her to offer alcohol to the children. Nanny locked them in cupboards, beat them, and bludgeoned their pet bullfinch to death. She was still not sacked, and only finally left of her own accord on discovering to her indignation that the children had been sent on holiday to the seaside without her. When Dorothy eventually went to the Slade School of Art her choice was regarded by her parents as undutiful and wrong-headed, but she was all the more bravely determined to persevere in her course.

The writer Philip O'Connor's father, known as 'the cad', was absent and unfaithful; he never saw his son, which was just as well as he had threatened to drown any male child of his in a bucket. Philip was brought up by his mother, with erratic help. When he was three his nurse dropped him twenty feet from a window on to a stone courtyard; and once pulled him out of the bath by his hair. She was sacked. Philip's mother then abandoned him to the care of a Frenchwoman who was over-affectionate, and took the child into her bed. As he grew up Philip was increasingly aware of how little he fitted in with English society. Bohemia was to be his place of asylum, a retreat where this damaged and unhappy outlaw could find solidarity and an ever-open door.

Edith Sitwell was slighted and maltreated by her parents to a degree which affected her for the rest of her life. She was unloved, regarded as hideous by her father, and neglected, apart from the infliction – as she saw it – of two instruments of torture. One was an orthopaedic brace to correct incipient curvature of the spine, the other a contraption that she was made to wear at night to rectify her beak-like Sitwell nose. She christened these oppressive devices her 'Bastille'. In the face of such unhappiness, Edith retreated into the world of her imagination; for the rest of her life poetry and art were to be her solace and *raison d'être*.

<div align="center">*</div>

Tyranny and negligence, oppression and permissiveness: the poles of parental attitudes can be seen nowhere more clearly than in the artists' uncharted world. Here creativity clashes with its negative force, and the neglected child feels in the dark for absent boundaries. The child in Bohemia experienced all the elation of liberty, but also all the precariousness of insecurity and loss, for freedom can be as oppressive as captivity. A child without rules and restrictions may have to impose them for himself – few so drastically as Augustus John's second son by Ida, Caspar, who decided in 1916 that he

wanted to join the Navy. The unbridled informality and freedom of Alderney had given him an overpowering desire for a life circumscribed by rigid routine, and security of an orderly kind. Augustus, despite his affection for them as babies, developed into a cantankerous and unreasonable parent to his teenage boys, and Caspar found approaching his father with his request to become a naval cadet a terrible ordeal:

I could only guess at what his reaction might be. I was right. '*What?*' he shouted. 'You want to subject yourself willingly and wittingly to the harshest discipline in the world? You must be mad, boy!'

Caspar persisted; Dorelia helped to persuade Augustus to finance him, motivated by a willingness to get the older members of the family off her hands; and in due course he was dumped unceremoniously at the gates of Portsmouth docks. It was the beginning of an impressive trajectory from Bohemia to the establishment, culminating in Caspar's knighthood and his appointment as Admiral of the Fleet. Would Augustus have turned in his coffin to hear such a turncoat of a son read the lesson at his memorial service?

The Woman Who Did, Grant Allen's progressive novel of the late nineteenth century, demonstrates the monstrous disappointment felt by parents whose high hopes for their children are dashed against the rocks of conformism. Herminia Grey had set out possessed by the ideal of giving her children . . . 'the unique and glorious birthright of being the only human beings ever born into this world as the deliberate result of a free union, contracted on philosophical and ethical principles . . .' The daughter born to this free love union, Dolores, is fated to suffer the ostracism of society because she is the child of a single mother. She is bitterly resentful, for all 'Dolly' wants is to be ordinary, to have married parents, material blessings, clothes and money like everybody else. She hates being condemned to Bohemian status, and when she grows up she makes it her mission to infiltrate polite society. An upper-class weekend house party represents everything Dolly has ever dreamed of:

For the first time in her life, she saw something of men – real men, with horses and dogs and guns – men who went out partridge shooting in the season and rode to hounds across country, not the pale abstractions of cultured humanity who attended the Fabian Society meetings or wrote things called articles in the London papers. Her mother's friends wore soft felt hats and limp woollen collars; these real men were richly clad in tweed suits and fine linen. Dolly was charmed with them all . . .

Her daughter's rejection of her most cherished hopes is unutterably galling to Herminia, whose life now seems to her to have been spent on wasted endeavours; and at the end of the novel she dies, heartbroken.

Although it neatly illustrates the point about how children can react against their parents' values, the black and white world of *The Woman Who Did* does not do justice to the agonies and complexities of real people's relationships. Kitty Garman was the daughter of the sculptor Jacob Epstein by his mistress Kathleen Garman. After she grew up, Kitty came to feel that she had been the victim of a selfish and narrow-minded disregard of other people's points of view. She and her brother and sister (also Epstein's children) were practically brought up by their Garman grandmother, whom they adored, while their mother, Kathleen, was a remote, occasional visitor. She would appear at Granny Garman's at weekends, dressed in smart, exotic London clothes, and embarrass her children. Kitty believed her mother was really a witch; she was frightened of being touched by her, and shrank from Kathleen's cold-hearted dismissal of her childish fears. Epstein himself was equally remote, though benign, and Kitty, who yearned for someone to call 'Daddy', developed a substitute in the form of a fantasy father. Though Kitty made her peace with her mother before she died, she spent much of her adult life resentful of her Bohemian parents, whom she felt never looked after her properly. She remembered how when she was only seven, Kathleen went out with Epstein and left her, terrified, with her brother Theo, alone in the house at night. Though the children were often dirty and ragged, Kitty always felt that their mother took no responsibility for this: 'She had a way of making us feel it was our fault, not hers.' She once upbraided her mother for having children for whom she didn't care, and was fobbed off with: 'I had no choice . . .' Jacob Epstein and Kathleen Garman may have been pioneers in their way of life, but, according to Kitty, they didn't have to pay the price for their fearlessness: 'It was their luckless children who suffered!'

Kitty's two cousins, Tess and Anna Campbell, the daughters of Roy Campbell and his wife Mary, were taken by them while still very young to live in the south of France. On the face of it this was an idyllic upbringing, the little girls free to wander the wild prairies of the Camargue and swim in its inland salt lakes, brown and barefooted. As well as picking up French from their friends at the nearby château, they learnt everything there was to know about the facts of life from these local children. But Anna later questioned her upbringing:

I did notice [my mother] was an unusually unworried sort of parent. She never seemed to notice what we were eating: sometimes we would be given bread and

milk, or sour milk, every night for our suppers, for weeks on end. Luckily, we always had neighbours who filled us up with brandied cherries, dried fish (which we liked eating raw), plenty of strong coffee with milk, and other delicacies of this sort.

Mary, like her sister Kathleen, opted out of taking responsibility for her children. Perhaps it was a Garman family trait. She would leave their hair to get dirty for weeks on end and then get unreasonably annoyed when the necessity of washing it became manifest. Mary didn't even interfere when Tess and Anna contracted measles and allowed them to go on bathing in the lake. Once they were absent for a whole week staying with their château friends before Mary noticed and suddenly became consumed with anxiety. There were furious reproaches when she got them home, 'which seemed, under the circumstances, terribly unfair, and a bit late in the day'. When, in due course, the children were sent back to stay with their Garman grand- mother in her English country house, it was a blissful contrast:

The lavender-scented baths, after the salty bathes in the lake. The delicious cooking of Mrs Beeton after bouillabaisse with rouille sauce. The soft green fields after the blazing forest fires . . . Even the contented paddling of ducks after the soaring of a thousand flamingos – crimson in the setting sun. Of course Grandmama . . . spoilt us and cosseted us. At Tour we suffered from an excess of freedom.

Nicolette Devas (née Macnamara) picked up the same theme: too much freedom. She was enriched by her time spent with the Johns at Alderney. There were times of ecstasy, and yet a large part of her felt desperately insecure. The disappearance of her philandering father made a profound impact. Yvonne, her mother, was handicapped without him. With her four young children she drifted from harbour to harbour, indecisive and lost 'in a desert of freedom'.

After Alderney the Macnamara family moved on to Blashford, not far from the Johns; there the children grew up with little guidance, and a lot of fresh air. The only form of discipline was their hardening morning wash: the girls were made to stand naked in a row in the bath, while their mother drenched each of them with a jugful of cold water. It was agony, but the children grew up exceptionally healthy. In winter they took pride in wearing as few clothes as possible; anyone who caved in and donned a sweater while the others were all in short cotton sleeves was subjected to cries of derision: 'Woolly, woolly, woolly!' Apart from these internal codes of conduct, the family conformed to no accepted precepts. Nobody expected the children

to write thank you letters for presents. Their clothes were 'odd'. They spat in public. They defied local disapproval by bathing naked in the Avon. The gamekeeper regarded the children as hooligans who disturbed the ducks and upset the salmon. Letters of complaint were sent to their mother, but she calmly tore them up – 'What rot'. Once they were nearly caught, and only escaped by whipping off their knickers and skirts and wading through the stream beyond the angry keeper's grasp.

There were advantages to this lack of formality. Looking back Nicolette was able to see that her upbringing had made her a survivor, someone able to bypass the tramlines of convention and cut to her objective; above all she felt it brought her into closer contact with fundamental realities – birth, copulation and death. And yet she also felt deprived, bored, intolerant. More than anything, Nicolette reproached both her parents for not giving her an education.

<div align="center">★</div>

Sooner or later this question had to be addressed, and Bohemia's liberalism made education a complex and vexed issue. Not for the Bell and John boys the traditional middle- and upper-class conveyor belt from prep school to public school to university. Not for their sisters the predictable route from schoolroom, through the care of a governess, to launch them at the age of seventeen, endowed with appropriate accomplishments (French, music, drawing), into their first season and onwards to marriage. The generation of artists growing up in the early decades of the twentieth century felt scarred for life by their strict and repressive education, and were determined not to inflict it on the next.

Richard Aldington portrayed the pre-war English public school in his bitter novel *Death of a Hero* (1929), in which sensitive, artistic George Winterbourne is sent off to have the finer feelings hammered out of him:

'The type of boy we aim at turning out,' the Head used to say to impressed parents, 'is a thoroughly manly fellow. We prepare for the universities of course, but our pride is in our excellent Sports Record. There is an O.T.C., organised by Sergeant-Major Brown . . .

On such occasions he invariably quoted those stirring and indeed immortal lines of Rudyard Kipling which end up, 'You'll be a man, my son.' It is so important to know how to kill. Indeed, unless you know how to kill you cannot possibly be a Man, still less a Gentleman.

But George resists all attempts to turn him into a soldier 'in spite of infinite manly bullyings'. The headmaster punishes him for his 'abominable' games record, and for the contemptible and unmanly 'secret practices' (i.e. masturbation) in which he has allegedly indulged:

'We want no wasters and sneaks here . . .'

'You will receive twelve strokes from the birch. Bend over.'

George's face quivered, but he had not shed a tear or made a sound as he turned silently to go.

'Stop. Kneel down at that chair, and we will pray together that this lesson may be of service to you, and that you may conquer your evil habits. Let us together pray GOD that he will have mercy upon you, and make you into a really manly fellow.'

George retreats into his own world of poets and painters, 'his only real friends', who give meaning to his life and preserve the inner vitality and soul he is so anxious to express. The more oppressed he is, the more obstinately he clings to this essential Bohemian core, and the minute he is released he puts manliness and the suffocating uniformity of school life behind him.

Aldington's portrayal of what traditional schools inflicted on the artistic spirit was no exaggeration. Accounts by artists and writers of what they had to endure at some of these quasi-lunatic asylums make harrowing reading. The painter C. R. W. Nevinson could not remember his education without a shudder. His well-intentioned parents packed their 'artistic' son off at an early age to Uppingham, an institution which had the reputation of being more lenient and more tolerant than other 'great' public schools of the day:

Since then I have often wondered what the worst was like. No qualms of mine gave me an inkling of the horrors I was to undergo.

Bad feeding, adolescence – always a dangerous period for the male – and the brutality and bestiality in the dormitories, made life hell on earth. An apathy settled on me. I withered. I learned nothing: I did nothing. I was kicked, hounded, caned, flogged, hairbrushed, morning, noon and night. The more I suffered, the less I cared. The longer I stayed, the harder I grew.

In his memoir *A Little Learning* (1964) Evelyn Waugh left a grim description of how he was forced to endure the black misery of schoolboy life at Lancing College. The pointless, perverse hierarchies, the chill and the chilblains, the appalling food which 'would have provoked mutiny in a mid-Victorian poor-house', the disgusting latrines, the barbarity of the boys

all ate into the very being of the young Waugh: 'I urgently besought my father to remove me. He counselled endurance . . . I believe it was the most dismal period in history for an English schoolboy.' Waugh never forgot that time, and as an adult made his own children include 'all desolate little boys' in their prayers.

Waugh's friend Harold Acton was another sensitive soul subjected to the repellent regime of school. His prep school in Berkshire stood in stark contrast to a halcyon upbringing in Tuscany. He remembered having seldom been more miserable; the food in particular was revolting. Acton felt out of his element, his finer feelings nipped in the bud, his love of art and culture defiled by contact with such horrors as cricket and football. His copies of Ernest Dowson's poems and Shaw's plays were confiscated, and to console himself he clung tenaciously to his private treasures, reminders that there was another world where aestheticism had meaning. Other boys might hide naughty pin-ups in their lockers, but the young Acton's esoteric vice was a reproduction of Boldini's portrait of the notorious femme fatale Luisa Casati with one of her greyhounds; beside this he kept, very secretly, a lump of amber and a phial of attar of roses.

Not surprisingly, Nevinson, Waugh and Acton all sought, and found, kindred spirits in contemporary Bohemia after their horrible education concluded. Nevinson revelled in the freedom of the Slade, and was at the heart of the pre-war Café Royal set. Acton set out to live for beauty in Paris. Waugh went for a while to Heatherley's Art School. But at least as boys they managed to scrape an education, leaving school able to parse Latin and with the rudiments of Euclid drummed into them. Both Waugh and Acton then went to Oxford, arguably learning there more about alcohol and social networking than about their chosen subjects. But even in this they were better off than their female counterparts.

In the nineteenth century, intellectual achievement in girls was regarded at best as being unnecessary for their station in life, at worst as being sick and degenerate. Education for girls was, like sex, religion and lavatories, one of those things that 'nice' people didn't discuss. Girls whose parents took the conventional view of learning were obliged to endure years of futile inactivity, like Diana Cooper. 'Nothing much was done about my education,' she remembered. A series of inadequate governesses left Diana with a soupçon of French, and she was an avid reader. But mathematics was a closed book, German, Latin and Geography were non-existent, philosophy unthought-of and domestic science ignored. She remembered a good deal of piano practice and embroidery – 'making our dreadful Christmas presents of sachets and velvet holders of shot to act as my father's paperweights' –

and little else. What was left to this incapacitated young woman, except to become a Beauty? – in Cecil Beaton's eyes, an apotheosised Bohemian in her gypsy straw hat, peasant dirndl skirt and sandals.

Being sent away to school was thought to be very 'modern', while day schools for girls were generally considered 'bad'. Further down the scale girls might be sent to inadequate private establishments where the emphasis was on 'accomplishments', otherwise they were left more or less uneducated.

Towards the end of the nineteenth century certain enlightened spirits were looking critically at the unwieldy giant that was the Victorian school system and asking whether there was not some better way to educate children. The First World War divided the progressives from the authoritarians; those who gloried in its outcome claimed supremacy for that system which had instilled unquestioning obedience and reverence for hierarchy into a generation of young soldiers; while those who deplored the war equally denounced its negation of individualism.

For such as these there was, at the turn of the century, very little to choose from. Rosalind Thornycroft's mother was not content for her daughters to waste their childhoods embroidering paperweights; when Rosalind was only eight she taught them herself at home, drawing up a rigorous timetable for their lessons which included Dictation, Arithmetic, Design, Reading, Dancing, Geometry, Clubs,* German and Skipping. She showed a rare commitment in this; few parents were prepared to assume the burden of educating their own children, whatever their reservations about the choice available. Bit by bit however, the new wave of thinkers began to put their ideas into practice, opening schools that took a Rousseauesque view of human nature, and claimed to respect the individual. The names of Dr Reddie, Homer Lane, J. H. Badley, Dora and Bertrand Russell and A. S. Neill were to become indelibly associated with a certain kind of progressive education, one that elicited sympathetic responses from the libertarian or Bohemian parent.

Badley's school Bedales was one of the first and most successful, becoming famous ever after for breaking all the rules and introducing co-education. This was little short of revolutionary in 1898. Contemporary theorists had argued that co-education was strongly detrimental to both girls and boys; it was thought to thwart progress and to undermine sexual roles. Boys would lose their manliness, while girls would develop undesirably assertive qualities. No other boarding school had ever attempted this, and several parents withdrew their children, regarding Badley's move as a 'preposterous

* A popular exercise using light weights

experiment'. But what is perhaps even more surprising to us today is the ground-breaking curriculum adopted by such pioneer educationists: it included butter-making, taxidermy, Swedish woodcarving, 'and a frightful lot of digging'. It was also the pupils' job to cart away the excrement from the 'sets' or earth closets in wheelbarrows. Admittedly there was a slightly devitalising earnestness about Bedales, a 'do-gooding' institutional quality which cramped some people's style. The twelve-year-old Julia Strachey felt like an oddball, alienated from the hearty, clean, positive approach of her seniors. Caught playing a jazz record on the gramophone, Julia was taken aside by a prefect and given a well-meaning but infuriating lecture on irresponsibility:

'The school is in a sense a sort of lifeboat, you know. Life is a difficult sea, and the Principal and the Vice are trying their very hardest to help us row across you know, and teach us to play our part in the body corporate.'

'I don't think the body corporate, whatever it is, minds my playing a Boston one-step in my free time, if I'm alone and nobody else hears it . . .'

'But THINK! A Boston one-step BEFORE BREAKFAST! Have you lost all your sense of values? You see,' she continued on a lower tone, 'they are giving us the benefit of such a new, free way of life, preparing for a beautiful new world, where people can throw off the old constraints and prejudices and revel in light and freedom and loveliness. And they trust us so!' Her voice trembled happily. 'And that, you see, is why it seems a little underhand and – well – cheap to do ugly mean things, even if no-one is looking.'

Julia's best friend Frances Partridge, also a pupil at Bedales, remembers how punishments included being asked to weed the maths master's flower-bed. She remembers too the girls bathing naked in the school pool while the masters squinted at them through the cracks in the surrounding fence. But there were excellent things about Bedales, the best for her being the way reading was encouraged: 'It was the thing in my day, to go from one class to the next with one's nose in a book – I mean, books were "in".' At fourteen Frances was reading the recently published *Problems of Philosophy* (1912) by Bertrand Russell – 'easier to understand when you're young'. She was also encouraged to take up botany, which became a lifelong interest.

The success of Bedales opened the door to more educational experiments. Gresham's School, Holt was available to progressive parents who didn't care to risk going the final mile by sending their son to a co-educational school, but in other respects it had much in common with Bedales. St Christopher's

School in Letchworth Garden City was vegetarian and co-educational. Then there were the Rudolf Steiner schools, which offered a spiritual and holistic approach to education, while King Alfred's School attracted the sons and daughters of progressive parents in north-west London. When Rosalind Thornycroft and her sister outgrew their mother's ability to teach them, the family moved to Hampstead to send them there; it was co-educational, non-religious, and there were no exams or artificial inducements to work. At King Alfred's the girls learnt English folk songs from the great Cecil Sharp himself, while carpentry was taught by George Earle, who was also an inspiring English teacher:

Indeed a combination of the two went on in the carpentry class. Keats and Shakespeare lines flew about with the wood shavings, and in his white carpenter's apron and flashing glasses he actively demonstrated the mystery of spirit and material made one.

When Bertrand and Dora Russell were unable to find a school that they could contemplate sending their children to, they decided to found one. Beacon Hill School opened in 1927. It was co-educational, and the emphasis was supposed to be on the development of independent judgement and personality, on freedom, and on 'a natural evolution to maturity and self-discipline' along Rousseauesque lines; it was thought that children could pick up dates and facts at any stage with no trouble. Unfortunately the Russells found that Beacon Hill was a popular choice for parents who could find no other place willing to take their problem children, and these wilful individuals soon had all the others at their mercy. Russell was depressed by the jungle law he saw prevailing, for physical punishment was not permitted. The children had been divided by the Russells into 'bigs', 'middles' and 'smalls': 'One of the middles was perpetually ill-treating the smalls, so I asked him why he did it. His answer was: "The bigs hit me, so I hit the smalls; that's fair." And he really thought it was.' Two other pupils made a bonfire on which they attempted to incinerate a third child's pet rabbits, thereby nearly setting fire to the house; another child was caught putting sharp objects into people's soup. Bertrand Russell now began to question the Rousseauesque experiment; children without order or routine in their lives were bound, he concluded, to turn to bullying and destruction.

Bunny Garnett sent his nine-year-old son Richard – not a problem child – to Beacon Hill. There Richard learnt about the reproductive systems of worms and snails; he also learnt how to construct fireworks under the tutelage of a pyromaniac Russian called Uvarov, and under Ted 'Wozzums'

learnt how to distil cherry brandy. Wozzums also demonstrated the effects of constriction on respiration by hugging the younger girls in the class so tightly that they couldn't breathe. Bunny Garnett had hated his own conventional schooling, and was thrilled at the prospect of having his son taught mathematics by the great man himself – but unfortunately the Russell marriage had split up and the 'great man' had packed his bags and left by the time Richard got there. Without him, Dora's influence was everywhere. She encouraged drama, particularly improvisation, which she felt expressed the deepest feelings of the pupils; but according to Richard these 'improvisations' were orchestrated by a teacher who largely edited, wrote and directed the dialogue:

Dora liked to think that there was something miraculously spontaneous about the whole thing, and that *das Volk dichtet* – but not as I recall it . . .

If my memories of these plays are at all accurate they seem to indicate that Dora was not fully aware of what was going on in the school. From a child's point of view she was somebody who talked about us to visiting adults in a way that we found embarrassing. We were exhibits, we were being used to prove a point, and much of what she was saying about us was, we felt, untrue. This added to the embarrassment of being 'seen over'. There was much talk of freedom, and in many ways (especially our superb environment) we were freer than most.

But 'freedom' was taken too literally by some, and the more wayward children rebelled when required to do simple things like wash their faces and clean their teeth. It put the staff in an awkward position when sarcastic older pupils growled at them, 'Call this a free school!', and the naughtier ones pushed at the limits continually.

The children had an equally superficial understanding of Dora Russell's dearly held tenets of atheism, sexual liberty and communism. At a school council meeting – in itself a great innovation – the pupils earnestly agreed to abolish private property, but Richard Garnett recalled the children's way of adapting to this edict: 'Do you mind if I borrow the chess set that *used* to be yours?' Richard had his entire stamp collection expropriated, stamp by stamp. As a result he became a bit cynical about isms and notions. Even more off-putting was Dora's gushing maternalism. When Richard first arrived Dora had recently given birth to her child by the journalist Griffin Barry and was breast-feeding: 'She put some of her milk in a mug for me to drink. I think she would have liked to have given suck to all the children in the school . . .'

But the progressive school that carried this 'child-centricity' to its extreme

was, and remains, A. S. Neill's Summerhill, founded in 1921, a school in which freedom was a way of life:

> I've started a school called Liberty Hall
>> Upon the latest system;
> We take them big, we take them small,
>> And we try not to mould or twist 'em;
> Repression is the great pitfall,
>> Of this we live in terror,
> So we do our best to do nothing at all,
>> Lest we should commit some error.
>
> We don't have lessons, we don't have sports,
> We don't have rules of any sorts,
> And the boys and the girls write their own reports
>> In Liberty Hall, the free school;
> We don't encourage, we don't suppress,
> We don't say No, we don't say Yes,
> And when we want, we just undress
>> In Liberty Hall, the free school.
>
>> (From *Nine Sharp and Earlier* by
>> Herbert Farjeon 1938)

Farjeon's send-up was barely an exaggeration. 'If you turned up to lunch in a loin-cloth nobody would take much notice,' Ethel Mannin recalled. The cornerstones of Neill's educational philosophy were, like Rousseau, a belief in the innate goodness of children, and a commitment to absolute freedom for each child. This meant that lessons at Summerhill were strictly optional: 'All outside compulsion is wrong, . . . inner compulsion is the only value. And if Mary or David wants to laze about, lazing about is the one thing necessary for their personalities at the moment.'

Ethel Mannin was one of Neill's most ardent disciples, and when she wrote *Commonsense and the Child* (1931) he contributed an enthusiastic preface. In this book Mannin declared that '. . . there is no such thing as the naughty child . . . there are only happy children and unhappy children'. Incalculable damage was caused by the imposition of 'moral training' and 'orthodox education'. Children would be much better off parted from their parents, whom she saw as damaging, authoritarian fusspots, blighting the child's self-expression and autonomous carefree existence:

Ideally, children should run wild until they are twelve or thirteen or fourteen, and then, when they have outlived their childish interests in climbing trees and whittling sticks and sailing boats and all the rest of it, *when they are ready*, in fact, they might be taught to read and write and do simple arithmetic. The despised Three R's, do you see. Not having had their minds cluttered up with a lot of superfluous information for years before, they would learn these things very quickly . . .

Neill stuck to his principles, but had to battle to keep the Whitehall 'busybodies' from inspecting his school; he knew that they '. . . would certainly be greeted by Colin (aged six) with the friendly words, "Who the fucking hell are you?".' Summerhill was nevertheless admired by many, and regarded as a piece of important educational research which could not afford to be ignored. It was, however, an uphill struggle getting funding to keep it going, and Neill suffered from the fact that, apart from the Russells, he was the only headmaster who would accept seriously delinquent children. He had to combine the roles of headmaster, therapist, parent, fundraiser.

'Here am I absolutely gravelled to raise cash for a pottery shed. Pioneering is a wash out, man . . .'

he wrote despairingly to Bertrand Russell.

I am getting weary of cleaning up the mess that parents make. At present I have a lad of six who shits his pants six times daily . . . his dear mamma 'cured' him by making him eat the shit. I get no gratitude at all . . . when after years of labour I cure this lad the mother will then send him to a 'nice' school. It aint good enough . . . official indifference or potential enmity, parental jealousy . . . the only joy is in the kids themselves . . .

But despite the growing number of experimental schools, there were few options open to the liberal-leaning parent. The painter Robert Medley, who attended Gresham's, attributed the unusual coherence of early twentieth-century artistic society to the narrowness of educational choice available to right-thinking, culturally inclined parents in those days. He cited brothers and sisters, close friends, loves and artistic bonds between contemporaries, formed at an early age within the precincts of Bedales or Gresham's. Stephen Bone was sent by his artist father Muirhead Bone to Bedales, thence to the Slade where he was a contemporary of Medley's. Ben Nicholson (ex-Gresham's) married Winifred Roberts (sister of Mervyn Roberts, also ex-Gresham's). John Moorman (ex-Gresham's) married Mary

Trevelyan (sister of Julian Trevelyan, ex-Bedales). One could trace many more 'progressive' old-boy and old-girl networks. The homogeneity of tastes, of ethical ideals and social codes experienced at an impressionable age created a kind of freemasonry that for Medley and many other Bohemians like him was to last a lifetime.

*

Nicolette Macnamara hardly went to school. The sum total of her education was four terms at a Catholic girls' seminary in Cannes. Her father, Francis, quoted Rousseau in support of his view that education for women was a waste of time, and refused to pay to send her to school. In his view the three girls were adequately trained if they could cook and make themselves desirable to men. The purpose of females was to be beautiful, have babies, and see to the needs of men, so what was the point in filling their heads with useless learning? Eric Gill was another artist who did not believe in education for his daughters. The John girls, Poppet and Vivien, were left to drift too. Their parents held the view, like Ethel Mannin, that school squashed their 'dear little budding personalities' and gave them a conventional outlook. They must be left to run free whittling and climbing and expressing themselves. In fact they were bored. Despite pestering for lessons, Nicolette did not learn to read until she was twelve. Then she found out what she had been missing. But for the rest of her life she was completely ignorant of arithmetic, historical dates and geography, and came angrily to resent her parents' 'enlightened' theories:

The wastage of time for a person ignorant of the methods of learning is quite appalling. Having suffered in this way all my life, I now believe in formal education; drilling information into the sensitive little minds, and to hell with the little budding personality. It will bloom anyway if it is worth anything.

Parents like the Macnamaras were determined to circumvent any kind of formal education, which meant either none at all, as in Nicolette's case, or selecting an approved tutor or governess to teach one's children. Here again, sexual discrimination was manifest. The John girls, like the Macnamara girls, were abandoned to ignorance, but their brothers and half-brothers benefited from Augustus's choice of John Hope-Johnstone as tutor. Hope-Johnstone arrived at Alderney pushing a child's pram full of rare books acquired on his Middle Eastern travels, and set out to teach the boys to recite long passages from the Old Testament and to write in Gothic calligraphy. His taste for arcana suited the Bohemianism of his employers perfectly. He understood

Arabic, played the penny whistle, and could recite the names of the Hebrew kings. His enthusiasm for practical science led him to set up a laboratory full of flasks and smelly substances in one of the cottages, and he tried to explain the general theory of relativity to Romilly aged ten, but his recondite breakfast-time disquisitions on symbolic logic or four dimensional geometry sent the boys racing for the heath and their games. Dorelia didn't mind; she was happy for the children to remain uneducated, and anyway the invaluable tutor would then join her in the kitchen to entertain her and her sister Edie with readings from *The Fairchild Family*, or in discussing food preservation and gardening lore, on both of which he happened to be an expert.

Hope-Johnstone's younger friend Gerald Brenan also found employment as a tutor to the children of Boris and Helen Anrep. At twelve, Igor had never learned to read, though he could speak Russian. Brenan discovered that the boy appeared to have re-ordered the letters of the alphabet in a mysterious personal hierarchy, and when he came to a word he tried to read the letters in that order. Once it was explained to him he quickly rectified the problem. Baba was slower than her brother, 'somewhat retarded' according to Brenan, but she had a simplicity and fresh outlook that made it a pleasure to teach her.

At Charleston, during the First World War, Vanessa Bell's endeavours to provide an education for her sons were ill-starred. At first Mabel Selwood was promoted from nursemaid to teach Julian and Quentin alongside the two daughters of H. G. Wells's ex-mistress Amber Blanco-White. Julian took violently against the elder girl and pelted her with cow dung, and this experiment ended in tears after one term. Mabel's successor, Miss Eva Edwards, was perhaps chosen for her looks rather than her abilities. She was quite out of her element at Charleston, and after only a month Julian delivered the *coup de grâce* by pushing her into a ditch. Next came the plain but capable Mrs Brereton, who managed to survive Julian's violent and recalcitrant stage; he was gradually compelled to submit to her authority. It was with Mrs Brereton that Vanessa hatched the plan of setting up a school at Charleston. Unfortunately when she advertised for pupils there was only one taker, and this plan soon bit the dust.

But the Bell children and their friends did have, for a while, their own school; when Lytton Strachey's younger sister Marjorie set up her blackboard in Gordon Square it was a relief and a blessing for everyone. All accounts agree that Marjorie was a born teacher, infectious in her enthusiasm, and with a marvellous ability to bring her subject matter to life. Her pupils at this school included a younger generation of Stracheys, the Anrep children,

Stephens, Furses, Hendersons and Raverats. Marjorie had the sense to play to their strengths. Quentin Bell, who went to her for piano lessons, was an inept musician who suffered acutely on hearing himself play a wrong note on the piano. Perceiving this, she set out to educate his taste by taking him to concerts. They listened to Beethoven and Schumann together, and he developed a profound love of music. In the summers of 1924 and 1925 Marjorie's school took over Charleston. The children all moved in with their nurses, crowds of them doubled up in attics and bedrooms. They had their lessons in the downstairs study and crammed into the dining room for their meals.

Angelica found Marjorie somewhat formidable; her emphatic quizzing of the baffled seven-year-old – 'If you have *five* peas in a pod and take away *two, how many* are left?' – intimidated her and turned numbers into a lifelong battleground; but her approach to drama was inspirational. Marjorie's love of Shakespeare was boundless, and she was to be found striding across the Downs reciting *Macbeth* at the top of her voice. She produced the children in *A Midsummer Night's Dream*, with Angelica as Peaseblossom, Baba Anrep as Bottom, and Elizabeth Raverat as Hippolyta. Vanessa and Roger Fry helped with the costumes and masks.

Igor Anrep's education lurched onwards by a process of trial and error. After his mother, Helen, took up with Roger Fry the boy was sent off to a boarding school that had been established in Great Missenden by Fry's sister Isabel, something along the lines of Bedales but on a much smaller scale. It was roughly co-educational, but contrary to Bedales was basically a girls' school, with only five or six boys to its forty girls. Isabel Fry believed that children should have contact with animals; thus at her 'Farmhouse School' the timetable was scheduled according to milking times. The children were busy in the cowshed for an hour before breakfast and again afterwards. There were lessons in the afternoon, followed by evening milking – 'much better than football' – though Igor much enjoyed the netball and rounders that took its place.

His eccentric schooling did not stand in the way of Igor's eventual emergence as a professional doctor. Likewise, with no university education or degree to his name, Quentin Bell was to become a highly respected academic. It is tempting to conclude, with Rousseau, that early book-learning can be limited and superficial.

*

In the end, some parents gave up on their hopes of finding a reasonable, liberal education. Attrition set in; they funked the issue and sent their

children away to mediocre boarding schools. On Roger Fry's advice the Bell boys were packed off to Leighton Park School, a Quaker establishment in Reading, where both boys were utterly miserable. Even Augustus John caved in, and he and Dorelia hawked David and Caspar around a number of local public schools until they found one that wasn't too awful. 'You must take these two boys,' declared Dorelia, adding, 'there are three more somewhere – you may as well have them too if I can find them.' Dane Court was thankfully small, with only eleven pupils, so the John children numbered nearly half the student population and thus were able to form a combat force against potential tormentors. 'The boys go to a beastly school now and seem to like it,' grumbled Augustus. It was run on conventional lines, but Mrs Pooley the headmaster's Danish wife added an artistic touch with her taste for preposterous hats; and both she and her husband were tolerant of the John boys' odd appearance in their home-made clothes and long golden hair. Nonetheless, Romilly John, with the acute self-consciousness of childhood, was intent on keeping the two sides of his life separate:

I became infected with the disease of schoolboy conformism. Sometimes I lay awake at night wondering what revelations of home life I might not, in my previous innocence, have made. I hoped the boys might have forgotten that I had told them how we ran about naked in the fields at home – but that is just the sort of thing little boys do not forget . . .

I was especially afraid that one of my brothers would let out some frightful detail of our life at Alderney, and thus ruin us for ever; a needless alarm, as they were all older and warier than I. I contracted a habit of inserting secretly after the Lord's Prayer a little clause to the effect that Dorelia might be brought by divine inter-vention to wear proper clothes; I also used to pray that she and John might not be tempted, by the invitation sent to all parents, to appear at the school sports.

Children rarely thank their parents at the time for their upbringing; how much more so in Bohemian families. The children were sensitive; they hadn't chosen to be different. They were aware that their upbringing set them apart, and they grew up instilled with the belief that they were superior to 'normal' families, but they were up against the innate conservatism and diehard conformity of their contemporaries, and they were in a minority. As such, many of them were persecuted.

'Seager House doesn't like girls who don't know who their fathers are and have holes in their socks!' was the taunt at Kitty Garman's school. Bunny Garnett was ridiculed for his literary precocity by his hated schoolmaster Mr

H., while Quentin Bell, overweight and hopeless at games, was mortified by his brief boarding-school experience and left before taking school certificate. The fictional Sanger children in *The Constant Nymph* were driven almost demented by their feelings of isolation at their school:

> DEAR LEWIS,
>
> Will you please come and take us away from here? It is a disgusting school and we have endured it as long as we are able . . . We shall kill ourselves if we are not soon taken away; we cannot exist here, it is insufferable. The Girls are hateful, they say we don't wash and are liars. The governesses are a Queer Lot and not fitted to be teachers I'm sure. They think of nothing but games. Why should we have to play games if we don't like? . . . You will be a murderer if you don't take us away before we end our miserable Lives . . .
>
> PS. Probably we shall hang ourselves.

The values of the independent romantic collided with school and its structured set of values. Despite hankerings after routine and rules, their imposition brought rebellion. Bunny Garnett's aversion to the unpleasant Mr H. nearly had extreme consequences. Having watched two little boys who were boarders at his prep school being ferociously beaten by a master, the young Bunny determined that, if forced to endure beating himself, he would murder the perpetrator. His opportunity soon came. Mr H. caned Bunny for some minor incident; the child felt pained and outraged. Leaving the school, he noticed a crow on the fence, and knowing that Mr H. had a rifle and was in the habit of shooting these birds he returned and slyly informed him about the crow:

He often let favoured boys carry his rifle and sometimes allowed them to have a shot. If I could have got the rifle into my hands I would have shot him. Disappointed at not being able to commit a murder to vindicate what I felt to be my honour, I got on my bicycle and rode home. Was I abnormal, or was there something wrong with my bringing up?

In his autobiography Bunny Garnett concluded that his parents were wrong in giving in to his pleas to be allowed to leave that school. Looking back, he reproached them for bringing him up to believe that he was somehow superior, and that the rules which applied to most people did not apply to him.

*

The Bohemians' experiments in child-rearing were at the extreme end of a broader social awareness. Contemporary educationists, social reformers and novelists shone a new, bright light on to childhood, and illuminated an unfamiliar region. Samuel Butler's *The Way of All Flesh* (1903) and Edmund Gosse's *Father and Son* (1907) were both autobiographies which exposed the misery of the oppressed child, delving deep into individual psychology. Books like this were ammunition for the generation war and, even where love and sympathy were present, influenced people like the young Arthur Calder-Marshall, who felt driven into Bohemianism:

In retrospect I feel sorry for all parents whose children grew up during the twenties . . . [*The Way of All Flesh*] exploded like a delayed-action bomb to make innumerable casualties in families unconceived at the time of its composition. A literary fashion was set . . . childhoods of misery and misunderstanding were the vogue . . .

Caught into this war between the artists and the Philistines, we enlisted enthusiastically in the ranks of the artists, swallowing modernism at a gulp and rejecting out of hand the moral and social values which our parents hoped to imbue with us.

Where previously children had been suppressed and largely ignored, children in the twentieth century now took centre stage in a way that magnified their experimental upbringing. Freud's case studies, with their emphasis on the early formation of neuroses, and the libertarian experiments in education, both so dear to the hearts of twentieth-century liberals, made of the child a laboratory guinea pig, an object of scrutiny. Poor Kathleen Hale's over-nervous husband forbade her to cuddle their children:

He caught onto Freud and all his quirks, and he said to me when my children were born, he said you mustn't kiss them and you mustn't hug them, you must never do that with sons, you'll turn them into Queers . . .

Each age is a victim of its own theories. Demographics played their part too, for the turn of the century saw a sharp drop in infant mortality. Families stopped regarding the breeding process as the provision of 'spare' children to take up the slack of natural wastage when the inevitable proportion died from disease. Instead the individual child was endowed with special, unique, irreplaceable qualities.

But the ideology was new, and the expression of aspirations through one's children, the determination to see them realize a new kind of society, has left us with not only a legacy of impossible-to-fulfil hopes and dreams, but also the certainty of guilt in our child–parent relationships. Vanessa Bell's

"My parents have a theory about bringing up children."

Pont's dry observations of the English character appeared regularly in *Punch* from 1932.

'benign neglect', the 'desert of freedom' referred to by Nicolette Macnamara, Mary Campbell's unworried irresponsibility, all embodied an attitude quite different from that of the Victorians, with their heedless sentimentality and oppression. Permissiveness towards children was a statement. Ethel Mannin believed that complete freedom would result in 'a new heaven and a new earth for children':

There would be no orthodox schools on this new earth, and no Sunday schools, and no starched nurses with set ideas about things; parents would be ruthlessly segregated, and only allowed to visit their children at the children's invitation – which means that a very great many parents never would get invited.

. The Bohemians may have reacted in extreme ways against the nineteenth century; they were finding their way, but they were nothing if not committed. They resolved to bring their children up as happy, carefree, creative individuals, and they were determined to spare them the boring, punishing childhoods that so many of them had been forced to endure. It was Rousseau versus repression. The predicament is still real today, as the middle classes agonize over the state of education, and chastise themselves mercilessly over the perils of a too strict, or too lenient, or too protective, or too insecure upbringing. We have never been so obsessed by our children. But one thing

is certain, nobody ever gets it right. 'Dear Reader,' wrote the artist Gwen
Raverat in her memoirs, as she pondered this conundrum,

You may take it from me, that however hard you try – or don't try; whatever you
do – or don't do; for better, for worse; for richer, for poorer; every way and every
day:

The little pests – Gwen Raverat's woodcut
'Children', 1926.

THE PARENT IS ALWAYS WRONG

So it is no good bothering about it. When the little pests grow up they will certainly
tell you exactly what you did wrong in their case. But, never mind; they will be
just as wrong themselves in their turn. So take things easily; and above all, *eschew
good intentions.*

4. Dwelling with Beauty

*How can one recognise a Bohemian interior? – Does one really need
furniture? – How can one live beautifully and cheaply? – Is innovation
in design compatible with authentic living? – Do things have to match?
– What is the point of wallpaper? – Must furniture be new? – Is
comfort more important than appearance? – Is living the
simple life the answer to poverty?*

It is a spring day in 1939, and Theodora Rosling, young, upper class, beautiful and single, is sitting in the Café Flore near St Germain des Près. But she is not alone for long; drawn into conversation with the distractingly handsome artist sketching at the next table, they are awkward at first, but after a few glasses of wine feel as if they have known each other for years. Intimacy progresses, the next move is to his place. They buy food, and champagne, on the way. Laden with packages they arrive at a little hotel in the heart of the Latin quarter, climb endless flights of stairs, and arrive at last in the artist's garret. As Theodora recalled:

The room was an attic of large proportions, with a skylight on one side. It was cold, the patterned wallpaper was peeling and almost the entire floor space was covered with pieces of screwed-up paper. They looked like surrealist children's boats. The bed hadn't been made for some time, was rumpled, crumpled and littered with tubes of paint, more pieces of paper, and a beautiful silk dressing gown rolled into a ball. There were the ashes of a fire in the grate, empty wine bottles, stained glasses, dirty plates, and more tubes of paint on the shelf above the fireplace. An easel stood in the centre of the room, and on it was a half-finished painting of a large room, empty except for a trestle table. The walls and floor of the room were painted in very delicate rainbow colours, each hue merging into the next. The contrast between the painted room and the actual one was startling. There was a sagging armchair by the fireplace and a hard chair with a cane bottom by the easel. Stacks of disordered newspapers were in one corner and a small pile of logs. The other furniture was sparse and battered.

And so the curtain rises on Theodora's first passion, in which she plays muse to the young artist, against a backdrop of mess, dirt, dilapidation and the

familiar props of the artistic calling. As the detailed description builds, recalled with all the precision of an indelible memory, the scene becomes increasingly familiar. No one could fail to recognize the stereotype – we are in the timeless Bohemian heartland: the garret, with its wine glasses, unmade bed and easel. Here art, in rainbow tints, clearer and brighter than drab reality, is centre stage, and if a room is a portrait of a mind, this one has an explicit statement to make: 'Look around, I am not bothered by propriety, money or convention; one thing only matters to me, and that is my art.'

The artist's garret has so transcended fashion and time that it has become one of the most enduring clichés of the age, shorthand for an ideology and an identity, synonymous with both aspiration and despair. Garrets placed one literally and metaphorically above the world: '. . . the proper writing place is a garret,' insisted the *fin-de-siècle* poet Richard le Gallienne. 'There is an inspiration in skylights and chimneys.' By elevating themselves above bourgeois standards of interior decoration, artists declared their transcendence over frills and façades, artifice and ostentation of every kind. So powerful was this romantic stance vis-à-vis the world of interiors that for artists to survive without comforts, in dust, disorder and want, was to declare their sense of themselves as creative individuals, even as geniuses.

<center>*</center>

It is turn-of-the-century London; the young Arthur Ransome sets out from his suburban home, fired by poetry and thirst for life, practically penniless, but 'mad to be a Villon'. He piles his books, clothes and a railway rug on to the back of a grocer's van, bids goodbye to his relatives, and sets off for Bohemia – which in his case is an unfurnished room in Chelsea at two shillings a week, with a water supply two floors down. Ransome possesses books, but no furniture. Undeterred, he wastes no time in setting himself up in his new home with three-and-sixpence worth of wooden packing cases purchased from the nearest grocer:

The boxes were soon arranged into a table and chairs. Two, placed one above the other on their sides, served for a cupboard. Three set end to end made an admirable bed. Indeed my railway rug gave it an air of comfort, even of opulence, spread carefully over the top . . . I placed a packing-case chair by the open window, and dipped through a volume of poetry . . .

I was alone in a room of my own, free to live for poetry, for philosophy, for all the things that seemed then to matter more than life itself . . . Brave dreams flooded my mind . . .

Ransome was twenty, young enough to find poverty liberating. His entire Bohemian youth is seen through rose-tinted spectacles, as he himself admitted, and yet one need not doubt that the uncluttering of life provided him with poetic vistas that more well-upholstered members of society may have lacked. Kathleen Hale too was consumed with nostalgia remembering the early 1920s when she lived in a single large room in Fitzroy Square. 'It was beautiful, but terribly shabby and dirty,' she remembered. Though she too had hardly any money, Kathleen was determined to afford the guinea-a-week rent for this space, but there was almost nothing left over to buy furniture. She acquired a fourth-hand table, 'scrubbed until only the hard grain survived, leaving ridges like bleached corduroy', and got a carpenter to make her a bed for three pounds. Her boyfriend Frank stole some army blankets for her, but in the winter she was still too cold, and used to layer the blankets with newspaper, which rustled all night, keeping her awake. Friends gave her a chair, a bucket and a jug.

Early each morning I would blissfully survey my humble possessions. The spacious bareness around me was heavenly after a childhood spent among heavy furniture, thick carpets and pictures in ponderous gilt frames ... The sense of freedom, the lack of responsibility, was quite wonderful ...

Such people were living the Bohemian legend. When Horace Brodsky visited Gaudier-Brzeska's filthy cold studio in the King's Road, they became so engrossed in talk that Brodsky missed the last bus to Herne Hill where he lived and, not being able to afford a taxi, was forced to stay the night. The discomfort of the experience was long recalled. Gaudier's only furniture consisted of two benches, a deckchair and an ordinary kitchen chair, and there was no bed. At three a.m. Gaudier finally curled up on the deckchair and was asleep in no time, but Brodsky was allocated a work bench studded with projecting pieces of wood to support carvings, and could not sleep a wink. Then Gaudier woke up, cursed, and started hammering at a piece of stone. Brodsky abandoned all attempts at rest and came to watch. All night they talked and Gaudier hammered; at dawn they smelled new bread baking and hurried out to get some breakfast. Then Brodsky went home, having done his best to clean off the traces of 'a crazy night with an irresponsible artist', adamant that Gaudier's company was no compensation for discomfort and lack of sleep.

Ransome, Hale, and Gaudier were wretchedly poor. There are many more examples – the young Jacob Epstein sleeping on newspapers, the Johns' bare-boarded apartment in Paris, Dylan and Caitlin Thomas's furniture

Long-suffering Husband. "I SAY, MONICA, DO LET'S LEAVE CHELSEA AND SIT ON CHAIRS AGAIN."

Living the Bohemian legend was not for everyone (*Punch*, 12 March 1924).

improvised from piles of books, the painter Sophie Fedorovitch's humble room where she slept on a chair for lack of a bed, too poor to have the broken window mended. And it wasn't always romantic and liberating. Young and hard-up in London, the writer Sybille Bedford got 'a strip of a room', a slice of greasy carpet and a single awful curtain, the whole smelling of trapped air and badly cooked breakfast. Dorothy Richardson's St Pancras slum accommodation was so damp that her belongings grew fungus. These rooms were plain and unembellished, but they were also grim – from need as much as choice. Typically, the Bohemian was too busy living for art to notice the filthy mess, which was, in any case, probably part of a still life. The pigsty interior carried messages of rebellion, distaste for decorum, and determination to live outside the conventions.

Nevertheless, the reduction of living to the essentials had an element of pride. According to one Bohemian writer all you needed to support life was a camp bed, a table, a chair and some poetry books. Damp and shivering, needy artists felt reassured that their Spartan surroundings expressed their very sense of themselves, as individuals for whom things of the soul, the mind, and art were more important than appearances and material possessions.

*

It follows that Bohemianism, though it adopted many styles, was not about style at all. When people like Arthur Ransome or Kathleen Hale set out to 'decorate' the spaces in which they lived, they were not shopping for a 'look', they were expressing their own convictions. The interiors of Bohemia are as motley, as various as their inhabitants, but what unites them is a set of attitudes. Walk through the door marked 'Bohemian' and whatever is beyond makes the same set of unequivocal statements:

I do not value what money can buy.

If I choose decorations and colours, it is for their beauty, not because they flatter my social status.

My environment reflects the life I've led, the places I've visited and the people I've loved.

I'm not afraid of being thought tasteless, because I make my own taste.

It can be a filthy garret or a comfortable studio, a white cell or a treasure trove of knick-knacks, but a room that communicates these attitudes is recognisably Bohemian, and it doesn't come off the peg.

★

These attitudes were, of course, a reaction to the recent past, the nineteenth century. Kathleen Hale was one of many Bohemians who recollected with disgust the smothering interiors in which they had grown up and from which they now released. Augustus John remembered with a shudder the 'respectable' home of his childhood – he grew up in a 'mortuary' of rubbish – stuffed birds under glass domes, mahogany veneer furniture, fake majolica, fake Old Masters, macabre ornaments. Above all he objected to their inauthenticity.

And those houses seemed so boring. The immemorial stasis of the English home is captured in Lesley Lewis's memoir *The Private Life of an English Country House 1912–1939* (1992). The interiors that she describes have a dullness that could be from almost any age, right up to the present. There was the book-lined smoking room, and the front hall, sombre, oak-panelled, with dark curtains and Persian rugs. There were the 'good' antiques – a Queen Anne chair, a walnut table with cabriole legs. Flower arrangements in the house were always unmixed, sweet peas or peonies, but never both. The dining room (redecorated only once in fifty years, with top-quality eau-de-Nil paint) was dominated by a portrait of Lesley's great-uncle in full regalia as Master of Foxhounds, on horseback. More horses appeared

depicted on the walls of her mother's bedroom, whose mantelshelf bore bronze dogs and a china goat. Such a house had nothing to do with fashionable interiors and everything to do with the immutable standards set by conventional society.

The gentleman's establishment was expected to be correct in all details, for it was the plain duty of every middle- and upper-class household to set an example to its inferiors. At the time of Ursula Bloom's country rectory upbringing it was vital to understand the semiology of silver cutlery, lace pillow-slips, and Spode dessert services, because everyone was catalogued by their possessions. But these possessions were only on show when guests came. The rest of the time the family made do with inferior articles. Grandmamma's ivory-handled knives were only brought out for company, the shamrock embroidered linen was preserved for special lady guests, and the drawing-room fire was only lit for visitors:

We never used the room when we were to ourselves, for patches of blue mould had spoilt the wallpaper, and one always shivered there. But nobody must think of us as anything but drawing-room folk . . .

For decades the home had been a showcase for wealth and the best place to demonstrate your standing in society. The architecture, and the entire internal disposition of the upper- or middle-class home, had been determined with social rituals in mind. From the moment he arrived in front of the perfectly whitened doorstep, the Victorian visitor was in no doubt as to the status of his host. A suitably attired parlourmaid would usher him into the hall – which acted as a holding area while the mistress of the house exercised her prerogative to be 'at home' or 'not at home'. Of course if he was a tradesman or business caller he was provided with a dedicated door – at the back. The internal hierarchy of the house ranged from drawing room and dining room to private chambers, offices, servants' quarters, attics. At the pinnacle of social aspiration stood the drawing room: 'This is, par excellence, the lady's room . . . and the character of the lady herself may be told by inspecting that one room . . .'

How vital it was to get it right – what if somebody should notice the mouldy wallpaper?

Elegant refinement should reign predominant, cheerfulness should go hand in hand with taste. Easy chairs are here a *sine qua non* . . . Tables must be placed here, there and everywhere, and yet not seem in the way; flowers or plants in vases, scattered about; and a variety of ornaments, simple or costly, as the case may be . . . But the

drawing room will not be complete, nor yet have its properly comfortable look about it, unless there are plenty of books to be found on the tables, and these should be readable and entertaining volumes of prose and poetry, illustrated works, and magazines, which will not only serve their original purpose, but also supply subjects for conversation at all times, and more especially during that *mauvais quart d'heure* which precedes a dinner.

(Lady Colin Campbell, *Etiquette of Good Society*, 1898)

A few years later a book of rules for home decoration appeared entitled *Our Homes and How to Beautify Them* (1902). Its author, Mrs H. J. Jennings, was polite but firm in her insistence on what she called the 'Grammar of Decoration'. This is her ideal drawing room:

The general effect should be restful, even, and devoid of any startling distractions by way of ornament . . . it wants judgment, well-considered care, a reverent taste, a nice sense of colour, and a knowledge of what goes with what . . . However precious a thing may be in itself, however notable as a work of art, it must be ruthlessly banished if it spoil the picture . . .

Lady Colin Campbell and Mrs Jennings seem to have been unaware of the profound change and social upheaval convulsing English life in those years before the First World War. In her novel *The Edwardians* (1930) Vita Sackville-West observed the old order as it gave way to a new, racier, more adventurous future. With a keen eye for detail she observes Lady Clementina Burbidge, a superannuated relic of a bygone age, seated in her overcrowded drawing room, where silver bibelots jostle family photographs, potted palms and aspidistras fight for space amongst forests of occasional tables, and buttoned satin and fringed damask drape and festoon the windows and furniture: 'The whole effect was fusty, musty and dusty. It needed destruction, it needed air . . .' Comfortably oblivious among her knick-knacks and fetid upholstery, Lady Clementina was living, literally, in the past, unaware of a new generation of artists and thinkers who felt stifled by this hothouse existence. The home-beautifiers had had their day. There was a strong reaction in favour of plainness and simplicity.

William Morris led the way in the rejection of all things varnished, tasselled, and flounced. Not far behind him came such adherents to the cause of minimalism as Edward Johnston and Eric Gill, who started the radical Housemakers' Society to set new standards for modern house design. Architects like Voysey, Lutyens and Gimson aimed to bring their buildings back into a sympathetic relationship with nature, using traditional materials

and old crafts. Edward Carpenter was another who hated the excess and flamboyance of the nineteenth century. For such as these the time had come to question the way contemporary man was living, and simplicity was their watchword. The utopian Carpenter fondly imagined the dawn of a day when 'we shall build our houses . . . so simple and elemental in character that they will fit in the nooks of the hills . . . without disturbing the harmony of the landscape or the songs of birds'. Morris himself took a cool look at the average drawing room, ripped the drapes off the piano legs, and mentally eliminated three-quarters of its contents, leaving a bookcase, a table, some chairs, a bench and a cupboard. Decoration consisted of some pictures and a bunch of flowers, but nothing else. In *Ragged Banners* Ethel Mannin's young poet Starridge lives a pared-down existence in a recognisably Morris-style garret:

He liked this bare room with its tall window and pale walls and bookshelves and the divan with the hand-woven blue and yellow striped linen cover, and the weathered oak chair with the rush seat, and the blue-painted table and the rush-mat . . . It somehow reduced the business of living to the simplicities . . .

Thus the Arts and Crafts movement appealed strongly to the Bohemian who rejected grandeur and opulence: *I do not value what money can buy.*

<div align="center">*</div>

If I choose decorations and colours, it is for their beauty, not because they flatter my social status. In those early years of the twentieth century, no decor or colour scheme seemed more beautiful to the eye of the artist than the explosive new look introduced by the great metteur-en-scène himself, Diaghilev. His influence was felt as much in the salons of Mayfair as the garrets of Bohemia. This was the development described by the satirist and cartoonist Osbert Lancaster in *Homes Sweet Homes* (1948), with characteristic superciliousness, as 'First Russian Ballet Period'. Self-consciously scandalous and Bohemian, the young Iris Tree was one of numerous art students and dilettanti with just enough money to adopt for themselves the most thrillingly exotic style to hit Britain's shores for a century:

> I have a studio in
> Fitzroy Street, red and
> white floor in checks,
> black velvet sofa
> black velvet blinds

blue cups and plates
red rimmed looking
glass red table –

The ostentatiously gaudy details picked out in her word-picture tell us that Iris was among those in thrall to Bakst's and Benois's colourful costume and set designs for Diaghilev's ballets. No respectful eau-de-Nil walls for her; this room would have been an affront to Edwardian canons of taste. Note the blue plates, for example, which would have had tremendous shock value when this was written around 1916. Even in the twenties debutantes like Mary Clive and her friends were scandalised by the 'aesthetic' young men at Oxford – apparently they lay about on *divans* all day and went in for *blue* china – 'enough to make anyone feel queer'. For young ladies from the shires brought up amongst oak panelling and silver epergnes, such tastes would have seemed deviant, heretical.

The studios of Bohemia now began to resemble sultan's palaces or Moorish pavilions. Osbert Lancaster's illustration shows us such an attic. A beaded and bandana-ed Iris Tree-type is seen lounging on, sure enough, a striped divan, her languid outstretched arm wafting an immensely long cigarette holder. An aesthetic-looking male is playing, one suspects, Debussy at a grand piano draped with fringed Chinese shawls and adorned with a Buddha. Behind him is a large framed portrayal of Nijinsky in the role of Faun, while on the floor a Petrushka puppet lies abandoned. The air is full of the perfume from sticks of incense mingling with the vapours from the lady's Pera cigarette. The walls are most probably painted orange or emerald green. The components of this seraglio scene were replicated in a multitude of attics, studios and salons by upper-class balletomanes and Bohemians alike.

Before they were married, Rosalind Thornycroft and Godwin Baynes kept house together with a group of friends in Bethnal Green. Both were great music lovers and had followed the Ballets Russes since their first arrival in London. Under their influence, Rosalind took charge of converting the shabby East End house into an oriental bower. She turned all the beds into divans, and flung over them rich coloured shawls and cushions, which she had picked up as bargains in street markets. The Caledonian Market was a happy hunting ground for colourful pieces of junk crockery with which she enlivened their drab rooms. You could live like Schéhérazade for very little. After the First World War another season of Ballets Russes continued to inspire a new generation of art students, like Robert Medley, who decorated his Belsize Park bedroom in orange, black, lemon-yellow and white in

'First Russian Ballet Period' from *Homes Sweet Homes*
by Osbert Lancaster.

homage to Benois and Picasso. Unfortunately the ineradicable green
linoleum on the floor rather spoilt the effect.

Medley's friend the writer Mary Butts played out the seraglio scenario for
all it was worth. When Quentin Bell visited this notorious red-headed
femme fatale in the rue Montessuy in Paris he was awestruck by the exoticism
of her Bohemian pad. Every surface was strewn with lighted candles, except
the floor, which was strewn with underclothes. Mary, naked except for a
bedspread, lounged on the spacious bed, which Quentin inevitably com-
pared to 'the divan of Sardanapalus as Delacroix painted it'. It so happened
that my father was accompanied on this occasion by a rather proper girlfriend
of his called Monica. The conversation grew stickier by the minute, as Mary
first produced a drug peddler wanted by the police from the wardrobe, and
then launched into an account of her father's part in the Crimean War,
which involved the use of some highly scatological language. When Mary
discovered bed bugs under the sheets it was the last straw. Quentin and
Monica fled.

Douglas Goldring's description of Mary's flat corroborates Quentin's.
There is the enormous divan again – 'piled high with purple cushions' – but
he evokes it with the keen interest of someone aware that he is presenting a

Augustus John in Norfolk, 1909: 'Henceforth I was to live for Freedom and the Open Road!'

Illustration to the 1879 edition of *Scènes de la Vie de Bohème* by the grandfather of Bohemia, Henri Murger.

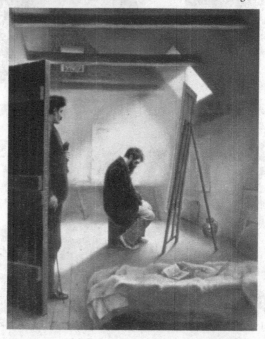

The unromantic reality of the garret: 'An Unfinished Masterpiece' by Philip Burne-Jones, c. 1900.

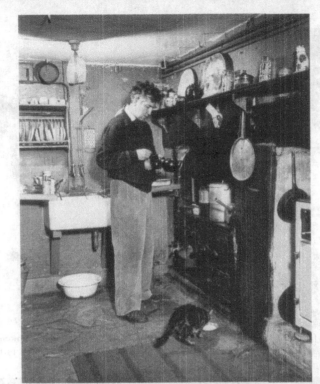

Mixing poetry
and domesticity:
Robert Graves
in his kitchen at
Galmpton.

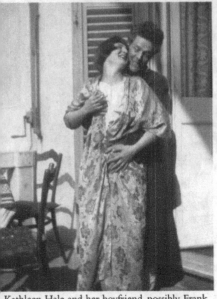

Kathleen Hale and her boyfriend, possibly Frank
Potter, on holiday in Italy, 1926.

In 1920, to avoid the scandal of her divorce,
Rosalind Thornycroft fled to Italy with her three
small children.

Quentin and Julian Bell, c. 1914, photographed by their mother Vanessa.

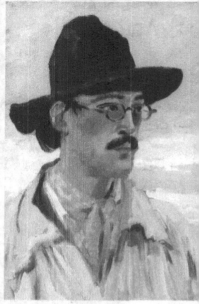

'The Tutor', John Hope-Johnstone, portrait by Augustus John, c. 1911.

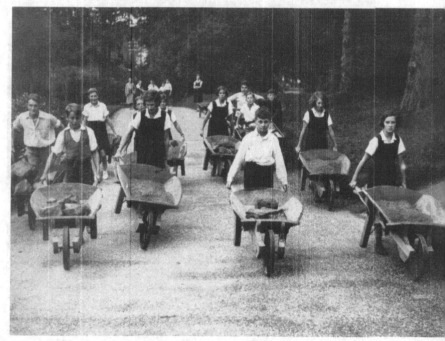

The curriculum at Bedales, then as now, laid emphasis on healthy outdoor work.

Dorelia's second son, Romilly; bronze by Jacob Epstein, 1907.

By the Avon, 1930. *Left to right*: Poppet John, Jean – a friend, Nicolette Macnamara, Vivien John, Caitlin Macnamara.

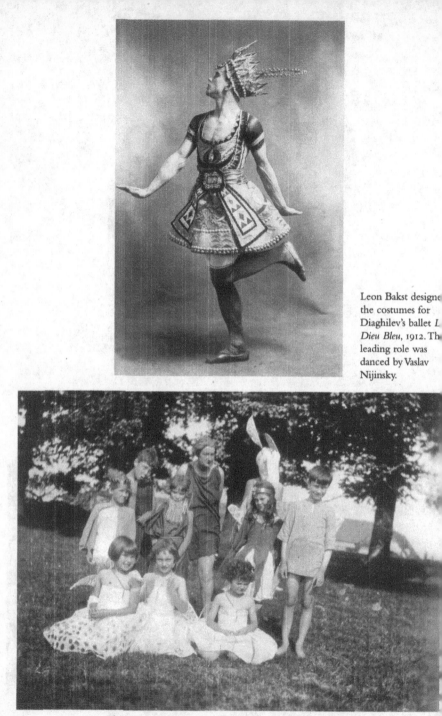

Leon Bakst designe[d]
the costumes for
Diaghilev's ballet *L[e]
Dieu Bleu*, 1912. Th[e]
leading role was
danced by Vaslav
Nijinsky.

The cast of *A Midsummer Night's Dream*, Charleston, 1925.

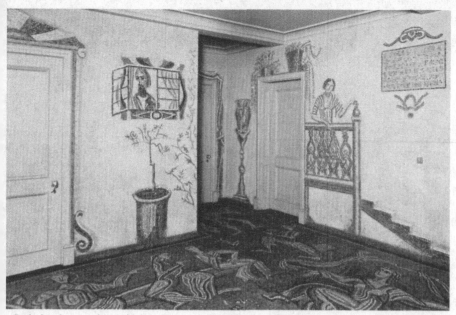

Both the photographs on this page appeared as illustrations to *The New Interior Decoration*, by Dorothy Todd and Raymond Mortimer, 1929. Boris Anrep incorporated a *trompe l'oeil* head of Lytton Strachey into the mosaic decorations of his patrons' hallway.

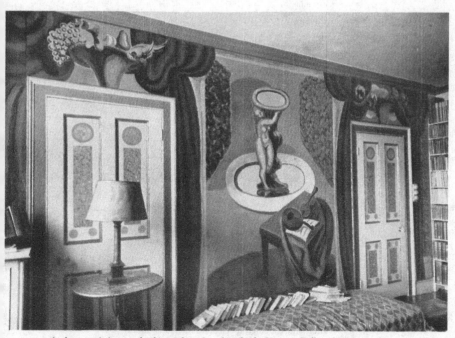

A characteristic mural scheme for a London flat by Vanessa Bell and Duncan Grant.

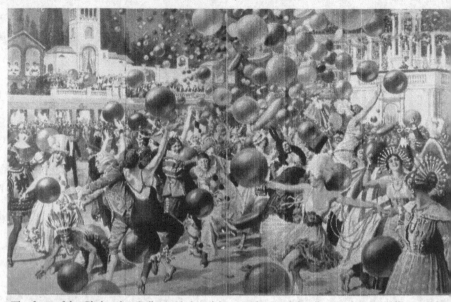

The fame of the Chelsea Arts Ball spread abroad; here, in the Swedish *Allerj Family Journal*, illustrated by Fortunio Matania, 1926.

Brett and Carrington celebrate their new-found androgyny in '*les pantalons d'ouvriers*'.

museum exhibit of the future. Every detail tells us not only about the owner of this attic (fourth floor, no lift), but is a component of the time capsule labelled 'Bohemian sitting-room, circa 1925':

[There were] three or four rickety chairs, a bright green piece of sculpture by Ossip Zadkine, two flower-pieces by Cedric Morris, a water-colour by Kit Wood and a clever portrait-drawing of Mary by Jean Cocteau. One wall of the room was taken up by bookshelves which stretched from floor to ceiling and were crammed with all the literature in vogue. Sex, sociology, Loeb translations, Abramelin, Lévy's *History of Magic*, *The Golden Bough*, the *Chansons de Maldoror*, T. S. Eliot, Virginia Woolf's latest, Aldous Huxley, Jean Cocteau, Radiguet's *Bal de Conte Orgel* – in short, all the 'period exhibits' of the future. On the divan, on top of the purple cushions, lay the sky-blue bulk of *Ulysses* . . .

Not, perhaps, the 'readable and entertaining volumes of prose and poetry' Lady Colin Campbell had in mind to while away the awkward gap before dinner. Art, arcana, erotica, and clashing colour combinations set the scene for a quintessential Bohemian gathering. Then Mary gets out the absinthe, and it is the start of a night of intoxication and abandon.

Gwen Otter was another Bohemian of reduced means who had played hostess to the *fin-de-siècle* Chelsea art world but continued in faded glory through the twenties, a little deaf but still capable of a mordant anecdote, a memorial to the passing of aestheticism. The younger generation were susceptible to her inexhaustible hospitality and happily attended her salon, where they would be sure to meet some lesser celebrity of the art world or, on a good day, some acclaimed star of the Chelsea or Bloomsbury firmament. Evelyn Waugh was a regular, and recalled the black walls of her drawing room, its gold ceiling, and the piles of 'tasselled cushions in the style of the earlier Russian ballet'. Ethel Mannin went too, and left a detailed description of her hostess's home:

One passes into a room vaguely like a studio, with a deep blue ceiling, canvas coloured curtains tied up with deep blue glass beads, over the mantelpiece a Venetian mirror, and on the mantelpiece itself a photograph of Epstein's Tomb of Oscar Wilde, a restaurant-gala-night 'novelty,' and a beautiful little alabaster idol with a cheap bead serpent twined ludicrously about its neck . . . There is a very low divan piled with shabby cushions, in a recess a grand piano thick with dust, an entire wall of the room given over to books, the eighteen-nineties rubbing covers with the very latest of the nineteen-twenties . . .

Downstairs there is a dining-room designed by Mrs E. V. Lucas, canvas-coloured walls with reddish-orange paint-work, striped orange linen curtains, and on the wall opposite the fireplace a John lithograph of Alister [*sic*] Crowley . . .

The company ate at a table decorated with a single shell in a yellow bowl

<p style="text-align:center">★</p>

Alabaster idols and exotic curiosities had been run-of-the-mill in Bohemia for a century. The great dandy poet Baudelaire was alleged to have adorned his room with stuffed crocodiles, while the writer and journalist Alphonse Karr hung skulls on the black walls of his attic bedroom. A taste for the weird and gaudy was nothing new, but this penchant for exotica also displayed a growing admiration for the real qualities of ethnic art that was particularly marked in Bohemia. The Victorian age was largely blind to the qualities of art outside the Greco-Roman tradition; not so Roger Fry. In 1910 he made a special visit to Munich to review the Mohammedan exhibition held there, and was one of the first to extol the virtues of the art of the South African bushmen. Gauguin, Gaudier-Brzeska, Picasso, Braque and Epstein were immeasurably influenced by ethnographic art from Polynesia and Papua New Guinea, with its primitive, elemental forms, and soon aboriginal fetishes began to make their appearance on the tops of Bohemian bookshelves.

The Epsteins were both tireless collectors of exotica. Jacob amassed such a quantity of rare ethnic sculpture that it was all but impossible to enter the house. Every room jostled with Easter Island or Benin trophies; shelves and mantelpieces were crowded with priceless objects from ancient Assyria, India, and Africa. Above his bed towered a pair of six-foot-high figures from Dutch New Guinea. There was no floor space left, and one could only reach the door to the bathroom by a narrow pathway between the pieces of sculpture. Henry Moore wondered how he got into bed without knocking something over. Margaret was just as obsessive, filling her own private 'treasure chest' with oddments picked up from visits to auction rooms, costume jewellery, Spanish mantillas, mink coats, embroidered saris. Number 18 Hyde Park Gate was fast becoming a warehouse for the Epsteins' collections.

The early decades of the twentieth century were a time when artists found it expedient to travel, for the Continent was much cheaper than England. In Italy, France and Spain their eyes were opened to inexpensive peasant pottery, brightly woven textiles, woodcarvings, picture frames, cheap colourful glass, kitsch, kitchenware, kites, toys, cushions, and gewgaws of

every kind. Like pirates returning from a successful foray, artistic tourists came home laden with treasures pillaged from faraway lands, and proceeded to decorate themselves and their environment with memories of their travels.

Take Charleston, admired by historians of decorative art for the boldness of its painted interior, but in some ways equally noteworthy for the profusion of ethnic and Mediterranean odds and ends scattered around the house. A Chinese Buddha sits in the front hall, a naive Italian fairground figure hangs in the studio; there are Moroccan vases on window ledges, a Benin head in Duncan Grant's bedroom, a Turkish textile from Broussa over Vanessa's bed, Spanish plates ranged along the dining-room mantelpiece, Provençal cottons reappearing as lightshades and cushion covers, Venetian chairs. Charleston is more than a testament to the talented artists who used blank walls and deal tables as carte blanche for their decorative schemes. It is equally a memorial to travels and holidays, to sunny days fingering the fabric stall in an Arlésien market or a stroll through the souk in Fez. *My environment reflects the life I've led, the places I've visited and the people I've loved.*

Vanessa suffered from a lifelong addiction to pottery shops, for which she was mercilessly teased by her family. In Ravenna an attractive display of ceramic merchandise tempted her away from her avowed intention to go and appreciate yet more twelfth-century mosaics:

We saw we were undone as soon as we got well inside. The owner of the shop is a most charming and friendly man whose chief joy and interest in life consists in breeding canaries. He had them at all ages, in the egg, in the nest, and on the wing, and we had to look at all. But also he was most sympathetic over pottery and in the end, reckless of consequences, we found ourselves possessed of several large jugs, flasks, bowls, etc. They are really lovely, a very nice glaze, good colours and shapes, and some very odd and unusual in colour. But I quite realize our folly and foresee the mockery awaiting our arrival in London . . .

That wasn't quite the end of the story however, for the canary man informed Vanessa and Duncan, always in pursuit of the ultimate pot, that all his stock was made in a remote village. So they set out, and spent a day tracking down the potter. When they eventually found him he demonstrated his artistry with great aplomb, and the pair had a happy few hours admiring the finished products and buying a great deal more.

Vanessa was able to laugh at herself for her hopeless pot fixation, but her love of strong shapes and unusual colours was deeply rooted, and in her heart she was quite unapologetic. She could be fiercely condemning of other people's taste when it fell into what she saw as the fatal traps of prettiness

and refinement. Staying with her lady artist friends Ethel Sands and Nan Hudson in Oxfordshire she found herself repelled by the contrived and excessive care that had gone into their choice of decor – everything matched, merged and chimed; she found it dispiriting. It reminded her perhaps of the dull, tasteful gloom of the recent past, the Hyde Park Gate years of her youth with its gloomy colours that wouldn't show the dirt. Vanessa's newly discovered Post-Impressionist aesthetic made her as impatient with elegance and propriety in furnishing as in painting.

<center>★</center>

I'm not afraid of being thought tasteless, because I make my own taste. For people like Vanessa Bell, Mrs Jennings's grammatical rules were made to be broken, for if Bohemia stood beyond the portals of mainstream society, then who cared whether the doorstep was white, or green or crimson, or any colour under the sun? Now your home could be a portrait of your own personality, instead of a reverent reflection of respectability. Cecil Beaton exactly summarized the Bohemian point of view:

Only the individual taste, in the end, can truly create style or fashion, since it is not concerned with following in the wake of others. Hence, whatever an individual taste may choose, be it a stepladder or a wicker basket, it must always be based on a deep personal choice, a spiritual need that truly assesses and gives value to that particular ladder or basket. The beauty of these things is somehow transmitted through the personality of the one who chooses. It is in our selection, after all, that we betray our deepest selves, and the individualist can make us see the objects of his choice with new eyes, with *his* eyes.

The joy of this position was that it was suddenly no longer necessary to spend large sums of money on Louis Quinze daybeds or festooned cretonne curtains in order to create the right impression. The vulgar implications of violet notepaper or mixed flower arrangements were irrelevant to these social outsiders. If you were inwardly beautiful then your room became beautiful as an extension of your personality. With the new emphasis at the beginning of the twentieth century on the formal qualities of art as opposed to its content, it was now becoming theoretically possible to approach a room as one might a canvas, to enter it and 'read' its contents not as expressive of social aspirations, 'elegant refinement' and 'reverent taste', but with the liberated sensibility of the aesthete. The true Bohemian simply asked the question, 'Is this beautiful?' It was an immensely liberating position. All beauty needed was a paintbrush, some glue and an experimental spirit.

Harold Acton remembered his college friend Evelyn Waugh settling into domesticity in unfashionable Islington, where he first painted the walls, and then proceeded with William Morris-like zeal to apply his own skills to humble household items:

When Evelyn could devise nothing further to paint he bought innumerable tup-penny and threepenny packets of postage stamps at the Islington stationers, and I would find him squatted on the floor, deeply preoccupied, surrounded by confetti-like pools of these bright little stamps which he would stick in elaborate patterns on an ugly old coal-scuttle, his hair all tousled and his fingers dabbled in glue. Later he would give the object a coating of varnish, endowing it with the patina of Sir Joshua Reynolds . . .

On a larger scale, the critic Raymond Mortimer entertained the young Cecil Beaton in a dining room which he had entirely papered with varnished foreign newspapers. This was one of Beaton's early sorties into the thrilling world of the 'illuminati', and entrance to these unorthodox chambers sent a rush of blood to his head: 'I sensed a marvellous freedom of the spirit.' To be deemed a friend of those 'glorious people . . . who painted in mud colours or lived in Gordon Square in rooms decorated by Duncan Grant' seemed to the young Beaton to be the realization of his highest ambitions.

Mrs Jennings raised words of caution: 'Frescoes, let me say, are not suited to the modern dwelling house, and even panelled landscapes or figure groups are scarcely "practical politics", save in the château or the palace . . .' but the painters of Bohemia disregarded such timid advice. Wyndham Lewis and his Vorticist comrades at the Rebel Art Centre went to work with a lot of red paint on the walls of their premises in Great Ormond Street. The finished effect resembled 'a butcher's shop full of prime cuts'. Carrington was much in demand for her whimsical murals. Walls and fireplaces across London and the south of England were covered in Bell's and Grant's nudes, flower vases, cats, fountains and violins. They were immensely prolific, and were commissioned so frequently to adorn the homes of the illuminati that they had to take on help. The young Robert Medley was employed to redecorate the Stracheys' entrance hall and five-flight stairwell. Under Duncan Grant's direction he brewed up powder colour, chalk and rabbit-skin size (a fixative) over a gas ring in the dining room. This concoction produced the desired 'fresco-like' effect of depth of colour, with a character-istic 'bloom' floating on the surface like the fuzz on a peach. For a short while Kathleen Hale also worked as an assistant to Bell and Grant, executing the areas of 'faux' marble while her employers got on with the more serious

side of things – nudes, urns and angels. Duncan's approach was an education to the young artist, for although her job appeared simple – to stipple black, white and grey marblings down a panel – she discovered when he pointed it out to her, that the undiluted colours she had chosen to mix together resulted in an uninspiring and flat effect. She took his advice, and introduced subtle myriad tints into her black and white palette, whereupon the surfaces came alive with vibrant depth. The philosophical impact of this discovery was to stay with her: you cannot paint, or live, by numbers. Black is never just black, and white is never just white; thus in life as in art, one must question the inner truth of everything.

Meanwhile experimentalism continued to thrive, and the Post-Impressionist interior seemed within everyone's grasp. In his teens Igor Anrep took a paintbrush to his bedroom walls at their house in Suffolk and produced some 'Charleston-y urns with flowers and spouts of water coming out of them'. Lytton Strachey's vacated rooms at Cambridge were taken over by his younger brother James who violently redecorated them in apple-green. In their village retreat in Islip, Nancy Nicholson redesigned the interior of their cottage, repainted it and built some of the furniture herself. Down in Dorset Augustus John's children were let loose on the gardener's cottage in which the family were camping until repairs and alterations were completed in Alderney Manor – they covered its walls, its furniture and themselves from top to toe in black and scarlet paint. What this said about their deep spiritual needs is hard to fathom.

When Lady Ottoline Morrell moved into Garsington Manor she had the house renovated and redecorated. She herself was not above donning overalls and pulling her weight alongside Percy, the house painter, and they worked as a team. Ottoline was exigent about colours, and was forever sending Percy scuttling off to Oxford on his bicycle to obtain the exact shade of Venetian red she dreamt of, or the precise sub-aqueous green. The hall was painted with a winter sunset in mind. The old panelled room was red. Guests were dragooned into helping gild the panels: among them D. H. Lawrence, his wife Frieda, Duncan Grant, Alvaro Guevara and Bertrand Russell:

We were an odd-looking company [she remembered], tall and short, thin and thick, dressed in white overalls, egg-cups of gold paint in our hands, creeping slowly round the room, outlining each panel with a fine paint-brush . . . Lawrence of course did his far quicker and straighter than any of us. Frieda sat on the table in the middle of the room, swinging her legs and laughing and mocking at us, giving advice as to what curtains she would have . . .

Ottoline and her maid Eva sewed the curtains, and great consultations took place over their suitability for each room, Philip Morrell being called upon to deliver judgement. Visitors to Garsington variously described the house as having 'a sort of sumptuous homeliness', 'patched, gilded and preposterous', or as 'that fluttering parrot-house of greens, reds and yellows'.

<center>★</center>

After Matisse and Picasso, there was no going back to nice pale yellow morning rooms and quiet pretty bedroom wallpaper. The time had come to dazzle. At Asheham, the Bells' first Sussex home, Vanessa hung up flame-orange curtains lined with mauve. At Wissett Lodge, her rented house in Suffolk, she and Duncan distempered the walls a brilliant blue, and dyed the chair-covers with coloured ink. They even painted the hens' tails blue. When they moved to Charleston Vanessa painted her bedroom black with red stripes down the corners. Her son Quentin's early years in London were stamped with a consciousness that the family was quite different from its neighbours – because all the other houses in Gordon Square had sober front doors, while theirs was 'a startling bright vermilion'.

'First Russian Ballet' people favoured orange, purple and emerald green. Viva King papered her sitting room navy blue. The young Clifford Bax and his flatmate painted one bedroom in brilliant gamboge yellow, the other in scarlet. In 1925 Robert Medley arrived at a turning point when he settled into a flat in Swiss Cottage and, putting Bakst, Benois and Matisse behind him, went for a more radical look – white.

Cleaned up and repainted in white distemper, this room with its Victorian marble mantelpiece and the mirror fixed over it was recognizably the prototype of all those rooms I have since liked to make.

Medley was looking for a colour that would reflect light, and a neutral background for his paintings, but it was around the same time that the craze for white took off. Mayfair adopted the Bohemian studio look. The fashionable interior designer Syrie Maugham's unearthly white rooms, furnished with lavish white sofas, were an end in themselves. Cecil Beaton loved them, and went for the 'albino stage set' look at his country house in Wiltshire, Ashcombe, where fashionable *haut* Bohemia gathered in the twenties. Until people discovered how miserably impractical it was, the delicious clarity of white brought a breath of badly needed fresh air into English homes.

But Beaton loved brilliant colour too. As *arbiter elegantiarum* of artistic

society for thirty-odd years, he exhorted his readers (in *The Glass of Fashion*, 1954) to wake up to the potential of luminous, vibrant hues, rebuking the unconfident English whose demand for 'off' colours resulted in the murky shades obtainable from paint merchants: 'One can never buy a clear blue, but rather a grey-blue or green-blue; pinks are seldom clear but are called cedar or squashed strawberry, and seldom can one find a rich crimson red.' There was more at stake here than personal taste. Detectable through Beaton's appeal for richness and clarity is an insistence on something more fundamental – authenticity, honesty, unpretentiousness, conviction. Cecil Beaton always reached out for the individualistic in his response to beauty. 'Squashed strawberry' stank of the craven, the cowardly, and it made him sick at heart.

*

Dreary colour wasn't the only thing to be depressed about in England. Equally Beaton found fault with manufacturers, whom he believed responsible for the hideous vulgarity of design available in shops throughout the land. Mass production was putting the small craftsman or artisan out of business, to the great detriment of public taste in this country, whereas on the Continent in those days any village shop would sell you 'good simple designs in pure colours'. Beaton and Vanessa Bell would have seen eye to eye on this. So would Ford Madox Ford, but for him this was not just a matter of aestheticism. For Ford, as for William Morris, mass production was the demon corrupting our inner life, and surrounding oneself with well-crafted objects carried a moral imperative:

The very process of mass-production is deleterious to the public. It is appalling to think that there are millions and millions of human beings to-day who never have and who never will taste pure food, sit in a well-made chair, hear good music played except mechanically – or use all their muscles or so much as cook well or properly polish the woodwork of their homes.

At the forefront of the outcry against terrible design in England was Roger Fry who, in starting the Omega Workshops in 1913, took matters into his own hands.★ The bracing artistic climate of the immediate pre-War years was

★ Fry's commitment to good design extended to drawing up the architectural plans and supervising the building of his own house, Durbins near Guildford – which incorporated such original features as a double-height hall with frescoed alcoves overlooked by a gallery, central heating, huge windows, and a classical French-style façade enlivened with brick pilasters.

encouraging. The controversy surrounding his own two Post-Impressionist exhibitions, and of course the Ballets Russes, made him feel the world was ready for a shift in taste. Fry's vision was of a kind of Bohemian back-to-work scheme where penniless but talented artists could regain their self-respect, earn some money and sweep away some of the ugliness prevalent in the English home. Furniture, screens, boxes, curtains, cushions, lampshades, parasols, fabrics and carpets were duly produced in energetic Post-Impressionist-inspired designs. Blue sheep paraded across orange folding screens, goldfish swam among waterlilies on a rickety table top. Not everyone liked them: 'Would you let your Child Play in this Nursery?' raved a *Daily Sketch* commentator about Duncan Grant's linear elephants and rhinoceri. Nevertheless Fry had an impressive range of high society contacts who were prevailed upon to patronise the workshop, and before long ladyships like Cunard, Morrell, Drogheda and Desborough were buying into the Bohemian look. It made Naomi Mitchison feel good to subsidise adventurous artists, and she purchased some boxes and lamps, but was dissatisfied with their rather makeshift construction. The silk lampshades were covered with annoyingly thin silk which rotted quickly. Omega was in fact a little too spotty and blotchy for Mitchison's taste, and when her Omega dressing table began to look dated she disposed of it to a museum. Though the Workshops didn't last, succumbing to internal disputes and foundering in 1919, their influence continued and, partly as a result of Fry's passionate advocacy, from the 1920s onwards interior design began to acquire artistic legitimacy.

*

Roger Fry and his followers were preoccupied by the need to create interiors that complemented contemporary works of art. Love of art was, after all, the *raison d'être* of such people; how vital then, to ensure that the admired object was hung well, in the right light, with compatible neighbours. You did not have to be rich, genteel or even fashionable to possess an eye for beauty. Osbert Sitwell, whose devoted cook, Mrs Powell, was a discriminating art-lover, hung modern works in the kitchen. She was delighted with her master's choice, and disgusted when a hack journalist ran a column taunting the Sitwell brothers for having 'achieved the impossible' by persuading their cook to work alongside pictures of the modern school. 'Servants are individuals like other people, and not a separate race. I happen to like modern pictures,' she protested.

And, whether servants, artists or patrons, how fortunate such people felt in not being condemned to the fate of the wretched upper classes, who, with

their interminable dreary equestrian portraits, reproductions of 'Bubbles' and
the 'Good Shepherd', treated art as something 'to keep down a wallpaper'.
Wallpaper was becoming outmoded in artistic circles, anyway. Somehow
Derain and Stanley Spencer didn't look right against floral garlands. At the
turn of the century the use of distemper – an unstable mixture of chalk and
pigment – was still seen as a radical departure from accepted middle-class
practice. C. R. W. Nevinson described his mother as a pioneer who 'used
distemper instead of wallpapers', causing him to be jeered in the streets
'because our house looked different from the others'. But Stephen Spender's
experience visiting the country house illuminati of the twenties showed that
modern art patrons tended towards pale neutral distemper as a backdrop for
their collections. At Charleston, despite the received opinion that no surface
remains undecorated, this is by no means the case. Vanessa and Duncan
ruthlessly obliterated every trace of the dainty Victorian and Edwardian
wallpapers they found when they arrived in the house, but did not inevitably
replace them with patterned surfaces. Nor did they fall prey to the fashion
for strong colours. Several of the rooms are distempered a dull, subtle white,
as are all the passages; other rooms are an almost unrelieved black. Even the
studio walls are painted in bands of 'mud' colour – a dirty green, a sludgy
pink, a mottled black-grey. Against these undemanding shades the clear
colours of paintings, ceramics and objects sing with vibrant clarity. It is this
contrast that gives the impression of resonating colour everywhere in the
house. Charleston is both an artists' home, and a carefully composed work
of art in itself – some would say, Vanessa's most successful creation.

This inner creativity was also manifest at Alderney Manor. It seemed to
many that Dorelia John only had to choose an object or a colour for it to
become mystically endowed with a part of her own beauty, and incorporated
in the living work of art that was her home. Nicolette Devas:

For her, there was no advance blueprint; nothing was bought or made because it
'picked up the yellow in the carpet' or matched something else. Objects in the
house had a quality of character and an intrinsic beauty of their own; they were
admired and loved as people were; for their personality.

Or Cecil Beaton again:

Here is the dwelling place of an artist. It would be difficult to find one object in her
house that does not fulfil its useful purpose with an inherent beauty. On her
window sill a goblet of daffodils seems to regain the pristine beauty that is lost by
overfamiliarity. With Mrs John, as with all true people, the everyday triflings of life

are noble: a basket of bread, a bowl of tomatoes, a bottle of wine have innate beauty . . .

and he continues . . .

No intention to decorate the house ever existed . . . The colours have gratuitously grown side by side. Nothing is hidden; there is an honesty of life which is apparent in every detail – the vast dresser with its blue and white cups, the jars of pickled onions, the skeins of wool, the window sills lined with potted geraniums and cacti, while close to the windowpanes tits swing on a coconut shell hung from a tree. The Modigliani bust stands with a cactus pot on its head. In the corner of the entrance hall, boxes of apples and croquet mallets are spontaneously thrown together, constituting a picture of life that is full of sentiment and completely lacking in pretension.

'Mrs John's Window Sill' by Cecil Beaton.

*

Beauty, truth, honesty, lack of pretension – these are qualities that are hard to define yet easy to discern. I have stressed that people like Vanessa Bell and Dorelia were ahead of their time, but if that is the case, where does such a person stand in relation to the advances made by Art Nouveau, the Arts and Crafts movement, Art Deco, the Bauhaus, the Jazz Age? How did they react to chromium-plated cocktail cabinets, tubular steel, unpolished

furniture and beige carpets? Or might it not be more 'truthful' to go for pokerwork fenders and peasant handicrafts from Czechoslovakia?

The answer is that the contemporary mania for smart interior design presented the committed Bohemian with a dilemma, for artists were inevitably implicated. A single-minded pursuit of beauty put one several steps ahead of the complacent masses. But being in the avant-garde carried with it the risk of creating a following, and a following soon became a fashion. Fashion, for the true outsider, is a snare and a delusion. Fall for fashion, and you are fated to become not an innovator but a victim. And yet Bohemians needed rich fashionable people to buy their wares. Over the last century artists have played a cat-and-mouse game with the world of fashion; today this has reached a point where the artist can feel trapped by the imperatives of public relations and self-promotion. In becoming a fashion leader, the Bohemian had to make a difficult choice between the decadent world of smart society, and the lonelier path in pursuit of beauty and true taste.

You have to be artful indeed to dodge all these influences, and in truth, almost nobody is immune. So strong was the 'Bohemian' look that anyone with artistic aspirations could requisition its components – like Florence Dodd in *The Constant Nymph* (1924). Doing up their new home in London, Florence calculates the social messages conveyed by its interior with precision:

'One does produce a definite impression on people, whether or not one makes any conscious efforts about it, so one might as well take pains, and think a little. I want this house to look like us ... pleasantly Bohemian ... a sort of civilised Sanger's circus, don't you know, with all its charm and not quite so much ... disorder.'

Lewis looked very doubtful.

But Florence is resolved to convey to the world that she has married a genius, and relentlessly paints the walls yellow, places a divan piled high with cushions in the drawing room, and adorns the chimney-piece with a Russian ornament studded with coloured enamel. The dining room is distempered white, its oak cottage dresser ominously decked with *blue plates*. Let there be no mistake, this house says, you are in Bohemia. But the 'real' Sanger children, Tess and her sister Paulina, are deeply sceptical of Florence's exertions, which they find too bogus for words. As Beaton said – one's selection betrays one's deepest self. True taste was discernible to the truly tasteful. It is obvious to the Sanger sisters that Florence is trying too hard,

and that her own appetite for beautiful things has had little to do with her inauthentic selection.

There is likewise a fascinating episode in *Antic Hay* (1923) where Aldous Huxley's character Theodore Gumbril Jr. (inventor of 'Gumbril's Patent Small-Clothes', or inflatable trousers) sets out to pick up a girl. To boost his confidence, he has disguised himself as an Artist, with a false beard. Thus attired, he strolls down Queen's Road, and in due course catches the eye of a pretty young woman window shopping. They engage in conversation in front of an antique shop called 'Ye Olde Farme House'. The young woman is so impressed by Gumbril – taking him to be a True Artist – that her own genuine liking for pretentious 'artistic' furniture disintegrates under his scorn. Pretence is heaped upon pretence:

'How revolting this sham cottage furniture is,' Gumbril remarked . . .

The stranger, who had been on the point of saying how much she liked those lovely Old Welsh dressers, gave him her heartiest agreement. 'So v-vulgar.'

'So horribly refined. So refined and artistic.'

She laughed on a descending chromatic scale. This was excitingly new. Poor Aunt Aggie with her Arts and Crafts, and her old English furniture. And to think she had taken them so seriously! . . . In the past, when she had imagined herself entertaining real artists, it had always been among really artistic furniture . . . But now – no, oh no . . .

'Yes, it's funny to think that there are people who call this sort of thing artistic. One's quite s-sorry for them,' she added, with a little hiss.

Poor Rosie, disabused of her longing to buy her way into arty circles by getting the 'right' furniture from a shop. It couldn't be done.

<p style="text-align:center">*</p>

Again: *If I choose decorations and colours, it is for their beauty, not because they flatter my social status.* At Alderney, as in so many studios and Bohemian homes of the period, a rebel spirit was abroad among the arty junk, the objets trouvés, the quirky diversity of this ragbag look. This spirit refuses to 'match', to 'pick up the yellow in the carpet', or to obey the rules of Mrs Jennings's 'grammar of decoration'. For the inhabitants of these cluttered rooms, Mrs Jennings and the Home Beautifiers spoke a dead language. In Bohemian homes your choice of village mugs, of a bleached wooden table, or a jug of daffodils conveyed eloquently your intention to make your own choices, and to live for higher things, for Art.

But the harmony in disparity that Nicolette Devas and Cecil Beaton so

readily recognised and warmed to are qualities of yet another easily recognisable Bohemian scene. We have moved from the garret, through a cabaret of settings – Russian ballet, exotic treasure chest, Post-Impressionist interior, white studio. Now we come to the Jumble Sale.

Arthur Ransome felt liberated by his packing-case room in Chelsea, but he also felt a sense of belonging when he was taken by an actor friend to visit a Bohemian Chelsea hostess known as 'Gypsy' ('No one ever calls her anything else'). Her backdrop was 'a mad room out of a fairy tale'. This was clutter with a vengeance, but not the 'fusty, dusty, musty' Clementina Burbidge kind. The room in which Gypsy entertained her circle of artist friends was reminiscent of a curiosity shop, but with elements of exoticism that recalled Gypsy's obscure West Indian origins. The walls were dark green, and every available space on them was hung with brightly coloured sketches, paintings and a gigantic double-edged sword hanging from a hook. Besides bottles of painting ink, strange paperweights, books and portfolios, the room was stuffed with loose sheet music, heaps of crimson silk, and lit with a multitude of candles. Incense burnt in an urn suspended from the ceiling. Oriental ceramics and Hindu deities crowded the shelves, along with miscellaneous gimcracks of every kind. On top of a pile of folders a woolly monkey perched grinning at the company.

In *Ragged Banners* Ethel Mannin takes her poet hero Starridge to visit Lattimer, a jumble-sale Bohemian living in a kind of madhouse in Camden Town. Lattimer's room is so stuffed with miscegenated objets d'art that Starridge can hardly breathe, let alone cross from one side to the other. Busts of Wagner and Beethoven are crammed in with ivory Buddhas and a Chinese fertility goddess. The centre of the room is taken over (inevitably) by a huge divan covered in every kind of cushion from hand-woven linen to oriental embroidery. Everywhere, you trip over magazines, gramophone records and books. There are objects of great beauty and others of undeniable junk: 'The room looked as though its owner had bought everything on a world tour and finished up in Tottenham Court Road.'

Mrs Jennings would have had an apoplexy. The drawing room, as she saw it, was a good place for the modest collector to display his or her acquisitions. These need not be priceless majolica, but she insisted that they must have artistic value – small items of Sèvres, Meissen or Crown Derby were ideal to display in glass cabinets, or perhaps on a shelf running over the dado rail. Above one hung appropriate engravings, watercolours 'by *well-known* artists' (my italics), or 'framed autograph letters of eminent people'. Furnishing one's home from antique shops has a respectable pedigree, and has always been acceptable in circles which revere relics and

heirlooms. Furnishing one's home with junk, however, lacked social cachet – no wonder Bohemia took to it so enthusiastically. We take it for granted today that 'a bit of driftwood', or 'something I picked up off a skip' can be an object of pride. Not so in the early twentieth century, when browsing the flea market was a déclassé occupation for those who could afford nothing new. The Bohemians were pioneers of the 'puces'. From bottle racks to garden sheds, bits of bicycles to human ordure, the artist has for many decades now been foremost in looking at society's detritus with fresh eyes.

Junk had all the advantages; it was cheap, cheerful, and individualistic. Carrington's happiest hunting ground was Mr Jarvis's shop in Newbury, which combined secondhand books with a number of unusual pieces of china, glass and musical instruments. The singular Mr Jarvis persisted in claiming that all his antique violins were Stradivari and, recognising an art lover in his keen customer, would often draw her attention to his latest acquisition: '. . . a charming Rembrandt I picked up last week. You recognise the master hand in the drapery?' A letter to Gerald Brenan in 1921 tells of a trip with Lytton Strachey and Ralph Partridge to Jarvis's shop, only to find the shutters down and reports that the poor man had suffered a stroke. The party were devastated, their misery compounded by a frightful lunch in Newbury's White Hart. Fortunately after lunch Carrington's mood rallied, and she tracked down Mrs Jarvis, who took pity on them:

She let us go into the curiosity room and choose some china. I selected 5 exquisite old coffee cups, of finest china, with saucers, all sprigged and different. Three without handles. Then we found two large decanters square shaped, which cost 6s each; very old glass. A deep Spanish bowl for salad and 8 very old liqueur glasses of great beauty and I am sure of much value, which only cost 3/6 each. And 3 very heavy glass drinking tumblers for 4/- each, one which was dated 1720.

And they carried their handleless, non-matching coffee cups home in triumph. It was still a time when bargains were to be had, for the general public had not yet caught up with the idea that yesterday's rejects very quickly turn into today's valuable collectables.

Carrington's predecessor at the Slade, Edna Clarke Hall, also had a keen eye for beauty in unlikely places. She discovered a lovely, unwanted 1820 Clementi piano in a pub, and an inlaid pearwood writing desk only waiting to be stripped of its brown paint. Rummaging in her own sheds, she was able to assemble the components of a four-poster bed from some oak posts and a bed frame that she found there, together with some canopy irons

which she got the local blacksmith to make, and some ancient hangings. This improvised but much-loved bed made its appearance in Edna's drawings for years afterwards.

Innate taste, such as that of Dorelia, Carrington or Vanessa Bell, went a long way to superimpose harmony on the jumble sale. These women were home-makers par excellence. Vanessa Bell claimed that moving furniture around relieved frustration. A great deal of their energy was expended on thinking about and arranging their domestic surroundings. All these women had enough help in their homes to keep the clutter relatively clean, and over time, as they became more financially secure, they were able to equip their homes with modest comforts, even central heating.

<p style="text-align:center">*</p>

However, Bohemia instinctively shunned anything that smacked of luxury. Easy chairs in warm rooms were good, expressing liberalism, tolerance, even culture – but a hatred of empty show was at the heart of the Bohemian philosophy. Luxury was expensive and, as we have seen, Bohemia's attitude to money was deeply anti-materialistic. You could be sensual, glorious, exotic, but if your choices were motivated by a desire to display your wealth you were despicable. In her novel *Sounding Brass* (1925) the prolific Ethel Mannin confronts the issue of materialism versus Bohemia in her usual full-frontal fashion, with home furnishings as the battleground. Mannin's hero Rickard is tempted by Bohemia, but eventually capitulates to capitalism. Here, Rickard spends the weekend chez Pringle, the nouveau riche business client who he hopes will underwrite his fortunes:

The Pringles called their exceedingly ugly and aggressively new house The Manor, and it was full of costly furniture. John Pringle was never tired of telling people how much he had given for every individual piece . . . [He] was intensely proud of his collections of furniture, pictures, china, rugs, and he knew the price of every single object and quoted it with a naive delight in which there was no snobbery. He had never got over being able to pay high prices for things. He was obsessed with Things. Purchases. Possessions. Prices. And everyone of his possessions he loved with a deep and intense passion because of its full-blooded monetary value.

Ottoline Morrell's biographer states that Garsington was not luxurious. Nevertheless many visitors felt that the house was 'preposterous', and that all that gilt and plumage was over-sumptuous and palatial. Bohemia wanted to feel set apart from ornate grandeur, from the stuffiness and sterility of the Pringles and their costly Manor House. Nobody could possibly accuse

Ottoline of being dull, but her tastes were certainly expensive, as she herself recognised:

We had a great discussion on riches. Logan said it was unbecoming and did not produce happiness . . . Like all these questions it is so intricate. I think very often we might be happier if we gave up Bedford Square. It gives an impression of grandeur and wealth, too gorgeous for what we are or wish to be . . .

What a foolish, childish dreamer I have been, always thinking of beauty and piling up colour. Shall I do it again and again, I wonder? I heap up beautiful things, oriental cloths, old embroideries, Italian damasks, painted silks. The same ungoverned love of beauty . . . I wish I could feel it wrong. On the contrary, I really feel the dreary, ugly rooms I see in other people's houses to be all wrong . . .

Ottoline felt herself to be treading a fine line between empty ostentation and genuine splendour, and in her insecurity feared that she might be criticized for having delusions of grandeur. She had reason to be apprehensive. Many of her artist friends were quick to judge, their aesthetic antennae particularly sensitive to evidence of philistinism and self-aggrandisement. For example, Vanessa Bell visiting the American art historian Bernard Berenson's Italian home, I Tatti, was caustic:

The house is luxurious to a degree – private sitting rooms and bathrooms, comfortable beds, endless servants, huge motors, roses everywhere, chairs, sofas, old furniture in all the bedrooms, all very American I suppose, and one can't help feeling if only they had got in an ordinary Italian workman from the village to tell them what colours to use, how different it would have been. Colour is simply non-existent as it is.

Vanessa's use of the word 'American' is utterly damning, conjuring up everything that the Bohemian home – for all its shortcomings, its squalor, its severity, its insanitariness – was not. The garret dweller was hors de combat in the competition to appear costly, just as his country counterpart distanced himself from the property rat-race by choosing the rural equivalent, a cottage.

<p style="text-align:center">★</p>

Poverty among artists was widespread. The back-to-the-land movement of the late nineteenth and early twentieth centuries was particularly popular among painters and poets who were losing the battle for survival in the harsh metropolis. Such free spirits rediscovered the simple life, and even if they

weren't exactly building their dwelling places in the nooks of hills, there was a quite noticeable cult of the cottage around the turn of the century. Increased urbanism in the wake of industrialism, and the subsequent rural depression, meant above all that little damp cottages were cheap – about five shillings a week to rent, or as little as £23 to purchase in the years before the First World War. You furnished them with deal tables, pine chairs and a bucket, or maybe just with packing cases; and if there were roses round the door, so much the better.

'Yes, yes, I will come and live in a cottage . . .' Carrington wrote to Christine Kühlenthal from rural Hampshire, where on a country walk she had discovered a tumbledown dream in ruins, with the ghost of a garden and a wonderful view: 'Christine, be brave and live with me there . . . Even if the remaining roof falls in on us, we shall at least die together!'

The reality of the rural idyll was often less romantic. The draughts entered through every cranny, the mud encroached steadily, and the damp got into your very bones. Stella Bowen, Ford Madox Ford's lover, endured it for several winters before insisting they emigrate. A painter herself, she was quite unable to work while looking after their baby daughter, minding pigs, and coping with Ford's botched attempts at carpentry. Having acquired a job-lot of old oak floorboards, he employed them to construct first a pigsty (the pig caught cold and died), and then a kind of 'cock-eyed lean-to' outside the back door. Here they housed their temperamental oil stove, which was in the habit of spewing black smuts all over the kitchen: 'When Ford's oak cook-house was finished, there was just one spot where you could stand upright as you tended your stew pots. When it rained, the floor became a puddle bridged by an oak plank . . .'

Moons, sunsets over poppy fields, wood fires, and a beautiful view were barely a compensation:

You can almost live upon a view. Almost. Ford and I subsequently lived in all sorts of places and with all sorts of drawbacks, but they all had beauty of one sort or another. It was more necessary to us than comfort and convenience, and generally, as a commodity, cost less.

*

The Bohemian home is easy to recognize on sight, but less easy to encapsulate in a phrase. It moves through apparently disparate incarnations, its style shifts, sometimes leading, sometimes following the prevailing fashions, but there is nevertheless an intelligibility about its underlying intentions. Though

the scene keeps changing, the look of these interiors was fundamentally determined by the rebellious, modern, unconventional individuals who lived in them, not by external requirements. Their choice of surroundings was a rejection of a whole way of life.

Yesterday's design revolution is today's tired revival. Many late twentieth-century and contemporary trends are in themselves tributes to the influence of the Charleston artists, to the Diaghilev ballet designers, to the aesthetes, to Omega, and to the makers of the Arts and Crafts movement. The modern fashionable interior pays homage to a creative surge among a relatively small sub-section of society in the early decades of the twentieth century. So much of what those artists did has been assimilated and re-assimilated, that one should not be surprised that their tastes are yet again being re-cycled for the 'World of Interiors' readership, even if their origins are not always acknowledged. But what the imitator of 'Bohemian' style cannot hope to do is shock. Copying Charleston is already passé, blue china no longer makes us feel queasy, and a red front door is just a red front door. If we want to be astonished, disturbed or excited we must look to today's artists.

5. Glorious Apparel

*What do one's clothes tell people about one's beliefs? – Does one have
to wear what other people wear? – Must one wear sober colours? –
evening dress? – corsets? – Which is more important, comfort or
appearance? – Must women wear skirts? – Must men be
clean-shaven? – Is jewellery wrong for men? – Do clothes
have to be expensive to be beautiful?*

In the second half of the nineteenth century, Balkan and Eastern European
gypsies were on the move. They travelled in their painted horse-drawn
wagons into Poland and Germany: the Kalderasà, or coppersmiths; the
Ursarì, or bear-leaders; the Lovarà, or horse-dealers; the Boyas, or gold-
washers; and many others from those swarthy tribes known as Rom. Western
Europeans had seen nothing like them in living memory. Some penetrated
into Belgium and France before being driven back. The Kalderasà were
among the most determined. They pitched their camps in Holland, and in
1868 one group came across to England. Still more reached these shores in
1886, coming from Serbia, Bulgaria and Rumania, and early in the twentieth
century the Lovarà arrived here from Germany. By 1913 Kalderasà gypsies
were to be seen in encampments outside towns and villages across the British
Isles. Though they didn't stay – many were on their way to the Americas,
and others returned whence they had come – their arrival dazzled and
alarmed all who saw them.

Picture a nation ruled over for decades by one elderly mourning widow,
who dies as the new century dawns. At her funeral all London dons crape.
Only white faces are visible under a sea of black hats, as the old queen goes
to her last rest.

Now, against this, visualize a parrot-rabble of the gaudy Rom – women
in abundant ragged skirts, shawled and patched, into whose unkempt tresses
are woven gold coins that cascade and jangle over their bosoms. Their
menfolk are no less fine and fantastical – baggy colourful trousers are tucked
into top-boots, their shirts are gay and tawdry, their coats and waistcoats
mended, but decked with lines of huge silver buttons. Their white teeth
and dark eyes glint like the brass rings in their ears. To the British public in
their mourning such people presented an alarming threat. The gypsies

brought the barbarity of foreign lands and strange ways to the outer-city wastelands of England. In Wandsworth you might come across them, or in Liverpool. You might follow their trail into Wales or across the south, always seeking the remains of a campfire, the trace of a foreign tongue, the locals' report of the passing of a group of gaudy wayfarers, from whom children and belongings must be protected. For they were not to be trusted.

Yet to the artist, the poet, the free spirit of whatever calling, the gypsies carried with them romance in the raw, and a liberation from the black tyranny of the past. For them, these people represented something profoundly free, and profoundly true. They were human beings released from the restraints of civilization. They could be who they wanted, say what they felt. They belonged to no country, obeyed no laws, and revered no leader. They submitted to no system, paid no taxes, and lived outside the worlds of politics and capitalism. At their death, their belongings were burnt with them. Their language and customs bonded them to like-minded spirits across national divides, yet they answered to none save nature and their own people. All this made them threatening to the establishment because they did not answer to the establishment's rules. It also made them exotic, sexy, mysterious, dangerous, endlessly inspiring.

George Borrow externalised all the yearnings of nineteenth-century gypsophilia in *Lavengro* (1851) and *The Romany Rye* (1857). Borrow's books, half novels, half memoirs, delved deep into the gypsy world, telling of the campfire, the horse fair, of gypsy history and customs, citing songs and snatches in Romany, while his characters Mr and Mrs Petulengro seem drawn from life. Borrow was, as far as anybody could be, an insider of the gypsy world; a generation of Bohemians lived and breathed his books. Arthur Ransome taught himself Romany from them, and took himself off to the nearest encampment where he sang and drank with the gypsies and learnt from them how to pick pockets.

Another gypsy-insider was the curious figure of John Sampson, the University Librarian of Liverpool. This complex, learned, much respected academic, with a passion for ancient languages, made it his life's work to trace and analyse the dialect of the Welsh Romanies. Sampson fell under the gypsy spell, and though he managed for years to cover his tracks, he lived a double life. For months on end he would leave his wife and family and take to the road, and with his devoted disciple Dora Yates ('the Rawnie') by his side they would live like the gypsies. An excerpt from W. H. Hudson's *Hampshire Days* (1906), selected by Sampson for his 'gypsy anthology' *The Wind on the Heath* (1935), captures the essentials of gypsy life:

The blue sky, the brown soil beneath, the grass, the trees, the animals, the wind, and rain, and sun, and stars are never strange to me; for I am in and of and am one with them; and my flesh and the soil are one, and the heat in my blood and the sunshine are one, and the winds and tempests and my passions are one. I feel that 'strangeness' only with regard to my fellow-men ... when I look at them, their pale civilized faces, their clothes, and hear them talking eagerly about things that do not concern me. They are out of my world – the real world. All that they value, and seek and strain after all their lives long, their works and sports and pleasures, are the merest baubles and childish things; and their ideals are all false ...

Augustus John met Sampson in 1901 when he took a post at the Liverpool School of Art, and it was through him that Augustus became increasingly obsessed with the world of gypsies. The pair went off on jaunts to the encampments outside Liverpool, where they would listen bewitched to the gypsy harps, and absorb the magic of their poetic language. The sight of the painted wagons, the horses, the campfires and the wild-eyed children who played around them stirred Augustus's blood in a way he could hardly explain. He felt akin to these ancient, free, outlawed peoples, and he longed to be one of them.

Augustus rarely did things by halves:

Henceforth I was to live for Freedom and the Open Road! No more urbanity for me, no more punctilio, and, as for clothing, according to my Golden Rule, the 'importance of appearances' insisted on at home, already made my neglect of them a duty. But now a new kind of exhibitionism was born; in its way, as exact and conscientious as my father's cult of the clothes-brush: a kind of inverted Dandyism. If my shoes were unpolished, they were specially made to my own design. If I abjured a collar, the black silk scarf that took its place was attached with an antique silver brooch which came from Greece. The velvet additions to my coat were no tailor's but my own afterthought, nor were my gold earrings heirlooms, for I bought them myself: the hat I wore, of a quality that only age can impart, might have been borrowed from one of Callot's gypsies, and was as a matter of fact a gift from one of their descendants. My abundant hair and virgin beard completed an ensemble, which, if harmonious in itself, often failed to recommend me to strangers ...

... and so much the better for that. Thus clad, Augustus felt himself to be at one with the rain, the wind, the sunshine and the brown earth, a living embodiment of the rebel. Shining with silver and brass, down-at-heel yet bravely swaggering, his appearance told the world: 'I have no truck with respectability. I am a child of nature and a Lord of the Universe. I am a

Bohemian.' Dorothy McNeill now metamorphosed into the gypsy goddess Dorelia, her graceful figure swathed by Augustus in yellow folds or sculpted in blue draperies. In his paintings her head is scarved or turbaned, and smocked children caper at her feet, which appear bare from beneath the folds of her long dress. A bright medieval-looking tunic follows the contours of her form. She raises her arms to the sky. So successfully did Augustus re-create the gypsy image in his own life that his fame as an artist was soon inextricable from his fame as a symbol. His extraordinary talent was bound up with his extraordinary appearance. Those like him who adopted the image of the gypsies felt illumined by their unique charisma.

There was Betty May, as described by Anthony Powell: '. . . her hair tied up in a coloured handkerchief, she would not have looked out of place telling fortunes at a fair'. There was Ida John's friend Mary, the wayward daughter of Lord Borthwick, who appeared at a dinner party with kerchiefed head, short striped petticoat, bare legs and sandals like a vagabond gypsy. John Sampson called her by the Romany word 'Rani', meaning 'Lady', and so she stayed. There was Edna Waugh, who even after her conventional marriage would be overcome by the desire to run barefoot, climb trees, wear light cotton dresses, and sleep under the stars 'akin I imagine to the "raggle taggle gypsies"'. The John children's tutor John Hope-Johnstone paid homage to his employer by adopting an eclectic gypsy look, which included a corduroy suit with swallow-tails behind, a 'diklo' (Romany for neckerchief), and a big black felt hat. Combined with his horn-rimmed glasses, he presented a distinctly odd spectacle. Meanwhile at Garsington the villagers nicknamed their lady of the manor 'The Gypsy Queen', which Ottoline herself believed arose from her habit of wearing Russian linen dresses with a silk handkerchief on her head. It is likely that at times, in her full skirts, her copper-red coiffure and her embroidered shawls, she was even more indistinguishable from the glamorous Kalderasà than she suspected.

In *The Silent Queen* (1927), the writer Seymour Leslie based his heroine Juanita on the model Chiquita (best known for Epstein's bust of her). This somewhat breathless teenager captivates the heart of the hero, Geoffrey, with her airy naiveté, but despite being completely one-dimensional, Juanita serves as a thumbnail sketch of the gypsy-girl type that frequented Bohemia both before and after the First War:

There steps out, running towards us, a small bare-limbed gipsy girl in sandals, her red petticoat flying, a black bodice laced in front, a coloured scarf round her neck, her black bobbed hair tumbling wildly about her face. Juanita! Throwing herself on and around me, she cries:

'*Pound*, you *must* lend me a pound, I've come all the way in this funny cab from Bloomsbury. From such a good party.'

'You've broken my only pair of spectacles, Juanita . . .'

She was never still for one moment . . .

'You look like a Spanish gipsy, Juanita.'

'I love the gipsies,' she replied, 'and hate being in towns and having to wear stockings.'

'Tell me everything,' I asked . . .

Juanita is absurd, and she is not chic, but she has come a long way from the hushed crowd of darkened mourners that watched in the new century. In 1901 she would have looked like a bird of paradise let loose in a graveyard. To eyes attuned to the muted tones of acceptable wear, the red petticoat and coloured scarf flash and shimmer to stunning effect.

<center>★</center>

So many rules and observances governed the dress of the Victorian age. It is worth remembering the appalling rigours which fashion and convention imposed on both men and women in late nineteenth-century and early twentieth-century England. From the cradle to the grave, from morning till night, convention dictated what must be worn, how and with what. Bright colour was very definitely to be treated with caution, for it had explosive potential. In her book of etiquette written in 1898 Lady Colin Campbell is adamant that 'decking [oneself] out in all the hues of the rainbow' is an infraction of the rules governing taste. It is quite wrong, she insists, to appear 'bedizened like a harlequin' – and for 'harlequin' read 'harlot'. Clothes worn for paying calls must be sober not gay; gloves should be either tan or of a colour harmonising with the rest of the lady's outfit; 'delicately tinted' fabrics may be worn for garden parties, bazaars and flower shows.

Propriety was all. Legs were treated as non-existent in the late nineteenth century; the problem of preserving modesty while bathing must have seemed at times almost insuperable. Not even children were spared. Gwen Raverat felt her heart bleed looking back at old photographs of herself and her brothers and sisters playing in their garden in summer, with their legs sheathed in black wool hosiery and button boots, their arms and heads covered. She watched in horror as her room-mate got dressed one morning around 1900. In the following order, this young lady put on:

1. Thick, long-legged, long-sleeved woollen combinations.
2. Over them, white cotton combinations, with plenty of buttons and frills.
3. Very serious, bony, grey stays, with suspenders.
4. Black woollen stockings.
5. White cotton drawers, with buttons and frills.
6. White cotton 'petticoat-bodice', with embroidery, buttons and frills.
7. Rather short, white flannel, petticoat.
8. Long alpaca petticoat, with a flounce round the bottom.
9. Pink flannel blouse.
10. High, starched, white collar, fastened on with studs.
11. Navy-blue tie.
12. Blue skirt, touching the ground, and fastened tightly to the blouse with a safety-pin behind.
13. Leather belt, very tight.
14. High button boots.

Corsets were probably the worst thing of all. As Gwen Raverat says, they were 'very serious'. When Margaret Haig (later the social reformer Viscountess Rhondda) was about to leave school, her mother broke it to her that she would henceforth have to wear a great box-like restraint from bust to thigh, full of whalebone and prickly bits. As the bones broke one by one, Margaret rebelliously removed them. 'Comfort has always stood high on my list of necessities,' she wrote. Not only comfort, but health. In the worst days of tight-lacing the goal of an eighteen-inch waist was often achieved only at the cost of serious internal damage to women's organs, as was confirmed when autopsies revealed livers practically ruptured by this self-mutilatory practice.

Men were not exempt. Even in 1928 (after the invention of the zip-fastener) a disgruntled correspondent wrote to the *Daily Mail* complaining of the tyranny of men's clothes: 'The button and eyelet holes on my apparel (without overcoat) number 90. Thus: coat 14, vest 6, shirt 9, trousers 6, undervest 4, collar 3, boots 48.' And in the 1930s James Lees-Milne complained about the incessant changing of clothes deemed necessary at an upper-class house party:

We . . . first assembled in breakfast clothes at 9 o'clock. We changed for church at 11. We changed for luncheon at 1.30. Those of us who went for an afternoon stroll in Windsor Park changed at 3. We certainly changed for tea at 5. Thereafter I do not think we changed again until the dressing gong went at 8. Then we changed to

some tune, the women into long trailing gowns, and the men into tails and white ties. Some of us therefore put on six different garments that day as a matter of custom, not vanity.

Whether down at the Drones Club or up the jungle, middle- and upper-class men until the Second World War and after were most tyrannised by the obligatory ritual of changing for dinner. Even Bohemians often compromised grumpily with the conventions in this area; Murger's Bohemians go to some lengths to scrape together evening clothes. Until 1920 in the upper echelons of society, the tail coat with white tie was de rigueur for a dinner where ladies were present, and dinner jacket with black tie was expected when dining in all-male company. Until 1939 many circles still conformed to the rule of black-tie dressing for dinner, whether at home, at the theatre or in a restaurant. Few men were daring enough to challenge the might of the boiled shirt. Wyndham Lewis was one, though his friends warned him not to:

'For the sake of your car-*reer!*' [my friend Harry Melville] would boom impressively at me, 'you *must – four* times a week – make up your mind to put on a *boiled* shirt!' But the boiled shirt game did not seem to me worth the candle.

Lewis defiantly turned up to an aristocratic dinner party in ordinary clothes, thereby earning the enmity of C. R. W. Nevinson who, in his own 'inoffensive white tie' took the lapse personally. The working-class Mark Gertler was more daunted by the prospect of social disapproval than Wyndham Lewis. When the impeccable aesthete Edward Marsh invited him to an 'at home' he was driven to confess that he did not own a tail coat, and wrote begging for advice: 'What do you think? Would it be absolutely outrageous? Please tell me honestly, as I should feel most uncomfortable if I were the only person in a dinner jacket.' He would have to resort to borrowing or hiring if the tail coat turned out to be obligatory.

It seems that there were limits beyond which one just couldn't go. Gypsy finery was welcome in Bohemia, or even in the Tottenham Court Road, but it took more bad manners and effrontery than people like Gertler possessed to turn up at, say, the Royal Opera House wearing plain clothes. In any case, evening dress was compulsory at the Opera, so to hear Mozart or Wagner one was forced into it. When Ottoline Morrell generously decided to take the two Spencer brothers, Stanley and Gilbert, to Covent Garden to hear *Don Giovanni*, the problem instantly presented itself, for neither of them possessed evening clothes. Unfortunately both Spencers

were extremely slight in stature – little over five feet tall. Ottoline made a lot of telephone calls, and scraped together the rudiments of two suits. With these, and the help of a great many safety pins, she got them kitted out. They presented such an odd spectacle – Stanley's coat-tails trailing on the ground behind him, the trousers buckled in folds around his ankles – that Ottoline feared they would be prevented from entering, so she spread her black silk opera cloak around them and (she being nearly six feet tall) escorted the diminutive pair up the stairs to the grand tier and finally to the safety of their box: 'I felt like a great hen moving about with a brood of unfledged chickens under my wing. From the front they were fairly well hidden; what the back view was like I didn't mind.'

No such gauntlets needed to be run in Ottoline's own home, Bedford Square, for here on Thursday evenings, before and during the First World War, up-and-coming Bohemia was welcomed in all its gaudy glory. Ottoline was as hospitable to the older generation of artists and writers as she was to the new, but found the former reluctant to shake off the conventions. Henry James was pained by his hostess's willingness to admit such a rabble to her home. Their lack of a dress code so greatly distressed his social sensibilities that he literally begged her not to descend to their level: 'Look at them. Look at them, dear lady, over the banisters. But don't go down amongst them.'

Though Ottoline daringly disregarded his injunctions, hers was a rare case. Violet Hunt was an artistic hostess who rigidly insisted on her guests wearing evening dress until almost the Second World War. Ethel Mannin insisted that dressing up came more from a sense of decorum than from snobbery; '. . . though we joked about boiled shirts,' she remembered, 'they were worn a great deal'. It would seem that the tuxedo has still to die a lingering death. Some might say that, uncomfortable and stuffy as it is having to dress like a waiter for ceremonies and banquets, it at least saves having to make complicated decisions or purchases for such occasions.

For the acquisition of clothes could be a daunting ordeal, particularly for women. Ready-to-wear clothes were the exception. Thus one had first to brave the draper's, where pompous shop walkers addressed one as 'Madam' and pressurised one into buying things not really wanted; '. . . one was thankful to escape,' remembered Viva King. Middle-class people like Lesley Lewis's mother had their own dressmaker or tailor. Her crêpe de Chine or Macclesfield silk dresses were made up by the Mesdemoiselles Lehmann in Wigmore Street. Daniel Thomas of South Molton Street would tailor the lengths of tasteful Scottish tweed sent to Mrs Lewis as gifts from Highland shooting parties into excellent, durable suits. Her shoes were hand-made by

the firm which also made Mr Lewis's boots. All this entailed innumerable fittings, all the more anxiety-inducing because each frill, each buttonhole conveyed legible clues as to one's social status. An inch of hemline could spell the difference between respectability and being thought 'fast'. An ostensibly small aberration like omitting to wear a tiara to a court ball could cause disproportionate reverberations and give one an undesirable reputation.

Putting all these clothes on and taking them all off again dominated one's day. Hours were consumed tying tapes, looping buttons, pinning pins, brushing mud off yards of hemline, adding false bits to one's hair, one's bosom and one's bottom, tying ties, shaving and coiffing, gloving and hatting, ribboning and lacing, starching, frilling and goffering . . . There were better ways to lead one's life surely, and, as in so many aspects of everyday life, it was artists who broke through the stranglehold of middle- and upper-class conventions.

<p style="text-align:center">*</p>

One way of rejecting the proprieties was simply to ignore them altogether, which had the advantage of being cheap, if not entirely cheerful. Why bother to be smart, when you could cover your nakedness and protect yourself against the elements just as effectively with rags and tatters? Murger and his Bohemians had bequeathed an honourable tradition on this approach to clothing. *Scènes de la Vie de Bohème* is full of the pawning, borrowing and conning of overcoats and evening clothes, while back in the garret one dressed in whatever miscellaneous clothes one could scrape together. There were risks attached of course. A landlady might not tolerate a tenant who gave her house *mauvais ton* by his scruffiness, but on the whole Bohemia disdained such squeamishness. Society would have to endure it if you showed up in odd shoes – and if a friend borrowed your only pair of trousers you stayed in bed. *Nostalgie de la boue* made shabbiness seem romantic rather than degenerate – degeneracy was wanting to trick oneself out in frippery and tight collars – and many artists took an honest pride in appearing undisguised:

Duncan and I have both become very disreputable by now . . .

boasted Vanessa Bell in a letter to her sister from the Loire valley,

as black as niggers and dusty to a degree. He has no ties, no buttons to his shirts and usually no socks. I have lost my only decent pair of shoes and wear red espadrilles,

and my hat flew off yesterday and was picked up by a dog who bit Duncan when he tried to take it from him . . . The hotels here will hardly take us in . . .

But I am becoming shameless since I realized that one has only to change one's conception of oneself into some sort of charwoman or tramp to walk the street comfortably in rags or barefoot. Why one should ever think decency, let alone smartness, necessary I don't know, as one has no wish to hob-nob with the other decent and smart.

Caitlin and Dylan Thomas too were defiant in their poverty; for them shreds and patches constituted protest clothing. Caitlin felt that by wearing down-at-heel, slovenly clothes they could shame respectable people into buying drinks for them. Even when Dylan's mother gave Caitlin some money to smarten herself up, she bought one brassière and then blew the rest on a drinking binge with Dylan in Swansea. But Caitlin confessed that deep down the pair had 'secret conventional tendencies', and that their shabbiness was really a front.

Given a chance, and some money, there was something of the Bohemian dandy in Dylan. For all his slovenliness, he cared enough about clothes to buy a suit and have it dyed bottle-green. He would agonise between the spotted bow and the long tie for a poetry reading, always ending up with the spotted bow. He had a mania for shirts, so long as they weren't his own. 'I doubt if in my life I have bought as many shirts as he stole,' recalled Constantine Fitzgibbon. Dylan could accommodate buttons and ties into his scheme of things, so long as they weren't dull or anonymous:

As an individual you should *look* individual, apart from the mass members of society . . . I don't look a bit like anybody else – I couldn't if I wanted to, and I'm damned if I *do* want to . . . Man's dress is unhygienic and hideous. Silk scarlet shirts would be a vast improvement. This isn't the statement of an artistic poseur; I haven't got the tact to pose as anything. Oh to look, if nothing else, different from the striped trouser lads with their cancer-festering stiff collars and their tight little bowlers.

<center>★</center>

Each generation fights a battle against the previous one. Back in the 1880s the Cox girls, Rosalind Thornycroft's mother and aunts, had been the belles of Tonbridge society. Grandmother Cox despaired at her daughters' refusal to wear bustles. 'Just a little something, dear,' she would plead. But Agatha and her sisters sternly refused, for they were 'enlightened' and 'rational'. In

artistic circles in the second half of the nineteenth century there was a gradual unfastening and loosening. Hair began to tumble, dresses to flow, collars and bodices to soften. The aesthetic movement, with its coloured embroidery and rich colours derived from the canvases of Rossetti, Burne-Jones or Holman Hunt, gathered pace – though this look was still regarded as very 'advanced'. Agatha brought up her own children to shun coiffures and stays. This was in 1900 when the hourglass figure had reached its apogee. She dressed Joan and Rosalind in Liberty smocks and left their hair loose. Garters – bad for the circulation – and button boots were banished and replaced with suspenders and 'nature-form' shoes. Rosalind makes it clear that much of this dissenting current in fashion can be attributed to the influence of Pre-Raphaelitism, while the unrestricted, flowing look also had a powerful impetus behind it which came from the dress propagandists of the day.

The Rational Dress Society was founded in 1881, and the Healthy and Artistic Dress Union soon followed. Such groups took the first faltering steps towards freedom wear, and a fair number of shakers and movers, including Oscar Wilde and Marie Stopes, gathered for enjoyable drawing-room meetings to discuss such popular topics as immodesty, baby clothes, the health benefits of going hatless, and reducing the quantity and weight of undergarments. Dr Gustav Jaeger was to become the guru of the rational dress movement when he published *Essays on Health Culture* (English translation 1884), in which he expounded his theories about the evils of wearing vegetable fibres next to the skin. Jaeger's panacea for all known ills was his revolutionary Sanitary Woollen System, for which he produced natural yarn sanitary shirts, woollen leggings held up by braces, a tight coat, a hat and gloves, all of wool. Woolly handkerchiefs were also provided. Bernard Shaw fell for it completely – when kitted out his appearance was by all accounts utterly extraordinary.

Jaeger enjoyed an enthusiastic following among 'arty' freaks who did not mind what people said about them, and among others who, finding the woolly look too cranky to contemplate, nevertheless wore their woollen vests just in case. All these people were minorities, ahead of their time, who challenged the old axiom that *Il faut souffrir pour être belle.*

At the turn of the century, particularly in artistic and libertarian circles, the climate was against mortification of the flesh. Fashionable garments in which you could not move your arms, head or remain standing for long periods made painting impossible. Thus a fashion-conscious painter was simply a contradiction in terms. Above all, the liberators turned their attention to foundation garments.

The nineteenth century had already seen a wave of opposition to restrictive underwear among artists and aesthetes. Ruskin propagandised in favour of 'right dress'. G. F. Watts even joined the Anti-Tight Lacing League. In crusading spirit, he draped the uncorseted bodies of his models in Grecian-style robes to pose for his elevated mythological history pieces. But die-hard Bohemia took things a stage further and often abandoned underwear altogether, as Nicolette Macnamara remembered:

The John girls did not stop at dresses, but probed deeper to underclothes. The girls suffered bitterly from the cold. For not only were stockings and closed knickers banished, but wool vests or combinations too. I shall never forget the horrible chilliness of draughty linen against the skin . . . We lived with a permanent wind blowing up our legs.

When Nicolette got married to Anthony Devas she found herself conflicted by her longing to impress his bourgeois relatives, and her own unconformable nature:

Now, to conform with the Devases, I squeezed myself into a whalebone corset, donned a severely-fitting tailor-made suit, hat, gloves and shoes. It was fun to dress up like this for an hour. But later the clothes restricted my gestures and made me feel sweaty and exhausted. I stamped on the gloves, ran barefoot and abandoned the tailor-made on the floor.

Fortunately for Nicolette the 1920s saw such a radical alteration in ladies' fashion that underwear, which as ever determined the female silhouette, became perforce comfortable. The disappearance of the waist and the suppression of the bosom allowed women to adopt the camisole, a convenient bodice which encased without pressurizing. This soon evolved into the camiknicker, which, buttoning up between the legs, combined bodice and pants. The bra did not come in until the end of the twenties. But most people in the twenties and thirties wore wool next to the skin for eight months a year. There are those who still remember the overpowering stink of a London Underground train on a warm day.

Meanwhile the dress-reform movement continued to work at persuading men to loosen their collars and relax. The sculptor and calligrapher Eric Gill wrote *Clothes* (1931) as a diatribe against our unthinking acceptance of fashion's dictates. Women were not its only victims; men were condemned to the wearing of tailored suits whose iconography was that of the accountant's office:

Trousers versus tunics in Eric Gill's *Clothes*.

You have a body of skin and bone – ghastly thought! Cover it up – put thick trousers on its legs and trousers on its arms. Put, if it be possible, a trouser on its trunk. Let these things be of a dull and serviceable colour such as will not distract their wearer from his account books ... Above all things let these trouserings be dull – dull and drab – drab and sober. Let there be no suggestion that the man of business has any concern with the passions, whether of love, of sport or of art ...

In their stead Gill pleaded with the public to take pride in their bodies, to reject sexual differentiation, and to embrace the only truly universal and beautiful garment – the robe, or tunic.

Gill may have felt encouraged by the sight of emancipated and educated women who, earlier in the century, had had a brief love affair with the jibbah, a shapeless Arab-style robe much favoured by corsetless schoolmistresses at Bedales and vegetarians in Letchworth Garden City. Gill himself was a lifelong tunic-wearer, with or without underclothes. This suited his libertinous and exhibitionistic tendencies as well as his rational and aesthetic principles. His only concession to respectability, if you can call it that, was red silk underpants worn for such gala occasions as the Royal Academy dinner. Gill's odd clothing proclaimed him to be special, unconformable, beyond even Bohemian – but his plea for a male tunic was doomed to fall on deaf ears.

★

A more successful campaign was waged by the liberators of the human foot, which, too long imprisoned in agonisingly tight buttoned boots or painfully narrow fashionable high-heeled shoes, ached for release. Button-hooks were thrown out along with the stays and the collars, and sandal-wearing took on a significance and identification with a certain ideology that it has never since shaken off.

The vegetarian nature lover Edward Carpenter can be held largely responsible for this. His utopian approach to the simple life extended to clothing. Throwing away his dress suit was the first step. He then dispensed with waistcoats, underlinen, socks, ties and other such superfluities, replacing them with a minimal outfit consisting of woolly shirt, coat and pants. 'As to the feet, there seems to be no reason except mere habit why, for a large part of the year at least, we should not go barefoot, as the Irish do, or at least with sandals.' Carpenter was initiated into the secrets of sandal-making by a fellow-travelling back-to-the-lander, and took to the craft with enthusiasm. One could order a pair from the master for 10s 6d, 'lower terms for children'. For long-confined feet sandals were a revelation, and people like Naomi Mitchison were happy to pay over the odds to feel the wind between her toes – for in the twenties it was well-nigh impossible to buy 'a simple classical sandal', and she had to have them specially made. But the look of them was so new, so curious, that sandals became emblematic of a particularly earnest stance towards life. Evelyn Waugh could spot the type a mile off, living as he did within easy reach of Hampstead Garden Suburb, 'largely inhabited by people of artistic leanings, bearded, knicker-bockered, flannel-shirted, sometimes even sandalled'.

Sandal-wearing communicated libertarian ideals, a preference for beauty, health and comfort over respectability, and a rejection of materialism. Despite being expensive, the wearing of sandals was anti-affluence. So convincingly did the practice convey this message that the French lady curators of Cézanne's house in Aix-en-Provence were touched to the core by Dorelia John's plight – her sandalled feet showed that she was clearly too destitute to afford proper shoes – 'pauvre femme'.

Going barefoot was all the more a statement of one's allegiances. Generally associated with abject poverty, the Bohemians who rejected footwear entirely declared themselves above material things, and attuned to nature. Gwen Raverat would have envied the John or Bell children, or Igor and Baba Anrep who went barefoot all summer long. Igor liked to maintain that they couldn't afford shoes, but in reality he genuinely preferred going barefoot. Rupert Brooke and his Neo-pagan friends felt themselves to be above boot-wearing – but their practice of removing them at all times fell

foul of Brooke's landlady in Grantchester. He had to warn his free-and-easy visitors that they would have to keep their boots on, otherwise she would throw him out. In due course he left anyway, and took up residence at the Old Vicarage next door, whose owner didn't seem to mind a barefoot poet sleeping under the stars in her garden.

<center>*</center>

The Neo-pagans, the group surrounding the poet Rupert Brooke, were particularly addicted to naked bathing. Shedding one's clothes seemed in those heady decades to be a glorious activity. Brooke, Bunny Garnett, Ka Cox, the Olivier girls, the Raverats, Radfords, Cornfords and their friends pitched their camps by the seashore or rivers, where they could swim and dive in a state of nature. Then they lit fires and talked about poetry and love. Their bare bodies were imbued with a kind of innocence and an artist's love of the human form. Nakedness represented the ultimate emancipation – the breaking of a final taboo. For in Victorian England there were even cases of married couples who had never seen each other naked. Nina Hamnett saw her body unclothed for the first time at the age of sixteen; it was such a revelation that she immediately did a self-portrait. 'Man has to undo the wrappings and the mummydom of centuries . . .' insisted Edward Carpenter in *Civilization: Its Cause and Cure* (1889). He saw the removal of clothes as a move towards enlightenment:

The instinct of all who desire to deliver the divine *imago* within them, is, in something more than the literal sense, towards unclothing . . .

Then, and only then . . .

. . . the meaning of the old religions will come back to him. On the high tops once more gathering he will celebrate with naked dances the glory of the human form and the great processions of the stars . . .

Encouraged by Carpenter, and by the Freudians, who saw nudism as eradicating repressions, nudist camps were briefly popular in the twenties and thirties. But there was something humourless and ultimately un-sexy about them to the majority of British people who, whether bourgeois or Bohemian, preferred to leave institutional nudism to the Germans. Bohemian nakedness was exhilarating, and daring – Nina Hamnett danced naked to Russian balalaikas, Robert Medley cavorted in a figleaf at the Cave of Harmony, the composer Philip Heseltine stripped off unbidden in

Piccadilly Circus. Heseltine's displays of streaking were somewhat unhinged. Naked, he would tear through village streets on his motorbike, or rip off his clothes in the Queen's Hall. Inhibitions were for the faint-hearted, and it was fun to upset Mrs Grundy.

<p style="text-align:center">*</p>

Sadly the naked human form does not always live up to one's hopes, and we live in a cold climate. However, it was still possible to deliver the divine *imago* in yellow silk or emerald corduroy, in cheerful colours and flamboyant fabrics. For Dorelia and her sister Edie much of their creativity was expressed in the clothes they sewed themselves, whose flowing lines were designed to their own pattern, and whose seams were brightly saddle-stitched on the outside in contrasting coloured silks – orange on blue, emerald on crimson. They made all the children's clothes too. The boys wore pink smocks and brown corduroy knickerbockers (their picturesque appearance gained them the nickname 'Persians' at school), and the little girls wore miniature versions of the women's dresses, which trailed on the floor and entangled their feet.

The emphasis was on fun, and on colour and beauty rather than fine workmanship. Vanessa Bell would often seize her Singer and run up a skirt or a party dress for Angelica. The result was gay but frequently relied on safety pins as fastenings. Igor Anrep remembered his mother Helen's full-length home-made dresses which she continued to wear when everyone else was going knee-length in the 1920s. Their sewing machine only did chain-stitch, which meant that if a thread got pulled the whole seam would unravel, leaving Helen clutching at the sections of her skirt in panic until she could get home.

Being unable to afford clothes led to creative solutions. Caitlin Thomas would make shirts for Dylan by hacking her way into a checked table-cloth. It was easy to fold the thing in four, cut a hole for the head and a notch for the arms. 'And, presto, that was it . . .' Dylan was proud of his clever wife with her needlework, but Caitlin couldn't help feeling embarrassed by her own ineptitude and Dylan's absurd appearance in these garments.

Kathleen Hale would save up to buy four art silk squares from Liberty's:

They were big – and ever so artistic! – reproductions of Indian patterns, and one of them would make the front of the tunic, and another the back, and then one for each of the sleeves, just like that! I didn't know anything about tucks or fitting. I

thought I looked wonderful; they were the only things I could afford to make, and I couldn't afford to buy any.

Iris Tree acquired yards of ethnic material and devised Gauguinesque sarongs . . . Sewing, hand-weaving and knitting, Bohemians were full of the spirit of improvisation, the human love of self-adornment triumphing over meagre means and narrow-minded standards.

Brilliant, exotic colour leaps out at one from the pages of contemporary memoirs, just as it does from the canvases of Augustus John, Vanessa Bell, Mark Gertler and their contemporaries. Bohemian clothes weren't intended to blend in. At one of Ford Madox Ford's tea parties three young writers seated on a divan caused their host anguish by their Fauvist ankles: '. . . clothed, as to the one in emerald green socks, as to the next in vermilion and as to the next with electric blue. Merely to look in the direction of that divan was to have a pain in the eyes.' Arthur Ransome tells in *Bohemia in London* how at the Algerian Café in Dean Street one might, if one was lucky, chance upon a Bohemian in emerald corduroy, smoking his pipe and talking poetry over his coffee; while a regular at the Café Royal was Betty May, dressed like a parakeet from top to toe:

I could only afford one outfit, but every item of it was of a different colour. Neither red nor green nor blue nor yellow nor purple was forgotten, for I loved them all equally, and if I was not rich enough to wear them separately, rather than be parted from any one of them, I would wear them, like Joseph in the Bible, all at once!

As if to endorse Bohemia's appropriation of vivid colour, the London fashion world was soon reeling from the arrival of Bakst and his splendid orientalism, let loose on the stage of Covent Garden in the Russian ballet's *Schéhérazade*. Simultaneously, Paul Poiret's sub-oriental collections, with their complex and voluptuous barbarity, rocked Paris. Though such high-fashion extravaganzas were not for impoverished Bohemians, Poiret's love of colour and ostentation was in tune with their approach to dress – the anti-taste approach. In 1911, Turkish houris rubbed shoulders with purple shawls and black sombreros, Egyptian coiffures mingled with poetic locks in the auditorium of Diaghilev's productions. There was Edith Sitwell in green brocade and queer Chelsea types in flannel trousers and multicoloured pullovers, alongside the starchiest of boiled shirts and most resplendent of evening gowns – a colourful throng of the chic and the shabby; for fashionable, intellectual and Bohemian London were united in applauding the art of Nijinsky, Lopokova and Karsavina. Russian-ness in all its forms now

became intensely fascinating to the cultured section of society. There had been nothing like it before.

*

This was the great era of disguise and fancy dress; it was as if the combined corps de ballet of *La Boutique Fantasque*, *Carmen* and *Schéhérazade* had all joined hands and taken to the streets, dancing into every salon, dance hall and nightclub, and making their final entrance en masse at the Royal Albert Hall. For this was the usual venue of the Chelsea Arts Ball, an unmissable event in the Bohemian calendar.

The Chelsea Arts Club had been founded in 1891 with an agreement that it should be 'Bohemian in character'. Men only, the Church Street premises provided a retreat for a prominent crowd of 'devotees of the brush and mallet', many of them leading lights of the art schools or Royal Academicians. Whistler, Sargent, Tonks, Steer, Sickert, Brangwyn and Augustus John were all regulars who enjoyed the informal companionship of other artists that it offered. Certainly the club was homely and raffish, and far from pompous, but in effect it eschewed the avant-garde and maintained a rather gentish, uncontroversial character. This made it easy for more conventional people to approve of, and the ball became the moment when artistic and high society London united to let its collective hair down – its great innovation being that fancy dress was compulsory.

On Mardi Gras 1910, four thousand three hundred revellers arrived at the Albert Hall for the biggest motley extravaganza ever held in London, a whirling, dancing crush of crazy outfits. Most of the artists had designed their own costumes. Forty girl art students transformed themselves into an eighty-legged microbe – the 'Flu Germ'. Flashing its electrically lit red eyes, it wove past a cute little model *en travesti* astride an attenuated giraffe, while to the music of massed bands, Halley's Comet took the floor with Joan of Arc, and an elephant turkey-trotted with a Sioux chieftain. Meanwhile Romeo and Juliet shared a joke with a pair of cowboys, and teddy bears, red devils, mad hatters and toreadors danced till dawn. 'The fun of it all!' sighed one delirious party goer, remembering that phantasmagoric night.

Never perhaps has so much mileage been extracted from the dressing-up box as during those flamboyant early decades of the twentieth century. The year 1910 saw possibly the most outrageous example of exotic stunt-dressing, if one can call it that, when His Imperial Majesty the Emperor of Abyssinia and his suite arrived to inspect the flagship *Dreadnought* at anchor in Weymouth harbour. None of the officers on board suspected their real identities: Duncan Grant, Anthony Buxton, Guy Ridley, Virginia Stephen and (in

plain clothes as their interpreter) her brother Adrian Stephen. The instigator
of the hoax, Horace Cole, pretended to be an official from the Foreign
Office. Clarkson's, the theatrical costumiers, from whom they had hired
their Eastern robes, were brought in to dress them and apply their make-up
and false beards. Despite a few close misses – as when the rain threatened to
wash away Duncan's moustache – the impersonators remained undiscov-
ered. A few days later the '*Dreadnought* Hoax' hit the headlines of national
newspapers, and the Admiralty realised it had been shamefully humiliated
by a group of posers got up in fancy dress and sunburn powder. For a while
the Navy was the laughing-stock of the press and the music halls; questions
were even asked in parliament. Eventually the episode slipped into history,
and mythology – a milestone among masquerades.

Perhaps the *Dreadnought* hoax figured in Virginia Woolf's memory of
that year when she later wrote, 'on or about December 1910 human character
changed'. Her husband, with more characteristic caution, cited Freud,
Einstein, Proust, Joyce, and the Post-Impressionists as being among the
writers and artists who made pre-war London feel like the most exciting
place on earth to be alive. Modernist camp followers needed to feel that
their external guise was of a piece with their experimental art, and that it
expressed their ideal of authenticity as opposed to the fake, gutless com-
placency of the bourgeoisie. They were determined to stand apart from the
herd, to cast a new sense of identity. What was wrong with tennis pumps
under evening dress, with breaking the rules in a black wedding dress, with
walking down the Tottenham Court Road in odd shoes and coloured
stockings, if they showed you were original?

But, paradoxically, unconventional dress was also a kind of camouflage,
for those natural exhibitionists were also a companionable crowd. Bohemian
dress conferred a sense of belonging, and protective colouring:

A man does not set out saying, 'I am going to be a Bohemian' . . .

explained Arthur Ransome,

. . . he trudges along, whispering to himself, 'I am going to be a poet, or an artist,
or some other kind of great man,' and finds Bohemia, like a tavern by the wayside.
. . . and, looking into the tavern, [he] catches glimpses of a hundred others as
extravagant as himself . . . [and] tells himself with utter joy that here are his own
people, and, being like everyone else a gregarious creature, throws himself through
the door and into their arms.

For without wanting to belong to the anonymous masses, there has always nonetheless existed a kind of freemasonry between artists, and it had some unmistakable badges of office.

<div align="center">★</div>

How could one fail, for instance, to understand the explicit declaration carried by an unconventional hairstyle? In the Edwardian era all serious men wore their hair 'short back and sides'. It was greased with brilliantine, and you were daring indeed if you braved a right-hand or centre parting. But from the early days of French Bohemia shaggy locks had denoted genius. W. M. Thackeray wondered at the ringlets, curls and scented tresses worn in the artist quarter of Paris when he visited it in the 1830s. For Théophile Gautier long hair was an article of faith: 'Make no mistake, if you cut your hair or your moustache, you cut off part of your talent . . .' for, like Samson, long hair was a symbol of potency, artistic or otherwise. The aesthetes of the nineties went in for abundance of hair, emphasising their sensitive pallor, their refined emotions. Augustus John allowed his hair to grow, and soon the camp following – Henry Lamb, Lytton Strachey, John Currie, John Fothergill and Mark Gertler – were growing theirs in his wake. Arthur Ransome was impassioned in his defence of such unconventionality. He pointed out that the need to shock one's relatives went deep. In growing his hair long, the Bohemian showed that he was 'one of the prophets', and demonstrated his horror of 'being indistinguishable from among the rest of the human ants around him'. Unfortunately this attitude was painfully easy to send up:

> The youthful, inexperienced person
> Who finds that he can write in verse on
> Passion and moonshine keeps his hair
> Uncut, to show he is that rare
> Superior kind of thing, a poet,
> And wants his fellow men to know it.
>
> St John Adcock
> *A Book of Bohemians* (1925)

Even more emphatic was the wearing of beards. Long associated with radical opinions, the beard was, in the first decades of the twentieth century, such an anti-fashion statement as almost to constitute an affront to decency. Wedded to his rituals, the middle- and upper-class male was condemned to half an hour each morning with a cut-throat razor, stropping, frothing,

POETRY

'One of the prophets'. Illustration by Fred
Adlington to *A Book of Bohemians*.

scraping and blotting. The whole performance was quite needless if you
grew a beard. Soon there was no keeping them down, for there was the
great role model Augustus John flaunting his red one down the King's Road,
terrifying the cab drivers – he claimed to have been the only officer in the
British army to wear a beard apart from the king. They wagged in the
auditorium of the Russian ballet, and sprouted like fungus between
the ornate pillars of the Café Royal's Domino Room. There were beards at
Garsington, beards in Letchworth Garden City, beards in the Fitzroy Tavern,
such an outbreak indeed that the sport of beard-spotting soon became a
popular craze. It was called 'Beaver', and it went on for years. Two people
walking down the street competed to collect points. The first to spot a beard
cried 'Beaver!' and scored, but you got extra points for white ones, and
there were bonuses for rare and unusual varieties of beard such as forked
ones or very long ones. But the objects of this ridicule banded together and
in solidarity formed the Secret Society of Beavers, who solemnly swore
never to appear barefaced and to wreak vengeance upon anybody who
mocked beards. Their heroes were George V and George Bernard Shaw.

In *Antic Hay* Aldous Huxley exploited the Beaver craze to farcical effect
with his hero Gumbril Junior's fake beard escapade. Gumbril's friend Cole-
man persuades him that a 'Beaver' can be very seductive:

'You hear someone saying, "Beaver," as you pass, and you immediately have the right to rush up and get into conversation. I owe to this dear symbol,' and he caressed the golden beard tenderly with the palm of his hand, 'the most admirably dangerous relations.'

'Magnificent,' said Gumbril . . .

Gumbril acted on the hint. Not long after, equipped with a 'stunning . . . grandiose' false beard, he picks up Rosie. Bowled over by his artistic, 'Russian' appearance, she invites Gumbril back to her flat for tea. Rosie is soon down to a pink kimono, and the pair exchange tickly embraces. The situation only becomes Feydeau-esque when Gumbril discovers that Rosie is married to his friend Shearwater, whom he then encounters on the stairs.

Eric Gill, whose beard was quite real, was perhaps its most forceful apologist. In *Clothes* he deconstructs the whole issue of facial hair at length, concluding that 'the beard is the proper clothing of the male chin, and the all-sufficing garment of differentiation'. Women, however, were now setting out in their turn to break with convention, and that meant blurring those distinctions as far as they possibly could. Here, from Gilbert Cannan's *roman-à-clef*, *Mendel* (1916), is an exchange between the eponymous hero (alias Mark Gertler) and a friend about Greta Morrison (alias Dora Carrington):

'Did you know that Greta has cut her hair short?'
'Her hair?' cried Mendel. 'Her beautiful hair?'
'Yes. She looks so sweet, but the boys call after her in the streets. All the girls are wild to do it.'
'Her hair? Her beautiful hair? Why?'
'Oh! She got sick of putting it up. She is like that. She suddenly does something you don't expect.'
'But she must look terrible!'
'Oh no. She looks too sweet. And if all the boys at the Detmold [Slade] wear their hair long, I don't see why the girls shouldn't wear theirs short.'

Several women claimed to have been the first to do it. Whether it was Dorothy Brett, Nina Hamnett, Ida Nettleship or Carrington, the look caught on. Iris Tree cut off her golden plait while travelling on a train and left it behind on the seat. They were known as the Slade cropheads, the Bloomsbury Bunnies, the 'top-knots' – their bobbed hair declaring that they were unambiguously emancipated. It was so low-maintenance, too,

compared to those elaborately dressed Edwardian coiffures which, even after they were dismantled, needed a hundred strokes of the brush every night.

As explicitly as hair, hats sent out clarion clear messages about the wearer's allegiances. This was an age when hats were universal. You wore hats for luncheon, for tea dances, in town and in the country. A woman without millinery was regarded as having forsaken the human race. Carrington caused shock waves because she went bareheaded; even Sickert was scandalised at the sight of a hatless Nina Hamnett emerging from the Fitzroy Tavern carrying a mug of beer.

When they did wear them, artists took hats seriously. Perhaps more than any other item of Bohemian regalia they put a spin on the individual who wore them. Big-brimmed and black, the felt sombrero or Austrian velour was the accepted Bohemian headgear in an age of stovepipes and bowlers. Augustus John's came from Paris. Wyndham Lewis wore his all the time, indoors and out. Ezra Pound was aggressively sombrero'ed. Katherine Mansfield wore one like a man, over her bobbed hair. Expansive, floppy, but at the same time rather threatening, these hats were positively bulging with self-expression.

And then there were the ties. The wearing of a coloured tie was loaded with meaning in a man's monochrome world. Bow ties, flowing ties, cravats, neckerchiefs, political ties, poet ties and painter ties, art ties and no ties . . . Above all, brightly coloured ties, which, blazoned across Bohemian breasts, betrayed the protest that burned within.

'I used to wear a scarlet tie . . .' remembered Stephen Spender of his student days at Oxford. One night a gang of philistine 'hearties' came to Spender's rooms armed with buckets and bludgeons, determined to teach the 'arty' poet a thing or two. Spender deflected them by quoting Blake, and the gang retreated in confusion, convinced that the poetic pansy was probably mad. But the red tie had inflamed the bullies; later they returned and, finding the offending neckwear, cut it into little shreds which they festooned over the frames of his Post-impressionist reproductions.

Spender may have got more than he bargained for, but the contretemps was symbolic, like seizing the enemy's standard. Ties meant so much more than just ties. The sight of Lytton Strachey in his dark red tie in the Savile Club in 1912 stirred up an agitated discourse in Max Beerbohm's mind. Who was this man? Why did he dress like that? What did it all mean? He noted every detail of Strachey's appearance, the long beard, the soft shirt, the velveteen jacket. What was this man trying to say? In the end Beerbohm felt honestly compelled to admire him: 'Hang it all,' I said, 'why *shouldn't* he dress like that? He's the best-dressed man in the room!'

One of the aspects of Strachey most noticeable to Max Beerbohm was the softness of his garments. For a hundred years the well-dressed man had been carapaced in tailored suits and tight collars. They were starched and pressed, padded and interlined. Bohemia reacted to the discomfort and rigidity of this kind of wear by choosing clothes in fluffy, comfortable fabrics. Strokeable and inviting, these shaggy tweeds, velveteens and rich corduroys implied in their plushy depths of colour the freedom, licence and liberality of the wearer. The fact that these sensual materials quickly became shabby only added to their rather abandoned lustre. The Slade School of Art was full of dandies like John Fothergill in blue velvet jackets, not the most practical choice for a painter one might suppose, but the emphasis was on artistic status, not suitability for dry-cleaning. Arthur Ransome became famous for his corduroy suit which acted like a beacon to his admirers – Clifford Bax dreamed of wearing one to be like him. Artists appeared so frequently in corduroy trousers that Iris Tree eventually used the word as a sobriquet for herself and other such 'rag, tag and bobtails': they were the 'corduroys'. Tweed too, if sufficiently hairy, also carried Bohemian connotations. Osbert Sitwell was impressed by the clothes worn by Monty Shearman's guests at his Armistice night party at the Adelphi. Those who had fought came to the party in uniform, but a proportion who had been conscientious objectors came in their 'ordinary' clothes . . .

. . . if ordinary is not, perhaps, a misnomer for so much shagginess (the suits, many of them, looked as if they had been woven from the manes of Shetland ponies and the fringes of Highland cattle in conjunction), and for such flaming ties as one saw . . .

But the decisive clue for the Bohemian-spotter was an ostentatious pair of checked trousers or a checked suit, which cropped up like the measles wherever artists gathered together. These dazzling chequerboards of Op art squares danced down the legs of poets, painters and poseurs from Chelsea to Paris. Paul Nash dashed off an illustration to Carrington, showing himself squared up like a bistro tablecloth: 'I have just got a check suit that will stagger humanity. My word it is a check suit.' They were really very loud – the point being, that nobody could mistake you in a crowd. The *Punch* cartoonist who wanted to depict a Bohemian artist invariably tricked out his legs in check. When he became more confident, Gertler wore them instead of evening clothes, while the painter Michael Wickham teamed his with an orange-sprigged waistcoat. Sickert got himself up to look like a bookie in checks and a bowler. Evelyn Waugh overdrew at the bank to

purchase a pair of checked trousers in 1925, and Dylan Thomas dressed in loud check suits because he thought they made him look like a successful scriptwriter. My father, Quentin Bell, used to wear blue and white checked trousers bought from a cooks' outfitters in Old Compton Street, but the pattern gradually disappeared beneath incrustations of plaster.

*

And what about the female of the species? For women a turning point was the radicalism of trousers. Bobbed hair was an approach to androgyny, but trousers went much further. In H. G. Wells's *Ann Veronica*, the heroine clashes with her father over his refusal to allow her to attend an art students' fancy-dress ball. For Mr Stanley and his timid, craven sister the idea of a respectable girl consorting with liberated 'arty' types is anathema, but Ann Veronica is determined to go to the dance. In a chapter entitled 'The Morning of the Crisis', our suburban Cinderella goes for a walk to ponder her course of action while the aunt goes snooping in her room on behalf of Mr Stanley. There she finds a Zouave velvet jacket and an overskirt:

The third item she took with a trembling hand by its waistbelt. As she raised it, its lower portion fell apart into two baggy crimson masses.

'*Trousers!*' she whispered.

Her eyes travelled about the room as if in appeal to the very chairs.

Tucked under the writing table a pair of yellow and gold Turkish slippers of a highly meretricious quality caught her eye . . .

Then she reverted to the trousers.

'How *can* I tell him?' whispered Miss Stanley.

The resulting fracas drives Ann Veronica into a bid for freedom, and she flees to London, where she becomes a suffragette and has an affair with a married man. Clearly the trousers presaged the depths of sin to which this prodigal daughter was prepared to sink. Would she become like that wicked authoress George Sand who went about dressed as a man? – but then she was French.

Legs were still very much taboo. A few 'new women' like the unconventional children's author Edith Nesbit wore bloomers for cycling, but the pre-war Slade girls shamelessly wore corduroy knee breeches or calico peg-tops, indoors or out. In the early days, not being used to trousers, Dorothy Brett admitted she found them vexatious; they were unpredictable and wouldn't stay up. At first Brett had her breeches made for her by a tailor. Being measured was a solemn ordeal, the man putting his tape measure

up her skirt without a smile. It was a relief to find in Paris '. . . a marvellous shop where *les pantalons d'ouvriers* hang up by the thousand = I bought a pair promptly'. She got some for Carrington too, and when she got back the pair drew cartoon likenesses of themselves looking like a couple of demented yokels with their button breeches and straw-like hair sticking out from under their hats. Twenty years later fashion caught up with trousers, and bathing belles on the Côte d'Azur adopted floppy pyjamas as regulation, but for many years after that women in trousers anywhere but on a beach continued to scandalise.

Depending on how you wear them, trousers can either disguise or enhance your sexuality. A poetess in tight white buckskins could look far sexier than Brett in rustic cord breeks; but for some women, fed up with overt femininity, male attire was a refuge from the sex war. Mannish dress could also help to define your sexual orientation if it didn't happen to be orthodox. In the twenties and thirties Bohemia was overrun with cross-dressing 'Sapphists' in a caricature of male business garb: double-breasted jackets, severe ties, waistcoats, and shingled hair. Oddly, they quite often wore skirts under all this. Viva King was utterly bewildered when she was taken to hear a band in Chelsea and the leader, 'Dicky', stood up from behind the piano at the end and revealed herself to be female. 'We had not seen the like until then.'

As sex definitions began to break down, Bohemia gave the all-clear to cross-dressing. There were women with short hair, men with long; women wearing trousers, men in robes or tunics, and pierced ears for both sexes. Earrings for men were to become as symbolic of the libertine as of the creative spirit. A man wearing earrings was a gypsy, a pirate, a predator. Here again, Augustus John was the living embodiment of the Great Bohemian. You could pick on any aspect of his appearance and it would reinforce his pre-eminence in the field.

In 1917 a band of over thirty Slade girls in various stages of undress draped themselves across the stage of the Chelsea Palace Theatre and performed a history of artistic Chelsea as a benefit for the soldiers in France. It ended with a rousing finale in praise of everyone's Home Front hero – Augustus:

> John! John!
> How he's got on!
> He owes it, he knows it, to me!
> Brass earrings I wear,
> And I don't do my hair,
> And my feet are as bare as can be;

When I walk down the street,
All the people I meet
 They stare at the things I have on!
When Battersea-Parking
You'll hear folks remarking:
 'There goes an Augustus John!'

Lady Colin Campbell wrote in her book of etiquette in 1898, 'It is not considered good taste for a man to wear much jewellery.' But being an Augustus John was not about being tasteful or seemly. Garish, flashy jewellery was part of the whole picture, for women as much as for men. One of the great delights of this was that one could glitter and jingle in a profusion of bangles, ornaments and colourful fake beads without spending a fortune. The urge to decorate oneself could be as easily satisfied with the purchase of a string of Woolworth's pearls as with an emerald parure. Big, ostentatious jewellery soon became part of the uniform: there was Mary Butts with one jade pendant earring shaped like a mill wheel, and Nancy Cunard with her 'signature' ivory African bangles from wrist to elbow. E. M. Delafield's *Provincial Lady* (1930) spots the arty guest at a party the moment she walks through the door, from her 'scarab rings, cameo brooches, tulle scarves, enamel buckles, and barbaric necklaces'. The provincial lady disapproves, for there is something vulgar about such profusion.

But vulgarity was no longer off limits. Make-up was the thin end of the wedge. The Victorians saw rouge and lipstick as restricted to women of easy virtue. Gwen Raverat remembered how as a child she wandered by mistake into the boudoir of an elderly lady and found, to her horror, a jar of face powder on her dressing table: '*Could Mrs. H. really be respectable?*' A few women did use lip-salve, a pinkish cream which they applied with the excuse that it moisturised their lips, but Gwen's own mother never used make-up of any sort, and she knew that only very wicked, fashionable women, or worse still, actresses, ever applied rouge or lipstick. Thus the merest touch of green eye-shadow, not to mention more dramatic effects caused by chalk-white face powder or scarlet 'lip rouge', provoked intense shock.

And then, as if revelling in their turpitude, these women smoked. A favourite pleasure of the gypsies themselves, tobacco smoking had long been regarded by some male Bohemians as an activity of primary significance, almost a poetic initiation. Like the smoking of marijuana in a later epoch, it was celebrated by Théophile Gautier's romantic contemporaries in verse

and fiction. Arthur Ransome placed talking, drinking and smoking together as the three indispensable pleasures of life – to be enjoyed in the company of 'half a dozen honest fellows'. But females were not content to be left out of such pleasures, and soon Ransome's male havens were invaded by advanced women brandishing cheroots. Ethel Mannin recalled how flagrant such behaviour seemed in those early years:

The year would have been 1916 or 1917, not later. The girl, whose name I remember as Monica, gave me a De Reszke Turkish cigarette from a small packet, and there we two young girls viciously sat, with our pot of tea and our toasted scones, *smoking*, and *in public* . . .

By the 1920s everyone was puffing at Turkish, Egyptian or Virginian cigarettes. For women this was, as Mannin said, 'the outward and visible sign of sex equality'. One by one, the bastions were falling. The sex divide would never be the same again.

<p style="text-align:center">*</p>

Undoubtedly, the Bohemian in Britain was now emerging from the margins, and becoming an easily recognisable archetype, fitting neatly into a range of consistent models. We can parade some of these 'classic' Bohemian fashions along a notional catwalk. First, the stage dandy:

Nobody looks the part of a poet so well as Pound . . .

. . . writes an admiring observer of the American writer . . .

In his velvet coat, his open shirt with Danton collar, his golden beard, his long hair well brushed up and back from a high forehead, he suits the romantic conception of the poet . . .

Next, the droopy, home-made type: Helen Anrep, described by Angelica Garnett:

Of all our friends she was closest to what in those days was called bohemian, meaning unconventional and penniless. She wore long, flowered dresses pinned at her bosom with a brooch, a shawl dripping from one shoulder, white stockings and little black shoes – rather as though she had stepped out of a picture by Goya or Manet.

Nina Hamnett, having her photograph taken with a poetess friend, personifies shabby chic:

I put on my ancient and historic trousers, which I had worn before the war at parties, with Modigliani's blue jersey. We thought that if they wanted a *real* picture of 'Bohemia' we would give them something really good.

Next, the Slade Art School meets the Café Royal – Kathleen Hale on one-armed 'Badger' Moody:

An archetypal Bohemian, he wore a waisted jacket secured by one button, immensely wide checked grey trousers, a silk scarf in lieu of a collar and tie, and a large black sombrero at a rakish angle.

And the show comes to its climax with the gypsy goddess herself, Dorelia. Nicolette Devas reported that Augustus John encouraged his women to wear these clothes because he found contemporary fashions unpaintable. Certainly he believed that women 'should . . . attire themselves with grace and dignity without bothering about the fashion too much'.

Dorelia's clothes were quintessentially 'artistic', and hugely influential,

Cecil Beaton captures 'the Dorelia look' in *The Glass of Fashion*.

producing an unmistakable 'look'. All the girls in Chelsea wanted to look like Dodo. Carrington, Reine Ormonde, Sine McKinnon, Christine Kühlenthal, Viva King, Edith Sitwell, the John harem were all copying her full skirts and gypsy colours. In Gilbert Cannan's *Mendel* the artist Logan (alias John Currie) is looking for a new image for his girlfriend Oliver:

'How shall we dress her?' asked Logan.

Mendel took out his sketch-book and drew a rough portrait of Oliver in a gown tight-fitting above the waist and full in the skirt.

'I should look a guy in that,' she said. 'It's nothing like the fashion.'

'You've done with fashion,' said Logan. 'You've done with the world of shops and snobs and bored, idiotic women. You're above all that now. In the first place there won't be any money for fashion, and in the second place there's no room in our kind of life for rubbish. You're a free woman now, and don't you forget it, or I'll knock your head off.'

So influential were Dorelia's clothes in Bohemia that Cannan safely assumes his readers cannot fail to recognise her unique style in Mendel's sketch. Not to be outdone, the males of the species emulated Augustus, and strode around the Slade in capes, black hats and soft collars looking like Courbet. There are many more variants, all of them different, all of them Bohemian. And what partly defines them as Bohemian is that they have all 'done with fashion'. Not one of these looks features in the procession of shifting hemlines and changing silhouettes that is the accepted history of twentieth-century costume.

<center>*</center>

Where does fashion fit into the Bohemian world view? Standards of fashion, like standards of female beauty, are notoriously relative, capricious and hard to nail down. It takes a confident, iconoclastic vision to see behind the current modes, to brave charges of heresy against the fashion elect who ordain women's perpetual discontentment with their self-image.

There was an attitude among nineteenth-century intellectuals that subservience to fashion was the worshipping of false gods, therefore to take pleasure in dress was sinful. One's *duty*, however, was to dress well and appropriately, without display, and according to one's class. The Rational Dressers moved beyond this: their emphasis on comfort, hygiene and woollen underwear made fashion at best an irrelevance, at worst a tyrant. Bohemians inherited elements of both these attitudes, but introduced a number of other unquantifiable ingredients. There is no single summing-up of such

an eclectic attitude to dress, and yet one could recognise the type at twenty paces.

As with their relationship to interior design, artists were highly aware that they were running risks by creating an image. Where your orange decor might be safely regarded as being outside public consumption, your apparel proclaimed you the minute you set foot in the street. How you looked, what you wore, was not a peripheral issue, and Bohemians knew it. But it could be hard to know which way to turn. If you marched to the beat of a different drummer, should you break step as soon as the trendy horde caught up with your unique self-created look? If you cut your hair short in protest at fancy female coiffures, did you grow it again when the flappers and shopgirls all cut theirs? If you were truly artistic did you, when hemlines soared, retreat into long full dresses? Artists of integrity felt that they stood outside the fashion rat race, but they still had to decide what to put on each morning, and it was not always either helpful or desirable to stand out from the crowd.

There is a story of how one night at the Café Royal, Augustus John, C. R. W. Nevinson, Mark Gertler, Horace Cole and John Currie were drinking together when Cole chanced to overhear some bookies making derogatory comments about their appearance. In no time at all a tumultuous brawl broke out which left the Café knee-deep in soda water and broken glass. After the mess had been cleared up, the management decreed that, in future, artists were to be barred from the Café. The next day when Nevinson strolled by for his customary drink he was refused entry. Indignant, he went elsewhere, for he had not been personally involved in the fight. Two days later he came up to town and in due course presented himself at the Café Royal. To his astonishment the commissionaire let him in without a murmur – surely the ban hadn't been lifted? 'Oh, no, sir. But it only applies to artists.' It took Nevinson some time to deduce that, having set out to town that morning, he was dressed in a suit and bowler hat. And for the porter, that meant he was not an artist.

The caricature image of the artist, so prevalent in the pages of *Punch*, made some of them perversely eager to shake it off. Nevinson was one such. In his Slade days he and a group of his fellow students had terrorised Soho in black jerseys, scarlet mufflers and black caps, outraging passers-by who took them for 'dirty foreigners'. But being disapproved of eventually got wearisome. Nevinson became disillusioned with 'long hair under the som-brero, and other passéist filth', and took to dressing like a stockbroker. Unfortunately this approach turned out to be a minefield. No sooner had Nevinson reverted to a conventional appearance than other artists, a step

ahead of him, took refuge in the caricature artist image, so as not to look too obviously like revisionist painters. Ethel Mannin once asked an artist acquaintance why he grew a beard:

He replied that it was partly laziness and partly so that he shouldn't look like an artist. 'You can always tell an artist,' he said, 'because he looks like a stockbroker,' or, he glanced at Epstein, 'a plumber.'

It was perhaps safest, and less studied too, to stick with an unambiguous uniform.

The Bohemian wayside tavern was a welcoming haven for the unconventional dresser; in fact it was a place where not to be eccentric was eccentric, as Mary Colum, a Dublin writer visiting London, found out. She entered a Bloomsbury pub and happily got chatting to the Bohemian clientèle within, only to find herself being asked 'Do you hunt?' She had arrived dressed in Irish country clothes – tweeds, a soft felt hat and leather gloves – and had been taken for a lady deer-stalker instead of the free spirit and associate of the great poet Yeats that she saw herself to be:

I really looked a shocking outsider. Almost anything else in the world – sky-blue taffeta trimmed with spangles, or even the skirts of a ballet dancer, would have been more in keeping with my surroundings than the garments I was attired in.

It was all very complex, for despite this the true Bohemian was temperamentally unfitted to conformity. He had to be vigilant if he didn't want to end up looking like a music hall parody of an artist, or be mistaken for a poseur. In Paris it was only the gullible Americans who dressed up in velveteen and *bérets Basques* and got their photographs taken *en bohème*. And as Chelsea became inexorably gentrified in the 1920s, the old, cheap studios were invaded by bogus 'John'n'Dorelia' lookalikes. Even the popular press denounced them:

– the moneyed dilettanti who love to ape the ways of the Bohemian, to dress in bizarre colours, with barbaric jewellery, big earrings, crimson bedknobs, clashing necklaces of strange stones, jazz frocks and cushions borrowed from the Russian ballet, and pseudo culture stolen from anywhere.

The Star, 1924

Then again, there were complex gradations between the disciplines. A novelist didn't want to be mistaken for a poet – at least Ford Madox Ford didn't. In his view, poets, with their 'flowing locks, sombreros, flaming ties, eccentric pants' were treated prejudicially, and novelists didn't want to be in the firing line. The poet Roy Campbell eventually lost all patience with the accusations and counter-accusations:

Mr. Peter Quennell recently took me to task for being a professional poet. 'Most poets look like business-men,' he says . . .

He objects to a poet's behaving like a poet: and he objects to myself as a 'professional poet'. He would have me go jousting and bullfighting and galloping about in a top-hat, spats and a dickey, looking like a black-beetle, and carrying one of those black umbrellas. Why should one write in the garb of 'business'? He might as well ask one to copulate and make love 'like business men' . . . A poet should be an imaginative, creative being . . .

Artistic temperament being what it is, it would seem to have been a minority of Bohemians who preferred to look like 'trouser lads' or city men with their black umbrellas and bowler hats, despite Peter Quennell's citing of T. S. Eliot and Paul Valéry to support his case.

*

One workmanlike, cheap and egalitarian solution to the problem of looking like an artist in fancy dress, was to dress in the clothes of the proletariat. These had the advantages of being cheap, durable and ideally suited to any messy medium such as oil paint or clay. And there was something appealingly humble about looking like a plumber or a bricklayer, when really you were a genius. Round the artists' colony of St Ives, the painters were often indistinguishable from the fisher-folk. Locals 'in the know' could point out to visitors some rugged type in blue overalls and whisper that he was really the 'brilliant Mr X' whose pictures hung in the Academy, or identify a face in a street of shawled women as being that of one of the foremost watercolourists of the day.

The writer Gerald Brenan's father was a military man of the old guard whose fetishistic correctness made him intolerant of his son's 'sartorial eccentricities'. Fed up with the rows caused by his long hair and collarless shirts, and searching for a new ideology, Gerald determined to run away from home. He made careful plans, and decided that the best way to escape detection was by disguising himself as a gas fitter; unfortunately his expensive education and upper-class upbringing had left him ignorant of a gas fitter's

actual appearance. Rummaging in second-hand clothes stores he managed to get a wing collar, a purple bow tie, and a high black hat for a shilling. He also packed a false moustache and some hair dye, *The Oxford Book of English Verse*, and the latest issue of *Gas World*. It was not until he got to Paris and met up with his co-fugitive John Hope-Johnstone that Brenan realised how ill-considered his choice of disguise had been – for by now, with indelible black hair dye staining his neck, he was getting odd looks wherever he went, and was further embarrassed by the warm attentions of a tart, whom he fobbed off with the purple bow tie. As soon as possible he dispensed with the gas fitter outfit, and he and Hope-Johnstone went out and purchased glorious new disguises. They reappeared wearing the uniform of the Parisian navvy, as appropriated by Bohemia: blue cotton jackets and trousers to match, with colourful sashes round the waist, and on their heads floppy Breton berets. 'No one looked at us. I was enchanted to think that I was at last dressed in a way that was both inconspicuous and beautiful.'

In truth, proletarian camouflage answered to many artistic ideals, but only in France could navvies and poets alike carry it off with such romantic swagger. People like Brenan had every reason to feel that wherever the true Bohemia might be, it was not in England, for English society would seem to have been particularly intolerant about unconventional dress. Down on the Côte d'Azur nobody bothered if one sat in the Café de la Rade at Cassis in shirtsleeves and sandals, or even in a dirty singlet and a pair of patched cotton trousers. Such spectacles were not uncommon, and it was yet another reason why British artists felt more appreciated on the Continent than they did at home.

But by 1940 the pioneer sexual psychologist Havelock Ellis was able to look back on his life and feel that even in England many of the battles his generation had fought for were being won:

A new graciousness has become interfused with life, a faint perception that living is an art. I cannot see now a girl walking along the street with her free air, her unswathed limbs, her gay and scanty raiment, without being conscious of a thrill of joy in the presence of a symbol of life that in my youth was unknown. I can today feel in London, as in earlier days I scarcely could even in Paris, that I am among people who are growing to be gracious and human.

*

In 1976 my father, Quentin Bell, published a new edition of his theoretical treatise on fashion *On Human Finery*. In it, he argued that one day fashion

may well vanish altogether. Perhaps he was aware that this was wishful thinking, for in the foreword he admitted that 'we should all be happier if we could wear that which suits us best'. He himself did pretty much that. His checked trousers, carelessly fastened, his shabby clay-covered jerseys, their sleeves unravelling and burnt in places by dropping ash from his pipe (to my mother's perpetual despair he regularly failed to notice whether he was wearing some old rag or his best lambswool in the pottery), his cheerful ties donned with a blithe disregard for their state of cleanliness or harmony with whatever frayed shirt he had put on that morning, his comfortable old slip-on sandals, his unkempt beard – all betray the Bohemian artist that, in his sympathies, he felt himself to be. Quentin had grown up with the smell of turpentine in his nostrils. Wherever the family lived the house was always full of painters. Sickert drew him, Picasso was on close terms with his father, many luminaries of the British art scene were his friends and associates. Bohemia was his world. Though Quentin was no maverick, and stoutly claimed that he just wanted to be comfortable, his appearance linked him to a way of life which was at its most powerful among his parents' generation, the Bohemians of the early twentieth century. I do not think he would object to my associating him with such a group. The creation of an alternative set of sartorial aesthetics by those Bohemians was empowering. It was a break from the past and a celebration. Our outlook at the beginning of the twenty-first century can seem confined and limited by comparison.

6. Feast and Famine

Must one eat English food? – Are table manners important? – Must
one eat meat? – What are the alternatives if one can't cook? –
Are creativity and cookery compatible? – Where do Bohemians
dine out? – Is it possible to eat on an artist's income? –
Why must women prepare meals?

The scene, the great dining-hall of Newnham College, Cambridge. The date, 20 October 1928. Virginia Woolf, invited to lecture on 'Women and Fiction', was dining there with the students and staff, an occasion immortalised in her famous polemic *A Room of One's Own* (1929):

Here was the soup. It was a plain gravy soup. There was nothing to stir the fancy in that. One could have seen through the transparent liquid any pattern that there might have been on the plate itself. But there was no pattern. The plate was plain. Next came beef with its attendant greens and potatoes – a homely trinity, suggesting the rumps of cattle in a muddy market, and sprouts curled and yellowed at the edge, and bargaining and cheapening, and women with string bags on Monday morning. There was no reason to complain of human nature's daily food, seeing that the supply was sufficient and coal-miners doubtless were sitting down to less. Prunes and custard followed. And if anyone complains that prunes, even when mitigated by custard, are an uncharitable vegetable (fruit they are not), stringy as a miser's heart and exuding a fluid such as might run in miser's veins who have denied themselves wine and warmth for eighty years and yet not given to the poor, he should reflect that there are people whose charity embraces even the prune. Biscuits and cheese came next, and here the water-jug was liberally passed round, for it is in the nature of biscuits to be dry, and these were biscuits to the core. That was all. The meal was over.

And we may as well all abandon hope . . . But Virginia Woolf's typically extravagant evocation has a propagandist function. This meal – this mean, functional, anti-life dinner which makes the spirits droop and the taste buds wither – demonstrates why the deprived, underfunded women's colleges can never be as great as the men's, and why oppressed women must fight against the odds to bring forth their creativity. A grudging meal like this can

never inspire flights of poetry or a song in the heart, only the flattest, drabbest prose. The feminist, the artist and the aesthete in Virginia Woolf rebelled.

The British were then, and still are, deeply equivocal in their attitude to food. On the one hand we are patriotic about our traditions of beef, beer and apple pie; on the other we nurture puritanical feelings that it is self-indulgent to enjoy food. If we are not feeling that eating well is a sinful luxury, we are feeling guilty because it makes us fat. It seems we are incapable of conducting a straightforward relationship with what we eat.

In *Today We Will Only Gossip* (1964), Beatrice Campbell's preposterously titled memoir of the Bohemian milieux of her youth, she recalls the uninspiring food of her childhood. Her mother dismissed the children's complaints about the eternal mutton chops on which she fed them with an airy wave: 'You have the trees, the birds and the flowers. Food is not important.' When as an adult Beatrice went on holiday to Italy with her Swedish friends Harry and Signe Eriksson, Harry's absorption in food astonished her. She had never before encountered someone who gave themselves over so utterly to the eating experience. Harry explained: 'A person like you, with luck, may have a few odd moments of ecstasy in your entire life. As for me, if I can get the right food, I can have a moment of ecstasy every twenty-four hours.'

He was right. Moments of ecstasy were not inspired by meat and two veg, the joyless English food that so many of our parents and grandparents grew up with.

One cannot think well, love well, sleep well, if one has not dined well. The lamp in the spine does not light on beef and prunes . . .

The sad fact was that English food was usually uninspiring; dull but plentiful. The copious and unending regularity of middle-class meals stunned Sybille Bedford when, after a childhood spent between Sicily, the Tyrol and Tunisia, she was thrown into a vast Midlands household full of remote relatives and a panoply of female servants. Middle England lived like this:

Main meals [were] a steady rotation; after wishy-washy soup and a bit of fish, beef and mutton, hot joint, cold joint, mince, cutlets, hot joint, cold joint – pickles, bottled sauces, dispirited salads, custards, vegetables . . . puddings . . . Drink was water, soda water or barley water. Tea was offered again at bedtime.

For such households Mrs Beeton's magisterial *Book of Household Management* (first published 1859–60) was holy writ. Its author sternly warns her readers that 'most cooks like to work only with fresh materials, a practice which

must be carefully guarded against', and she follows this with a disheartening litany of ways to use leftovers, mostly comprised of hashes, moulds, curries and 'rissolettes'.

There was likewise a fearful rigidity about the eating habits of the upper classes. Vita Sackville-West's re-creation of her childhood home Knole, *The Edwardians*, dwells on 'those meals! Those endless, extravagant meals' at which the aristocracy partook of ortolan, quail and truffle. Guests at Edwardian house parties were served up a suffocating superabundance of food. All day long one was crammed.* Navigating one's way through the excess was not easy. The young architect Clough Williams-Ellis took to reading the menu card at the beginning of each meal and deciding in advance what courses to skip. At the end of a weekend, oppressed by superfluity, he was thankful enough to return to his habitual diet of kippers.

English food could seem particularly offensive to those with European tastes. Harold Acton was sent to prep school in England after a Tuscan childhood. Reading Acton's memories of the meals he endured there is a stomach-turning experience. The 'hairy brawn and knobbly porridge' fed to him at this institution was so nauseating that the young Harold slid as much as possible off his plate and into his handkerchief, to be later flushed away down the lavatory. Aesthetes do not just respond to the visual sense. He could never forget the taste of the 'blotched oily margarine' that accompanied every meal. When he went on to Eton the meals were at best 'indifferent'. The insipid pap that passed in England for pasta insulted his memories of the genuine article. He shuddered with horror at seeing boiled macaroni dished up on toast with tomato ketchup, or cooked to a pulp with milk and sugar like a tapioca pudding.

The English squirearchy traditionally distrusted the lurid sexiness of foreign food, whose fancy sauces and seasonings seemed artfully to mock the ungarnished honesty of good plain British beef. But the socially ambitious middle classes were eager to display *bon ton* through their consumption of 'French' dishes. An aspirant quality emerges from Mrs Beeton's recipes: mince patties are 'croustades', poached eggs are 'oeufs pochés', beetroot salad is 'Salade de Betterave', and so on. Yet the real France had not

* Why weren't they huge? Probably many of them were; Vita Sackville-West hazarded that wealthy Edwardians' yearly trips to Marienbad and Baden-Baden took care of the surplus in the same way that the vomitorium dealt with overeating in Rome in the first century BC. Houses were colder too, and keeping warm burnt more calories. For the rest, poverty and the necessity of walking everywhere probably kept people thin. It was not until the late 1920s – at a time when meals were gradually becoming lighter – that people started to become obsessed with slimming and the newly discovered vitamin supplements.

penetrated. Suspicion lingered around ingredients perceived as 'common' or 'unsuitable' – steak, tomatoes, even lemons. Mrs Beeton is clear that garlic is a bulb whose 'flavour, unless used very sparingly, is disagreeable to the palate'. Coffee was considered to be 'not quite nice' – wine was 'tabu'. It would seem that the Frenchification of English food was barely skin deep, the nation at large clinging xenophobically to its roasts, hashes and 'Pouding au Riz'.

<center>*</center>

It is shaming to reflect what a dismal story our food betrays to the world outside. For whether we like it or not, our eating habits – from banqueting hall to fast-food outlet – reflect the emphasis we place on relationships, hierarchies, and conventions. The table is an ingrained symbol of society in miniature. What we place on it tells the world how we see ourselves, and Victorian and Edwardian England was a place where respectability ruled.

No dinner-table will *ever* look well unless neatness and refinement are displayed in the minor details . . .

declared Lady Colin Campbell in *Etiquette of Good Society* (1898).

Very much depends on there being a fine white linen damask cloth, without crease or crumple, placed very exactly on the table. You cannot be too formal or too prim in laying out a table.

Never mind the quality of the food you place on it. To entertain a party of twelve, Lady Colin Campbell lists forty-six essential categories of cutlery, glass and napery, from sauce ladles to grape scissors, from decanters to doilies. The expectations of guests placed in such a formal setting were that they would comport themselves with the utmost correctness. Woe betide the diner who ate or drank noisily, took large mouthfuls or fiddled nervously with their cufflinks. These were 'unforgivable awkwardnesses'.

<center>*</center>

Such restraining expectations and observances were enough to make any self-respecting Bohemian revolt. One was bound to protest against such idiocies. Those prim tables with their cloths, napkins, plate and china, silver, candelabra, boiled potatoes and soggy greens were just waiting to be

overturned. Fancy food and faddy manners were for the finicky, not for the free spirit.

Emphatically independent, Bohemia now turned and bit the hand that fed it, spurning the worthies and matrons of Middle England and all they stood for – their fish forks and coasters, their vile prunes and custard, their miserable jugs of water. Spitting out the unappetising meal placed before them, Bohemians and their fellow-travellers set out in pursuit of a diet that answered not only to their tastes but also to their ideals – art, truth and anti-materialism:

We were full of experiments and reforms [remembered Virginia Woolf]. We were going to do without table napkins . . . we were going to paint; to write; to have coffee after dinner instead of tea at nine o'clock. Everything was going to be new, everything was going to be different. Everything was on trial.

Now, as the art world started to look to Matisse, Cézanne and Derain for its role models, so at mealtimes the cooks of Bohemia were starting to re-create the *daubes*, the *pasta al sugo*, and the *potages bonne femme* remembered from their continental travels. 'I am having a glorious time, living a somewhat bohemian life and eating bohemian spaghetti,' Iris Tree wrote home from Florence. The discovery of continental tastes was indeed a joyful one for many who had been brought up to regard food merely as fuel. Fifty years before Elizabeth David transformed the British palate with revelations about Mediterranean cookery, women like Vanessa Bell, Stella Bowen, Helen Anrep, Carrington and Dorelia brought the flavours of France and Italy on to the tables of Bohemia. French food was the chief model to which all aspired. For Vanessa Bell the delicious bread, the wonderful wines, the mustardy mayonnaises were as much evidence of French excellence as the nation's art and literature.

Simple dishes – a thick steak or a perfect purée – sent her into raptures. 'Fancy French food' – paupiettes, timbales and mousses, however chic – gave off all the wrong messages for people like Vanessa Bell. The bourgeois cooking of the French provinces, with its excellent ingredients, its hearty simplicity, its economy and robust use of flavourings – garlic, a bunch of herbs, a rind of pork, the last inch of a bottle of *vin de table* – appealed strongly to the Bohemian consciousness of themselves as liberated, sensual, experimental individuals. For these artists the countries where olive trees grew were a paradise of the senses. After struggling to keep dry and warm through a Sussex winter Stella Bowen and Ford Madox Ford moved out to

sunny Villefranche on the French Riviera. Let loose in Toulon market, Stella almost hyperventilates with excitement:

What flowers! What oranges, lemons, and tangerines! And what vegetables! Fennel, and pimentos, and courgettes and herbs and *salade de mâche* and aubergines. And in the fish market, sea-urchins and octopus and langoustines and mussels, as well as all the serious fishes, and everything you could want for a bouillabaisse, even to the *rascasse*. A shop nearby sells nothing but olive oils, which you will taste from a row of taps, on a piece of bread, whilst next door is a noble selection of sausages and cheeses and a choice of olives. Daily life has richness and savour here . . .

Even more lyrical, the poet Roy Campbell evokes an outdoor meal over-looking the 'limitless sweep of the Crau, the Camargue and the sea, under a crimson and violet sky with the stars coming out and the crickets relieving the cicadas'. Campbell and his comrades roast a haunch of herb-fed lamb over a fire of vine prunings. As they wait for it to cook they eat fennel-flavoured green olives with bread and '*poutargue*' – cured mullet's roe – washed down with bottles of Châteauneuf du Pape. The cattle graze, the light fades, the embers smoulder. We are in the land of eagles, lovers and troubadours. For Campbell, such meals were sacred. His recipe for bouillabaisse (somewhat edited) is an initiation ceremony into the mystery of one of the great Provençal dishes:

The pot is first of all lined with onions and tomatoes, a few sprigs of fennel and bay leaves, which grow every ten yards of the way up through the pines: some bits of garlic: a little olive oil. This is all fried together. In go six or seven big rascasses, three big crayfishes and crabs, with a few grey mullet; a big silver bream; and water, up to the brim. You put the pot on the fire now and start grinding your pepper, and the dried anthers of the crocus-flowers, which is the chief flavouring and colouring of the bouillabaisse. The colour is a brilliant saffron-yellow tinged with tomato. You salt it, throw in the pepper and saffron, and remove it the second it boils. The bouillabaisse consists of four simultaneous parts: 1. La Soupe (soup). 2. La Rouille (the 'rust'). 3. Le Pain (bread). 4. La Friture (the fried stuff). The rouille is the Soul of the bouillabaisse.

The rouille is made in a big stone mortar: four or five quarters of garlic and one whole redhot chillie are pounded up in it, and then it is filled with soup from the main pot . . . No decent fisherman will eat bouillabaisse without the *rouille*, which is the spur and rowel both of one's thirst and one's appetite . . .

The *friture* is supplied by the net-and-trawl fishers; it consists of bass, silver-bream, golden-bream, sole, and slices of red tunny, fried crisp in olive oil . . .

But, first, we open the big illegal bonbonne of strong home-distilled pastis and drink a few apéritifs . . . We sit back on the crisp springy cushions of wild sage, rosemary and thyme with which the ferigoulet is thickly mattressed . . . With the pines waving overhead . . . one passes the afternoon of the bouillabaisse in perfect bliss, sipping coffee and vieux marc. Then after a siesta, the group returns to the town arm in arm, women and men, to join in the farandoles and the dances.

Back in London, such travellers tried to recapture the aromas of France. Helen Anrep, who had spent much of her youth there and had experienced the heady scents and flavours of Provence, encouraged her cook to make *ragoûts*, veal and *coq au vin*. The writer Mary Butts was full of contempt for the British joint blanketed in opaque gravy. Her aromatic leg of lamb, its crisp skin basted with herbs and olive oil, was cooked the way she had learnt in France. Theodora Rosling, having discovered Paris young, continued a lifelong culinary celebration of the French capital, becoming the well-known cookery writer Theodora Fitzgibbon (after she married Dylan Thomas's friend Constantine). Her *A Taste of Paris* (1974) is as much a paean to the culture and art of that city as to its food. For Theodora there was something irresistible about 'the strong sweet-sour smell of Paris; the aroma of garlic and olive oil; the taste of Pernod; the gritty feeling of French cigarettes between one's lips; the vitality and realism of the people'.

Memories of Italy and France helped Harold Acton to survive the rigours of school food. He and his friend Brian Howard would indulge in escapist fantasies of foreign delicacies, in which Acton would attempt to conjure up for them both 'the succulence of *ravioli al sugo* or indeed of any of the varieties of macaroni'. Or bread rolls spread with white truffle paste, or Neapolitan pizza . . . But his finest flights took wing when he transported his friends into *marrons glacés* heaven:

[They were] of classical proportions, neither too large nor too small; they were neither too brittle nor too compact in texture; they just opened their luscious chapped lips and let their somnolent juices ooze within you, and the frosting of sugar melted gently down your throat, warming the red corpuscles so that they played gay tarantellas while you masticated, and even for some time after . . .

The glorious sensuality of these vigorous and delicious flavours knocked insipid English food into the background. In the better-off establishments of Bohemia, like that of Dorelia and Augustus John, eating well could be a joy. Away with the curried leftover fowl, mutton mould, and stale bread pudding . . . Alderney Manor was like the land of Canaan. There was

copious honey from the bees which Dorelia kept, and the dairy provided butter and cream – a cream so rich it tasted of caramel. She loved to cook pheasant in wine or trout with cream and saffron – 'impossible to go wrong with such expensive ingredients' marvelled Kathleen Hale. The family and their guests feasted on sorrel soup, huge casseroles flavoured with garlic, cooked in olive oil, washed down with rough red wine. The 'disagreeably flavoured bulb' was lavished on salads, which were prepared and served with fantastic rituals, the leaves being finally tossed with her bare hands by the senior virgin present. When very small, the awestruck Romilly John would lurk at these dinners, hoping to go unnoticed behind his parents' chairs:

Those were the days of our most unstinted liberality, before the war. The table seemed to groan under the weight of dishes, and to be lighted by a hundred glittering candlesticks of brass. Dorelia and John appeared, for the first time in the day, in their true characters and proportions; they were like Jove and Juno presiding over the Olympian feast . . . Once, when I was . . . ejected from my lurking-place behind Dorelia's chair, I bitterly remarked, 'You grown-ups have all the good things of the world to eat for supper, whereas I have nothing but a little dried froth.'

Like her friend Dorelia, Carrington was infected by a love for continental flavours. Though she employed a cook at Tidmarsh and Ham Spray, she too enjoyed preparing food, and from the mouth-watering descriptions she gives in her letters, one can tell what a good and greedy cook she herself must have been. There was *crème brûlée*, 'zambalione' [*sic*], rabbit casserole, lobster, velouté sauce and stewed wild mushrooms. There was salmon with tartar sauce, and strawberries macerated in kirsch. English food was not banished, but it was embellished; there was marmalade tart, home-made toffee, and a lovely steak and kidney pie flavoured with 'rare spices' which tragically had to be fed to the hens when it decomposed in hot weather, for there was no refrigerator at Ham Spray.

Carrington often illustrated her correspon-
dence with playful drawings showing daily
life at Ham Spray.

Carrington loved wine. By the 1920s she was writing to Dorelia tempting her to visit with the prospect of 'Chambertin for every meal'. When I talked to the historian Noël Annan not long before his death, he pointed out that the literary and artistic generation reaching maturity before and after the First World War were, in his view, the first British people to drink wine at meals as a matter of course. Not the minute glasses of sherry, champagne or vintage claret served at Victorian dinner parties, or the fine old port consumed by gentlemen after dinner – Bohemia quaffed *vin de table*. Dick Mitchison stocked the family cellar with inexpensive red bought direct from Ardennes vineyards, and the Bells returned from Cassis each year with barrels of their landlord's Château de Fontcreuse. Carrington ordered wine by the demijohn from France, and bottled it herself. Parties at Ham Spray were carefree and convivial. In September 1925 Carrington wrote to Lytton about the dinner she had served to Helen Anrep and her friends the Japps:

[It was] indescribably grand. Epoch making; grapefruit, then a chicken covered with fennel and tomato sauce, a risotto with almonds, onions and pimentos, followed by sack cream, supported by Café Royal red wine, *perfectly* warmed . . . I shall repeat this grand dinner for our next weekend. We all became very boozed.

Grapefruit and pimentos are now so easily available – despised, even – that it is hard to imagine how exotic they seemed in the 1920s. At that time one had to seek out expensive imported citrus fruit at Harrods or the Army & Navy Stores. Other fruit like melons or pineapples might cost as much as half a crown.*

<center>*</center>

The sensuality of booze and almond risotto were all very well for those who could afford it, nor did Carrington grudge time spent preparing delicious food. But many artists, preferring to reserve their energies for the page or the easel, opted for a simple, anti-materialist life – preferably self-sufficient – in harmony with nature. This too was radical and, for its time, innovatory. In the spirit of William Morris and Edward Carpenter you might keep hens or bees, or cultivate a vegetable garden. You might take up making home-made bread as Vanessa Bell eagerly did at Charleston during the war. Such activities were both virtuous and productive, in a way that satisfied the creative soul.

* This sheds light on Evelyn Waugh's indignant diary entry (August 1930) in which he notes, while staying at the Sitwells' family seat Renishaw, that Osbert's breakfast consisted of large slices of pineapple and melon. 'No one else was allowed these.'

The Neo-pagans were in love with simplicity. These young friends revelled in the open-air life. For such romantics, camping and picnics encapsulated the joy and freedom of the great outdoors. They would swim and go for lengthy hikes; then, with appetites kindled by the fresh air, they would cook meals over an open fire and sing songs while watching the stars appear in the night sky. In August 1913 a group which included three of the Olivier girls, Duncan Grant, Adrian Stephen, Vanessa Bell, Roger Fry and a number of others set up camp at Brandon in Norfolk. It poured with rain. Roger, the chief cook, made toasted cheese and they all kept cheerful in the soggy tent by singing rounds. But the following day the weather improved and everyone dried out. Vanessa wrote to Clive about the simple pleasures he was missing: 'I am sitting over the fire keeping watch on a wonderful stew R. has made with a chicken, bacon, potatoes, a touch of apple, mint, etc.! We also had an omelot [*sic*] made by him for lunch.'

The romance of the campfire was not easily quenched. Who wanted conventional seven-course dinners when one might live like our ancestors as nature intended, in harmony with the seasons, gathering food from the hedgerows and woods? When Rosalind Thornycroft fell in love with the magnetic Godwin Baynes, he swept her off her feet into a marvellous world of total freedom where, by the power of love, they left civilization behind them. In 1907 the pair went on holiday with a friend on the Yorkshire moors, taking a lightweight tent and a Primus stove. Godwin carried a fishing rod and a catapult. With this equipment they lived almost without any form of food other than what they were able to pick, trap, or shoot. They bought some potatoes and a bag of oatmeal, but there were mushrooms in abundance that year, and Godwin managed to hit a tough old rabbit using his catapult. Rendering it tender enough to eat used up almost their entire supply of paraffin. But for Rosalind this simple life was like paradise.

Such a fundamentalist approach to living called into question many assumptions about the way we eat. These questions had lain tacit since Shelley's day:

> Never again may blood of bird or beast
> Stain with its venomous stream a human feast!

The rise of vegetarianism coincided with increased prosperity. As society became richer and more able to afford meat, people began to ask whether it was necessary to kill in order to survive.

The Vegetarian Society was founded in 1850. By the end of the nineteenth century pioneer reformers like Henry Salt (author of *Animals' Rights*, 1892)

had gained much ground in their advocacy of a non-flesh diet. Questioning accepted ways of eating set one apart from the masses, and gave one the ethical, humanitarian edge over the gluttonous rich. The base carnality of meat-eating revolted many a tender-hearted utopian if only on aesthetic grounds. Their revolution championed home-made wholemeal bread with a chunk of cheddar, nuts, vegetables, fruit, honey from the bee, frothy milk, and boiled eggs. Vegetarians were as exalted, as rejecting of convention, and as artistic in their way as those possessed of more earthy appetites.

Idealism is infectious. The influence of noted vegetarians like G. B. Shaw and Tolstoy spread speedily through the 'advanced' sector of society, who began to see vegetarianism as the truer, healthier, more compassionate way to live. In 1906 the young art student Clifford Bax brought a copy of Tolstoy's essays on holiday to the Alps. Reading it one evening before meeting his cousins for dinner in a Swiss hotel, he tumbled upon the author's description of a slaughterhouse. When the meal started to arrive the appalled Bax rejected course after course. 'My elder cousin asked me if I were ill. "To eat dead bodies", I told him, "is barbarous and disgusting."' The cousins reacted with embarrassment, incomprehension and solicitude. He was misguided; he must be mad . . . Or was he suicidal? Despite threats and entreaties Clifford Bax remained obstinately loyal to salad.

Bax was one of many. Augustus John tried vegetarianism in the lean days when he was a hard-up Slade student. He and his sister Gwen lived 'like monkeys, on a diet of fruit and nuts', though John-like, he refused to be rigid about this and happily ate steak in a restaurant when asked out. Frances Partridge remembered vegetarianism as being so smart among her fellow students at Cambridge that Newnham College offered a vegetarian option in hall: 'It was probably one tomato . . .'

Frances, like many of her contemporaries, appreciated the high-minded ambience, not to say inexpensive menus, to be found in the vegetarian restaurants that were springing up all over London in the early twentieth century. She used to go to Shearn's in the Tottenham Court Road where 'even the bread seemed to be made of vegetables', but many people preferred the Chandos Street establishment run by Eustace Miles, a well-known dietary reformer. To be seen here was to be associated with the fashionable avant-garde, for this was where Bohemian London met, ate and flirted. Miles had introduced the daring innovation (in the era of chaperones) of providing small flags on each table, which one hoisted to indicate a willing-ness to consort with one's fellow diners. Rupert Brooke was a regular, and so was the poet Edward Thomas when he was in town. He took Bunny Garnett to lunch there and they ordered nut cutlets and spinach sprinkled

with plasmon powder – a milk derivative advertised as increasing energy, brain power and strength. These early vegetarians adopted the nut cutlet in the belief that it would compensate for any lost nutrients. This slightly absurd substitute for meat was made by shaping nut mixtures into the form of a cutlet, and even poking a stick of macaroni into one end to resemble the bone. Bunny, one of nature's gourmets, was sceptical, and teased Thomas that his vegetarianism was in fact the cause of his dyspepsia. But converts continued, as they do today, to insist that vegetarianism was the natural, healthy and moral diet for mankind.

This argument was further propagated in the 1920s by the influential New Agers of the day, the Theosophists and Transcendentalists, who included vegetarianism in their manifestos of healing and enlightenment. In 1927 Robert Medley and his partner, the dancer Rupert Doone, gave up meat under the influence of a friend who had espoused Eastern transcendentalism. She persuaded them that vegetarianism would be both spiritually elevating and cure Rupert's rheumatism. They gave up smoking too. Unfortunately every meal now became an onerous, self-denying task of preparation. Vegetables were so complicated compared to frying a chop. Robert found the results deeply unsatisfying, and grumbled too that the quantities needed were expensive. They stuck it out for two months before giving in to temptation – beef, roast lamb, and a nice cigarette: 'With great relief I lit up again. I was pleased that the fad was over . . .'

Though he continued to worry about Rupert's health, Robert Medley really felt much more at home among like-minded carnivores than Tolstoyan salad eaters. He was no fundamentalist by nature, and he resented the scrubbing and chopping which took up so much valuable painting time.

*

Time. One returns inevitably to this most fundamental of problems for the artist who has, unlike the man about town or the lady of leisure, an important activity which demands hours of that valuable commodity, and who grudges every minute spent in the kitchen rather than the studio. Time spent at the stove was time spent not painting, writing or composing. But still somebody has to chop vegetables and stir sauces.

It should be pointed out that women like Carrington and Dorelia who were prepared to roll up their sleeves in the kitchen were, for their class, unusual. There is an important divide between those who could and those who could not afford a cook in the first half of the twentieth century. Before 1914 a family with an income of £300 a year could afford to employ a cook whose wages were up to £18 a year. They could also afford a kitchen-maid

at £8 a year. After the war in the 1920s the Mitchisons lived comfortably in Hammersmith on £700 a year paying their cook £1 a week. Today anyone who wanted to employ a live-in cook would expect to have to pay them around £12,000 a year. It is not a highly paid job; nevertheless one would have to be earning a substantial income even to consider paying such a salary for a cook. In the first half of the last century, the employment market was still heavily biased in favour of the middle-class employer, who, while living on what we would consider a very moderate income, was able to take for granted that the labour and drudgery of the kitchen was the lot of the servant class. The thought of providing meals for guests without any help left Vanessa Bell quite aghast, and she strongly resented the rare times between cooks when she had to make the family's meals herself. Quite simply, most middle-class housewives knew that they would hardly ever have to cook a meal or wash it up in their lives, so long as their incomes didn't fall too drastically low.

Heavenly freedom, one might think. Having a cook undoubtedly saved precious time, but the emotional energy that the relationship consumed could be seen as neutralising the advantages. Skirmishes with the servants were a constant feature of life before the Second World War. Nor was it easy to find good ones. Already in the 1920s the never-ending cascade of advertisements offering 'good plain cooks' had reduced to a moderate flow, and such as could be had might well be more plain than good. With sufficient confidence and good cookery books, these unadventurous servants could be chivvied and cajoled into producing food to the taste of their employers. Carrington trained Olive to cook the kind of food that she and Lytton liked, but in due course Olive left: 'I dread starting all over again teaching someone to cook, and our habits.' Carrington committed more of those precious hours to showing Flo, her replacement, how to make omelettes and '*soupe à la bonne femme*', but reforming working-class tastes was an uphill task. She had to give Flo an emotionally fraught lecture when she made cheese on toast instead of cheese fondue, and it churned them both up dreadfully. An earlier cook, Mrs Legg, had been discovered to be a thief, who had read all Carrington's private papers: 'It is despairing!' Employers who cared less about their food, and were less patient than Carrington kept their distance from the kitchen, leaving the 'good plain' cooks to run things their own way.

Anthony Powell recalled that at Cyril Connolly's in the thirties 'the succession of cooks went up and down in quality'. Connolly's gourmet standards were unfortunately no guarantee of a good meal, and guests leaving his King's Road flat were sometimes relieved to find a conveniently parked

mobile coffee stall outside, where they could satisfy their hunger with a couple of sausage rolls. Ottoline Morrell's cook produced a stodgy and unvarying diet of risotto, boiled celery and rice pudding. The drunken Irishwoman taken on by Harold Acton and his brother, in the mistaken belief that a tipsy cook would be more imaginative, turned out to be a disaster. She laced every dish with sherry, kirsch, whisky or maraschino. When incoherent howls started to echo from the kitchen she had to go, to be replaced by an almost equally mad Czech, who produced uninviting meals from bizarre combinations of vegetables: '[They were] calculated to give you a vague feeling of impending doom: lurid egg-plant, depressing parsnips or lugubrious potato salad besprinkled with bleeding red cabbage . . .'

*

Harold Acton was never poor. He could afford a cook, and despite the drawbacks continued to do so, but those who couldn't were forced to cook for themselves. This posed all sorts of problems for the déclassé Bohemian who had grown up separated from the realities of food preparation by a green baize door. If you didn't have servants there was, between inadequate, inefficient kitchen equipment and the accomplishing of a three-course middle-class dinner, an almost unbridgeable gap.

For as we explore the eating habits of Bohemia, it is important to remember how labour-intensive the preparation of food was a hundred years ago. Take soup – readily available today in tins, cartons or takeaway outlets, quickly heated and consumed. Now look at what that simple meal involved eighty years ago. Mrs Beeton estimates an hour and a half for the preparation of carrot soup, not including the additional five or six hours needed to simmer a good bone or vegetable stock. The stock needed to be skimmed and clarified before being added to the chopped vegetables, and the cooked vegetables had then to be reduced to a runny purée by pushing them through a fine sieve. There were simply no short cuts in the way of bouillon cubes or blenders, and Campbell's canned beef noodle was still many decades away from providing its own special contribution to the art scene. Soup was unequivocally off the menu unless one was prepared to give hours to its preparation. Many other dishes were equally impracticable in the circumstances in which artists lived. How could food be kept fresh in a studio without a refrigerator? How could washing up be done when the cold water tap was two floors down? How could you simmer stock, roast meat or bake potatoes on a gas ring? How could you cook at all when you had never been taught to?

Although gas cookers were generally available at the turn of the century, only better-off households could afford one. The studio dweller was more likely to cook over a single gas-ring (Kathleen Hale's was situated at floor level, not a practical position for cooking), while houses in the countryside had to make do with open fires, solid fuel ranges or paraffin stoves – all of these being dirty, hard to control and laborious to maintain. Electric cookers didn't come in until the late 1920s.

Water too, was very often not piped into homes, and had to be drawn, fetched or back-breakingly pumped by hand from the water supply to the tank. In Ditchling the Gills drew all their water from a pump. Mary Gill cooked over open wood fires, and visitors might wait for hours for a meal while the damp logs failed to catch, tummies vainly rumbling as they watched a Gill child attempt to blow up a blaze with the bellows. Keeping food fresh was a headache. One could prevent the butter from melting by putting it in an insulated box containing ice, which was bought from the horse-drawn cart of an ice-vendor. Refrigerators were deluxe innovations. Clive Bell, who enjoyed such extravagances as ice in his gin, provided the Charleston household with one in the late 1930s. Until that time the cold larder was the only repository for fresh food or leftovers. Getting dinner on the table in these circumstances was a very hit-or-miss affair, and one can only marvel that people managed it at all, let alone made food that anyone actually wanted to eat.

In the days of Carrington's romance with Mark Gertler the pair were living a few notches above subsistence level, so Carrington attempted soup. Did she sieve it, I wonder? It appears to have been a success since, away from London, she wrote to Gertler 'Do you miss my soups?' But she continued eager to extend her repertoire. Not long after she was writing: 'I am going to learn to make some puddings & good dishes to cook for you when I come back, as I am sure in time we will get tired of eggs on plates.' Gertler was unimpressed, but recognised the point that preparing good food left no time for more creative activities: 'You certainly ought to learn something about cooking. I should always prefer my girl friends to be better cooks than artists. Don't let this annoy you.' Gertler had grown up with the assumption, not uncommon in a working-class Jewish household, that it was the woman's job to provide meals for her man. In the event Carrington's efforts went unrewarded, for Gertler managed to persuade his landlady to feed him for two shillings a week. For this she cooked him a large Sunday lunch, but to his dismay it didn't include dessert. Like a thwarted child, Gertler sulked horribly at this oversight:

After the first course I waited and waited and nothing else came. Now, I simply must have sweets. After waiting for about fifteen minutes I gave my mouth a final wipe, got up and walked off in despair. What if I never get sweets! I sat and brooded all the afternoon about it and couldn't work.

He might have done better to accept Carrington's kind offer of puddings.

<div align="center">*</div>

Necessity first propelled Carrington into the kitchen but, once there, she gradually developed an enthusiasm for all things culinary. Being forced to cook could be surprisingly pleasurable. Ida John, stranded with two toddlers in Essex, unable to paint, and with Augustus largely away in London, found respite in the kitchen. Cookery was so much more relaxing than childcare, which she increasingly delegated to their servant Maggie:

I have begun to learn to cook, and can make several puddings and most delicious pastry . . .

I have been cooking and cooking and cooking – and have been so successful. I want to try and make Maggie nurse, and be cook and odd woman [myself] . . . And cooking is so charming . . .

Bohemian foodies even in the days of their poverty, Stella Bowen and Ford Madox Ford creatively braved the inadequacies of their ramshackle cottage kitchen. 'Ford was one of the great cooks . . .' Stella remembered:

And if the cook-house was a primitive hovel and the oil-stove a little horror, if the kitchen shelves were wobbly, the table a packing-case and the sink non-existent, it was nevertheless in these surroundings that I received my first – and how valuable! – instructions on the importance of food . . . Of course [Ford] was utterly reckless with the butter and reduced the kitchen to the completest chaos . . . But he did not mind how much trouble he took, and he never wasted scraps. Every shred of fat was rendered down, and every cabbage stalk went into the stock-pot which stood eternally on the living-room fire.

Soon Ford was able to trust Stella in the kitchen, and there, while he retreated upstairs to find inspiration with a new manuscript, she would prepare their meals and await his judgement. Over a late dinner (he was usually oblivious when summoned to eat until overcome by hunger) they would relish the food and enthusiastically discuss his novel and the progress of her cooking. Those were happy, self-sufficient days.

People like Carrington, Ida John, Stella Bowen and Ford Madox Ford discovered the joy and artistic satisfaction to be had in the kitchen. They were natural cooks for whom making food was a complement to their creativity. For cookery is, of course, an art form. The plate corresponds to the canvas in its composition, its colour, its appeal to the senses, and the revelations to be experienced from unexpected combinations. With a little imagination an orange jelly can become a surrealist experience, while baked apples eaten at midnight are somehow more profound and poetic than served with custard for lunch. Munching sardines on the Downs in a thunderstorm has an epic quality. Roast flamingo has unconquerably romantic resonances, and grilled mouse on toast (the creation of Epstein's model Betty May) has all the shock of the new. For Arthur Ransome even selecting a filling for his sandwich is transformed into a work of virtuosity:

Veal, potted liver, chicken artfully prepared, *pâté de foie gras* . . . tongue spiced and garnished . . . lobster paste, shrimp paste, cockle paste, and half a hundred other luscious delicacies, wait in a great circle about you, like paints on a palette; while you stand hesitating in the middle, and *compose* your sandwich . . .

The stallholder, meanwhile . . .

. . . does the rough handiwork, and executes your design, often, like the great man of the art school, contributing some little detail of his own that is needed for perfection, and presents you finally with the complete work of art, cut into four for convenient eating, for sixpence only, an epicurean triumph . . .

Next to such masterpieces, pouring rice pudding into the stockpot sounds less like self-expression and more like a botch–up – as it was for Duncan Grant, who meant well, but was quite clueless in the kitchen. Carrington commented wryly on the chaos she discovered at Asheham House where she was staying in 1915. Her fellow guests, Duncan, the Bells and Lytton Strachey muddled their way through the catering with pathetic ineptitude. 'They were astounded,' she reported 'because I knew what part of the leek to cook!' and 'the vaguest cooking ensued'. It was often the case that middle-class women – and men – who were also artists found themselves floundering in the kitchen, for the mysteries of domesticity could seem impenetrable to all but the initiate.

Being in charge of a household was daunting. There was so much the lady of the house was expected to know. Dealing with servants and tradesmen was only the start. She needed to be versed in everything from the household

accounts, to how to tell if a herring is fresh, to the price of a stone of flour. True, shopping for food was in some ways easier than it is today. The corner shop – fruiterer, butcher or fishmonger – was still all-important. Groceries were generally delivered, even in rural areas, by establishments who took orders by postcard. In some cases the proprietor himself would attend the mistress of the house once a month and take instructions in the drawing room over sherry and macaroons. But there was a mystique and formality about this way of doing things that seemed archaic to the newly emancipated women of the early twentieth century.

The dilemma lay in having to give thought to meals, having to purchase provisions, when what one really wanted to be doing was composing poetry or painting. What was the difference between pork and veal? How many potatoes were there in a pound? Julia Strachey had no idea. Dorelia had to find out the hard way that the giblets are supposed to be removed from a chicken, not roasted inside it. How long does one cook a cutlet for, and how hot should the gas be? Naomi Mitchison burned cutlets whenever she attempted to cook them. How does one keep a stove hot anyway? And how do you tell when sweetcorn is cooked enough? Laura Riding found that beyond her. And is that pepper or Keating's Insect Powder? If one wasn't accustomed to making daily meals such imponderables could seem very trying.

Dorothy Brett's biographer tells us that she complained to her dying day of never having been taught to cook, and guests to her home in New Mexico confirmed the dismal state of Brett's kitchen. One friend had to tip a festering stew out of the window before tactfully suggesting they dine in a restaurant, while another was received for a week's visit with the bleak news that they had just one tin of Spam to sustain them for the duration.

Caitlin Thomas was a capable cook, whose *pot-au-feu* were among the best, but Dylan's rare sorties into the kitchen did not encourage her to make it a regular event:

The most he ever attempted was a super fry-up of all the leftovers: spattering, in the process, the walls, the floor, and even the ceiling with flying scalding fat; producing in the end, as he invariably forgot it to go on with his book, a black, charred pulp which he smothered in 'Daddie's' sauce, and swilled down with fizzy cyder for breakfast.

The male artist was adept at avoiding domestic duties. Dylan's culinary incompetence gave him the excuse he needed to back out of any kind of domestic contribution.

Inexperience in the kitchen has a comic function in *I Capture the Castle* (1949), Dodie Smith's fanciful novel about a Bohemian household surviving on nearly no money. The family are reduced to a bread-and-marge diet (margarine as a butter substitute was horrible enough, but 'thank heaven there is no cheaper form of bread than bread') while waiting for the eccentric father, James Mortmain, to complete his never-ending experimental novel. However a chance encounter with a pair of rich and romantically inclined Americans restores the family fortunes, and our heroine Cassandra now discovers that they can afford to eat rather better. The problem is the cooking:

In those days we lived mostly on bread, vegetables and eggs; but now that we can afford some meat or even chickens, I keep coming to grief. I scrubbed some rather dirty-looking chops with soap which proved very lingering, and I did not take certain things out of a chicken that I ought to have done.

The novel also highlights a highly significant social development: convenience food. Daunted by the complexity of cooking, Cassandra falls back with relief on the delights of canned baked beans – 'What bliss it is that we can now afford things in tins again! I had bread-and-butter, too, and lettuce and cold rice pudding and two slices of cake (real shop cake) and milk.'

Tinned food – so fervently welcomed back by Cassandra Mortmain – steadily increased in availability through the twentieth century and, along with packets and powders, made feeding oneself a much more realistic proposition. Porridge took only two minutes with Quick Quaker Oats, and housewives soon succumbed to the copywriters' pleas to buy 'Creamola Custard – the Queen of Custards' or to make 'better pastry with Krusto'. Baked beans, Jello, tinned pineapple cubes and jars of bloater paste began to seem like the answer to a prayer. Purists were appalled. Ford Madox Ford deplored mass-produced food, while for Eric Gill, Bird's Custard Powder was little short of blasphemous; but these men could afford to scorn short cuts. They both lived with diligent women who were good cooks. Marooned at Ham Spray after a hurricane, with the telephone broken down, even Carrington was grateful for a supply of tinned herrings until the line was restored.

But even real shop cake and sardines weren't disaster proof. The end of the First World War left Lieutenant Osbert Sitwell of the Grenadier Guards ill and emaciated. After his discharge from military hospital he ran into Roger Fry in the street who, much struck by his starveling appearance, kindly invited him to lunch at his Fitzroy Street studio. This studio had a

gas ring but no kitchen, which was, it is true, somewhat limiting. No doubt Roger meant well, but it would appear that his skills with toasted cheese and chicken stew had, on this occasion, deserted him. Osbert arrived to find a table laid for two, and there amid the clutter of turpentine and brushes found that his host had extravagantly provided a starter of oysters:

As I tasted the first, a horrible doubt assailed me . . . Waveringly, I began:
 'What *unusual* oysters these are, Roger! Where did you get them?'
 'I'm glad you like them,' he replied, with the spirit and intonation of the quarter. 'They come from a charming, dirty little shop round the corner!'
 After that, I somehow curbed my hunger, and hid the oysters under their shells. As he cleared away the plates, he took a tin out of some steaming water, and said, 'And now we will have some *Tripes à la Mode de Caen*.'
 Setting my jaw, I ate on.

Perhaps Roger Fry could have done with a copy of Mrs J. G. Frazer's invaluable work *First Aid to the Servantless* (1913), which demonstrated with irrepressible cheeriness how easy it was to prepare meals without short cuts or domestic help. After all, 'a good dinner . . . can be prepared in two hours, including the setting of the table. Two hours and a half at most are needed for any dinner.' 'Mr Smith' comes home and finds his 'Lucy' still fresh from the kitchen:

She had never been outside all day. The dinner was just perfect; all was cooked to a turn, and the Smiths spent the happiest evening possible, taking two and even three helpings of every dish. Then Mr Smith sat in the dining-room easy-chair by the fire, while the young wife gracefully flitted about, folded the linen, put it in the press, refilled the salt-cellars and the sugar-basins. Finally she brought in a handsome large china bowl with boiling water, and at a side table she washed the dinner ware, drying it with a soft white cloth. It formed quite a picture . . .

Mrs Frazer's first aid would have been a great help to Beatrice Campbell and Katherine Mansfield. The Campbells spent a chilly weekend at a damp cottage that Katherine and Middleton Murry were renting near Chesham. Their contribution to the catering was a rather dubious leg of mutton, and it was this that was their downfall. Beatrice managed to cook the leg for dinner in the primitive cottage kitchen and, though not very nice, it was edible. The meal over, these two middle-class women, brought up to expect kitchen operations to be invisibly dealt with by armies of competent domestics, struggled with its aftermath:

The grease from the leg of mutton . . . completely defeated us in the washing-up operations. We had very little hot water and no washing-powder, and the grease was in thick layers over everything. Even the outlet to the sink was blocked with it, and it was quite impossible to get it off the knives and forks. I tried to make a joke of our predicament but Katherine was beyond jokes; she started to weep ceaselessly and hopelessly . . .

Katherine Mansfield's life story presents greater tragedies than sinks blocked with mutton fat, but as Beatrice Campbell instinctively realised, the distress that this episode prompted went somehow deeper than the occasion itself merited. 'I want lights, music, people!' she cried out, and Beatrice remembered this *cri de coeur* as being the more desperate in being uttered with her wrists submerged in blobs of congealed grease.

<p style="text-align:center">*</p>

There comes a time when one can't stand the relentless round of shopping and preparing and clearing and washing-up any more. One wants to head for the bright lights, and sit back in their sociable glow knowing that somebody else has done all the hard work. At such a time, Taglioni's, Quaglino's and Boulestin's were the gourmets' choice. After the austerity of the war years, their pampering atmosphere was irresistible.

Harold Acton became an obsessive diner-out, addicted to the sociable spectator sport of restaurant hopping: 'Once one acquires that habit it is like a drug.' He and his contemporaries were unanimous that for seeing, being seen, eavesdropping, arguing, flirting, meeting friends, doing deals, gossiping, wasting time or even eating and drinking, nowhere in London before or since has ever equalled the Café Royal. It was a home from home for cultured, Bohemian and literary London; in a sense it *was* Bohemia. At the Café you could get a four-course meal or just a snack at any time of day or night, a dozen of champagne or a cup of coffee, a quick steak after the theatre or a plate of chips for sixpence. If Augustus John were there (and he usually was) he could be relied upon to foot the bill.

If he wasn't he could probably be found at that other favourite Bohemian canteen, the Eiffel Tower. Much has been written about this famous Percy Street establishment. Nancy Cunard composed an ode in its praise, Michael Arlen thinly disguised it as the Mont Agel in his novel *Piracy* (1922), and in Seymour Leslie's *The Silent Queen* (1927) it appears as The Big Wheel. Hardly a memoir of the period appeared without some nostalgic reference to the great days of its proprietor, the Austrian Rudolf Stulik. But it was not cheap. This was the headquarters of *haut* Bohemia, a place to go when one

was in funds, or when somebody else was paying. It was not somewhere for a struggling Bohemian artist like Robert Medley, who in the early thirties decided he really must return the frequent hospitality of his rich patron Sir Edward Marsh by taking him out to dine at the Eiffel Tower. In preparation he went to the bank and withdrew ten pounds, trusting that this would amply cover the bill. The evening was nearly a disaster, for as Medley watched Sir Eddie gaily working his way through all the most expensive dishes on the menu – soup, sole meunière, roast pheasant, dessert and coffee, all washed down with Chablis and an excellent claret – he found he could concentrate on nothing but the prospect of being unable to pay. The tension was so oppressive that conversation became impossible. He stammered, looked vacant and repeated himself. Finally . . . 'sweating, I accepted the bill with trembling hand, and exhaled audibly with relief that the ultimate shame had been narrowly avoided'.

In Seymour Leslie's novel *The Silent Queen*, illustrated by Nina Hamnett,
the Eiffel Tower is thinly disguised as 'The Big Wheel'.

Luckily restaurants didn't have to cost a fortune. At the turn of the century dining out was on the increase, and food in a Soho bistro was astonishingly cheap. But there was more to eating in such places than mere economy; foreign food in these Bohemian surroundings represented something excitingly risqué and ambiguous. A Soho restaurant sent a sexy frisson down the

spine. Parmesan and Chianti seemed saturated with sexual innuendo, hors d'oeuvres, steak and *vin de table* were permeated with Gallic romance. Cheap as they were, these were the surroundings for seduction; the pink-shaded lamps on their tables invited intimacies. H.G. Wells and Somerset Maugham led their heroes and heroines astray in these gastronomic byways of Soho, to risk their reputations over rush-covered flasks of red or a glass of Asti: 'every bit as good as champagne'. A crème de menthe might go down well afterwards.

Such Bohemian haunts were tarnished with the dubious notoriety of their clientèle. As the journalist Robert Machray (author of *The Night Side of London*, 1902) commented, 'Here you may certainly study types of men and women you will hardly behold outside of this district.' But for him, the prices on the menu were more to the point. Places like the Boulogne, where a meal cost 2s, or Guermani's – only 1s 6d – were 'amazing value'. Dinner at the Florence cost 3s, at the Italie 2s 6d. And they were good; though, as Machray reported, 'you may suspect that some of the dishes on the menu are fearfully and wonderfully made . . . As for the wines, you can have what you are willing to pay for.' The Lyonnais was cheapest of all, offering '*soupe, 1 viande, 2 légumes, dessert, café, pain à discretion*' for 8d. A cheap supper of frankfurters could be had at the German Schmidt's; but Kathleen Hale's favourite was always Bertorelli's in Charlotte Street, where a huge bowl of thick bean and pasta soup cost 6d. 'I loved that place,' she remembered:

Wife. "A GLIMPSE OF BOHEMIA! I LIKE THAT—WHY, *THEY'RE* DOING ALL THE GLIMPSING."

Seeing and being seen in Bohemia (*Punch*, 3 October 1934).

In those days it was just a long thin room with a hatch at one end, and the woman shouted the orders down the length of the room 'DUE MINESTRA!', and it resounded through the building. There were marble-topped tables, and a Negro or two sitting quietly eating . . .

Yet even at these low prices a restaurant meal might well be a rare extravagance. Arthur Ransome was painfully poor. 'I lived once for over a week on a diet of cheese and apples – cheap yellow cheese and apples at twopence or a penny halfpenny a pound,' he relates. At the end of that week his friend, also reduced to the same diet by poverty, received an unexpected cheque for 'TWENTY-FIVE POUNDS!' Unshaven and irregularly dressed, the pair dashed to cash it before the banks closed, then headed for their favourite Soho restaurant 'with an aim in life . . . to dine better that night than ever in [our] lives before'. There they ordered the best from the bill of fare, ate sumptuously, drank copiously, and finished up with coffee spiked with rum.

[We] went out into the narrow Soho street. Just opposite . . . was another of our favourite feeding places. The light was merry through the windows, the evening was young, and – without speaking a word, we looked at each other, and looked at each other again, and then, still without speaking, walked across the street, went in at the inviting door, and had dinner over again – an excellent dinner, good wine, and rum in coffee as before. Remember the week's diet of apples and cheese before you condemn us . . .

<p style="text-align:center">*</p>

Ransome was always either starving or bingeing. Bohemian daily life was a switchback lurching from famine to feast and back again. The unpredictability of the artist's income made it hard to budget for a balanced diet. In the world of the Bohemian garret one is far more likely to come across rare days of delicious over-indulgence, followed by brief periods when there is nothing at all to eat, and whole weeks when the occupant survives on a scratch diet of bread and apples, cheese, sardines and the occasional sausage, baked or mashed potatoes, mutton bones, toast, kippers, eggs and cheap meat pies.

In 1916 Nina Hamnett and her gloomy Norwegian husband, Edgar de Bergen, were living in Camden Town and struggling to make a living by their art. Their neighbour in the next-door attic was the Mexican painter Benjamin Corea:

He was even poorer than we were. I would buy two pennyworth of bones twice a week and make a stew, and on this and porridge and margarine, we all three lived. One day someone bought a drawing so I bought some real butter. Edgar and I had a dispute about people with Victorian ideas, which I said he had, and he threw the plate and the butter at me. I was so upset about the butter that I forgot to throw anything back. I looked despairingly round and saw it sticking to the wall. It was still, fortunately, quite eatable.

Best butter cost 10d a pound. After weeks of surviving on subsistence rations, it must have been galling indeed to see such a hard-earned luxury being used as an aggressive missile to prove a point – a perfect case of convictions taking precedence over bodily needs.

These artists were physically undernourished because of a choice they had made. Of course if you reject four meals a day in the cause of art you have only yourself to blame. For many of the poverty-stricken masses, there was no alternative to hunger. The great sociological surveys undertaken by Booth and Rowntree at the turn of the century demonstrated that under the glittering surface of Victorian and Edwardian England lay a vast, unsuspected substratum of degradation and want. They testified to deaths from starvation, to alarming levels of malnutrition. Would anyone in their right mind choose such an existence? If what you wanted was a full belly, you did not stake your all on painting and poetry unless you were prepared to go very hungry indeed. It is perhaps all the more surprising, and in truth impressive, how many aspiring artists there were who were ready to make such a sacrifice – in some cases risking serious illness and even death for their ideals.

Jean Rhys, living in Paris in the twenties, wrote a cheerless and barely fictionalised short story entitled, simply, 'Hunger':

For the first twelve hours one is just astonished. No money: Nothing to eat. . . . Nothing! . . . But that's farcical . . .

On the second day you have a bad headache . . .

On the third day one feels sick: on the fourth one starts crying very easily . . . A bad habit that; it sticks.

On the fifth day . . .

You awaken with a feeling of detachment; you are calm and godlike. It is to attain to that state that religious people fast . . .

I have never gone without food for longer than five days, so I cannot amuse you any longer.

(from *The Left Bank and Other Stories*, 1927)

Kathleen Hale, who did not die until she was a hundred and two years old, looked back at her long life with the air of one perplexed at having survived: 'I ought to have died long ago from malnutrition.' Her escape from her middle-class background to become an artist in London in the early years of the century landed her almost immediately in serious financial hardship. She often went without food – though 'never actually for more than two days and nights' she admitted. At such times the delicious provisions for sale in the local continental shops tantalised her and she forced herself to stay indoors rather than pass a patisserie or coffee shop. After two days of starvation she scraped enough money to treat herself to a bounteous breakfast at a Lyons café in the Tottenham Court Road, but the tray of porridge, cream, poached eggs, coffee, and toast and marmalade that was placed in front of her was so unwontedly rich that her stomach revolted and she fled from the premises. Kathleen's 'normal' diet was a nutritionist's nightmare, consisting of boiled eggs, cheese and bread, while every so often a friend would treat her to dinner at Simpson's or the Café Royal. This erratic eating caused a duodenal ulcer that was to plague her for the next thirty years.

For Arthur Ransome, you could only qualify as a Bohemian by being poor, but in Bohemia one could be blissful on a sandwich and a couple of bananas, which in his nostalgic memory 'seemed a supper for a Shakespeare'. Ransome conceded that he was undernourished at the time and, like Kathleen Hale, attributed digestive problems in later life to malnutrition in youth. He survived euphorically on haddock bought in the King's Road. This he cooked in his kettle while reading a chapter of his book, by which time it was ready and would sustain him for the next twenty-four hours. When the price of haddock was too steep, he lived off eggs at a penny each. Convenient, cheap and nourishing, the role of eggs in the lives of artists may well have been unrecognised. How many masterpieces owe their existence to the omelette?

Ransome described an average day in the life of an artist at the turn of the century. The model 'Serafina' keeps up a gentle chatter while the painter is absorbed by his canvas. Eventually he tires of his brush and she of her pose. It is then her job to slip down from the model's throne and light a little oil stove in the corner of the studio, take eggs, milk and butter from a cupboard and set about cooking '*oeufs brouillés*, the favourite dish of half the studios in the world'. The literature of the time bears this out. The egg is a leitmotif in the kitchens and studios of numerous artists, whether in sandwiches, scrambled with haddock, fried, poached or boiled. Today's nutritionists would probably disapprove of this egg-dependency, but nobody could fault its convenience. For the artist reduced in circumstances, with no

more than a gas ring and a frying pan, and no experience of cookery, what could be easier? The egg is nature's fast food.

Another simple solution was the bones-and-vegetable concoction (otherwise known as *pot-au-feu*) adopted by Caitlin Thomas and Nina Hamnett, which could be a cheap and sustaining alternative to the omelette. In his spartan Fulham studio the impoverished sculptor Gaudier-Brzeska lived on something similar. His friend Horace Brodsky visited him there. Judging by his description it is astonishing that Gaudier didn't meet his end from food poisoning several years before his untimely death in the trenches: 'I knocked, and the door was presently opened, and my nose and eyes experienced queer sensations. There was a whiff of a most nauseating smell, suggestive of stale cooking . . .' The source of the stink turns out to be Gaudier's *pot-au-feu*. Invited to join him for dinner, Brodsky tactfully declines. Undeterred, the sculptor tucks into the foul-smelling concoction with gusto, while cheerfully explaining his labour-saving solution to the food problem. Once a week, it appeared, he bought provisions and boiled them up in a pot together. Then all he needed to do every time he was hungry was reheat the contents. When they were finished he would start again.

On this particular evening the strength of the odour told me that it was not freshly made. Possibly, too, Brzeska's meat and vegetables were not of the best. Also I am sure he was not a good cook. In any case, it was not important to him. It filled his belly and kept him alive, which was all he troubled about.

The demons that controlled Gaudier's creativity were not concerned with the state of his digestion. Perhaps he had developed an immunity to food poisoning. That was certainly Roy Campbell's theory about the diet of the ex-lawyer Stewart Gray, an extraordinary character who had given away all his money and taken up squatting in empty Mayfair houses with the flotsam of models and washed-up artists of London's pre-war Bohemia. In his autobiography Campbell propagated the myth that Stewart Gray lived on scraps from restaurants sandwiched between slices of linoleum.* One would rather go hungry.

* Campbell recounted the elaborate legend of how Gray had poisoned one of his housemates with a decomposing kipper sandwich. The mere sight of this ancient and phosphorescent fish had brought about instant death to the unfortunate victim, whose ghost then appeared to him, commanding him first to paint its portrait 'and after that to go forth in the world seeking the bereaved and painting their portraits'. Whatever the truth, Gray himself lived on, painting odd pictures in white paint on lino scraps; he inhabited Kathleen Hale's basement, and survived on a harmless diet of tinned sardines.

Ransome, Gaudier-Brzeska, Kathleen Hale and Stewart Gray were all painfully poor. Nourishing themselves was a question of scraping by, but in all these cases the ideal is palpable through the hunger. In his autobiography Ransome looked back on the hungry days of his Bohemian youth, full of nostalgia for his penurious but idyllic existence. Kathleen Hale saw the lack of mealtimes as a liberation rather than a deprivation. For Gaudier good food was for the 'bloody bourgeois'. Such an ideological stance towards life took some of these rebels to the brink of starvation. No sanctuary stood between penury and an early grave, and it was far from unknown for penury to be the artist's lot. This theme provided the opening of George Moore's realist novel *A Modern Lover* (1889) in which the author follows the fortunes of his artist hero, Lewis. Here, the hungry Lewis feels his ideals collapsing around him:

For two days he had not left his miserable room, but had sat working at the drawings that Bendish now refused to buy at any price. He had lived on a few crusts and a little tea, afraid to spend his last shilling. And now, as he walked wearily, he took it out of his pocket and looked at it: it was all that remained between him and starvation . . . his resources were exhausted, his clothes were pawned, and he did not know who would lend him a sixpence . . .

'Surely,' he asked, 'I am not going to die, like a rat, of starvation in the middle of this enormous city?'

The river beckons; to drown himself might be the answer, but the thought of little Gwynnie, the neighbouring tenant in his shabby lodgings, who loves him, keeps him from finally giving up hope. The next day Lewis persuades a dealer to offer him a commission – but there is no advance:

'Three pounds isn't much, he ought to have given me five; but never mind, let's have some supper on the strength of it . . . I have a shilling tonight . . . and I shall have three pounds on Monday; it is all right, we can have a couple of sausages and a pint of porter.'

. . . In a few minutes Gwynnie returned with the eatables; she added a couple of baked potatoes to the sausages; there was no cloth to lay, and they had only to push aside the paints and brushes.

The sausage supper is a turning point in Lewis's fortunes. Revived, he sets to work, the commission is well received, and soon he starts to make money – poor devoted Gwynnie however is forgotten. Her heartless lover rises

over the course of three hundred-odd pages to become President of the Royal Academy, and the days of hunger are forgotten along with her.

*

One cannot live on dreams. The Bohemian dilemma impales its victims with sadistic consistency: 'As an artist I am above material things; this defines me. I resent giving time to keeping alive when I want to give time to Art. But if I don't feed myself I shall die . . .' One can't just live on egg variations. 'I *am* tired, my dear . . . tired . . . of eating hard-boiled eggs out of my hands and drinking milk out of a bottle,' complained Katherine Mansfield. But what were the alternatives? For, ideologies apart, eggs, bones and cheap cheese were the unromantic reality of the garret.

Day after day, meals of some kind had to appear on the tables of Bohemians and bourgeois alike, an inescapable round of shopping and cooking and clearing up afterwards, and inevitably the brunt of this fell on women. Who else would work all day cooking and doing housework unless driven to it by economic dependency? Preparing meals for a middle-class family was so laborious and time-consuming that cook-generals were expected to work a sixteen-hour day, with one day off a month. How could one do that, and be an artist? If one had other priorities in life – painting, or poetry perhaps – one had to fight for them, otherwise daily life threatened to become measured out with potato peelings.

Ida John's delight in cooking was short-lived, as domesticity closed in on her. She felt that she had been made for better things, but that children and washing and meals and shopping had come to dominate her daily life. Occasionally 'the curtain seems to lift for me a little . . .' and she glimpsed something of the idealist she once was. 'The other days I simply fight to keep where I am . . . I can understand the saints and martyrs and great men suffering everything for their idea of truth . . .' Ida's sufferings at that time seem too humdrum to be identified with martyrdom; but only two years later she was dead in childbirth, her resources stretched and weakened beyond their limits.

The one-time star of the Slade – Ida John's friend Edna Waugh – was virtually extinguished when she married Willie Clarke Hall. He betrayed their agreement that she would be left free to paint, and abandoned her to the kitchen. Her biographer writes that 'Willie's praise was no longer for Edna's genius for art but for her "genius for cooking".' The sexual revolution had failed to keep pace with revolutions in art; almost a hundred years later it is still the woman who stirs the sauce in most households.

The indignity and betrayal of domestic servitude were not reserved for the virtuosi of art and literature. In 1922 a painter called Christabel Dennison found herself pregnant by her lover John Adams, a writer. Dependent on John, and locked into a masochistic and servile relationship with him, Christabel gave her baby away to a friend who brought up the child. Many years later the daughter, Jane Spottiswoode, discovered her mother's diaries and embarked on a quest to find out about Christabel. The sad book that resulted, *Christabel Who?* (1998) reveals a picture of a woman's life stunted and blighted by domestic pressures. Her artistic aspirations and daily domestic reality were fundamentally incompatible. But although it seems extreme – Christabel's relationship with John is a pitiable apology for a love affair – her everyday life is one that in its constituents was surely typical. How many forgotten women can have found themselves as trapped by their decision to live unorthodox lives, as their more conventional sisters were in their suburban villas with servants? Christabel had no time to do her own work. She had no money, no space of her own, no leisure – and of course, no cook. A typical diary entry:

Friday . . .

Me 'Will you give me some money then, I have none?'

John 'No I will not.'

Me 'Then I shall have to borrow.'

John picked up that new unopened two pound jar of marmalade and threw it across the table. I dodged and it hit the mantelpiece and crashed on to the floor. I whispered fatuously, 'Oh Honey, you mustn't throw the marmalade about.' He jumped up and seized me by the throat saying, 'I'll kill you.' He hurt me. I was frightened and started to shiver. He stopped and I ran out of the kitchen into my room and locked the door.

When he'd gone I went back to the kitchen and saw the mess of broken glass and marmalade under my chair. I wonder if he just wanted to frighten me or if he really meant to kill me . . . I cleaned up the mess of marmalade and glass. Washed up, made a pudding, stewed some figs and tidied all the house. It seemed impossible to go . . .

And so it goes on. We see John burning the toast, Christabel bemoaning her cramped kitchen – 'never anywhere to put anything down', Christabel scrubbing potatoes and scraping uneaten food off plates into dustbins, Christabel deciding to leave John, but making him a rice pudding first, and

then coming back again. We see John slumped in his armchair waiting for Christabel to get supper, or make his toast, we see her slaving over a dinner party to entertain his friends – 'a wretched day . . . It isn't civilised to have to spend the whole day getting a meal ready . . . I have been tormented with the fatigue of meals since I was twelve years old.' Few and far between are the intervals of happiness – one rare morning John kisses her in bed, 'the first time in over a year'; another day the beauty of early celandines stirs the artist in her. More often she records, 'I feel as if I can never be happy again. As if I've lost the key. I spend my life by the gas fire, getting meals at the same time every day with no lightening of the heaviness in my heart.'

In 1925 Christabel Dennison fell ill; at the age of forty-one, worn out, death released her from the treadmill. A few black and white illustrations, including a haunting self-portrait which her daughter reproduces in her book, hint at the sensitive artist she might have been. Christabel paid a heavy price for refusing to be a slave to convention. The essence of her predicament is still relevant, still unresolved. One can only guess at the numbers of submerged women who, like her, were defeated by domesticity.

7. New Brooms

*Must women give all their time to housework? – How can one cope
with housework without modern machinery? – Is an experimental
lifestyle compatible with having servants? – What are the advantages
of remaining dirty? – Must one have baths? – Can one admit to
the existence of lavatories? – Must creativity be sacrificed for
the sake of cleanliness and order? – Does domesticity have
any value for the artist?*

Mrs Beeton described housekeeping as 'the linch-pin of life's daily round'. That bible of the middle classes, her *Book of Household Management*, left nothing to chance in its seventeen hundred pages of domestic commandments:

The cleaning of the kitchen, passages, and kitchen stairs must always be over before breakfast.

Once a week the stairs will need a thorough clean, the stair-rods must be removed, two or three at a time, and the carpet underneath carefully brushed. Paint-work must be washed, and the banisters and hand-rail polished.

It is not enough in cleaning furniture to pass lightly over the surface; the rims and legs of tables, and the backs and legs of chairs and sofas should be rubbed vigorously daily; if there is a bookcase, every corner of every pane and ledge requires to be carefully wiped, so that not a speck of dust can be found in the room.

This was an extreme state of affairs, ripe for a revolution, and Bohemia was preparing its subversion with a vengeance. The radical rejection by many artists of the rituals of domestic perfection, including cleanliness itself, can only be appreciated in the context of those times.

The almost neurotic obsession with domestic efficiency peaked in the late nineteenth and early twentieth centuries, a period when housework was a full-time occupation for innumerable women, and when consumption was nothing if not conspicuous, above all in the home. The excesses of upholstery, lace, glass, metalware and china all needed exacting attention.

This was the era of the knick-knack, a time when homes were adorned on all surfaces with decorative odds and ends. It was also a period when internal architecture was perhaps fussier and more convolute than ever before.

Keeping such establishments spruce and spotless was immensely onerous, even if in those days the burden fell largely on servants. Despite a sharp decline in the servant population (nearly half a million women servants took jobs in factories during the First World War and never returned), the assumption that domestic work was performed by cooks and maids died hard. 'Every family that can afford to do so will probably employ one or two or more servants,' wrote Lady Troubridge in 1931.

How did one keep one's home up to the mark if one could not afford servants? Luckily Mrs J. G. Frazer had the answer to that. Her book *First Aid to the Servantless* sets out to demonstrate that 'Lucy' can get through the housework without any help at all, having obtained a marvellous break-through gadget called the 'Ukanusa Drudgee', 'which with one pull wrings the cloth and which makes the duty of floor-scrubbing more of a game than a drudgery'. Polishing her floors with beeswax and wiping them with turpentine keeps Lucy and her Drudgee busy all morning. In any spare moments the young wife is gainfully employed practising those little economies that make all the difference in the servantless household. She boils fragments of soap in a jar to make soap jelly, or reuses wooden skewers to clean out tricky corners. Her day is just one long carefree round of pleasure, causing Mrs Frazer to burst into verse:

The Ukanusa Drudgee.

The end of drudgery?

L'ALLEGRA

... Now you must
Fight the dust.
Mop it, wipe it,
Brush it, swipe it,
Rub it, scrub it,
Till all is shiny
Like the briny
Ocean in the sun;
So that when you've done,
Not a particle
On any article
Remains above ...

*

So fold up the papers,
And blow out the tapers,
Put out the last light.
Good night! Good night!
So may every day
Glide away,
Ever busy, happy, gay,
Ever l'Allegra!

Even with a Drudgee housework took all day, and no wonder. Until well into the post-1945 era, many British women were still using cleaning equipment which had barely evolved over three centuries. In the 1920s, before modern detergents, washing up was done with soda, which left the hands raw. An alternative was soft soap, horribly slippery, so that breakages were frequent. Vinegar and silver sand or Vim and wire wool were used for scouring saucepans – punishing work. Stainless steel did not exist, and knives had to be cleaned in a machine using a kind of emery powder. You stuck the knife into a slot, poured in the powder, and wound the handle like an organ-grinder. Keeping the house warm was particularly time-consuming and unrewarding. Six shivering months of every year were dominated by fire-stoking, grate-riddling and ash-disposing. Some rooms just never seemed to get warm, and life was a battle with damp and draughts.

Until the advent of automatic washing machines, washday was – exactly that: an entire day devoted to washing. Mrs Beeton recommends an early

start on Monday morning. Very few British homes owned washing machines before the 1950s, and irons were non-thermostatic. Those who could afford it 'put out' their washing to the private laundry or washerwoman round the corner. But for many, there was a moral pride attached to home-washing, and it would appear that undertaking the lengthy and skilled task of doing one's own laundry gave the housewife a particular kind of self-esteem.

*

Housework and laundry were complicated enough, but personal cleanliness had its own special apparatus of ritual and adversity; this too helps place the Bohemian revolution in context.

Take bathing. Even in the best-run households, like that of Ursula Bloom in her country vicarage, taking a bath was a 'morning horror'. Ursula would lie in bed quaking while the servant brought a tin tub coated in chipped enamel up to her room, placed it on an enormous bath mat, and poured cold water into it. Another servant* staggered upstairs with a can of boiling water which she then added. The trick was then to avoid being either scalded or frozen, and it was one which Ursula never managed to pull off. However little cold water she mixed in, it was always too much, and the result was a shallow, tepid bath, in which she sat hunched and shivering: 'Nobody ever had a decent bath, how could they? After all the hard labour entailed to get the bath into the room and the hot water heated and up the stairs, the result was a tragedy.'

Even properly plumbed bathrooms in private houses were far from being places of luxury and indulgence. Having a bath was regarded as a utilitarian and no-nonsense activity, so they were generally floored with hygienic linoleum; Sybille Bedford remembered how such places were equipped with yellow coal-tar soap and tooth mugs full of disinfectant.

But one of the most excruciating ordeals imposed by conventional society on its cowed members was the compulsion to deny the existence of lavatories, and above all to deny the activity that took place in them.

No decent person did it [remembered Ursula Bloom], most certainly no lady. Regarded as the height of vulgarity, whatever personal discomfort or danger it entailed, one was secretive about it . . . The fact that it was a necessity to man, and to rich and poor alike, was disregarded. Nobody who was anybody tolerated it.

* The servants themselves, incidentally, were allowed one bath a week if they were lucky. At Charleston the Higgens's bath night was Friday; apart from that they washed in the kitchen sink, where there was no privacy. 'When I think about it now we must have honked a bit in the hot weather,' remembers Grace Higgens's son John.

Thus the accommodation provided was as nasty and uncomfortable as was humanly possible; to have made the lavatory at all commodious would have been to endorse the existence of urination and excretion. Though non-absorbent toilet tissue was available, one was just as likely to be provided with torn sheets of newspaper. The disownment of natural functions made outings particularly agonising. Public lavatories were few and far between,★ and 'restaurants were equipped with nothing so immodest'. Mrs Bloom and another of her daughters nearly fainted once on a shopping trip to London:

In the end someone took pity on them, and they were escorted into the indignity of a back yard where something rudimentary was arranged behind convenient packing-cases. They never forgot the experience.

★

Were these people mad? What was it about lavatories and dirt and draughts and damp beds that so haunted the upper echelons of late Victorian and Edwardian society? It must be conceded that their obsessive attention to cleanliness had a sound basis. Public programmes of sanitation and vaccination, alongside improved public health and hygiene, have done much to dispel the fear that was a terrifying reality for generations of British people. Tuberculosis, for the most part communicated to humans via contaminated milk, was thought at the end of the nineteenth century to account for nearly 15 per cent of *all* deaths in this country. Well into the twentieth century, many people were still alive who vividly recalled the terrible typhus and cholera epidemics of the previous one. The denial of lavatories was a denial of disease and death, which stalked its victims by way of bad drains, ill-ventilated houses, dirty bathrooms, verminous kitchens. The only weapon against these plagues was scrupulous cleanliness. Locked into an unwinnable fight with the forces of dirt and darkness, Victorian and Edwardian housemaids were dusting for their lives.

Against this terrifying backdrop, the squalor so often associated with Bohemianism appears reckless, defiant or fearless, depending on your point of view. The effrontery with which these people abandoned middle-class aspirations to tidiness and hygiene was neglectful and slovenly, but it was also audacious. This was a revolution. 'Sanitation be damned, give me Art!' cries Somerset Maugham's fictional Bohemian Thorpe Athelney: he has been told

★ In London, underground stations had public conveniences, but many felt squeamish about using such proletarian facilities. When Selfridges opened in 1909 they took the enlightened step of installing public lavatories, and other large stores soon followed suit. Relief was in sight.

his family must move out of their beloved home, which has been condemned for having bad drains. Above all, it was by turning its back on washdays and clean paintwork, by choosing to live in squalor and dirt, amongst vermin and bugs, that Bohemia came to acquire its dubious and unsanitary reputation.

Artist. "SPRING CLEANING? CERTAINLY NOT! YOU DID THAT IN 1911."

The abandonment of middle-class aspirations (*Punch*, 27 April 1932).

Even today, when we are arguably more relaxed about such things, there are those who find the sight of a dirty sink or a grimy bathtub, an unwashed child or mouldy food disturbing, even threatening. The abyss is full of putrid substances – filth, ordure, the inadmissible scum and refuse which we attempt daily to deny. Purity is blessed, but uncleanliness is next to ungodliness. To the outside world there was something almost diabolical about the festering conditions in which Bohemia chose to live. Nevertheless it is no exaggeration to say that the *âmes damnées* who plumbed those depths did so not from innate immorality, but affirmatively, provocatively, even honourably.

*

For there was another way to live, a way which was labour-saving, sloppy, but also uninhibited and imaginative. There was a world where neglect of housework was positive rather than reprehensible.

At the turn of the century something of this mood was already in the air. Cultured Victorian intellectuals felt themselves to be above the petty

keeping-up of appearances, while utopians like Edward Carpenter had suggested creating a society where everyone's possessions were held in a common repository, thus bringing about a simplification of architecture and interiors, and at a stroke releasing half the human race from their domestic captivity – no more horse's hoof inkwells to dust, or crystal decanters to clean. Meanwhile, some nineties aesthetes, taking their cue from Baudelaire and Huysmans, made a point of plumbing the depths. Mood, sensation, receptivity was all. 'When I am good, it is my mood to be good; when I am what is called wicked, it is my mood to be evil,' says Reggie Amarinth in Robert Hichens's *The Green Carnation* (1894):

There are moments when I desire squalor, sinister, mean surroundings, dreariness and misery. The great unwashed mood is upon me. Then I go out from luxury . . . The thoughts sit in the park sometimes, but sometimes they go slumming.

In Bohemia *nostalgie de la boue* was never far off. Dylan Thomas lived in a pigsty. A nomad in London, he nevertheless possessed a mattress, which he laid on the floor of whoever chanced to lend him a room. For a while he parked this mattress with three painters who lived off the Fulham Road. The flat was a festering repository for their belongings, without so much as a silk dressing gown to redeem it from squalor. One of his flatmates remembered: 'For yards around me I can see nothing but poems, poems, poems, butter, eggs, mashed potatoes, mashed among my stories and Janes' canvasses . . .'

Animals and ashtrays wreaked havoc in the simulacrum of a Fitzrovian pub inhabited by the composer Constant Lambert and his wife, Flo, where untidiness was endemic. Their cats roamed through the piles of empty bottles, newspaper cuttings and dead cigarette ends like refugees from a bomb blast; the relics of some rather good pieces of antique French furniture protruding through the debris. The Lamberts' less fastidious Bohemian friends felt as comfortable at Trevor Place as they did in the Wheatsheaf.

For Nicolette Macnamara and her friend Nancy Sharp, who, as Slade students in the 1920s shared a disgusting flat in Adelaide Road, the decision to dispense with cleanliness was utterly conscious:

We lived in squalor. The beds were like old dog baskets. Our dirty washing and laundry piled up in a corner for weeks on end, in an emergency I washed a vest and a pair of stockings in the bath with me; this was an old geyser bath that we shared with the rest of the house. The stews were wreathed in fungus and the food rotted in the saucepans. The washing-up fouled the sink until we washed up in desperation so that we could eat. Our clothes hung on hooks from the wall when they were

not on the floor among the canvases and empty beer bottles left over from parties. The mice approved of our way of living and multiplied. We were terribly happy.

Nicolette and Nancy had no qualms about their way of life, it didn't bother anybody else, and they certainly weren't wasting their time wiping specks of dust off bookcases, they were painting.

How can one reconcile pigsties such as these with art and beauty? The answer is that tidiness and cleanliness can be oppressive, while mess released one from bourgeois imperatives like tidying up. Poverty and high ideals didn't necessarily mean you had to be uncomfortable, however. The gentle settling of dust and grime on books and ornaments gave a kind of frowsy snugness to the Bohemian interior. It bespoke artistic priorities as opposed to bogus pride in the home. Robert Medley felt instantly at ease visiting the Carline family in Hampstead, whose sitting-room was hung on every side with a melée of Victorian and modernist works of art, and full of 'innumerable cabinets, bibelots, sit-down chairs and family bric-a-brac, [with] the cosiness of the seldom dusted . . .' This was somewhere you could relax, be yourself, and stop worrying if you dropped your ash on the rug. Nobody would notice, or mind.

<center>★</center>

When artists set out to rewrite the rules, personal hygiene was often rejected from the new constitution. The equation of dirt with liberty is one that recurs in the annals of Bohemia, for it is in the tradition of gypsies to hate water. Genuine gypsy communities felt a strong aversion to washing, and soap was for centuries practically unknown to them. So too there were those among their followers who felt that soap and water would dilute their artistic purity. To wash was considered by many to be conventional, an activity associated with the over-civilised. When Eliza Doolittle is raised from the gutter to be turned into a 'lady', the first thing she has to have is a bath. So, taken to its logical extension, filth meant freedom from oppressive bourgeois standards.

I hankered for sordidness – sordidness of situation, sordidness of act – because I thought that that would help to wash away my sheltered upbringing and to plant me more firmly in reality . . .

wrote Gerald Brenan. This was surely liberty of a kind. There was something thrillingly anarchic about declaring war on hygiene – it went with long hair and sexual licence. The threat posed to 1960s society by hippies, with their shaggy and dirty appearance, was identical to that posed by the Bohemians

of the 1920s. The critic James Agate complained about the invasion of his habitual Café Royal table by brigades of 'corduroy trousers . . . with unwashed Bloomsbury fingers . . . I expect young people to come knocking at my door. But why are the knuckles they knock with invariably filthy?' It sounds as familiar as the outraged correspondents who wrote to newspapers in 1968 about indecency at pop concerts.

For anyone who disapproved, adjusting to Bohemian squalor could be a learning curve. When in 1916 Ottoline Morrell went to see Katharine Asquith at her home, Mells Park in Somerset, her visit to this beautiful, conventional, orderly home with its perfect garden was entirely coloured for Ottoline by the devitalising, depressing character of its occupant. Nonplussed, she fled the following weekend to Suffolk where she visited Vanessa Bell and her unconventional household at Wissett Lodge. The contrast to Mells Park was striking – Wissett was 'dark and damp and exceedingly untidy', but its occupants were 'nice and real' and free and full of gaiety. Ottoline was forced to realise that she would have to retrain her 'proper' notions of cleanliness and orderliness, and learn to welcome untidiness as something creative and life-enhancing. All it took was a little open-mindedness, a little vision. Everyday life didn't have to be subjected to Mrs Beeton's despotic regime; and Bohemia has always been resolutely anti-authoritarian.

★

Can it even be that filth is a precondition of art? There were those who claimed that it was. Tristram Hillier was invited by a rich patron to spend time painting at his lovely villa on the French Riviera. He accepted gratefully and soon moved into his host's purpose-built studio, where he was left alone to enjoy the luxurious surroundings, and to eat the punctual meals served by silent servants. The expectation was that at the end of two months he would produce a masterpiece – but somehow nothing happened. Hillier's well-meaning patron was devastated to find that the perfect environment he had provided had, after two months, inspired no more than a tiny drawing of a dead mouse:

Like the flower that thrives upon a dung-heap . . .

wrote Hillier,

. . . the artist draws inspiration from disorder, and thus it is that, as a compromise to my dual nature, I am often compelled to abandon the comfortable but simple studio

in which a part of me is content and fulfilled, in order to spend long periods in the sordid surroundings of some dirty little inn where, spiritually, I can feed upon that squalor in which I find nourishment as a painter.

How can we reconcile the godliness of cleanliness with the spirituality of dirt? Artists who renounced cleanliness committed a kind of heresy which demands a complete reversal of our standards. This was a moral revolution, where dirty was clean, vice was virtue, Hell was Heaven.

In his fable *Jack Robinson* (1933) Gerald Brenan's hero transgresses all the accepted norms of behaviour in his quest for happiness and true living. His first act of defiance is to become a vagrant. One of the earliest discoveries he makes, in a tramps' hostel, is that a dirty and vile life can also be a life of personal fulfilment and self-realisation:

The old unwashed clothes I could not change became as familiar as close relations . . . I slept more luxuriously on a truckle bed whose single sheet was stained with grease and blood than on the feathery mattress of my little bedroom. Going further I even lay listening with secret delight to the hoarse coughing and spitting and scratching that went on in the crowded restless dormitory till nearly dawn. The acrid pungent stench, the lack of air, the itching from fleas gave me through my irritation and discomfort a kind of spiritual ecstasy . . .

Against the dirt, lack of food and sleep, and general discomfort I felt my own distinct character and existence outlined more vividly . . .

Here, the individual's very identity is bound up with dirt and discomfort. Compared to the unscathed, vacant nonentities of the bourgeoisie, the artist is like his own canvas. He is smeared, daubed and befouled with the accretions of living; but he embodies the vital complexity of a creative personality. At its most extreme the artist who chose this form of self-expression could clear a space for himself at any gathering.

Richard Aldington remembered Gaudier-Brzeska as 'probably the dirtiest human being I have ever known. [He] gave off horrid effluvia in hot weather.' So when Gaudier came visiting one warm summer day, the Aldingtons took good care to seat him at the opposite end of the room from themselves. Unluckily they were joined soon afterwards by Ford Madox Ford, resplendent in formal morning clothes. The only available seat was on the couch next to Gaudier and, plainly overwhelmed, Ford soon left. The next day he returned to reprimand Aldington for allowing such a noxious creature into polite company. However, Aldington noticed that as the weather cooled Gaudier was promoted to the guest list for Ford's At Homes,

and Ford even went so far as to install the artist's phallic statue of Ezra Pound in his front garden.

The revolting revolution was no less than a war against all things hygienic and clinical. The more the English became obsessed with tidying up and warding off odours, the more squeamish and deodorised they became, the more vulnerable they were to the smell and dirt offensive waged by Bohemia. There was a time, it seemed – a more primitive, honest era – when people scratched and spat and farted with a kind of coarse candour, and when manure was recognised as being what it is, the source of fertility; but the trajectory of the twentieth century was heading ever closer to a cleansed, odourless condition, where everything pungent and poetic – garlic, attar of roses, sweat, shit, Turkish tobacco – was negated and abolished. The poet Roy Campbell was appalled by the number of advertisements he was beginning to see in the thirties promoting products to deal with bad breath, armpit odour, constipation and so on, which he interpreted as a denial of natural functions. Sex, likewise, was linked with horrible rubbery devices, health linked with medicine. Society was like a vast hospital full of doctors trying to cure the disease of Life.

It would be an exaggeration to suggest that Bohemia had any kind of lavatorial fixation; but one of the many differences between the inhabitants of those two worlds, Bohemia and the bourgeoisie, was Bohemia's willingness to recognise that our bodily emissions are no more frightening or embarrassing than breathing. Whether interesting or dull, chamber pots and lavatories and the things one did in them were back on the list of topics one could discuss. Could one afford to have a water closet installed as opposed to an earth closet? Wasn't emptying chamber pots a nuisance? Was French plumbing inferior to English? (– almost certainly). Why indeed were the French so neurotic about evacuation, and wasn't it ghastly the way French sailors relieved themselves on the beach? How satisfactory to have a pleasantly disinfected earth closet with a wooden seat and a nice shovel to cover up one's excrement 'like a cat', and how unsatisfactory to have only a ground floor lavatory and 'not a po in the house!' Not obsessive, smutty exchanges; speculations, more; curiosity, openness, and dismay at the prevalent hypocrisies of conventional society.

So with smells: the Bohemian nose was as acclimatised to natural human odours as it was to turpentine and tobacco. Given the very impractical realities of early twentieth-century plumbing, one should not wonder that people weren't queuing up to get clean. Remember, personal hygiene could be a battle – a time-wasting, elaborate, depressing process; and many people with better things to do just gave up the unequal fight. Thus while messy,

muddly Bohemia was a fertile territory for the arts, it was often also a breeding-ground for bad smells and insanitary habits.

Top of the Unwashed League after Gaudier-Brzeska comes Mark Gertler – who grew up without a bathroom and could only be persuaded to bathe when good friends, like Eddie Marsh or Brett, could provide him with the facilities *and* wash his back for him. 'I do not wash much: I think it is a waste of Labour. I only wash when I look dirty' was his position on the matter. Christabel Dennison comes a close second – she didn't bathe for weeks, and believed that nobody would notice that she hadn't washed her neck if she wore high-necked jerseys. 'I don't smell,' or so she claimed. And then there was Ottoline Morrell, who generally dispensed with bathing and made do with a rudimentary wash in a basin. Apparently she took a 'proper' bath only twice a year.

Getting clean was disagreeable and wearisome. Many accounts tell of artists' rudimentary, infrequent ablutions under a cold pump or in a bucket. At Charleston the bathroom was 'cramped and primitive', the leaky pipes lagged with yellowing newspaper. An attempt to give the worn-out enamel tub a facelift was unsuccessful – the paint congealed into a sticky mess and bathers found themselves emerging with patches of Chinese white stuck to their bottoms. Hot and cold running water was often unreliable, and gas geysers could be explosive and leaky. If one lived in lodgings, the prospect was gloomy: one carried towel and robe down two floors to a chilly bathroom shared with maybe three or four other occupants of a building, fed a geyser with pennies, and waited for a pitiable trickle of lukewarm water to emerge from the cistern.

In the early days of their marriage Anthony and Nicolette Devas lived in Regent's Square and tried to keep clean in a house with only one tap to serve the twenty-five occupants. A few doors away lived Nicolette's father, the poet and philosopher Francis Macnamara, who sublet a room to his other daughter Caitlin:

Francis gave me a key to his flat so that I could have a bath ... [He] arranged his house like ships and devised ingenious space economies. I could have a bath in the kitchen, my privacy protected by a curved wooden partition ... built on the principle of a ship's hull. Caitlin had a nasty habit of standing on the kitchen table to spy over the top of the partition at the person having a bath and would give a derogatory report on some physical aspect to those eating boiled eggs for breakfast.

★

Willing as Bohemia was to embrace stink and dirt, getting into bed with bugs usually resulted in swift disillusionment. Itchy spots and swarming mattresses recur with dismaying regularity in memoirs of that period. Because so many Bohemians had 'dropped out' of the middle classes, it seemed a short step from civilization and carbolic soap, to the terrors of lice and contagion. A poor poet like Liam O'Flaherty would seem to Mrs Beeton to be dicing with death when he moved into his 'evil-smelling hole in Charlotte Street . . . alive with bed bugs, if not vermin'. Driven away by the invincible insects, O'Flaherty decamped to Chelsea, but it was worse: 'low-lying . . . should have gone to Hampstead . . . Living in rooms is awful'. He escaped to the west coast of Donegal, still wistful for Fitzroy Street – if only it weren't for the 'bed bugs and fetid air'. Kathleen Hale was another Bohemian who emerged from the First World War homeless and broke, but managed to find herself a tiny squalid space to rent in Soho. She too soon discovered that the room was crawling with bedbugs which bit her at night. She demonstrated the evidence to her fat landlady, who reacted phlegmatically:

Blandly she assured me she would deal with them, heaving and rolling herself up the narrow stairs to stand the legs of my bed in saucers of paraffin. This deterred the climbers but had no effect on those bugs which dropped from the ceiling.

The sad tale of Nina Hamnett's descent over thirty years from talented, sexy art student to squalid, promiscuous lush reads like a Bohemian *Rake's Progress*. Her personal nadir was a stinking flat in Howland Street, infested with lice and littered with rat turds, with Nina and some anonymous sailor drunkenly taking their pleasures on a creaking mattress.

*

Evidently, not cleaning has all sorts of advantages for artists, being cheaper, less time-consuming and also, importantly, confirming one's sense of oneself *qua* artist. Nevertheless there were those even among the ranks of Bohemia who regarded squalor with suspicion, as being rather an extreme way of making a point. Being an artist might make one filthy, but being filthy didn't necessarily make one an artist – it wasn't that easy. C. R. W. Nevinson was one who on this basis preferred to keep clean, while muttering darkly about grotesque filthy so-called geniuses. Richard Aldington felt that it wasn't necessary to go to the extremes of grease, blood and fungus in order to get the message across. Aldington felt himself to be Bohemian in

his sympathies, a bit frowsty at the edges perhaps, but he found it impossible to give up his nice clean pocket handkerchief and in particular his daily bath; in Paris this habit was regarded as so recherché that he became known at his lodgings as '*le-Monsieur-qui-prend-le-tub*'. Aldington's tolerance was tested by the squalid excesses of his dirtier friends. There were limits. Without becoming neurotic about cleanliness, few would actively choose to live in foulness, but where did one draw the line, and how did one keep the chaos at bay?

The answer, of course, was servants. For those who could afford it, domestic help was an inevitable necessity. It is impossible to overemphasise the fact that for the cultured middle classes of that period, having the housework done by others was something they regarded as an immutable fact of life. And if housework was not to interfere with painting, or writing, then servants had to do it.

Today, with hindsight, people are embarrassed at the thought of the existence of an inferior class whose lives were dedicated to clearing up after their employers. 'Too bad,' was Naomi Mitchison's flat reaction to such squeamishness. Ethel Mannin agreed: 'It was snobbish; it was class distinction; it was exploitation; but it worked.'

The domestic labour market seemed to her to be balanced evenly between employers and employees, with vacancies always available for any maid who wanted a new or better mistress. Mannin was grateful for the system, yet she recognised that it was based on a fundamentally irreconcilable relationship. When, years later, she ran into a woman who had once worked for her, Mannin confessed how ashamed she still felt at having treated her servants *de haut en bas*, but the ex-housemaid warmly reassured her to the contrary: 'Oh, no, Madam! You were sweet!' She had spent years reproaching herself unnecessarily.

Guilt, angst and uneasy compromise are the themes of the servant problem, which runs like a plaintive refrain through both Vanessa Bell's and Virginia Woolf's correspondence and diaries:

I won't write any more about servants. I'm feeling as if I'd rather do all myself than have these to-dos. Their conversation is more exhausting than that of all the intellectuals in London . . .

(Vanessa Bell, *Letters*, 3 July 1918)

Nelly Boxall, the Woolfs' general servant, was like a thorn in Virginia's side. When she finally left the relief was overwhelming:

It is the freedom from servants that is the groundwork & bedrock of all this expansion . . . I say, as I walk the downs, never again never again. Cost what it may, I will never put my head into that noose again . . .

(Virginia Woolf, *Diaries*, 6 August 1930)

The Nelly years had driven Virginia almost demented, causing her to long for a 'domestic establishment . . . entirely controlled by one woman, a vacuum cleaner, & electric stoves'.

This vision of happiness incorporates labour-saving devices that are now fundamental to our lives. Instead of traumatic scenes with housemaids and cooks, might a tumble-dryer, a dishwasher and a set of Teflon frying pans have resulted in greater novels, more profound poetry, finer works of art? The dream recedes, for housework must be done, and washing up, and laundry, even in Bohemia.

For Vanessa, anything that interfered with her desperate desire to paint was a torment. Yet there were times when dealing with the servants became so dominating that everything else simply ground to a halt. Writing woefully to Duncan Grant, she tried to explain why she couldn't come up to see him in London. There was Mrs Pitcher's day off, and Nelly's day off, and there were too many burdens on Nelly to leave her all alone with the children. And Jenny the cook had recently quit, leaving a trail of disaster in her wake:

I have to listen to endless stories of the horrors Jenny left behind her. In fact she did leave the larder in such a state that I had to spend all yesterday morning cleaning it out preparatory to Mrs P's scrubbing it. How I hate these domesticities. I can't conceive what the female mind is made of . . .

I haven't been able to paint yet . . .

Vanessa's break with her Victorian past was unresolved. She felt an innate wish to have order and cleanliness around her, yet the conventional oppressed her. She felt imprisoned by households such as Cleeve House, the home of her Bell parents-in-law in Wiltshire. There the heavy oak panelling, stuffed wildlife, impeccable domestic staff, above all the unutterable dullness of the Bells themselves, seemed like a 'swamp and fog' around her, making her yearn to live differently, to throw off the trappings of so-called civilization.

But in the meantime one had to live in the real world. As Vanessa found out, it was not possible to be an artist and keep up Victorian standards at the same time, particularly if one had a family. The scrubbing of the kitchen stairs before breakfast had to take second place when the larder started

to pose a health risk, and wiping specks of dust off bookcases became a distant memory. Time at one's easel was way down the list of priorities. Thus it was essential to have a reliable support system in the form of efficient, pleasant, prudent servants, who understood and tolerated her way of life.

There were of course no guarantees of getting a 'treasure'. Servants are human beings, with problems, failings and foibles. The upper classes retreated from contact with their servants behind a cordon sanitaire of class status. By contrast Bohemia felt, in theory at least, a desire to treat the domestic underclass with respect and consideration, and that meant contact with them. Nina Hamnett took a special pleasure in charladies. She often used this lowly breed as models, and saw them as belonging to a singular race: 'Someone ought to do a book on charwomen with illustrations. No one has I think done it, and there are so many funny stories . . .'

Occasionally, servants turned out to have undiscovered artistic potential. Harold Acton spent his teenage holidays at a rectory near Brighton. He whiled away many idle hours in the kitchen with Hetty and Mabel, the housemaid and cook, encouraging them to develop their considerable poetic gifts. 'Sympathy', 'A Parting Token' and 'Midnight Fancies' were among their outpourings. They loved, too, to listen while Acton read aloud to them from Keats and Boccaccio.

Beatrice Campbell took on a servant who was inspired by her mistress's paintings and started to draw. Beatrice presented her with a paintbox, and she became very enthusiastic, neglecting the housework. But she had to go when she started painting on top of Beatrice's pictures. The gift was later discovered shoved away in the boiler room – 'she had given up Art'. Beatrice's memoir also gives one glimpses of a series of servants who turned the Campbells' daily life into a procession of near-calamities. There was the daily help who washed her hair in petrol and almost set the house alight when drying it in front of the fire. Mrs Conybear boiled cods' heads for her cat, and the stench was at times almost unendurable. Another servant got pregnant, while her successor went mad and tried to kill herself by drinking disinfectant. Then there was the cook's unemployed sister who, unknown to Beatrice, came and squatted in the maids' sitting-room sink for some days before she was discovered.

The close proximity of maids and mistresses could result in the build-up of volcanic pressures and stresses. Some servants felt close to despair at the pointless, footling endlessness of their work, the ironing of newspapers, and even of bootlaces. In Margaret Powell's memoir *Below Stairs* (1968) we hear the other side of the story:

It was the opinion of 'Them' upstairs that servants couldn't appreciate good living or comfort, therefore they must have plain fare, they must have dungeons to work in and to eat in, and must retire to cold spartan bedrooms to sleep . . .

But if 'Them' upstairs could have heard the conversations the parlourmaids carried down from upstairs, they would have realised that our impassive expressions and respectful demeanours hid scorn, and derision.

The housekeeper at Charleston, Grace Higgens, never uttered a word of complaint, and took pride in her standards of service, yet there can be little doubt that her employers exploited her loyalty. The Charleston artists weren't the easiest people to clean up after. They brought clay from the pottery into the house on their boots. A still life of a dead hare or a loaf of bread might not be disturbed though it putrefied on the sideboard. There were jolly dinner parties that went on till late, with the company sitting at table and Grace unable to clear until they had all moved to the drawing room. Once she returned from her annual summer holiday in Norfolk to find the entire week's washing-up waiting for her piled up in the kitchen sink. Grace's husband, Walter, who gardened, was expected to keep himself and his wheelbarrow clear of the front garden while the family were in the dining room, so as to leave their view of the pond unimpeded. Their son John was in hot water if he was spotted filching so much as a dangling pear from over the garden wall. Many of the assumptions, if not the practices, of the nineteenth century were bred into Vanessa's bone, and another genera-tion was to pass before any middle-class matriarch with the resources to employ a servant felt capable of scrubbing a floor or cleaning a saucepan herself. The wonderful freedom to be had, at so modest a price (when Grace retired in 1970 she was earning a mere £5 a week, plus her board), blinded Vanessa to this exploitation. Her vision was reserved for her painting.

The twenties and thirties were a curious transitional period for women who were for a few decades free of the household chores which had been thought for so long to be women's work . . .

commented Naomi Mitchison on this phenomenon.

Quite a number of women took advantage of this new freedom to write, paint, do scientific or historical research, become doctors, lawyers and so on. I was one. Clearly without domestic help I could not have had a family and been a successful writer.

To Naomi Mitchison this position was axiomatic. Like Vanessa Bell she stood with a foot in each camp, straddling the centuries. Part of her wanted to be a Victorian hostess with guests dressing for dinner, but another part wanted to forsake civilization and go to ground in cosy, squalid, dirty Bohemia, where she could kick off her shoes and write novels in peace. Spotless furniture and punctual meals weren't indispensable for her writing – Mitchison was often at her most productive on a train, riding round the Circle Line – but something in her required an orderly home.

This dilemma is one far more frequently experienced by women than men, but in his romantic youth Cyril Connolly was torn between Bohemianism and respectability. Connolly the Bohemian found conventionality ugly and soul-destroying, and hankered after a life dedicated to the quest for Beauty. Connolly the snob and socialite longed for a well-regulated home, and dreamed of sitting at breakfast with a wife 'with two newspapers and the marmalade between us'. The outcome was a messy compromise. Connolly found it difficult to curb his natural untidiness. His hosts commented on how he left dirty handkerchiefs lying about and unstoppered fountain pens open in books. Attempting to 'live for beauty', he also succumbed to piggery. Aldous Huxley was repelled by the 'Bohemian disorder' of the Connolly household, by the pet lemurs, ferrets and marmosets who, no more housetrained than their owners, were fed on raw bleeding meat by Cyril's first wife, Jean, who then wiped her stained fingers down the front of her embroidered Chinese dressing-gown. When another friend, Enid Bagnold, arranged for Cyril and Jean to take the tenancy of a house near to her in Rottingdean, she soon regretted it. The property was left in a sordid state, the carpet holed and stained, the furniture damaged and ink-blotted, the paintwork yellowed and blistered by burning cigarettes. It would appear that 'living for beauty' resulted in its antithesis.

<div style="text-align:center">*</div>

Caught between art and drudgery, Bohemia doubtfully, at times resentfully, and often incompetently confronted the ever-encroaching chaos. As ever in those proto-feminist days, when it came to tackling the domestic enemy, women were on the front line. It is true that some women were starting to question the assumption that their sole *raison d'être* was to keep house for their menfolk. In 1928 a public debate was held on the subject 'Should the home be abolished?' Mrs Cecil Chesterton was in favour of every girl's right to that cherished possession, a home and family. But Dora Russell argued fiercely that 'shutting women up in brick boxes . . . will result in a surplus of empty-headed women who would become the curse of civilization'. The

audience voted in favour of abolition, and the few men amongst them left complaining that they felt humiliated.

Nevertheless a reading of the correspondence of women artists of this period shows how completely the majority of women still accepted that domestic labour was their lot in life. For such artists this burden was doubly damaging. They suffered both from men's selfish assumption that housework was women's work, and from the intense frustration of being unable to work in their chosen field.

That Dora Carrington was able both to paint and to keep house for Lytton Strachey must in some part be attributed to her childlessness, for it fell entirely to her – with one living-in servant – to run their home, first the Mill House at Tidmarsh and subsequently Ham Spray near Hungerford. Some have surmised that Carrington's willing absorption in housekeeping was a tactic to avoid commitment to her art. Gerald Brenan was less kind – he dismissed her as shallow:

Did you ever see a woman more absorbed in physical objects? If one looks for her interests, her affections, her desires, one will find them not lying coiled up in her head but stuck on to the garden, the meals, the furniture, the hot-water bottle . . .

Brenan was, like so many of her admirers, consumed by the kind of jealousy which makes of its object a scapegoat. For me, her correspondence betrays a refreshing focus on the detail of an artist's daily life – that platform from which all creativity must be launched.

Carrington was a part-time Bohemian. In London she was to be seen at the Café Royal wearing gypsy clothes and flirting with Augustus John. In her personal life she upturned the conventions. But away from Fitzrovia and the Cave of Harmony club, in Wiltshire where her heart lay, another side of Carrington emerges. Devotion to Lytton extended to the care she took over the small particulars of their everyday existence. She appreciated it when the chair covers were clean, she liked to fill her storeroom with bottled gooseberries and pickled pears. Carrington was a surprisingly committed housewife – if that is an appropriate word to describe a woman keeping house for a homosexual man who was not her husband. She tried to ensure that Ham Spray was clean and warm, she supervised Mrs Legg the cook, dug vegetables and made beds for their frequent visitors. Occasionally, she complained:

Clive Bell and Mrs Hutchinson came here last weekend. They aren't my style. Too elegant and 18 cent. French; for that's what they try and be . . . I had to make their

beds, and empty chamber pots because our poor cook Mrs Legg can't do everything and that made me hate them, because in order they should talk so elegantly, I couldn't for a whole weekend do any painting and yet they scorned my useful grimy hands.

Lytton's attenuated white fingers were rarely expected to come into contact with anything more grimy than a volume of Voltaire, though his condescension in helping her when the servant was indisposed was noted with gratitude by the faithful Carrington:

What a horrid scene to see before one when one starts a letter to an orderly young gentleman *of taste* in Nottingham [she wrote to Lytton's young Cambridge friend Sebastian Sprott]. Breakfast, lunch and tea mingled with fragments of Vita Wheat. Jam on the plates, whiskey jostling with ink pots. You see to what a pass I am reduced and my chamber pot is still unemptied and the beds NOT made, or is it merely an excuse for drawing a still-life après le grand maître Monsieur Fry? Who can tell, who indeed? Olive is away in bed with lumbago, so Lytton and I have to cook for ourselves. (Lytton is a first-class bed-maker.)

Carrington illustrates her letter to Sebastian Sprott with 'a still-life après le grand maître Monsieur Fry'.

With the objectivity of the true artist, Carrington notices things. She can create a still life from a messy table, just as she can make one feel her dismal rage at the unreliability of anthracite stoves. One admires her stoicism at having to carry pails up to the attic to catch the drips that ooze through the library ceiling after a winter gale has blown the roof tiles off. One sympathises with her frustration at the perversity of inanimate objects – 'motorcars refuse to start, scissors disappear and gloves walk off and hide themselves'. How close to the real texture of everyday nuisances and vexations these accounts

bring one. But Carrington is not downtrodden. Here is a life one can identify with. Her letters, adorned as many of them are with charming illustrations, testify to a wealth of absorbing interests – literature, painting, love affairs, friendships, parties. Carrington had her own interests, and she had Mrs Legg. She felt supported in her enterprise.

It is harder to envy Stella Bowen, a painter in her own right, living with the novelist Ford Madox Ford. While he wrote, she ran the house:

My painting had of course, been hopelessly interfered with by the whole shape of my life, for I was learning the technique of quite a different role; that of consort to another and more important artist. So that although Ford was always urging me to paint, I simply had not got any creative vitality to spare after I had played my part towards him and Julie [their daughter], and struggled through the day's chores . . .

Pursuing an art is not just a matter of finding the time – it is a matter of having a free spirit to bring to it.

Stella claimed that she was happy and grateful at the time to be housemaid and moll to the great man, but she recognised that this was at the expense of her own creativity. She saw painting as incompatible with cooking meals and doing chores. Certainly, there was not room for two obsessive artists in that small Sussex cottage.

The biographies and memoirs of the twentieth century are littered with the casualties of artistic male egos. What kind of contortionists were women expected to be? Placed on the customary pedestal, woman was also required to reach down and polish her worshipper's boots. It should not be forgotten how many artists have been supported by unpaid housekeepers – scullions, cooks, laundry maids, and muses all rolled into one.

There was Ida John mopping up after a squad of children, and Dorelia who gradually sacrificed her own talent to the demands of Augustus's rambling household. There was Edna Clarke Hall giving up art for mother-hood and housekeeping, and Caitlin Thomas borne along in the wake of Dylan's drunken disorderliness, gasping to keep her head above water, cook, wash and bring up the children. Nancy Nicholson had to compete with Robert Graves for time at her easel, while he increasingly objected that her housework intruded on the space he needed to write. Hilda Carline's desire to paint was squashed out of her by the demands of keeping house for Stanley Spencer, and poor oppressed Christabel Dennison's hands got sore with washing-up after her ungrateful lover. And not all of them were as patient with their lot as Stella Bowen. Katherine Mansfield was appalled to find herself a skivvy to John Middleton Murry. It didn't fit with her idea of

herself at all and, desperate with frustration and desire to get on with her writing, she berated him for his selfishness:

I hate hate *hate* doing these things that you accept just as all men accept of their women . . . I walk about with a mind full of ghosts of saucepans and primus stoves and 'Will there be enough to go round?' . . . and you calling (whatever I am doing) '*Tig*, isn't there going to be tea? It's five o'clock' as though I were a dilatory housemaid.

I loathe myself, today. I detest this woman who 'superintends' you and rushes about, slamming doors and slopping water – all untidy with her blouse out and her nails grimed. I am disgusted and repelled by the creature that shouts at you, 'You might at least empty the pail and wash out the tea-leaves!' Yes, no wonder you 'come over silent'.

. . . All the fault of money, I suppose.

Chained to the sink by tyrannical, unthinking men, one can but wonder that any works of art were produced by women at all.

<p align="center">*</p>

One may search in vain for accounts of British male artists rubbing, scrubbing or ironing.★ For them, the laundry was a no-go area.

Few of the gifted men of that era emerge as having any awareness of how their shirts and handkerchiefs got washed and ironed at all. Dylan Thomas scorned to bother with washing clothes. If he needed a clean shirt, he took one from a friend. Constantine Fitzgibbon found it difficult to imagine the poet taking his things to a laundry, and 'impossible to envisage his retrieving them or even remembering where the laundry was . . . all that sort of thing was left to women'.

If emancipation meant being let off wash-day, it would surely get most women's vote. But sending the laundry out could be prohibitive. In 1911 the Epsteins' quarterly laundry bill came to £2 3s 2d, and when such costs threatened to dominate the Johns' erratic budget Ida decided to take charge of the washing herself. In her pregnant state she found a certain maternal

★ The Ukrainian writer S. S. Koteliansky was by contrast extremely adept at laundry – he did all his own, even including the blankets, according to his friend Beatrice Campbell, but this was so surprising and foreign as to deserve special mention. Kot was intensely houseproud, and was apparently an expert polisher, having learnt a special method from Russian servants who tied dusters to their feet and slid across the floorboards; his hall floor was so highly polished that guests lost their footing and had to cling on to the banisters to get through the house.

satisfaction in the results of a laborious washday: 'It is such a proud moment when one puts on one's self washed drawers and nightdresses. And the muslin curtains are a picture.'

But for very hard-up artists the possibilities of keeping one's clothes clean and smooth in the approved manner were undoubtedly limited; cheap studios rarely had hot water. The model Betty May remembered having only one dress, which she would wash herself and then put on wet, having nothing else to wear. Kathleen Hale proudly recalled her expedient for laundering her own handkerchiefs, which, once washed, she would spread out on her small looking-glass, where they would dry beautifully flat 'as if freshly ironed'. Iris Tree had a bath in her dress which she soaped and rubbed and then hung up to dry while she rinsed herself.

But far more Bohemians went about soiled and grubby, just because it was easier. A lot of art is messy; it stains and it smells of turpentine. Also, artists felt that their lives should be conducted on a higher plane than that of the kitchen sink. The glimpses that we get of artists striving to keep abreast of the housework are few and far between, for housework is trivial and degrading, and relegated where possible to servants. Kitty Garman never saw her mother, Kathleen, do a stroke of housework. A down-at-heel charwoman was all she could afford, and if Mrs Mop didn't do the work, nobody did. 'I never saw my mother in an apron. She didn't even know what oven gloves were for.' Kitty herself was indignant when her husband, the artist Lucian Freud, expected her to sweep the studio floor: 'I felt made for better things.' Rendered semi-helpless by their upbringing, none of the Bohemian women who attempted the job themselves matched up to 'l'Allegra', even had they wanted to – which Caitlin Thomas didn't:

I knew how to do nothing in the house, none of the domestic things that most normal women learn as they are growing up. I thought that proved that I must be different, set apart, meant for 'better things' than being the abandoned housewife of a famous poet. Even when I was not abandoned, the very term 'housewife', as applied to me, made me squirm with disgust.

Kitty and Caitlin were raised as Bohemians; they had a relaxed attitude to squalor. But women who had been brought up with upper-class standards of cleanliness, utterly reliant on servants, often got a nasty shock when they emerged into the outside world entirely unable to look after themselves. Nancy Mitford won a hard-fought battle to go and be a Bohemian writer in a bedsit, but to her sister Jessica's disgust returned home ignominiously after only a month:

'How *could* you! If I ever got away to a bed-sitter I'd never come back.'

'Oh, darling, but you should have seen it. After about a week, it was knee-deep in underclothes. I literally had to wade through them. No one to put them away.'

Others of necessity submitted to doing the chores with a good grace. We even get glimpses of 'l'Allegra' in Ida John, who at one stage goes 'mad on polishing furniture'. We see Dorothy Brett helping Mark Gertler sort out his belongings; she devotedly dusts all his books 'and did many things which I shouldn't have thought of myself'. Kathleen Hale in the new-found independence of her 'beautiful, shabby' Fitzroy Square room, is consumed with pride at the purchase of her first slop pail – 'I'd wake up in the morning and see it there and think "It's mine!"'. Betty May spent a brief period playing house with one of her many husbands, rearranging the furniture and whitewashing the walls, but before long it was back to Bohemia: 'the pleasures of housekeeping grew stale as fast as the other pleasures of this provoking world'. Poor Christabel Dennison remains as ever submerged in ghastly domestic tasks. She lives in a kind of nether region, a sub-Bohemia colonised by dripping laundry, unwashed saucepans and incontinent cats. But just occasionally l'Allegra surfaces reluctantly even from these cheerless depths:

Never have I felt so happy and sufficient. I have washed my clothes and spread them on the lawn to dry. Prettily the thin white lies upon the luxuriant grass scattered with dull yellow leaves . . .

I have scrubbed the scullery and whitened the door steps and the stone of the copper. While I scrub, I think of nothing but the pleasure of the red wet tiles. Keeping things bright and clean is the pleasure of old maids.

The artist in Christabel couldn't help relishing the picturesque qualities of a simple activity. Humble household jobs can have a certain aesthetic satisfaction, even becoming a creative outlet for the frustrated individual.

Anna Wickham, for example, was a talented singer who had the misfortune to marry a dominating man with no interest in her as an artist. After their marriage she gave up her musical career, had four sons, and played the role of model wife until it became suffocating. Eventually she began to write poetry in secret, but when her husband found out he was outraged and forbade her to write any more. A violent row broke out, Anna smashing her hand through a glass door, at which her husband had her certified insane. She was forced to spend two months in a mental asylum. Afterwards, she returned to her husband and children and continued clandestinely to write

poetry. Thwarted as an artist, she vented much of her energy and passion on needlework. Betty May visited her and was bewildered to hear Anna declaiming about books and writers while furiously knitting. On another occasion Nina Hamnett arrived and was amazed to find every surface of the room festooned in garlands of boys' socks, full of holes, waiting to be mended: 'there must have been about one hundred'. Anna was sitting in their midst, darning like a demon, confident that the entire job would take no more than three hours.

Seemingly monotonous jobs can be very soothing. A ball of wool and a clutch of knitting needles by the Charleston fireside recall Vanessa's after-dinner habit. As her family and their friends waxed argumentative about art and socialism, knitting socks helped her to wind down from the pressures of the day. Robert Graves remarked on how quiescent the turbulent poet Edith Sitwell could become, spending a quiet weekend with him and Nancy sitting on the sofa hemming handkerchiefs. D. H. Lawrence was given to sudden rages. He would rave, roar, beat the table and abuse everything and everybody. There was great relief all round when the table-banging subsided and he settled down to some therapeutic needlework, hemming for preference.

Such useful toil was more than calming, it was economical, an important factor for many artists. Before the Second World War the 'make do and mend' ethos was still a primary consideration. Sheets were always repaired, buttons sewn on. Nobody could afford to throw out a pair of socks just because it had holes. The socks had to justify their expenditure, and time had to be dedicated to making them last as long as possible. Over such gentle thrifty tasks women through the ages have woven intimacies, remembering, dreaming, and hoping, stitching their loves and longings into the ravelled sleeves of worn-out woollies. Those were the happiest, the most peaceful evenings that Beatrice Campbell always treasured from her friendship with Katherine Mansfield, as the pair sat by the fire darning their husbands' socks, talking of their homes and childhoods, reliving the anticipation before a party, or recollecting their families across the sea – before it was up with the lark again to battle with the bedclothes and saucepans and pails and the endless, endless washing-up.

<center>★</center>

Rebecca West denounced housework as 'rat-poison', and fiercely defended the right of women to do as little of it as possible. Needless to say, there are certain risks attached to never cleaning the lavatory or allowing food to moulder, but there is nothing intrinsically wrong in neglecting housework.

The conflation of moral values with hygiene has led to misdirected accusations of depravity around a sector of society that had no cause for shame in that respect. Liam O'Flaherty fiercely defended the right to be dirty:

I know people who never cleaned their teeth or took a bath and were yet more interesting and fundamentally moral than the cleanest city clerk, who cleans his teeth after each meal and takes a bath twice a day. I loathe uniformity . . .

Unluckily the charge, like mud, stuck. The definitions of words like slattern and slut are blurred between slovenliness and sexual promiscuity. Bohemia's 'fault' has been in devoting more energy to the activities associated with art than to those associated with cleanliness; and in protesting at the exaggerated standards expected by the moral majority, which just seemed an absurd waste of time.

When Vanessa Bell and Duncan Grant visited the painters Nan Hudson and Ethel Sands in Normandy in 1927, their two house-proud hostesses outraged the Bohemian in Vanessa. 'Please,' she begged Roger Fry in a letter, 'send us a glimpse of ordinary rough and tumble, dirty everyday existence.'

I am beginning to collapse from rarefaction here. The strain to keep clean is beginning to tell. Duncan shaves daily – I wash my hands at least 5 times a day – but in spite of all I know I'm not up to the mark. The extraordinary thing is that it's not only the house but also the garden that's in such spotless order. It's also impossible to find a place into which one can throw a cigarette end without its becoming a glaring eyesore. Ethel goes out and hunts snails till there are practically none left. Old men come in and polish the floors, women come and cut the grass, others come and wash, Nan makes muslin covers to receive the flies' excrements (I don't believe Nan and Ethel have any – they never go to the W.), everything has yards and yards of fresh muslin and lace and silk festooned on it and all seems to be washed and ironed in the night. No wonder they hardly ever paint . . .

Vanessa was desperate to get back to her 'home dirt'.

Women like my grandmother were privileged in being able to pursue their careers liberated from the sink and the washtub. If only on this front, the tale of the twentieth century is a tale of progress. Such women were not prepared to punish themselves running around all day with a Ukanusa Drudgee. Impressive paintings resulted, many of them domestic in their subject matter. *The Tub* (painted 1918) is innovatory in its simple, highly Post-Impressionistic treatment of three fundamental motifs – naked woman,

bathtub, vase. Vanessa loved to paint the simple objects around her –
kitchens, cups and saucers, fruit and vegetables. Removed from the duties
connected with them, she felt able to celebrate the quotidian, the daily
matter in which our lives are rooted. Carrington's letters and diaries, ever-
attentive to the issues of washing-up, food and servants, are also surely a
remarkable testimony to the aesthetic rewards of domesticity.

In her illuminating study of early twentieth-century women's fiction, *A
Very Great Profession* (1983), Nicola Beauman makes a convincing case for
domesticity as a fruitful topic for the novel, in that it touches on preoccu-
pations that are of absorbing interest to a female audience. She points out
that a tradition of male-dominated criticism has expelled works that depict
the everyday details of women's lives from the canon of durable art. Today
the clichéd sneer 'Aga-saga' still attaches with regrettable ease to works of
fiction which dwell on the trivia of life. Nicola Beauman speaks for many
women who are left cold by 'important issues', and seek 'with a desperate
and almost perverted yearning for a mere crumb of everyday reality',
something with which they can wholeheartedly identify. The hard-won
freedom for artists to recollect domesticity in tranquillity is something to
celebrate.

8. The Open Road

Is it necessary to stay in one place? – What is the purpose of travel? –
Is it preferable for English people to live in England, or is France
better? – How does one differentiate the true traveller from the
tourist? – What does one need to pack? – Is it necessary to
have a roof over one's head? – Is the love of speed a
symptom of creativity?

In Autumn 1908, Kenneth Grahame published his classic children's story, *The Wind in the Willows*. His great creation, Mr Toad, epitomised the growing passion for what might be called Bohemian travel:

[Toad] led the way to the stable-yard . . . the Rat following with a most mistrustful expression; and there, drawn out of the coach-house into the open, they saw a gipsy caravan, shining with newness, painted a canary-yellow picked out with green, and red wheels.

'There you are!' cried the Toad, straddling and expanding himself. 'There's real life for you, embodied in that little cart. The open road, the dusty highway, the heath, the common, the hedgerows, the rolling downs! Camps, villages, towns, cities! Here to-day, up and off to somewhere else to-morrow! Travel, change, interest, excitement! The whole world before you, and a horizon that's always changing! . . .

'You surely don't mean to stick to your dull fusty old river all your life, and just live in a hole in the bank, and *boat*? I want to show you the world! I'm going to make an *animal* of you, my boy!'

Exactly at the time of *The Wind in the Willows'* first appearance, Augustus John, who shared certain Toad-like characteristics, was dreaming of uprooting his family and taking to the road in his newly painted bright blue caravan. 'The call of the road is on me. Why do we load ourselves with the chains of commodities when the trees live rent free, and the river pays no toll?' By spring 1909 they were ready to set off. As well as the bright blue caravan, they had a yellow cart, six horses, a couple of tents, and a crowd of ragged bare-footed children to complete the picture. Thus equipped the convoy made its ramshackle progress through the Home Counties, scandalising the

respectable elements of society and entrancing their disreputable counter-parts, in due course arriving in a field outside Cambridge where their appearance caused wonder and consternation among worthy dons and townspeople alike. The family were gypsies for four months. Of course, it turned out to be a most uncomfortable life: the children all caught whooping cough, the horses died, and September saw Augustus back in Chelsea. But he never lost his taste for the open road, that addictive thrill that accompanies departures and embarkations for foreign shores.

*

By the turn of the century 18,680 miles of railway track linked destinations across England. These were the great early days of the commuter. In 1900 these bowler-hatted gentlemen started work at ten, and were probably on the five o'clock train home to Metroland, in time for some healthful outdoor recreations, before changing for dinner. The commuting life was not such a chore as we may imagine. With the electrification of the suburban railways around London, travel by train improved each year. Some of the trains were luxurious; seated in upholstered easy chairs one was served with tea or alcoholic refreshments by uniformed attendants. The railway companies sought to make long journeys as painless as possible, providing civilised restaurants, commodious toilet compartments, perfumery and shoeshine facilities. A person would hardly know they had left home.

But this kind of airtight, shut-in travel was the antithesis of those mythic journeys for which the free spirit hungered, the wanderings of Ulysses, Aeneas, the tribes of Israel. Undiscovered countries beckoned the Bohemian; to be an artist was to be a gypsy-at-heart, dreaming of the wind on the heath, of odysseys, of limitless horizons. A whole world stood waiting to be explored.

For centuries travellers from this island race have sailed the seas, scaled peaks, explored and circumnavigated, driven by missionary zeal, avarice and scientific curiosity. Continental Europe was familiar to those young men whose parents sent them to experience culture and sexual initiation on the 'Grand Tour'. But the kind of travel bug that infected Toad and Augustus John was different. Its symptoms had started to appear in an acute form among artists and writers during the early nineteenth century. Although there were very specific political and personal reasons why poets like Keats, Shelley and Byron went abroad, their later wanderings in Italy left a legacy of rhapsodic imagery. The imagination was stirred by Byron's Venetian infamies, by Shelley's tragic end on Tuscan shores, by Keats the youthful genius wasting away in Piazza di Spagna, by Browning's Renaissance

duchesses and lovers in the Roman Campagna. And then how powerfully Stevenson appeals to the restless nomad: 'For my part, I travel not to go anywhere, but to go. I travel for travel's sake. The great affair is to move' These wanderers stirred up uneasy longings for flux and bustle among rats and moles who felt stuck in their fusty river bank. Something enchanted and fascinating seemed to emanate from those southern skies and ancient civilizations, something our chilly grey climate could never inspire.

Bohemian means gypsy. Insofar as the artist had already made the mental journey to that other, notional country of Bohemia, he was implicitly a traveller, and it only remained to set out. The true artist could never be content to rot interminably in Chelsea or Fitzrovia; as a Bohemian it was one's duty to explore in search of truth and sensation, to roam the surface of the earth seeking new colours, new voices, new tastes.

Cattle-throwing in Provence, bull-fighting in Spain, taming wild horses on the Russian steppes, joining the Gypsies or the Apaches for the life of a lawless vagabond, bathing naked in phosphorescent waters, climbing mountains in Connemara to faery lakes: these were the kind of exotic experiences that fed the Bohemian imagination. Imprisoned for pacifism in 1918, Bertrand Russell wrote a lyrical travel brochure of his fantasy life to Ottoline Morrell:

There never was such a place as prison for crowding images – one after another they come upon me – early morning in the Alps, with the smell of aromatic pines and high pastures glistening with dew – the lake of Garda as one first sees it coming down out of the mountains, just a glimpse far below, dancing and gleaming in the sunlight like the eyes of a laughing, mad, Spanish gypsy – thunderstorm in the Mediterranean, with a dark violet sea, and the mountains of Corsica in sunshine far beyond – the Scilly Isles in the setting sun, enchanted and unreal, so that you think they must have vanished before you can reach them, looking like the Islands of the Blest, not to be achieved during this mortal life – the smell of the bog myrtle in Skye . . .

Russell was no Bohemian, but he was intensely susceptible, driven by powerful desires, and resolutely unconventional. His yearnings give shape to the amorphous romanticism of a generation who, like him, felt locked up by a narrow-minded society. Those enchanted islands in the sea embodied the aspirations of the artist for whom the average British holiday – a day out in Epsom or a week in lodgings at Broadstairs – held all the appeal of a cold rice pudding. Savour life, they seemed to say, drink deep, breathe a purer air! Away from the oppressive conventions of English society, which frowned so

ferociously on bare feet, on beards, on homosexuality, on defiance and nonconformity of all kinds, you could be who you really were. In foreign lands you could glory in feeling yourself to be a misfit.

Ethel Mannin identified powerfully with the nomad. Her series of essays *All Experience* (1937) is a hymn of praise to wanderlust by one who from an early age nurtured dreams of seeing oranges growing on trees, and vineyards, and houses with green shutters: 'Going aboard a steamer by night; coming into a foreign port in sunshine . . . blessed are they who know the thrill, for theirs is the adventure of living, the colour of the world, and the glory.' For her, non-travellers were guilty of apostasy:

When people tell me, 'England's good enough for me,' I always feel like crying to them, 'My God, don't you realise that one day you're going to die, and that there's the whole of this amazing world to see . . .'

Mannin felt set apart from such stuck-in-the-muds. People content to stay in one spot didn't deserve to be alive – people like Jessica Mitford's father, Lord Redesdale, who exemplified English insularity and hatred of Johnny Foreigner:

According to my father, outsiders included not only Huns, Frogs, Americans, blacks and all other foreigners, but also other people's children, the majority of my older sisters' acquaintances, almost all young men – in fact, the whole teeming population of the earth's surface, except for some, though not all, of our relations and a very few tweeded, red-faced country neighbours to whom my father had for some reason taken a liking.

Xenophobia was rife among the ruling classes. Lord Redesdale was not untypical of his generation, which had seen the expansion of the British Empire in lands beyond Europe, and which, from its lofty position as imperial ruler, regarded most foreigners as contemptible and indecent. 'Abroad' was 'unutterably bloody', a place fit only for perverts and pinkos; if you didn't fall foul of the bad drains you were liable to be shot by anarchists or buggered by dagos. It was a place where people spat in railway carriages, where the food was full of nasty garlic and grease, and where you were lucky if you just got away with flatulence and rancid indigestion.

For the Victorians, the Continent was a place of banishment, or refuge, depending on your point of view. Offenders against the law or social conventions took themselves off to some small French or German town where they mouldered for a season or two and hoped that their faux-pas

would be forgotten by the time they returned. Only the colonies could be worse than such an imposed exile. Even writers of fiction preferred to remove their principal characters from British soil when they were too flagrant in their contraventions: Herminia Grey has her illegitimate child in Perugia, Ann Veronica runs away with the married Capes to Switzerland. These were lands – like Bohemia – where English conventions held no sway. The disgraced Oscar Wilde lived out his days in Paris after his release from prison; later the tolerant atmosphere of Berlin was to make it a haven for homosexual artists and writers. Violet Hunt, after her scandalous affair with the married Ford Madox Ford, became unacceptable in polite society. Her closest friends begged her to stay away from London for everyone's sake: 'Do be wise,' implored the novelist Mrs Clifford, 'and live abroad for a few years . . . I would do a good deal for you but I should simply quake if you came here on Sundays, and I believe other people would walk out. – *Go away for three years!*'

Rosalind Thornycroft, when her marriage to Godwin Baynes collapsed, did exactly that. In 1920 she decided to go, with her children, to Italy. It was a hard decision to leave her supportive family, but her resolve was strengthened by the thought of how damaging the publicity attendant on her divorce would be to them if she stayed. Rosalind was immensely helped in the practicalities of her self-imposed exile by her friend D. H. Lawrence, who was eager to leave England for different reasons – he was angry at the suppression of his novel *The Rainbow*, and felt drawn by sun and by the south. Lawrence was marvellous. He knew about visas and consulates. He checked the exchange rate for the lira, and told Rosalind how to get her heavy luggage sent out via a carrier in Pangbourne who would have it shipped to Rome. He advised her against sailing via Genoa, since Genoa harbour was on strike, and recommended that she go by train from Charing Cross to Turin ('22 hours only'), thence to Florence or Rome. He would go on ahead and meet her, either at Turin or Rome.

On arrival in Italy, Lawrence set about making strenuous enquiries on Rosalind's behalf for somewhere to live. An old family friend of the Thornycrofts who lived in a remote Abruzzese village was willing to help, but when Lawrence went to see the place it turned out to be quite unsuitable. To get there one had to ford icy rivers and climb craggy paths. The house proved to be 'staggeringly primitive'. Chickens wandered in and out, 'the ass is tied to the doorpost and makes his droppings on the doorstep and brays his head off'. The natives resembled brigands, and were unintelligible. There was no bath, and the children would have to be washed in the tub used for boiling pigswill. On his advice, Rosalind prudently opted not to live in this

mountain fastness, but chose instead Florence. How unaccountable it is to think of the author of *Women in Love* as this kindly and competent travel agent – but so it was. In Florence D. H. Lawrence was as conscientious as ever in his research and recommendations. He worked out that the little family plus their nanny could live in a nice *pensione* overlooking the Arno for less than £5 a week. And he knew all the train times from Paris to Pisa, and how to change at Pisa for Florence.

Soon after arriving there Rosalind took her three small daughters to Fiesole, where they lived in a succession of rented villas. Lawrence would come to visit them there. Always helpful, he cooked them English Sunday lunches and played with the little girls. In Frieda's absence he and Rosalind became very close. The Italian air was full of romance. Strolling through cypress woods and marjoram-scented hillsides, Lawrence and Rosalind talked about sex and poetry, sucked sorb apples and spat out the skins. Then they watched the sun go down over Florence, and kissed: 'My heart jumps with joy. We sit there until it is quite dark, our hands held together in union. And so to bed.' You couldn't get away with it at home.

<p style="text-align:center">★</p>

Meanwhile, England at the turn of the century stood isolated from the cultural ferment that was happening on the Continent. French literature and art, Russian novels and drama, the works of Ibsen: all were regarded as depraved, insofar as they were regarded at all. The rage, mockery and sheer incomprehension that greeted Roger Fry's first Post-Impressionist exhibition in 1910 was in part an expression of British narcissism and xenophobia in the arts. Conservatives saw the permeation of such foreign influences from beyond the Channel as a pretext for the suppression of 'degenerate' anti-English culture, particularly after the outbreak of the First World War. The Defence of the Realm Act (1914), popularly known as DORA, gave the government powers of censorship over publications 'likely to cause disaffection or alarm', thus making it possible for the authorities to deflect modernist ideas from the Continent. Meanwhile DORA also introduced passport regulations for travellers departing from or arriving in this country. Those regulations were never repealed after the war, and Fortress England was fast becoming impregnable.

The more the authorities – purity crusaders, bishops, Mrs Grundys and members of parliament – shored up our island defences against all things alien, the more beleaguered Bohemians were determined that nothing should prevent their escape. Feeling themselves to be surrounded by hostility in their own country, artists who valued what Europe had to offer were

overwhelmed by a sense that England was fast becoming an intolerable place to live.

How was modernism to stand a chance against Kipling and Morris dancers, Masefield and 'beer-swilling young men on reading parties'? complained Cyril Connolly. To read George Orwell's accounts of England in the twenties and thirties is to picture a country with a divisive class system, a malign education, intolerant politicians, and a corrupt press. It had ghastly food, hideous houses, ugly inhabitants, corrosive poverty. Its intellectuals were full of 'advanced' humbug, while its working classes were social climbers and snobs. The only solution was to get away – to France – to Italy – or best of all, in those early years of the twentieth century, for true artistic and personal salvation, to Russia.

'Everything Russian was fantastically moving to me,' remembers Frances Partridge. 'I was thrilled by the novels, translated by Constance Garnett, who was known to be the best; and I remember someone brought a Russian Prince to our country house in Surrey, and of course he wasn't really very glamorous, but anything Russian was so marvellous . . . Then my sister Ray went there in 1912, when I was only twelve, and she returned with photographs, and a book for me . . . And at the same sort of time I got taken to Diaghilev's ballet and we sat in a box and saw *La Boutique Fantasque* in the Coliseum.' Compared with the imperial territories of India, Africa and the Far East, Russia was still relatively unknown to the British traveller. The excitement of discovery was palpable. The glamour of droshkies and moujiks, the Bolshoi and the Nevski Prospekt seemed boundless. Bohemia was intoxicated by Russian literature, Russian cigarettes, Russian clothes, and of course the Russian ballet. Lydia Lopokova, Boris Anrep, S. S. Koteliansky, the painter and stage designer Pavel Tchelitchew and the sculptor Ossip Zadkine were familiar figures of London's Bohemia, and special cachet attached to people like Nina Hamnett, Bunny Garnett and Frances's sister Ray Marshall who had actually been there.

In 1904, when he was twelve, Bunny was taken by his mother, Constance, for an extended trip to Tsarist Russia; they went first to St Petersburg, where Bunny was most impressed by the sight of a fashionable lady seated in an open troika beside a large bearcub. In Moscow he learnt to plait birch-bark and to play the balalaika. Then they stayed on a country estate in Tambov province where Bunny made friends with the boys who herded the horses, sharing their kasha and stampeding with them across the prairies. Back on the Surrey Weald, his parents kept open house for political exiles, many of them Russian revolutionaries. When Bunny met his future wife, Ray Marshall, it was the fact that she had travelled to the Caucasus and followed

the course of the Volga to Nizhni Novgorod that made her unusually attractive in his eyes.

★

But Nizhni Novgorod was a long way to go in pursuit of artistic lustre. Across the English Channel, a few hours away by train and steamer, France challenged the Bohemian to ignore her. It was a challenge few could resist. Nowhere could be easier, for one could be in Dieppe by teatime, and Paris by dinner.

'Paris! Paris!! Paris!!!' – for Du Maurier's young artist in *Trilby* the word was magical, a name to savour, the embodiment of all his longings and dreams. Paris – that talisman for artists, that Mecca for the free spirit and the lover, that Bohemian country of the heart. If the notional Bohemia had any tangible existence, it was surely here, indisputably located on French territory, and comfortably separated from this island by plenty of water. For, of course, France was full of wicked and sinful French people, like George Sand, like Rodolphe and Mimi, like Nana or Baudelaire, Madame Bovary or Marie Duplessis. Fact mingled with fiction in British minds, but for most Paris was Babylon, the city of Sin, a sink of iniquity where men and women did unspeakable things, caught horrible diseases, and generally behaved with no regard for the decencies. The fears went deep. French political instability, memories of the Terror, ancient enmities, dread of social and philosophical subversion, instilled in British breasts a powerful disquiet about life on the other side of the Channel. At the same time, life in France held out dangerous and tempting promises of sexual liberty, fashion, and debarred pleasures. Its language was a code for secrets and intimacies, its food an aphrodisiac. Such a powerful combination made the French capital a place of alarming significance. For Mrs Grundy, Paris was like a malign blister. Not content with their tranquil middle-class life, she and her fellow-puritans became inflamed with a kind of fury against the French, affronted yet fascinated.

In 1928 a tour group from the Lord's Day Observance Society, chafed beyond endurance, set off to see for themselves. They did a European tour, including Sundays in Ostend, Montreux and Paris, and returned horrified by the appalling infringements of the Sabbath that they witnessed: people drinking alcohol in pavement cafés, theatres and cabarets playing to packed houses, 'frivolity – hilarity – betting – gambling – excitement – and revelries . . . Our Sunday in Paris was a Day of Desecration we shall never forget'. No good could come of it. In *Trilby* the quivering Mrs Bagot attributes her artist son's immoral liaison with a laundress to his residence in 'this accursed city':

Eric Gill's uncompromising appearance on the scaffold of Broadcasting House while carving *Prospero and Ariel* (*c.* 1930) – along with the rumour that he wore no underwear – brought him tabloid notoriety.

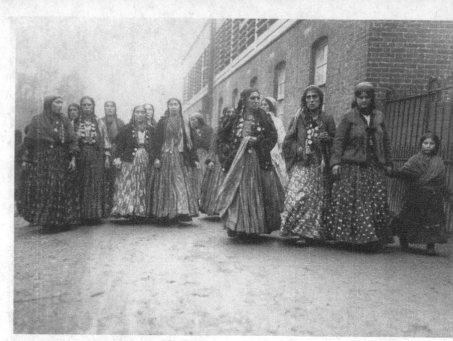

The Kalderasà invade Britain, 1911.

'The Slade cropheads' – Carrington, Barbara Bagenal and Brett, c. 1911.

'Study of a Gypsy' by Jacob Kramer, 1916.

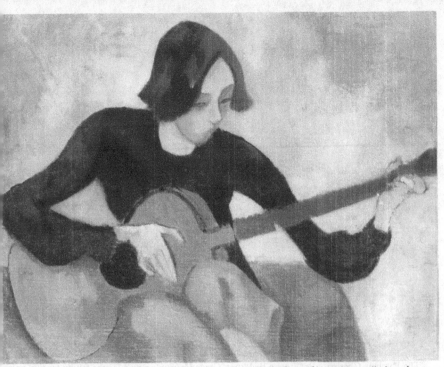

Roger Fry's image of 'Nina Hamnett with a Guitar', 1917–18, looks as if it could equally have been painted in 1968.

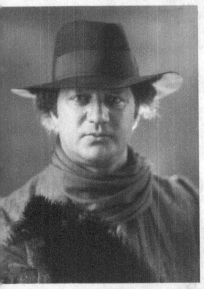

Jacob Epstein's 'court' rivalled Augustus John's in pre-First World War London.

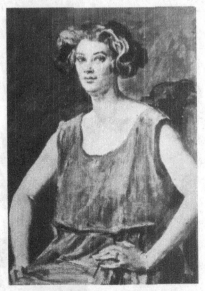

Augustus John's portrait of Viva King, 1922: 'I was known as "The Scarlet Woman", or sometimes "The Queen of Bohemia".'

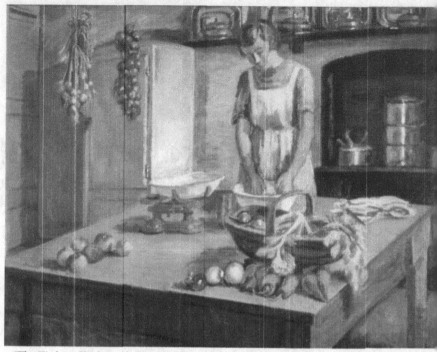

'The Kitchen, Charleston' by Vanessa Bell, 1943. Grace Higgens worked for the family for fifty years.

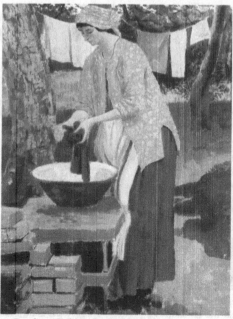

'Dorelia – Washing Day' by Augustus John, c. 1912.

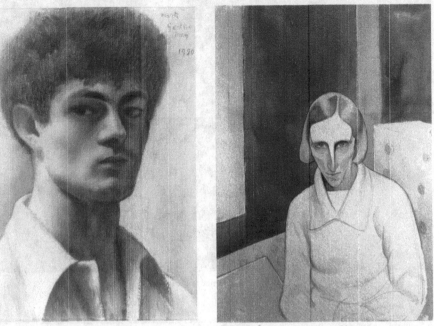

Mark Gertler, self-portrait, 1920.

Christabel Dennison, self-portrait, 1925.

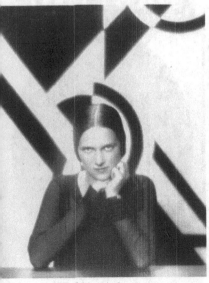

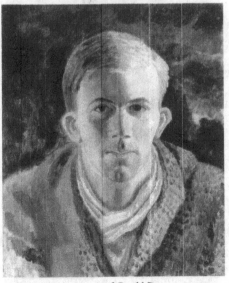

Ethel Mannin in 1930.

Carrington's portrait of Gerald Brenan, c. 1921.

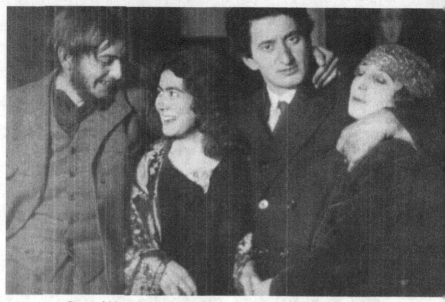

Roy and Mary Campbell, Jacob Kramer and the model known as 'Dolores'.

Betty May. This photograph appeared in her memoir, *Tiger-Woman – My Story*, 1929.

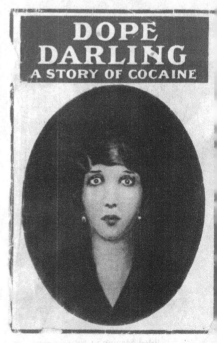

David Garnett's 'penny dreadful' *Dope Darling* (1919) was written under the pseudonym Leda Burke. Its heroine was based loosely on Betty May

The painter Ethelbert White and his wife, Betty, often provided the music for Bohemian parties. Nina Hamnett painted them around 1920.

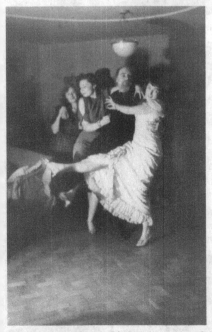

Nicolette Macnamara, with Augustus John and his daughters Poppet and Vivien, Christmas 1934.

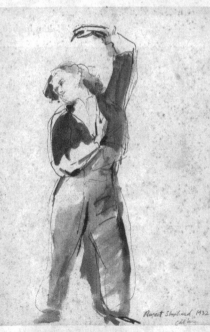

'I could feel the music running through me as if I was a tunnel, and nothing could stop me leaping to my feet and letting fly.' 'Caitlin Dancing', by Rupert Shephard, 1932.

Dylan and Caitlin in their natural habitat, around 1938.

'To the Ham Bone we would go,' remembered Ethel Mannin, 'we who were young, artistic, unconventional, and, in general, what we liked to call "Bohemian".'

'My son was as innocent and pure-minded as any girl . . . I could have trusted him anywhere – and that's why I gave way and allowed him to come *here*, of all places in the world – all alone. Oh! I should have come with him! Fool – fool – fool that I was!'

Although it sanitised and romanticised the *vie de Bohème*, the massive popular success of *Trilby* only served to enhance the allure of Parisian life. Beatrice Campbell cherished hopes of going there to study under Rodin, but it was not to be. Her father was adamant that 'going to Paris' was the road to ruin. Nothing would convince him otherwise, and he had the last word with: 'If you go to Paris it will break your grandmother's heart.' Beatrice caved in under pressure and for the time remained in Dublin, a Bohemian outpost of its own.

But Paris remained the great Bohemian vortex, 'the laboratory of ideas in the arts', according to Ezra Pound, and magnetic pole to the 'lost generation':

Intellectually Paris was the capital of the world, and the judgement of Paris was final [wrote Harold Acton]. The Entente Cordiale in the fine arts had never been stronger. Bloomsbury was only an extension of Montparnasse, and its prophet Clive Bell wrote in a language that was nearer French than English . . . English painters borrowed French eye-glasses for their landscapes, nudes and still lifes. Our standards were increasingly Gallic . . .

Johns, Lambs, Anreps and Bells colonised the Left Bank. Connolly, Acton, Christopher Wood, Robert Medley, Nancy Cunard, Mary Butts, Jean Rhys, Ford Madox Ford, Stella Bowen, Julian Trevelyan, Edith Sitwell, James Joyce, David Gascoyne and countless other British artists and writers all made the city a second home. When Mark Gertler went to Paris for the first time in 1920 he reported that in one day he had seen Roger Fry, Duncan Grant, Vanessa Bell, St John Hutchinson, Jacob Epstein, Iris Tree, Curtis Moffatt, and Nina Hamnett. By the twenties you could hardly move for the flocks of Bohemians jostling the pavements of Montparnasse under the plane trees, clogging up the bar at Le Boeuf sur le Toît, crowding the tables at the Dôme, the Select or the Rotonde. In the post-war period those Montparnasse cafés seemed the hub of the world to the international riff-raff of poets, painters and tarts who frequented them. They stayed open all night, and the saucers which acted as a drinks tally would still be stacking up till three or four in the morning, before somebody paid and a group would stumble off to the Jockey or the Bâteau Ivre to dance.

Paris was the fount of everything new and modern, not just in the arts but in everyday life. Sisley Huddleston, author of *Bohemian Literary and Social Life in Paris* (1928), credited Paris with the introduction of, among other things, underground railways, Cubism, Bolshevism, football, tennis, one-way streets, coloured photography, cinemas, cocaine, silk stockings, safety razors, beauty parlours, monkey glands, Freudianism, quick divorces, unnatural vices, wirelesses, Citroën motor-cars, and of course cocktails. For Huddleston, the cocktail was a symbol of Parisian society, a melting-pot of classes, categories and colours, in which the old divisions had broken down, and comédiennes sat next to princesses, cabaret-keepers beside diplomats, and Americans beside everyone. Here 'the very cabmen lived for Art', and one could savour the lees of life in its apache bars and brothels. The streets of Paris were literally and metaphorically crackling with electricity. Neon and naphtha lit the streets and cafés, the Eiffel Tower blazed like a beacon across the Parisian night, while a stream of brilliant life flowed festively along illuminated boulevards.

Those images of Paris had the profound impact of first love on its visitors, with something of the melancholy attached. Its glorious past stimulated powerful feelings of nostalgia. Richard Aldington went there before the First World War; he responded passionately to a people he saw as 'intelligently in love with life', peaceful and yet vivacious. 'Shall we ever see again the peace and the vivacity?' he mourned. But Stella Bowen was equally infatuated by the post-war city: 'Alas! There will never again be anything like the Paris of the nineteen-twenties in our life-time . . . from England in 1940 it looks like a remote and unbelievable Heaven.' Stella Bowen's love affair with France was a perfect marriage of minds. The French way of life charmed her in all its aspects – its precise language, its realism, its generous appreciation of femininity, its food, climate and rates of exchange. (She only took a dim view of French doctors, who neglected her lover Ford in the throes of bronchitis.) Her spirits never failed to lift the moment that beloved coast came into view from the Channel steamer. Mary Hutchinson, lover of Clive Bell, was another smitten devotee. Writing on board the ferry as it steams into Dieppe she picks out the joyful reds and blues of the houses, windowboxes, fluttering washing, flags and reflecting windows glinting in the sunshine. She even notices brooms painted emerald and scarlet. Mary is captivated by France's colourfulness and sense of *douceur de vivre*:

'So it is throughout,' philosophises the traveller; 'the French show you their wares, their tastes, their thoughts, and are proud to enjoy them.' In the heart of France there is a furnace; men are warm there, they are solid and certain, they believe in

their great men as they do in their wine – and just as they understand that there are ways to cook and to arrange a shop window, they understand that there are ways to write and to paint. 'Admirable land,' sighs the traveller, 'land of pleasure and sense; everywhere banners of good-humour!'

Such almost idolatrous francophilia was not uncommon. Wearied by the constant struggle to live and work as an artist in England's philistine environment, many regarded France as a panacea. The poet Liam O'Flaherty escaped to France as 'the only country where there is a profound respect for the human intellect in itself. Therefore I choose it as a sanatorium for my sick mind.' Vanessa Bell recognised in France that she was taken seriously as a painter 'not only by fellow artists but by the landlady and the man in the street'. For her it was an article of faith that the French were better than the English at cooking, dressmaking, mending cars, manufacturing paint, easels and stretchers. The French were practical, refined and enlightened. She only conceded that their plumbing was inferior.

Apart from Paris, the Midi was above all a magnet for artists. Those journeys to the south of France were saturated in romance, from the moment of scrambling through the barrier at Victoria Station to catching the boat-train to Dover or Newhaven, to a weary dawn awakening with the mist lifting over the Rhône valley. The seasickness, the endless clanking French trains, and the awful necessity of tipping importunate porters, remained imprinted on the memories of those southern fugitives. At the Gare du Nord one had the choice of alighting, piling into a cab and seeing all the main sights in eighty minutes before rejoining the train at the Gare de Lyon, or remaining in one's compartment while the train slowly dragged its way around the '*ceinture*' that encircled the city. At the Gare de Lyon rugs could be hired to tuck around the knees if one could not afford a wagon-lit. A more expensive option was that embodiment of romance, the Blue Train, inspiration for Diaghilev's ballet *Le Train Bleu*, in which you could 'sleep your way from the City's fogs to the Riviera sunshine'. One boarded this marvellous conveyance at Victoria Station. At Dover the entire train was uncoupled and loaded on to the ferry; passengers remained in the carriages for the Channel crossing. At Calais the train was reassembled before heading south. But all the weariness of the journey evaporated as dawn broke over a sun-loved land, studded with cypresses and olive trees, a land of 'horizons unbounded by all the little dreams men set their hearts upon'.

When Stella Bowen and Ford Madox Ford first went to live in Villefranche they were overwhelmed by the radiant landscape that met their eyes; but above all it was the sunny perfection of the climate that filled them

with gratitude. Stella was elated to find no mud, no rain, no fog. It was dry.

Climate is one of the few things in life that really matter. Other things, friends, fame, or fortune, may elude or disappoint you, but a good climate never lets you down.

The critic Paul Fussell argues convincingly that the twentieth century embraced sun-worship – 'the new heliophily' – with obsessive fervour; parasols, veils and solar topees being thrown aside in favour of suntan oil, art deco sun motifs, and vitamin D. Under unambiguously blue skies it was felt that honesty and sincerity in human relations could flourish. At the same time the leitmotifs of the Mediterranean holiday began to gain common currency – cheap wine in colourful cafés, garlicky meals, painted fishing boats, boules, siestas, melodious guitars played by brown-skinned natives. As Fussell says, this has become 'our version of the pastoral'. Gaudy melon-flowers have replaced buttercups, Matisse has superseded Constable.

Irresistibly lured by this southern utopia, flocks of Bohemians alighted like seabirds all along the Côte d'Azur, colonising the sunny resorts of Villefranche, Nice, Antibes, Juan-les-Pins, Cannes, St Tropez, Le Lavandou, Toulon, Sanary-sur-Mer, Bandol, Cassis, Marseilles, Martigues. They boozed in the port cafés, painted and partied, fell in and out of love, and bed, ran out of money and ran up debts, while from every gramophone poured the treacly notes of 'My Blue Heaven'.

There was the camp scene at Toulon, a real sailors' port, where an English crowd of Bohemian balletomanes congregated around Cocteau – Frederick Ashton, Sophie Fedorovitch, Edward Burra, Constant Lambert. Sybille Bedford spent her teenage years at Sanary, which was presided over by the Huxleys, though largely inhabited by a German Bohemian contingent. Cannes was a kind of expatriate Chelsea, though fast being infiltrated by Mayfair. For Augustus John and Roy Campbell the magnet was Martigues, near Saintes Maries de la Mer, site of a bullring where the locals played the '*jeu de cocarde*', and a sacred place of pilgrimage for gypsies. Cassis was Bloomsbury-sur-Mer; the Bells leased their house there from a retired colonel who had abandoned his wife and set up house with his mistress – he had no qualms about unconventional society. All the artists came to the Colonel's *vendange* lunches, where they were regaled with lavish amounts of food, wine and home-made brandy. Down by the port in the Café Liautaud one might bump into Clive Bell or Julian Trevelyan or the Greek artist Janko Varda. Later one could dance to the accordions of a fishermen's orchestra.

But by 1938 Cassis had become so popular that Mark Gertler felt he had entered a lunatic asylum full of exactly the kind of poseurs he had been so eager to avoid in London. Kathleen Hale's friend Yvonne Kapp depicted the Cassis scene in her novel *Mediterranean Blues* (1933), a gently withering satire on the *canaille* who wasted their youth soaking up sun and wine by the Provençal beaches:

Whatever the reason, there is no doubt that people who go to the South of France frequently adopt fancy-dress (in no way related to the local native costume), leave their wives or husbands, exchange or barter their mistresses and lovers, take up dancing, drinking, dope-peddling, card-sharping, sponging, cadging, procuring, pimping, embark upon marriage or creative fiction, alter the tone of their hair and skin, or even, it can happen, learn the French language.

*

Roger Fry justified the continuing exodus: 'It's almost impossible for an artist to live in England: one feels so isolated.' For Fry, for Vanessa Bell, for Christopher Wood, for large numbers too of writers – D. H. Lawrence, Norman Douglas, James Joyce, the Sitwells, Roy Campbell, the Durrell brothers, Robert Graves, W. H. Auden and Christopher Isherwood – regular displacement was one of the essential conditions of their art:

What I call poetry is not understood in England [wrote the poet David Gascoyne], but I believe it to be something of far greater value than what is at present understood there . . . – I belong to Europe before I belong to England. The values I believe in are European values and not English ones.

Even for those who did not set up house in Paris or the South of France, by the twenties going abroad was 'the Bohemian thing to do'. Across Europe there were writers and artists peddling their wares, sleeping rough, singing for their supper in gypsy encampments. These were the early backpackers. If the hippy trail of the 1920s didn't quite extend to Kathmandu, there were proto-Kerouacs putting up at *posadas* in southern Spain, hiking in the Alps, tracing the course of the Danube through Hungary and Rumania, penetrating the haunts of Sardinian brigands, all on very little money; playing their fiddles in return for food and lodging, drawing inspiration for their art from the simplicities of their nomadic existence and the adventures experienced along the way. And not far behind the pioneers came their followers, nosing out the hotel in Villefranche where Cocteau had once

stayed, writing postcards while sipping a *demi-bière* on the *terrasse* of the Rotonde where Modigliani once sat, buying sprays of almond blossom in memory of Keats from the flower vendor in the Piazza di Spagna. There was a muleteers' tavern near Palma where 'everyone' went, and of course the Bar Rostand at Cassis was like the Café Royal on a busy night.

Painters and writers have no ties and are free to live and work wherever they choose – so why choose to live in a land where the pubs closed early? After the compulsory confinement of the war years, there were so many compelling reasons to get out of England. Life on the Continent was much cheaper, and did not demand the expensive social apparatus in the way of staff, clothes and entertainments that society saw as essential marks of status. In the twenties an English pound went three times as far in France as it did in England. In 1926 bed and breakfast in Paris came to two shillings and sixpence; a meal with wine cost ninepence. Debt, too, was all relative in a sunny climate, or so it seemed.

Cyril Connolly's only novel, *The Rock Pool* (1947), is a cynically observed account of the arty flotsam and jetsam who, like Connolly himself, adopted the Côte d'Azur as their second home. His hero Edgar Naylor finds himself broke, owing six hundred francs for a picture. Naylor's friend Rascasse, who understands the natives and their ways, advises him to continue living on credit and post-dated cheques for as long as he can:

'I'll tell them you're a regular guy and they've got to trust you. If you have to borrow, remember there're only three people with any money in this joint. Foster, the Corsican, and Eddie-from-the-top. They support most of the population. If you prefer to borrow from a woman, Ruby gets her alimony about the middle of the month, and Duff and Varna turn the till out at the beginning. Well, well, so you're broke, eh! Remember, it's no good trying to get tick from the natives,' he went on, 'they're pretty shy by now, and if you have to skip, skip on foot and catch the slow train at three in the morning.'

In *The Rock Pool* Connolly dissects the fecklessness and instability of these 'sad rebels', but he also betrays an admiration for their 'refusal to conform, their independence, their moral courage'. The novel describes expatriate life in microcosm, and though not deep, it is nevertheless a suggestive account of that washed-up sector of society competing for survival in a stagnant backwater which its title prompts: too many fish in an undersized pond.

★

Wanting to live like a native while socialising with one's own kind was a balancing act. For Bohemians it was exacerbated by close proximity to the type of English who settled in the sunny climes of Mallorca, Venice or Cannes, but brought their own particular brand of Surrey along with them. Ethel Mannin was virulent about these 'Blimps'. The Englishman abroad, she wrote, is 'the most disliked traveller in the world'. He is determined not to learn any foreign languages or eat foreign food, and is always on the look-out for an English newspaper. Dressed in plus-fours or a dinner jacket, he thinks it is virile to be loud and aggressive; his wife has an equally penetrating voice, but swoons at the smell of garlic or the sight of a bidet. Why couldn't such people stay put in the Home Counties instead of coming and ruining beautiful places for those who truly appreciated them? If 'one's own kind' was represented by these golf-playing arrested adolescents, it was surely time to move on.

But by the late 1930s the problem for Bohemia was already prefiguring our own tourist explosion. It was now beginning to seem impossible to escape from dilettante Bohemia-watchers. More and more people were going on foreign holidays. Tours and cruises were no longer reserved for the rich. And many of these people wanted, by their choice of exotic location, to identify themselves with the avant-garde. Beauty was becoming debased by its accessibility. Venice was tarnished by Eurotrash in white beach pyjamas who danced and drank all night, and a layer of suntan oil floated on the Adriatic.

The natural desire to write about unspoilt places had to be resisted, since it contributed inexorably to their destruction by tourists. Douglas Goldring's book *Gone Abroad* (1925) described a lotus-eating summer spent swimming in crystal waters and drinking Spanish brandy with the locals of an unknown fishing village in Mallorca. The ensuing rash of American bars and vulgar hotels that sprang up on the Puerto de Pollensa seafront made Goldring feel he had betrayed a precious secret.

The pioneers moved on, but the camp followers were close behind. Spotting a trend, business hastened to cash in. One enterprising firm in Paris even arranged for tourists to be escorted around 'Bohemian' studios. The manager of Le Boeuf sur le Toît shrewdly persuaded Jean Cocteau to go into partnership with him, enabling him to serve champagne and caviare at inflated prices to pseudo-Bohemian Cocteau-watchers. Other managements followed suit. The Rotonde in Montparnasse profited from the far-flung fame of old habitués like Modigliani, and added a smart restaurant, cocktail bar and dance floor to attract star-struck Americans who wanted to visit 'the real Bohemia'. Across the road at the Dôme a crowd of disgruntled

Londoners watched their bogus rivals drinking gin slings at the tables once occupied by Derain, Apollinaire and Picasso, who had now decamped to the Deux Magots and the Flore. But the Dôme became commercialised in its turn. Nina Hamnett was so disillusioned when she saw its *patron*, M. Chambon, serving grapefruit and shredded wheat to American tourists (it 'seemed . . . like sacrilege') that for the first time in her life she felt happy to return to England. Roy Campbell was disgusted at the whole phenomenon: 'Thousands of "painters" . . . infested the cafés, discussing day and night the paintings they never did . . . The Vie de Bohème of Murger had become a universal trade or industry.'

Thus the merry-go-round of Bohemia in Paris mirrored the circuitous pilgrimages of Chelsea and Fitzrovia from Paris to the Côte d'Azur, from Berlin to Munich, from Rapallo to Venice, Florence to Amalfi, Mallorca to Barcelona, and back to Paris again. Just occasionally, in some unfrequented spot, the writer or artist might find a forgotten corner of the world – cheap, lovely, conducive to musing and meditation. Liam O'Flaherty, paying a peppercorn rent for a charming isolated cottage on the West coast of Donegal, wasn't going to fall into the trap of telling the world about his private heaven. In July 1927 he confided to his friend and editor Edward Garnett:

You said something – a long time ago – about writing a guide book. My dearest friend, that's dangerous. Tourists might find this place, and places like it. Nobody has found this place yet. It is glorious to think that few strangers have looked on the brave, strong legs of these peasant women walking on the bog, and one can look for a whole day at a crab gallivanting in his pool without being disturbed by a human being.

As O'Flaherty understood, travel writers have a lot to answer for.

*

Montaigne wrote: 'It is the journey, not the arrival, which matters.' Hopes of a promised land may indeed be dashed when one gets there to find a hell of sunburnt bodies and trashy souvenir shops. And though even Paris never lives up to the memories of youth, wanderlust remains insatiable. The thrust of pistons, the throb of engines, had the power to tantalise and stimulate. While still moving, one was still hoping, one remained in that aroused, pleasurable state that precedes the climax and the inevitability of post-coital melancholy. Motion seems to suspend time; one proceeds at the world's pace. Put the brakes on and the sun starts finally to set, night comes. On the road south, Cyril Connolly felt nearest to ecstasy:

Somewhere after Vienne, around Tain and Tournon, in the fields where the cicadas begin, and the Hermitage ripens, and the light becomes green and yellow behind the Cevennes. Valence, Montélimar, Pierrelatte, and, dear to geographers, the gap of Donzère . . . Here expectation is most intense, and reality most seducing, as the heart unwinds on the winding asphalt.

And so you set out, hope triumphing over experience. You woke your lover one morning and said 'Let's go to Paris!' No need to pack more than a toothbrush and a clean pair of socks; the boat train left at ten. You relished a perfect omelette and a bottle of wine in the restaurant car, as orchards, sunlit rivers and picturesque villages flashed by. Anticipation was the true thrill. The painter C. R. W. Nevinson described the wagons-lit as his 'spiritual home'.

For the young artist Julian Trevelyan the joy of travel was inextricable from the often gruelling reality. With very little spare money, Bohemians like him travelled third or fourth class, and expected to sit up all night, in great discomfort. Feeling sick, being squashed in a carriage with smelly peasants, sharing their food with them just as they shared their fleas and their crying babies and their life histories was all part of the bargain. Cramp, despair and exhaustion were its necessary conditions. A night journey sitting up could be an ordeal by suffocation, backache and reeking strangers who hogged all the space. But for the true romantic, a 'luxury rapide' would have been a betrayal of what travel was supposed to be about. Being soaked to the skin, or having to sleep on a railway station heightened the experience, and increased the romantic glow in memory. Drunk soldiers, ticket queues, officialdom, dysentery and bugs were all transcended by the view of the hyacinth sea, by the sound of strange tongues, by the scent of mimosa. If you couldn't cope with a little discomfort en route you hardly qualified as Bohemian.

The bug scourge recurs so frequently in travellers' memories that one must account it part of the endurance test. Viva King had only to set foot over the Channel to run up against battalions of the beasts. As often as she changed her hotel the bug armies followed her. It seemed they waited to attack until she was deeply asleep; then woke her with vicious itchy bites. Fleas and mosquitoes were frequently a problem too. Rosalind Thornycroft became adept at catching fleas using a piece of wet soap, a complex procedure which she described to her daughter:

When you feel the animal, remove nightgown and gradually turn back bed-clothes holding soap in one hand (and candle in other if in Ireland or other primitive places).

Turn nightgown inside out with lynx eye, pouncing on flea when seen. If the
nightgown proves empty after examination throw out of bed. Be sure no flea lurks
on naked body (unlikely) and continue search of bed-clothes . . . Also examine
under pillows. Once creature is embedded in soap he is easily disposed of in a basin
of water, there to perish. Repeat operations later in night if necessary.

<center>*</center>

Travel like this was not to the taste of the respectable British traveller,
the Cooks' tour-subscribing, Baedeker-carrying, P&O-sailing, Bradshaw-
scrutinising globe-trotter. When the bowler-hatted gentleman went abroad
he went well-prepared, bringing with him a travel thermometer, indiarubber
hot-water bottles, opium in case of seasickness, Earl Grey tea, ginger biscuits,
a mackintosh square and a reliable guidebook. He and his wife were careful
when travelling by wagon-lit not to emerge from their berths in a half-
clothed condition, they were wary of getting into conversation with fellow
passengers in trains, and never made friends with strangers in hotels without
being sure of their social status first. They travelled heavy. Sixteen suitcases
was not unusual, often augmented en route by bulky purchases such as
candlesticks, marble ornaments, and gilded picture frames. Their baggage
was painstakingly labelled.

Bohemia's suitcases, by contrast, were packed with necessities for the
mind and spirit. Frances Partridge remembers setting off on holiday with a
rucksack containing all eight volumes of *Clarissa* and little else. Gwen John
and Dorelia took mainly painting equipment and a minimum of personal
belongings for a walking trip round France.

Gerald Brenan and his friend John Hope-Johnstone negotiated long and
hard about what to take on their eastward journey overland to China.
Brenan had with him six books (mostly poetry), a notebook, a change of
clothes, and a packet of drugs, including two pounds of galingale, a lump of
hashish, and a phial of attar of roses. He was initially appalled at the plethora
of belongings piled up on Hope's bed. He had a paintbox and a large bundle
of canvases, and some books to read, plus a considerably larger number of
grammars and language books. Hope made the case that he intended to take
up painting, and that they would need one grammar for each country that
they proposed to travel through en route to China. On that basis they went
through his proposed library. Brenan conceded manuals on Arabic, Persian,
Italian, Serbian, Greek and Osmanli Turki, but could see no justification for
Bulgarian, Russian, Kurdish or Armenian. Hope argued that they might
lose their way or be carried off-course, but gave in (apart from the Armenian):

'And is this book on one of the dialects of Balkan Romany really necessary?' I inquired, holding up a tattered volume in French.

'We can't possibly leave *that* behind,' he answered. 'Why, who knows, we might want to settle down for a bit with one of the gipsy tribes.'

Hope was persuaded to compromise over the necessity of bringing the Gospels in a wide variety of languages for which no grammar existed:

'Only three hundred families speak Vogul,' I said, 'and they live in northern Siberia.'

'I know,' he answered. 'They sound an uncommonly interesting people and I should very much like to meet them and learn their ways. But I agree with you that we can leave these books behind. After all, we have to be practical.'

Then, with their library packed into a sack tied with rope, they headed south.

The first leg of this journey from Paris to Valence was accomplished by train, after which the friends acquired a donkey cart, and set off through Southern France. Through Italy the donkey was urged on with lines from Shelley's *Epipsychidion*. It rained, and they camped in old railway tunnels and barns. On the Italian–Yugoslav border their vagrant appearance caused them to be arrested and thrown into gaol. They were released after five days, and got through the border at Trieste, but it was December, and their money had nearly run out. Hope-Johnstone cracked, and decided to go back and winter in Venice. Brenan continued alone into the inhospitable Dalmatian interior, begging lodgings at farms, starving and almost penniless. His shoes had disintegrated, it was snowing, and he heard wolves howling. Brenan's extraordinary journey is recorded in detail in the first part of his autobiography, *A Life of One's Own* (1962).

Despite terrible vicissitudes, he managed to hold fast to his private philosophy, the outcome of much youthful pondering on the purpose and meaning of existence:

1. I have never desired and will never desire anything else but happiness.
2. Happiness is the feeling given by the consciousness of absolute freedom.
3. No one can be free so long as he has material possessions.
4. Therefore nomadic life rather than settled.

But in the end Brenan was defeated by hardship. He never reached China, nor fulfilled his ambition to follow in the steps of Marco Polo and join a

nomad tribe in Outer Mongolia. Nevertheless, the journey was a liberation. Radley School, the Home Counties, his parents, material gain, bourgeois values – all were left behind as he walked slowly eastwards beside his donkey, with his cartload of poetry and mind-altering substances. This was travel for travel's sake, not a means of getting somewhere, or a holiday, or even an exile, but a way of life in itself.

*

Such slow progress appealed to primitive instincts. The purist disdained the aid of wheels; walking had all the advantages. It was exhilarating; it revived the heart-rate, the appetite and the intellect. The finer points of churches and inns rewarded one's leisurely pace; natural beauties enhanced one's pleasure. Gerald Brenan and his generation were much influenced by W. H. Davies's *Autobiography of a Super-Tramp* (1908). Feeling hemmed in by the shackles of civilization, he was among many creative individuals who felt that the life of the lonely wayfarer held the answer to existence. Magazines like *The New Age* idealised free love and the open road; the gypsy and the tramp became heroes to ardent Neo-pagans and nature lovers, who took up hiking and camping out with fervour.

For Paul Nash and his girlfriend planning a tour of the Lake District, part of the fun was the certainty that their vagabond life would electrify their conventional families. They planned to walk or go in 'a cart or buggy of some sort', 'putting up at odd inns, or sleeping under hedges'. They paddled, and Paul sketched. They saw starfish, curlews and cliffs, and picked wild raspberries. There were wild woods and stony hills; 'there was all that the heart of man could reasonably desire'. Such adventures gave one a strong sense of identity with the wandering minstrel, the troubadour, the gypsy. One could be Villon, or Christian in *Pilgrim's Progress*, Goethe or the Scholar Gypsy.

Gwen John and Dorelia McNeill set out on their great walking adventure in 1903. With their paints and brushes they set sail for Bordeaux in August, intending to get to Rome. For four months the 'crazy walkers' made their way on foot through western France, sleeping rough covered in portfolios of pictures for warmth, fending off attempts on their virtue, revelling in beautiful sunsets and distant views of the Pyrenees, painting portraits and singing for money, living off bread and grapes. It was November before they reached Toulouse, by which time Rome seemed unattainable, so they gradually made their way back to Paris.

The poet Philip O'Connor, living a dependent life with his unsympathetic sister, decided one day that he had had enough. He robbed the gas meter

Paul Nash sketched himself and Bunty
Odeh on their walking tour of Cumbria.

and departed with the proceeds. For the next five months O'Connor tramped the roads of England, sleeping in barns or under haystacks, wretched and hungry but grimly determined to stay clear of 'civilization'. He met other vagrants, and scraped some pennies by collecting the money for a tramp wheeling a wind-up gramophone on a pram. They shared a tent together, where the old fellow had a go at seducing him, 'but the machinery was not suitable'. After a friendly goodbye kiss O'Connor headed on his way:

Walking had a saddening but soothing effect on me . . . I liked roads and moving . . . I liked very much the absence of the gymnastics of 'social life'. I felt 'the truth' would come too. Tramps here and there were very nice to me . . .

Moreover tramps were spattered with the road, with the roughness of sleeping out, with the spiritual *finesse* hidden within the grossness arising from lack of employment; their eyes were wild, darting, aimed directly by the purposive intelligence, and there hovered nothing about them of that greasy, insulating caution of expression, tartiness of behaviour, meanness of gesture, incumbent upon hard workers for their daily bread . . .

I was moved and thrilled too by their smell of distance and space, one of the greatest spiritual elegancies available to man, which polishes him like a knife. One man under his sky is an eternal image . . .

O'Connor got the boat to Ireland. But in the busy streets of Dublin he panicked, began to feel he was going mad and presented himself at a lunatic asylum. The doctor firmly rejected him – no chance of food and shelter there – so he went to the workhouse, but was forced into shovelling stones to make enough money for food. The Salvation Army gave him shelter for a few days, and then got a friend to send him the fare home. His adventures on the road were over.

*

That eternal image – one man under his sky – is ineradicable from the Bohemian landscape. In his guise as the Toad, Augustus John, influenced by George Borrow and by his mentor John Sampson, ardently adopted the gypsy life, strongly identifying with those 'children of nature'. Augustus learnt their language, their customs, wore their clothes, admired their beauty and mystery, supported them against intolerance. He was far from alone in this commitment, and indeed was to become a leading light of the Gypsy Lore Society, whose journal, launched in 1888, was the voice of a wonderful assortment of like-minded gypsophiles the world over. For in a society increasingly dominated by inward-looking, bureaucratic capitalists, the gypsies' lawless independence held a captivating glamour. The visitations of Eastern European gypsies to England in the second half of the nineteenth century fuelled the ardour of stay-at-home dreamers to forsake comforts and set out on the roving life.

Around the turn of the century there was a ferment among writers and artists eager to sample gypsy life for themselves. Titles began to appear like Gordon Stables's *Leaves from the Log of a Gentleman Gypsy – In Wayside Camp and Caravan* (1891), Elisabeth von Arnim's *The Caravanners* (1909), or Marion Russell's *Five Women and a Caravan* (1911). Such works extolled the 'wee wayside inns', bacon and eggs eaten in the open air, healthful slumber, and the feeling of being 'at home with all Nature'.

I can never forget this first experience of sleeping in the open . . . [wrote Marion Russell]. The rustling of wild things in the wood near me, the softness and sweetness of the air, seemed to develop a mood which brought me into communion with Nature, and vague thoughts as to the meaning of things came in waves approaching, so that I almost grasped them, and then receded, leaving only a faint impression of their meaning . . . I had the first faint dawning of what the meaning of Eternity might be . . .

The caravan craze touched a significant sector of Bohemian society in search of eternity, birdsong and an economical holiday, if only for a week or two every summer. Caravan-loads of artists began to appear on lanes across England, sometimes across France. One could hire fully equipped caravans by the week for a progress around the New Forest, though it was more affordable, Robert Graves discovered, to borrow a horse-drawn van from the local baker. In such a van he and Nancy and their three small children set off from Islip one August heading for the Sussex coast. The reality didn't match up to the ideal, for, mistaking them for real gypsies, some of the farmers whose land they tried to camp on were distinctly unwelcoming. The van too proved to be of flimsy construction, causing one of the children to fall out and get hurt. Then the weather conspired against them, and soon their wagon was draped with the baby's damp nappies, impossible to dry in the downpour.

THE CARAVAN CRAZE.
SCENE IN A LONELY PART OF THE HIGHLANDS.

Gentleman gypsies mocked by *Punch*, 19 June 1911.

Evelyn Waugh had one of the worst holidays of his life sharing a caravan with a friend at Beckley near Oxford. It rained and the vehicle leaked. Waugh took himself off to the church and sat down to read Gibbon, then they walked to Oxford and got drunk. He did not repeat the experiment. But Waugh's incorrigible friend Brian Howard, an unlikely candidate for the gypsy life, was in raptures over his caravan holiday in Scotland: 'It's more beautiful than words can describe, and I feel so well! I cook; wash up;

wash myself in icy water in little burns; rise at 8; sleep at 10 . . .' In fact the
gypsy life seems to have been particularly popular with the classier end of
Bohemia; perhaps playing at Carmen held an illicit charm for the debutante
that eluded the genuinely disadvantaged.

Another friend of Waugh's, Lady Eleanor Smith, daughter of the Earl of
Birkenhead, became obsessed by gypsydom. She set aside her career as a
fashionable gossip columnist to write first *Red Wagon* (1930), followed in
quick succession by *Flamenco* (1931), *Tzigane* (1935) and *The Spanish House*
(1938) – Brontë-esque novels pulsing with swarthy passions. *Flamenco* is the
tale of a Spanish gypsy girl who tries in vain to expunge her Romany origins.
She brings up her child as a gentleman – but nothing can alter the fact that
he has Romany blood in his veins, and Camila has no power to obliterate
the memories of her former life:

She would [never] talk to him of life on the road, but of hunting, shooting, and
books. He would lose, she thought, much that was beautiful – the blaze of stars
sprinkled thick across the sky, the harvest-moon . . . summer dawns . . . [etc. etc.]
. . . and for a moment she pitied him, until she thought of lashing bitter rain, of
sleet that bit like the teeth of wolves, of empty bellies, and of bodies stiff and numb
with weariness . . . and of the road, the accursed, damnable, seductive road that had
no end, that sooner or later maimed and killed all those whom it had once
enslaved.

*

The ineluctable advance of technology in the twentieth century changed
the world for everybody. Even the most uncompromising Bohemian could
not ignore its onward march, while for many of an adventurous spirit the
motor car and the aeroplane brought welcome opportunities to get further
away, and faster. Speed itself had a pure appeal for many artists who felt
temperamentally challenged to take risks in all aspects of life. When
Stevenson wrote 'Faster than fairies, faster than witches' in 1885, train travel
still seemed magical in its rapidity. But by the first decades of the twentieth
century even the *Train Bleu* had lost its ability to make one's hair stand
on end. Being a passenger meant, too, to be passive. The coming of
the automobile at the beginning of the twentieth century provided the
experience-hungry artist with a range of ever-escalating thrills that their
predecessors could never have imagined. By the mid-twenties a writer or
artist who was not in financial difficulties might find themselves at the
controls of their very own motor car, possessed of the ability to go where
the spirit moved, and fast:

'Glorious, stirring sight!' murmured Toad, never offering to move. 'The poetry of motion! The *real* way to travel! The *only* way to travel! Here to-day – in next week to-morrow! Villages skipped, towns and cities jumped – always somebody else's horizon! O bliss! O poop-poop! O my! O my!'

His caravanning days over, Augustus John exchanged a picture for a new yellow Buick at the earliest opportunity. After half an hour's instruction, he piled in a group of friends and set off for Alderney Manor in bottom gear. There was a small contretemps with a barrel organ, and they had to disentangle themselves from a train at one point on the journey down, but apart from this they arrived without incident – still in bottom gear. After this there was no stopping Augustus. His driving was to become legendary as, equipped with one bottle of gin and another of whisky, he speeded down England's highways, oblivious to steamrollers, pedestrians, junctions and lampposts. The Buick grew to be, as Michael Holroyd says, 'a magnified version of himself'. Though battered and dented, though its starting mechanism was temperamental and its action explosive, it nevertheless seemed indestructible. Augustus ran his friends over, and got run over by his friends. He barged into ploughed fields, over hedges and through closed gates. Time and again he and Dorelia emerged unscathed from amid masses of twisted steel. John and his car seemed invulnerable.

Motoring made so much possible that had seemed prohibitive in the past. No longer confined to views in the immediate locality, an artist could load up easel and canvas and drive off in search of new landscapes, new motifs. This was marvellous liberty; but even in those early days, the drawbacks of speed and convenience were becoming evident. It began to dawn on Vanessa Bell that not only could she go where she wanted, but other motorists might also go where *they* wanted. 'Now that everyone owns them one is never safe . . .' So many unwelcome visitors drove up to Charleston that she had to paint a large notice and stick it up at the bottom of the track, saying:

To Charleston
OUT

Cars were wonderful, conceded Richard Aldington in his autobiography, but he too had reservations. The activity of driving was in itself enervating, one missed everything there was to see, and its effects were already devastating the countryside:

England is a small country with a wonderful network of roads, so that three decades have already been long enough for the motor car to suburbanise most of the areas which industrialism had not touched. It isn't much fun to walk there now.

*

In 1929 Bunny Garnett took his first joy-ride in a two-seater biplane over the Huntingdonshire fens near his home. The experience proved completely addictive, and three years later he wrote *A Rabbit in the Air* (1932), from notes that he kept while learning to fly:

The sense, first of power, and then of complete abandonment to the will of the machine, is wonderful. The slowly rotating earth coming towards you as you hang over it, is a precious jewel; there is a feeling of freedom which was first experienced by the revolted angels cast out of Heaven. They came down in spins.

Over the two years that Bunny spent taking flying lessons he alternated between suicidal despair at his incompetence and muffed landings ('I would do well to shoot myself') and radiant feelings of exaltation, drugged with oxygen and the poetry of power and freedom. No thrill could ever again compare in intensity. Even the death of his close friend Garrow Tomlin, killed while practising spins in his plane, failed to dampen his enthusiasm. For the rest of his life Bunny watched the skies from the perspective of one who has ploughed the clouds alone.

Ethel Mannin, though she never took the controls herself, was another passionate air-traveller for whom the experience reawakened earthbound sensibilities:

Nothing of the earth was visible; we were in a new world in which the sky was blue and the sun shone, and where gigantic white mountains rose up out of a billowy white sea. It was like a child's dream of heaven, and wanted only white-robed angels with golden harps to complete the picture . . . I have known few experiences as exciting or as beautiful.

A tiny minority of intrepid passengers travelled in commercial aeroplanes before the Second World War; they were noisy monsters with a roar so loud that flyers had to plug their ears with cotton-wool. Once in the air they lurched and rolled like bobbing corks. Every few minutes they 'dropped' like a lift. Landing could be terrifying. Ladies in fact rarely flew, and Ethel Mannin frequently found herself the only woman on board.

The Grasshoppers Come was David Garnett's second book about flying. His wife, Ray, illustrated it with her woodcuts.

Long distance flights happened in stages. Ethel Mannin's five-hour journey from Croydon to Frankfurt had two stop-offs, the first at Brussels, the next at Cologne, where she had an hour's wait for the German plane which was to carry her on to Frankfurt. In the aerodrome café the nice pilot took advantage of this opportunity to get into conversation with her. They had lunch together and he flatteringly recognised the author of *Confessions and Impressions*, which his wife had read:

His wife would be so interested to hear that he had met me, and why had I such a down on marriage . . . I said because I regarded freedom as the most important privilege of the human being, and how late did he think the 'plane would be arriving in Frankfurt. He said about an hour, and surely I regarded love as more important than freedom . . .

For an hour they talked together of life and love, 'always the most interesting conversation between a man and a woman', until Ethel's flight for Frankfurt was ready to take off. She left him with regret.

*

It would be naive to wish to turn the clock back to a time when one could sit in an airport café and philosophise with the pilot. Ethel Mannin's travel writings can make us nostalgic for her sense of a 'brave new world' full of opportunities for exploration. It is growing hard to imagine how fresh, how enchanted, how remote some of those destinations must have seemed to pioneers like her. The dream of seeing vineyards and houses with green shutters can come true for almost anyone living in this country now.

In her biographical novel *Jigsaw* (1989) Sybille Bedford wrote:

What was it like that French Mediterranean coast between Marseilles and Toulon, Toulon and Fréjus, in the Nineteen-twenties? Le Petit Littoral, the unfashionable part of the Côte d'Azur (*not* the Riviera) with its string of fishing ports and modest resorts – Cassis, La Ciotat, Saint-Cyr, Bandol, Sanary, Le Lavandou, Cavalaire, Saint-Tropez? The sea and sky were clear; living was cheap; there were few motor cars, *there were few people* . . . Some of this changed soon. In that very 1926 Colette discovered the aestival Midi, the clarity of the mornings, the stillness of the sun-struck monochrome noons, the magic of the scented nights. She bought a summer house at Saint-Tropez, La Treille Muscate; clans of artists and writers followed with their entourages . . .

And the rest is history – a history which repeated itself across Europe, in the Balearic Islands, on the Italian Riviera, on the Costa del Sol, in Cornwall. It has taken less than a century for villages like Puerto de Pollensa, St Tropez and St Ives to metamorphose from primitive fishing communities into coach tour destinations. Though artists are by no means the only culprits, we must accept the paradox that many enchanted islands have been damaged by the very outpourings of those who loved them best.

Searching vainly for unspoilt territory, the artist may eventually conclude that only one realm still remains intact where the committed Bohemian traveller can retain a sense of identity. On the road, his restless quest for truth, beauty and meaning eternally finds shape – encapsulated in the image of a solitary man walking, slowly, across a distant landscape.

9. Evenings of Friendliness

What do Bohemians want out of life? – Is a party an occasion for the observation of the rules of Society? – How can one entertain with no money? – Must guests know each other, or their hosts? – What kind of behaviour is acceptable at parties? – How have pubs and clubs changed their status? – Is it necessary to stay sober? – Is it all worth it in the end?

What is life *for*? Sooner or later, in one form or another, the basic question arises. Bohemians in the early years of the twentieth century, though a tiny minority of society, seem to have been very clear about a number of things that life was *not* for. It was not for making money, not for status, nor social advancement, nor political power. It was not for God, not for property, not for fame.

It is easy to say, then, that such people lived for art. But if that were all, many of their lives would be overcast with a sad sense of waste and disappointment. So few of them were geniuses, so few of them produced work with any claim to immortality. Who still reads Geoffrey Taylor's poetry or Ethel Mannin's collected journalism? The general public are on the whole ignorant of the art of Daintrey and Kramer. And yet evidently significant and important changes in society were generated by exactly such people, who at their best, and despite poverty and hardship, felt themselves to be heroes, on the winning side in life.

Artists fought tooth and nail for liberty on so many fronts, emotional and sexual, aesthetic, social, political. Slowly but surely, feminism was winning ground. A new freedom was entering the relations between the sexes. In the upbringing of their children they espoused permissiveness; they let the light into their homes, garlic into their food, colour into their clothing. By the twenties people like Bunny Garnett were beginning to feel that 'the forces of intelligence and enlightenment were winning':

I was sure that the dark ages were over; the persecutors drawn from Church and State, if they had not been routed, were being sapped from within. The ice age of Victoria and the vulgarity of the Edwardians were over and a generation was

growing up which would enjoy – as many of us were enjoying – uninhibited freedom . . .

The twenties were years of joy, of freedom and of enlightenment.

It was above all in the conduct of relationships that people like Bunny experienced such release for the first time. Social life, high days and holidays, parties and gatherings, were the heart of Bohemia, its glory, and arguably its *raison d'être*.

*

Bohemia has always celebrated camaraderie. Murger's *Scènes de la Vie de Bohème* is full of descriptions of Latin Quarter parties, where poets and painters made merry for a few sous. When they were in funds they ate and drank, when they were not they danced and burnt the chairs to keep warm; the fires of their friendship were quenched only by the tears of their passion. To many English readers, this spontaneity was irresistible. *La Vie de Bohème* showed the way, and in *Bohemia in London*, Arthur Ransome describes the English equivalent.

The painter's day ends as often as not with an impromptu gathering of artists, poets and actors at somebody's studio. You may have to supply your own chairs if you want to sit down. A piano helps, or a witty model telling funny stories. The room fills up with tobacco smoke. There is chess, and chat, and the gathering breaks up late. Another night Ransome finds himself at Gypsy's place in Chelsea. The guests are picture dealers and artists, models and actors. They clamour for Gypsy to sing them a song, but first she offers them drinks:

'Who is for opal hush?' she cried, and all, except the American girl and the picture dealer, who preferred whisky, declared their throats were dry for nothing else. Wondering what the strange-named drink might be, I too asked for opal hush, and she read the puzzlement in my face. 'You make it like this,' she said, and squirted lemonade from a syphon into a glass of red claret, so that a beautiful amethystine foam rose shimmering to the brim. 'The Irish poets over in Dublin called it so . . .' It was very good, and as I drank I thought of those Irish poets, whose verses had meant much to me, and sipped the stuff with reverence as if it had been nectar from Olympus.

Enthroned in a chair covered with gold and purple embroidery, Gypsy tells Caribbean folk tales in the old Jamaican dialect which she had learnt at her nurse's knee. She sings, and recites Yeats's poetry. Then a beautiful Scottish

girl performs sea shanties while incense rises over the piano and perfumes the room; Ransome feels he has returned to the days of the troubadours. This was 'my first evening of friendliness in Chelsea'; there were to be many more.

Ransome luxuriated in those companionable hours spent talking, drinking and smoking. For him, to be among compatible, spontaneous, tolerant, informal friends was simple heaven. Those qualities gave a certain coherence to the ramshackle, amorphous network of Bohemian life. Money, status and material things were blissfully irrelevant if the atmosphere was one of trust, if one shared a common aim of enjoyment, and a mutually serious concern – the pursuit of art.

Yet 'evenings of friendliness' are by their nature ephemeral. How can one recapture the laughter, the talk, the glances, the heat and hubbub of an evening in the Café Royal in 1905, or a binge at Mallord Street in 1915? How can one bring back the atmosphere of a 'studio rag' in St John's Wood in the twenties, recapture the beery disreputableness of the Fitzroy Tavern, or invoke the glittering clientèle of the Gargoyle Club in the thirties?

<div align="center">*</div>

It is hard to characterise the flickering, fitful social scene that was Bohemia during those decades, without briefly recalling the sombre backdrop against which it was played out. For decades the upper and middle classes had held a tyrannous stranglehold over the conduct of everyday social life in this country. Those twin pillars of the social edifice, status and advancement, dominated the architecture of nineteenth-century social life. They were designed to ensure that whims and idiosyncrasies were limited within the walls of respectability and propriety.

Women, above all, faced a lifetime of behavioural constraints, fenced in on all sides by the complexities of etiquette. In the higher social classes, little girls were confined to the schoolroom from the age of five; at seventeen or eighteen, 'ripe for the feast and battle of the world', they were suddenly expected to put their hair up, lengthen their skirts, contribute to conversation, and 'come out'.

This upper-class ritual was not a release however, but merely a herding from one kind of captivity to another. The balls and dances at which a young lady and her chaperone was now expected to appear during the 'season' were regulated and selected with the aim of excluding socially undesirable elements. Important lists were kept by every mother, of eligible men. Once a man was on such a list, he was automatically invited to all the 'good' dances.

To many these occasions seemed overwhelmingly tedious and pointless. For Allanah Harper the platitudes of the 'list-men' made irksome listening: 'Jolly good band, what?'; 'Yes, and the floor's divine too'. Mary Clive's face muscles would go into spasm as she tried to think of remarks to make to the 'fish-faced' individuals kicking her shins while Charlestoning across some flower-banked Mayfair ballroom ('how was it possible for mortal men to be so ugly?'). She longed for the band to get drunk or the floor to give way so that they could have a topic of conversation. Standing neglected in a queue for supper Mary often wished she were dead.

Marriage, the *raison d'être* of all this stultifying monotony, often turned out to be yet another social cul-de-sac. If they weren't supervising the housework or dealing with the servants, married ladies were sitting at home doing fancy needlework or painting tea trays. Until the turn of the century, restaurants and nightclubs were not considered respectable for either women or men, and pubs were completely out of bounds.

'Fork luncheons' and formal dinners were the rule during the season. After a seven-course meal stuck beside some tongue-tied bishop, it might well be a relief to follow the ladies' procession to the drawing room. Once there, the conversation fell back on illness, children, servants and – as captured by Vita Sackville-West in *The Edwardians* – comparisons of other people's parties: 'Are you lunching with Celia to-morrow, Lucy?' 'Yes, – are you?' . . .'How too deevy' 'Friday was ghastly'. 'Ghastly! Horribilino! And the filthiest food.' 'Where are you going to stay for Ascot?' The men meanwhile pushed out their chairs, put their feet on the fender, and talked politics, guns, or money.

Within a fortnight of receiving whatever kind of hospitality, etiquette obliged one to write to, or preferably call on, the hostess. On these occasions it was sufficient to leave a visiting card. The streets of towns and cities seethed with ladies passing afternoons in this seemingly futile activity, but as a social code the leaving of cards carried heavy significance. Much could be read into their appearance, the promptness of the caller, or their omission.

*

Meanwhile, out there in Bohemia, a forbidden life was resolutely being pursued in parallel to the world of fork luncheons and visiting cards, the more thrilling because of its illicit nature.

In wartime London, Nancy Cunard, Iris Tree and her fellow art-students from the Slade held clandestine parties in Iris's secretly rented studio, which she had equipped with a supply of theatrical costumes and greasepaint. There by candlelight they dressed up, read poetry, smoked cigarettes and talked

through the night. Before dawn they would steal back to their parents' Kensington and Mayfair fortresses, evading servants and awkward questions. One morning, half delirious from a night of revelry, still dressed in chiffon and spangles, Iris and Nancy took a dip in the Serpentine. Emerging bedraggled they found themselves confronted by a policeman who charged them, having taken their names and addresses. That was the end of their freedom – but only temporarily, for they forged new latchkeys, broke out, and were soon back at the studio. Now with great daring they trespassed on such unladylike territories as foreign restaurants in Soho, public houses, or the cabmen's shelters where you could get coffee and savelous at three in the morning. They drank wine at the Café Royal or champagne at the Cavendish Hotel in Jermyn Street, whose free-and-easy proprietress Rosa Lewis ('Ma Lewis') insisted on charging their consumption of Veuve Clicquot to some unknown plutocrat's bill.

Iris Tree and Nancy Cunard enjoyed the best of both worlds. Iris makes it clear in her memoir of Nancy that they did not fully make the break from their establishment backgrounds. The Bohemian studio was a refuge from the tedium and empty inanity of the London season, and calls, and house-parties, but it was part of a titillating game these debutantes were playing. 'Transition and danger were in the air'; so too were court balls, champagne and millionaires. Nevertheless years later, when she looked back, Nancy's elegy was not for Hawaiian dance bands or dawn in Hyde Park, for Chelsea Arts Balls or steeplechases, but for the friendship that bound them:

IRIS OF MEMORIES

Do you remember in those summer days
When we were young how often we'd devise
Together of the future? No surprise
Or turn of fate should part us, and our ways
Ran each by each . . .

This emphasis on friendship, on the familiar discourse between what Virginia Woolf called 'congenial spirits', was at the heart of Bohemia's idealistic quest to live and love and create more truthfully. Though he wrote it many years later, E. M. Forster's manifesto for the individual in *Two Cheers for Democracy* (1951) touched on the quintessential Bohemian attitude: 'If I had to choose between betraying my country and betraying my friend, I hope I should have the guts to betray my country.' Forster believed that

each person's right to love and live in liberty was of far greater importance than society and its structures.

Artists usually work in solitude, and therefore tend to be people hungry for reassurance. It is likely that the rejection of formality and the replacement of family bonds with those of friendship by many artists arose from an exaggerated need for like-minded company. Feeling different from the rest of the world is easier if one has other people to be different *with*, and the intensity with which Bohemia partied may have had something to do with its own sense of itself as a tiny minority, stripped of the familiar social props. Bohemians who had cut adrift from the establishment still needed a rudder to their raft, and a colourful flag to wave. If one was going out to break the rules, in however small a way, it was morale-boosting – and a lot more fun – to do so in company.

And, for the uninitiated, how shockingly different that company appeared. Bohemians in public places were still liable to cause frissons of unease in those unused to the spectacle. Ladylike Stella Bowen, fresh from Adelaide, blushed to be taken to pubs by her artist friend and landlady Peggy Sutton, feeling that she had sunk to the depths of low life. She was horrified by Bohemian clubs where cropped women and feminine men sat at stained tables in open shirts and colourful pyjamas. Back at the Suttons' flat she would reel to find the bathroom occupied in the morning by some gorgeous creature with kohl-rimmed eyes who had climbed in at the window at 3 a.m. having failed to get the last bus home. Where were all the chaperones? Within months Stella was relaxing into the studio atmosphere, drinking at Bellotti's with Ezra Pound, falling in love with literary and artistic London. Stuffy Adelaide was on the other side of the world, and she put it behind her for life.

I have always had a passion for parties if they are given with no ulterior motive but that of enjoyment . . .

she wrote in her memoirs.

A good party is a time and a place where people can be a little more than themselves; a little exaggerated, less cautious, and readier to reveal their true spirit than in daily life. For this, there has to be an atmosphere of safety from exploitation – a sense that you are all amongst friends, and that nothing you say will be used against you. Social ambitions are death to such an atmosphere, and so is the presence of even one person who won't play, and remains coldly aloof.

During the First World War, when so many men faced the prospect of being blown up or gassed or having their limbs amputated, caution and social ambition seemed more pointless than ever. Indeed it seemed like a good idea to dance while one still *could* dance. As Zeppelins appeared over London, spectacular in the dazzling searchlights, Bohemia became wilder and gayer with a kind of mad abandon. For Betty May, '. . . it sometimes seemed as if everyone one had ever known would be killed – one went on dancing and rioting in an effort to forget how dreadful it all was.'

No Bohemian party at this time was complete without the painter Ethelbert White wildly strumming his guitar and singing bawdy ballads, while his dizzy wife Betty gyrated in a non-stop gypsy flamenco. 'It made one's heart thump in time to hear "K-K-K-Katy, beautiful Katy" bashed out by Bertie White's band,' remembered Viva King. At Lady Ottoline Morrell's Thursday evenings the guests would often pile on fancy dress and bound around as her husband, Philip, played old music-hall numbers like 'Dixie' or 'Watch your step'. 'Once a week there was this outburst of gaiety and giddiness,' recalled Ottoline. 'Next day we relapsed into the weary monotony of the war.' Best of all were Augustus John's riotous Mallord Street parties, gatherings populated by artists, barmaids, pimps, policemen, and anyone who could be fished out of the pub to join in. Caspar John, on shore leave from the navy, felt like an alien confronted by his father's cohorts of queer friends: 'I suppose they were Bohemians,' he conjectured. On these occasions Augustus got paralytically drunk; there were brawls, gropings, attempts on his guests' virginity and eventual collapse in unheroic disarray on some divan with his legs apart.

At eleven o'clock in the morning of 11 November 1918 the booming of the maroons across London announced the Armistice. The War had ended. With one accord the citizens took to the streets:

When we heard the cheers outside I dropped my brushes and rushed out with Kathleen into the Hampstead Road, where we jumped on a lorry which took us down to Whitehall . . .

remembered C. R. W. Nevinson.

With a thousand others in Trafalgar Square we danced, 'Knees Up, Mother Brown'; then to the Café Royal for food, where we were joined by a gang of officers, and drank a good deal of champagne, and raided the kitchens because the staff had knocked off work . . .

Celebrating the Armistice: another of
Nina Hamnett's illustrations to *The
Silent Queen*.

. . . then on to celebrate with his dealers, followed by a detour via the Studio
Club, back on to the streets for more dancing, and back once more to the
Café Royal. There Nevinson joined a group swarming like monkeys up the
gilt pillars to the ceiling ('often I marvel how this was done . . .'), then went
on partying till the early hours at a picture dealer's in Regent's Park.

Osbert Sitwell was one of many who, over the course of the next week,
fought his way through the crowds to the non-stop celebration being held
by the barrister and art collector Monty Shearman at his rooms in the
Adelphi. He recalled this famous party in his memoirs: 'Here, in these
rooms, was gathered the élite of the intellectual and artistic world . . .'
Bohemia was there in force: Duncan Grant, Bunny Garnett, Nina Hamnett,
Lytton Strachey, Carrington, Jack and Mary Hutchinson, Mark Gertler,
Roger Fry, Clive Bell, Lady Ottoline Morrell, Frankie Birrell, Beatrice and
Gordon Campbell, D. H. Lawrence, Lydia Lopokova and Léonide Massine,
amid 'a tangle of lesser painters and writers', clustered around the imposing
figure of Diaghilev himself. Augustus John appeared with a posse of sexy
landgirls in breeches. Everyone danced, even Lytton Strachey, who
appeared, as Sitwell recalled, 'unused to dancing'; nevertheless there he was
'jigging about with an amiable debility', reminding Sitwell of 'a benevolent

but rather irritable pelican'. Gertler threw himself around with Beatrice Campbell's sister Marjorie, who took off her dress to cool down in the overheated room. The industrialist Henry Mond stripped to his singlet to play the pianola, while the dancers poured champagne over him. The Russians presumably eclipsed everyone else with their prowess.

To everyone here [remembered Sitwell], as to those outside, the evening brought unbelievable solace . . . No one, I am sure, was more happy than myself at the end of so long, so horrible, and so more than usually fatuous a war. When the party began to draw to a close, I left the Adelphi alone, on foot. In street and square the tumult born of joy still continued. Smilingly, the people danced; or intently, with a promise to the future – or to the past, which weighed down the scales with its dead.

<center>★</center>

The dancing went on for the next decade. Possessed as if by demons, in celebration and forgetfulness, thrashing, vibrating, breathless, the twenties still reverberate to the sound of jazz bands. Even before the war, Mrs Grundy had been mustering opposition to the fearsome new ragtime dances with their indecent sexual closeness – the Tango, Turkey Trot and Bunny Hug – that were reaching London's *thés dansants* from the New World. Jazz was the latest assailant; its jungle rhythms seemed deeply shocking in an English ballroom. 'Disgusting . . . improper . . . the dance of low niggers in America . . . the morals of the pig-sty' – but protests were fruitless. The dances were unstoppable: the Toddle, the Jog Trot, the Ki-ki-kari, the Missouri Walk, the infamous Shimmy, and worst of all, the Charleston. Ezra Pound's floor show exemplified the fatal American influence:

[He] was a supreme dancer [remembered his friend Sisley Huddleston]: whoever has not seen Ezra Pound, ignoring all the rules of tango and fox-trot, kicking up fantastic heels in a highly personal Charleston, closing his eyes as his toes nimbly scattered right and left, has missed one of the spectacles which reconcile us to life.

The barriers were down and the puritans could only wring their hands and write letters to *The Times*, as the beat went on and on.

<center>★</center>

'Oh, Nina, what a lot of parties.'

(. . . Masked parties, Savage parties, Victorian parties, Greek parties, Wild West parties, Russian parties, Circus parties, parties where one had to dress as somebody

THE CAN CAN IN "LA BOUTIQUE FANTASQUE."

Bohemia's musical accompanist Ethelbert
White captures the spirit of 1919 for *The
Dancing Times*.

else, almost naked parties in St John's Wood, parties in flats and studios and houses
and ships and hotels and night clubs, in windmills and swimming-baths, tea-parties
at school where one drank brown sherry and smoked Turkish cigarettes, dull dances
in London and comic dances in Scotland and disgusting dances in Paris – all that
succession and repetition of massed humanity . . . Those vile bodies . . .)

Vile Bodies (1930) by Evelyn Waugh is an insider's evocation of the 1920s.
Waugh and his contemporaries were deaf to disapproval, bent on pleasure.
They were heady days – of dance and drink, of music and fancy dress, of
feasting, flirting and philosophising. A series of glimpses from some other
insiders will give a flavour:

November 1920: John Hope-Johnstone invites Carrington and Ralph
Partridge to his studio party. At 10.30 p.m. Carrington is ready, in silk
pyjamas, 'a frock affaire' and a shawl. 'How it brought back another world!
These familiar Bohemian figures.' The guests are an assorted crew from the
Café Royal and a gang of impoverished Fitzrovians, with music provided
by artists playing guitars and pipes. They include Lord Berners, 'Chile'
Guevara, Lilian Shelley, Sylvia Gough, the occasional head-turning Adonis,
but most are dingy and drunk – a fevered throng of B-list Bohemians,

singing and reciting poetry, yet somehow depressing, and, Carrington suspected, riddled with disease. Nevertheless, 'we danced all the time, and quite enjoyed it'. The inebriated figure of Augustus John lurched among them all 'like a cossack in Petruschka, from woman to woman', while Dorelia sat like a deity in a corner smiling mysteriously, remote, benign and beautiful.

Christmas 1921: the Johns have invited their friends for festivities at Alderney. The house is full with the home party of Augustus, Dorelia, Edie and eight children. The guests are Roy Campbell and Mary Garman, Viva King, Trelawney Dayrell Reed, Sophie Fedorovitch, Francis Macnamara and Fanny Fletcher. Sixteen-year-old Romilly John falls in love with Viva at first sight; his state of nervous excitement is almost overwhelming. On Christmas Eve 'the revelry went on long and late; we danced and danced'. At three in the morning a few early birds head for bed. The stayers toast sprats over the embers of the fire, and finally retire. On Christmas Day, after much feasting, Trelawney declares that it is time Roy and Mary were married. With great aplomb he affects an ecclesiastical air and convulses everyone by performing a mock marriage on the drunk and disorderly pair. There are kisses all round.

March 1923: it is Bunny Garnett's thirty-first birthday party in Duncan Grant's studio at 8 Fitzroy Street. There are twenty-five guests, some old Bloomsbury, some new, some American. A huge birthday cake is decorated with a design representing Bunny's fictional creation, 'Lady into Fox'. Duncan has talked Bunny into affording Vouvray and still champagne. The studio fills up. Carrington is there; she's bewitched by the beautiful American Henrietta Bingham, who as the evening ends captivates the company by singing Negro spirituals 'in her soft, faintly husky Southern voice'. Then Lydia Lopokova arrives from Covent Garden, in time to provide them with a grand finale: 'She was not too tired to dance for us again.'

Hammersmith, 1928: The poet and painter Norman Cameron has his friends round for an informal evening. Each new arrival is greeted with a friendly slap round the face with a banana skin, and a glass of gin-and-bitters. Then there is dancing. Robert Graves takes the floor, shrieking and rolling about. Norman makes toast. 'After this they sat round the stove and meditated, and became quite Russian.' The intense atmosphere is interrupted by crashes of broken glass, which turns out to be a break-in in the next street. Even more dramatic entertainment is supplied by a nearby premises catching fire, and everyone rushes outside to see the fun. This is apparently a typical Hammersmith evening.

April 1929: Brian Howard invites his extensive circle of 'haut' Bohemians

and well-born dilettanti to 'The Great Urban Dionysia', at 1 Marylebone Lane. The large invitation, 16 inches high, exhorts the recipient to come attired as a definite character in Greek mythology, and recommends that they copy their dresses from the Greek vases in the British Museum. Viva King goes as Sappho. A select gathering of kindred souls is guaranteed since, down the borders of the invitation, the host designates all his likes and dislikes. This was a party with attitude:

J'ACCUSE	J'ADORE
Ladies and Gentlemen	Men and Women
Public Schools	Nietzsche
Débutantes	Picasso
Sadist devotees of	Kokoschka
blood-sports	Duncan Grant
'Eligible bachelors'	Jazz
Missionaries	Acrobats
People who say they	Russian Films
can't meet so-and-so	The Mediterranean
because 'they've got	D. H. Lawrence
such a bad reputation,	Stravinsky
MY DEAR'	Diaghilev
Belloc	Havelock Ellis
The sort of young men one	The sort of people who
meets at great, boring,	enjoy life just as much, if
sprawling tea-parties	not more, after they have
in stuck-up moronic	realised that they have
country houses, who say,	not got immortal souls,
whenever anyone else says,	who are proud and not
at last, anything worth	distressed to feel that they
saying: 'Well, I prefer	are of the earth earthy,
Jorrocks' and snort into	who do not regard their
their dung-coloured plus-	body as mortal coils, and
drawers.	who are not anticipating,
	after death, any rubbishy
	reunion, apotheosis,
	fulfilment, or ANY
	THING.

*

The candle was burning at both ends, its extravagant glow illuminating gatherings of the art world across the city. Wealth and Bohemia frequently mixed, for this was still an age of patronage. The cultural aristocracy felt it incumbent on them to provide a milieu where artists could meet each other and cross-fertilise, while reflecting glory on them in the process.

Ottoline Morrell deliberately restricted her invitations to artists, aesthetes and Bohemians, finding that the disapproval of the 'fashionable' world inhibited their stimulating gaiety. She was nevertheless exhaustively conscientious about making introductions, separating bores, and mixing the ingredients of friendship, wit, erudition and beauty. 'My desire for other people to know each other and be friends is an instinctive, unreasoning passion with me.' Juliette Huxley never forgot one of her Garsington house parties. The guests at dinner that night included Clive Bell and Mary Hutchinson, Duncan Grant and Vanessa Bell, Lytton Strachey, Carrington, Bertie Russell, Brett and Mark Gertler, and the atmosphere was intoxicating:

After dinner coffee was served in the Red Room . . . and then Philip sat at the pianola and with his usual panache began to play Tchaikovsky and the Hungarian dances . . . The music floated, powerful and alluring, through the open windows, its rhythm pulsating; one after the other, the guests obeyed the compulsion, threw themselves into Russian ballet stances . . . outer clothes were stripped off for action, shawls became wings, smoking jackets and ties abandoned to a strange frenzy of leaps and dances by the light of the moon.

The other country outposts of Bohemia often overflowed with guests; at Alderney Manor the children squashed up at the end of the table and the extras slept in gypsy caravans or under the stars. At Charleston guests were distributed around the attics; the younger generation sometimes sat up all night. One guest at Charleston remembered, 'My main memory is of incessant talk. On one occasion it went on till a winter dawn; why should one ever stop?'

Talk itself was an art form, an ephemeral one, but, for gourmets like Cyril Connolly, delectable in its capacity to add savour to everyday life:

Good talk: the delicious pleasure of explaining modern tendencies to a very great lady: conversation, the only thing worth living for – or so a few of us thought – that bright impermanent flower of the mind . . .

Now, in the homes of Ottoline Morrell, Ada Leverson, Gwen Otter, the Sitwells, the Epsteins, Violet Hunt, and of course Bloomsbury, meaningless

drawing-room prattle (though not intrigue) was banished, to be replaced by sex, Cézanne, Mallarmé, Ibsen, Vorticism, the Russian ballet, Madame Blavatsky, Truth and Civilization itself as topics of conversation. Stars of the spoken word like Desmond MacCarthy attracted enthralled listeners. Bunny Garnett remembered the evenings at which Stephen Tomlin and Oliver Strachey would become locked into some fascinating intellectual argument, or Aldous Huxley held a group of listeners spellbound as he elucidated the history of sexual tastes over the last thousand years.

Many Bohemian parties were memorable for their originality, their inventiveness, the sense of inspiration that pervaded them. Informality was the common denominator, and Bunny Garnett enjoyed them all – admittedly, the orgiastic parties where lusts were requited among the hats and coats in a downstairs room being for him a particular favourite. But all tastes were catered for, in a dreamlike succession of entertainments.

There were homosexual parties where the painters Cedric Morris and Arthur Lett-Haines entertained their friends by performing the Charleston and Frederick Ashton provided camp cabarets; baroque parties lasting three weeks given by the decadent hanger-on Rudolph Vesey – 'Heliogabalian and Sardanapalian in the magnitude and lavishness of his hospitality'; Chelsea Arts Balls where the revellers went as Byzantine empresses, Rajput princes, or the back legs of horses; upper-class parties where the Bohemian contingent disgraced themselves by getting drunk; breakfast parties with bacon and eggs and bowls of coffee served in the French way; Hampstead salons full of poetesses in Burne-Jones drapery; midday champagne parties; 'No More War' parties; Boat Race parties thronging with beards and fantastic clothes; affected parties full of pouting would-be artists' models, garish and lipsticked, and clumsy poseurs reading aloud from Swinburne; and mornings-after-the-parties, red-eyed and ravaged, blotched and exhausted. 'Oh, Nina, what a lot of parties.'

★

And yet it is just possible to characterise this crazy circus. These parties had in common an identity which amounted to more than just groups of people drinking and dancing, and that identity was both new and of its time. For a start, a large proportion of them occurred spontaneously. Kathleen Hale remembered how '. . . one just sprang a party – a certain number of people collected, and some of them could play the guitar and we just started dancing – everything was fluid, and just developed on the spot . . . Everyone would bring a bottle; it depended what you could afford – sometimes it was just a

bottle of ale; somebody else might take a bottle of sherry, somebody else a bottle of gin – we'd pool the lot, you know.'

Lack of money could have been an inhibiting factor; it proved the opposite. One way to save was by getting the guests to lay on the entertainment, and Bohemian parties had a large pool of talent to draw on. With Bertie White or some other enthusiastic performer always eager to do a musical turn, one was rarely put to the expense of a band. Once enough sherry or beer had been consumed someone was bound to start singing. Mrs Varda, the proprietress of the eponymous Bookshop in High Holborn, kept the neighbourhood awake till the early hours by prolonged singing of 'The Hole in the Elephant's Bottom'. Bunny Garnett remembered being delighted by the bawdy music-hall song 'Never Allow a Sailor an Inch Above Your Knee'. Nina Hamnett could be relied upon at any gathering to sing dirty songs or recite from her seemingly inexhaustible supply of rude limericks. There were others too, prepared to do 'turns'. Betty May's party trick was her performance as 'Tiger Woman' – she would go down on all fours and lap her brandy from a saucer. Mark Gertler had wonderful powers of mimicry. He could prostrate an audience by acting all the characters in some imagined incident: Lopokova being visited in her dressing room at the Coliseum by, in turn, Lady Ottoline, Lytton Strachey, Edith Sitwell and Maynard Keynes.

As one might expect, these parties were inventive and creative. At Ford's literary parties the guests competed for a crown of bay leaves by writing *bouts-rimés*. At Garsington the guests were persuaded to dress up and participate in *tableaux vivants*. Juliette Huxley was Beauty to Philip Heseltine's Beast with a waste-paper basket over his head. Party games were popular too. A favourite chez Graves in Hammersmith was for a man and woman to eat a banana from opposite ends. Unashamedly childish, a group of Bunny Garnett's literary friends got down on the floor and played Hunt the Slipper round the Taviton Street bookshop that he co-ran with Frankie Birrell; searching beneath the stacks gave Boris Anrep ample opportunity for pinching the ladies' legs. At the Hutchinsons' house in Hammersmith charades were the speciality. Russia mania was at its height and, having improvised costumes from Mary's dressing-up box, Gilbert Cannan appeared as the Czar, Viola Tree as the Czarina, Mark Gertler as the Czarevitch, and Boris Anrep as Rasputin.

Fancy-dress parties were ubiquitous. Just for a night, one could be a Gauguin savage, Cleopatra, Jesus Christ, a Negro slave, an Athonite monk, Empress Theodora, a ringmaster or an acrobat. The avant-garde found scope

for modish eclecticism here, as a palimpsest of face paint, embroidery, and gypsy finery restated the themes of experimental poetry, novels and art. The modernist broke the rules, used allusions, drew from mythology, history and fragments of past literature for his or her creations. Surely the contemporary craze for oriental robes and greasepaint was somewhere in Virginia Woolf's mind when she wrote *Orlando* (1928), a novel which resembles nothing so much as a contemporary fancy-dress ball, whirling its hero/heroine through a bewildering series of chameleon-like transformations. Nowhere in literature is the search for identity through disguise more fully expressed.

Where clothes cramped their style, Bohemians were nearly always prepared to dispose of them. At the least provocation, and with a spirited lack of pomposity, party guests flung off their rags and tatters. In 1910 'all the Slade gang' attended C. R. W. Nevinson's twenty-first birthday. Although on this occasion not much drink was consumed, the gathering was high on genius and anti-bourgeois sentiment, and at its height one of the dancers removed every stitch and danced naked. 'At that time such a thing was as unusual as it is now commonplace, the only difference being that when I say naked I mean naked.' Any really successful party included somebody stripped to the waist or beyond. Kathleen Hale's exuberant landlady was a literary agent who regularly bared her pretty breasts at gatherings for her clients. Vanessa Bell ended up naked to the waist after dancing frenziedly at one pre-war party. It seemed that all the Victorian hostesses' worst nightmares were coming true.

One evening in the Café Royal Nina Hamnett and her date got talking to a group which included a pink-faced young man in a white tie and top hat. The toff was drunk, but eager to play, so they all went back to his place; at his family's Holland Park mansion, only the cook was at home. Soon the company were knocking back their absent hosts' excellent brandy and wine, and discussing life and art.

The young man in the white tie was causing a good deal of disturbance in a corner. Suddenly two members of the party shouted: 'Take your clothes off!' . . .

The young man, who was apparently always willing to undress at a party on the slightest pretext, began slowly to take his clothes off. Everyone had taken a violent dislike to him by this time. Finally, he was entirely disrobed and stood with nothing on with the exception of a pair of black socks and smart button boots.

We all said: 'Well, anyway, we like you better dressed than undressed.'

The situation degenerated further when another member of the party, a beautiful blonde in a purple silk dress, seized a walking stick with which she

attempted to attack their naked host. He fled and she chased him round the table. Just as she was about to catch him and flog him, he tripped headlong over the mat. Later it came out that the cook had observed the entire spectacle through the dining-room keyhole. This preposterous episode is typical of Nina's reminiscences, *Laughing Torso* (1932) and *Is She a Lady?* (1955), both of which proclaim the author's voracious lust for life. Poor Nina succumbed eventually to alcoholism, but at her best she was one of life's great enjoyers, irrepressibly bubbling over with vitality.

To me, one of the most sympathetic qualities that emerges from the accounts and memoirs of artists at that time is their sheer appetite for fun. They had no taste for self-denial, passivity or 'cool'. They worked and played with equal zest, though often play took over from work. Autobiographies like those of Nina Hamnett, Viva King, Beatrice Campbell, Bunny Garnett, Kathleen Hale and Brenda Dean Paul give the overriding impression of lives lived principally for enjoyment, at a time in history when it seemed that the gaiety was unprecedented. Probably everyone feels these things when they are young; and yet that generation was surely riding the crest of a wave: impetuous, reckless and insatiable – but high on sensation.

<p style="text-align:center">*</p>

In his old age my father was asked in an interview what had made him happiest in his life. Quentin reflected before replying, 'Being drunk, I think.' He then modified this to, 'Being *slightly* drunk.'

The bar has always been Bohemia's natural habitat: Arthur Ransome's 'tavern by the wayside', whose gaily painted sign tempts the wayfaring artist, inviting him to join the unconventional throng drinking within. At the end of a chilly day working alone in one's garret, how comforting and convivial it was to gather with friends in a bar, where music and a few glasses of beer or absinthe helped to dispel hunger, and numb the sting of failure, poverty and despair. It would be warm and smoky and there was sure to be a friendly face – someone to commission a painting, inspire a story, or lend five shillings. So synonymous with Bohemia did some of those meeting-places become that they have almost entered legend, their names evocative of louche romance.

Bohemia's nightclubs in many ways epitomise what the respectable world most feared and resented about the libertarian life. They were tainted by their dubious clientèle. Who were these deluded young people wandering the streets at night, drinking late, spending money, going out unchaperoned to dance and debauch? Why were they not at home in the bosom of their families, in bed and asleep? The fact was, the traditional family was in a stage

of painful transition, and the rearguard cited the growth of metropolitan nightclubs as scary evidence of degeneracy. Clubs such as the Crab Tree, the Ham Bone, the Studio Club, the Golden Calf, the Gargoyle, the Cave of Harmony, the Harlequin, the Nest, the Bullfrog were springing up overnight. There was an effrontery about their mushroom growth, their grotesque names, their lawless informality and their gypsy orchestras, that both frightened suburban matrons and threatened their very identity.

Clubs were nothing new – for men, at least; there was White's, Brooks's and Boodle's. The nineteenth-century 'Bohemian' clubber also had the possibility of joining the Chelsea Arts Club,★ the Savage Club, the Langham or the London Sketch Club. Slightly more informal – seedy velveteen coats and clay pipes being customary – these male preserves were nonetheless relatively orderly fraternities. The members had a jolly supper, and told lots of jokes, and played tricks on each other, and even did comic pencil sketches on each other's shirt fronts. But they all caught the last bus home to their wives.

The new generation was bent on modernisation. Evenings of friendliness didn't have to be quite so frumpy. The spirit of pre-war Bohemia was most flamboyantly captured at Madame Strindberg's underground nightclub, the Cave of the Golden Calf. Eric Gill had sculpted the idolatrous image which dominated the room and gave it its name; Wyndham Lewis, Spencer Gore and Epstein had also contributed to the decor. The patronne was a dark-eyed wraith in white fur attentively greeting her guests, from impoverished artists to bankers and socialites. An eclectic cabaret provided entertainment; there were folk songs and shadow-plays, Frank Harris reading Russian stories, or Betty May singing 'The Raggle-taggle Gypsies'. As Osbert Sitwell remembered it:

This low-ceilinged night-club, appropriately sunk below the pavement . . . and hideously but relevantly frescoed . . . appeared in the small hours to be a super-heated Vorticist garden of gesticulating figures, dancing and talking, while the rhythm of the primitive forms of ragtime throbbed through the wide room.

The Golden Calf was a victim of its own success. It was raided for breaking the law in asking for payment from non-members, but London nightlife thrived against the odds. The First World War saw an outbreak of nightclubs where survivors of the carnage could drink, dance and forget.

★ Women were finally offered 'Social Membership' of the Chelsea Arts Club in 1966.

A HERD OF WILD BOHEMIANS BEING ROUNDED UP FOR THE OPENING OF A NEW CAFE IN SOHO, WITH THE IDEA OF CREATING THE RIGHT ATMOSPHERE.

Degenerates or fashion leaders? (*Punch*, 8 October 1930).

In 1914 Augustus John helped to found the Crab Tree, a no-frills venue dedicated to hard-up artists. Its Greek Street premises were reached via a complex of rickety staircases, down which drunks and brawlers were occasionally ejected. The shabby interior was furnished with unvarnished wooden tables and chairs. There were no waiters, and often nobody to take money, but anyone who turned up in evening dress was fined a shilling. This went to subsidise the simple food, absinthe and cigarettes. The enter- tainment was usually home-made, provided by the talents of the members – modern poetry recitals, songs, boxing matches.

After the Armistice, the mood of celebration propagated a whole new crop of clubs. There was a huge demand; everywhere 'Bright Young Things' were deserting ballrooms and going on to more disreputable venues to dance till late. There was the Ham Bone – crowded, slovenly and 'chronically Bohemian'. Over its bar hung a notice: *Work is the Curse of the Drinking Classes*. There was the Cave of Harmony in Gower Street, opened in 1924 by the cabaret artiste Elsa Lanchester, Klimt-like with her orange curls, green eyes and starveling figure. Here, though one could not get alcohol (one had to go to the neighbouring pubs for that) one could foxtrot, enjoy the fruity re-wordings of Victorian love ballads performed by Elsa and the actor Harold Scott, and hobnob with painters and writers till 2 a.m. Most famous of all, there was the Gargoyle Club in Meard Street, an obscure

Soho alley. Accessible only by a 'Lilliputian' lift, its glittering recesses were decorated by Matisse with fragments of antique mirror-glass rescued from the salon of a French château. The wealthy socialite David Tennant started the Gargoyle as an ' "avant-garde" place open during the day where still struggling writers, painters, poets and musicians will be offered the best food and wine at prices they can afford. Above all, it will be a place without the usual rules where people can express themselves freely.' The Gargoyle's membership was a roll-call of Bohemia – Dylan, Caitlin and Augustus, Michael Arlen, Nina, Ruthven, Nancy Cunard, Brian Howard, Cyril Connolly, Tennants and Mitfords, Stracheys, Partridges, Bells, Sitwells.

<div align="center">*</div>

The association of various clubs with a Bohemian clientèle extended to certain restaurants. Many were cheap and cheerful Soho eateries like Bertorelli's or Bellotti's – but the Eiffel Tower, like its namesake, surmounted all. 'Discovered' by Augustus John and Nancy Cunard one snowy night, the Percy Street restaurant soon became Bohemia's favoured haunt. For Nancy nothing short of apotheosis was good enough for it, as she expressed in the last verse of her ode 'To the Eiffel Tower Restaurant':

> I think the Tower shall go up to heaven
> One night in a flame of fire, about eleven.
> I always saw our carnal-spiritual home
> Blazing upon the sky symbolically . . .
> If ever we go to heaven in a troop
> The Tower must be our ladder,
> Vertically
> Climbing the ether with its swaying group.
> God will delight to greet this embassy
> Wherein is found no lack
> Of wits and glamour, strong wines, new foods, fine
> looks, strange-sounding languages of diverse men –
> Stulik shall lead the pack
> Until its great disintegration, when
> God sets us deftly in a new Zodiac.

In the days of his prosperity, Rudolf Stulik, the Viennese proprietor, made his restaurant irresistible to London's 'illuminati' – Beaton, Sickert, Gilman, Firbank, Iris Tree, Eddie Marsh, Horace Cole, Nina Hamnett, Viva King, Anthony Powell, Marchesa Casati, Tallulah Bankhead, Brenda Dean Paul.

'On all sides one would hear "Augustus, Augustus"' for John was there more often than not, the places at his favourite table expanding to accommodate friends who paused for a drink, and stayed to enjoy his convivial company. The restaurant was an alternative community. 'I was always bound to find people I knew there,' remembered Viva King. Stulik himself was a caricature patron – fat, his black moustachios waxed at the ends, he spoke with a guttural Austrian accent. He infringed the licensing laws with impunity, and the restaurant stayed open so late that his waiters often missed the last bus and had to walk home. Charming and generous, Stulik stood drinks to friends, and was cavalier with debts. Augustus John lunched there one day and blew up when he found he had been charged £43 for two. 'Is not for lunch only,' explained Stulik sweetly. 'Little Welshman with curly hair . . . he come here. He stay two weeks and eat. He says you pay.' – 'Dylan!'

Eventually the restaurant fell badly into arrears. More than once Augustus John rescued poor Stulik, but his decline was inexorable. The writer John Davenport had to pay up-front for eggs with which to make the omelette he had ordered. The waiters grew surly and bent, and Stulik took to making half-hourly sorties to the Wheatsheaf round the corner, followed by his little dog, Chocolate. As the evening wore on both he and Chocolate became steadily more confused. The restaurant finally went bankrupt in 1938; Stulik did not live to see a solution to his problems.

Until its decline in the 1950s the Café Royal was the centre of the Bohemian universe. For more than five decades it was as essential to London's cultural life in the twentieth century as the Café Momus had been to Parisian Bohemia in the nineteenth. Guy Deghy and Keith Waterhouse have chronicled its glory days in their vivid book *Café Royal: Ninety Years of Bohemia* (1955). For Betty May the Regent Street premises were to become less a café, more a way of life, and she looked back on the nights she spent there before the First World War with acute nostalgia:

The lights, the mirrors, the red plush seats, the eccentrically dressed people, the coffee served in glasses, the pale cloudy absinthes – I was ravished by all these and felt as if I had strayed by accident into some miraculous Arabian palace . . .

No duck ever took to water, no man to drink, as I to the Café Royal. The colour and the glare, the gaiety and the chatter appealed to something fundamental in my nature . . .

Betty sat there every day, making a coffee last as long as she could to justify her presence, longing and hoping for a look from her gods, John or Epstein.

At last she was noticed. Epstein walked over; invited her to his table. Before long she was modelling for him:

Of course after that I met everybody of any importance at all who came to the Café, as Epstein knew absolutely everybody there was to know. And this was the manner of my introduction to the Bohemian fraternity.

Soon Betty herself became a Café celebrity, famous by association, a star among the galaxies of great suns and lesser lights who sparkled amid the rococo excesses of that much-loved interior. Here Bohemia celebrated, fought, philosophised. Great stories went the rounds about goings-on at the Café. There was the one about the washed-up scrounger known by his sobriquet 'Iceland' – his real name was Haraldur Hamar – who outrageously took C. R. W. Nevinson for a ride. Iceland waylaid Nevinson's lunch date, an American journalist, and, pretending to be the great artist, not only consumed a four-course meal and several bottles of Burgundy in his name, but gave the influential journalist a full and frank interview. Meanwhile the real Nevinson was impatiently waiting in the lobby. When soon afterwards he visited the United States, he was horrified to find *The New York Times* lambasting the arrogance of 'certain English artists' who held the American public in contempt.

There was D. H. Lawrence's famous farewell dinner which ended with Koteliansky breaking the wineglasses and Lawrence being sick on the table-cloth. On another memorable occasion a brawl broke out after Philip Heseltine insulted an eminent music critic who had given a hostile write-up to a friend's composition. The unfortunate critic ended up supine while the Mexican painter Benjamin Corea bounced up and down on his stomach. From time to time artists found themselves banned from the Café, when the clientèle would revert to its usual assortment of political exiles, bookies, prostitutes, blackmailers, hacks, and assorted bon viveurs in boiled shirts.

But Bohemia always came back there. A pretty girl could get a pound a day if she could catch the eye of a painter or sculptor looking for a sitter. Betty May was not the only hungry model who used the Café in this way. There was the saucy 'Chiquita', the mysterious 'Dolores', black-haired Lilian Shelley, 'Bunny', Euphemia Lamb, Eileen O'Henry, 'Puma', the blonde dancer Jessica Valda, each perhaps immortalised in some gypsy pose, in demand so long as they remained beautiful.

For others the Café was a home from home, peopled by such curious characters as the artist Alan Odle, who 'dressed like a dustman and carried himself like a duke'. Odle was a dilapidated, unhealthy individual, who

drank heavily, and was remarkable for his extraordinarily long hair, which he coiled around the top of his head like a kind of toupee. Ronald Firbank was usually to be seen there, his affected manner reminiscent of the nineties aesthetes. Effete to the point of eccentricity, he survived on champagne and little else, though he had been seen to eat violets, and occasionally a pea. The well-known charmed circle of Philip Heseltine, Bernard van Dieren and Cecil Gray were regulars too. The Heseltine table was always a magnet to those who found his ribaldry and invective entertaining. The Café's acknowledged king was of course Augustus John, remembered by Osbert Sitwell as presiding there 'like some kind of Rasputin-Jehovah'. Mellow with brandy, Augustus would grow talkative; he would charm, amuse and usually pick up the bill too.

When the Café was renovated in 1928 it lost much of its atmosphere; the old gilt and mirrors were replaced with a jazz age decor. Nevertheless it continued to be a focus for cultural London until Charles Forte took it over in 1951 and turned the Café into a restaurant. As such it ceased to function as a place for table-hopping, poetry-reciting, or just wandering in hoping to find a friend. Frances Partridge remembers feeling a real sense of deprivation.

When it died everyone was in despair. It was the kind of place you could go to at any time of day – after the cinema or a concert – and the waiter in his long apron would say, 'Oh Mr John's here tonight,' if they thought you'd be interested. I nearly always found lots of friends there. It was informal – I suppose artists lead less arranged lives than ordinary conventional people, and they do things on the spur of the moment – and it was always full.

<p style="text-align:center">*</p>

The decline of the Café Royal contributed to the rise of pubs as meeting places for the artists of the thirties. As Constantine Fitzgibbon points out in his biography of Dylan Thomas, public houses had hitherto been the preserve of the working class, but the economic depression changed all that. This period saw the rise of Fitzrovia as an artistic Mecca. Impoverished Bohemians resorted to the 'rough' haunts of the neighbourhood, such as the Duke of York, the Fitzroy Tavern (also known as Kleinfeld's after its proprietor), the Marquis of Granby, the Wheatsheaf, the Bricklayer's Arms and the Black Horse – a string of pubs down which a determined boozer like Dylan could crawl from Goodge Street nearly as far as Oxford Street. According to Fitzgibbon there were other advantages, too, to be gained from hanging around the proletariat:

The poor young who wanted to write or paint were . . . almost all of left-wing views. They believed that their and the world's future lay with the workers, and though they came almost entirely, like Dylan, from the middle class, 'bourgeois' was the dirtiest French word in their English dictionary. To go to the pubs, to mix with the workers, was therefore not only economically attractive but also politically virtuous.

Fitzrovia in the thirties thus became a promised land for rootless Bohemians who drifted boozily from one drinking hole to another. Now mapped in literary guidebooks as places of pilgrimage, even in the thirties Kleinfeld's was becoming famous, with Nina Hamnett always ready to act as tour guide for the price of a few drinks. On one occasion an acquaintance sought out Nina to assist a pair of sightseers who wanted to see 'Bohemia', hoping it would provide them with some lurid spectator sport:

The first thing they said was: 'Are there any dope fiends here? We have been looking all over London for them.' I said, feeling and, I suppose, looking rather startled: 'Good gracious, no, the people in this quarter when they have a few pennies and want to feel excited only drink beer, or, if they can afford it, gin and whisky. I think that you had better go back to Mayfair if you want to find people who take drugs.'
 This rather deterred them and they looked round with an air of disappointment at the occupants of the Tavern, who were laughing, talking and regaling themselves with beer.

Over time Kleinfeld's became invaded by 'tenth-raters' and 'might-have-beens', and the front line were driven to seek their drinks elsewhere. Thus it was in the rather quieter surroundings of the Wheatsheaf one evening in April 1936 that the Welsh painter Augustus John is reputed to have introduced the Welsh poet Dylan Thomas to Caitlin Macnamara. Caitlin's 'tawney mane and wild blue eye' had already proved too tempting for the priapic John. While she was still in her teens he seduced her, and continued to pounce on her for some years after. Caitlin later recalled the inevitability of the meeting with Dylan in a pub: 'Ours was not a love story, it was a drink story.' It was said that within minutes of being introduced Dylan and Caitlin were in bed together, and didn't re-emerge for several days. Typically, they booked themselves into a room at the Eiffel Tower where, yet again, Dylan charged everything to John's account.
 Like unruly hooligans, Dylan and Caitlin stand for everything that the bourgeoisie most disapproved of. They were penniless, dirty, drunk, dis-

orderly, debauched. But their vitality was dependent on such conditions. Caitlin would reach a point in the evening's intoxication when the last vestiges of self-consciousness would break down and something inside her would rise up and compel her to dance:

Of its own accord, without my volition, it suddenly broke loose, leapt into the air, and furiously struck out. My painfully strapped-in limbs, kept too long in a standing or sitting posture, struck out blindly, wildly, jubilantly . . . And I didn't care a damn what anybody thought . . .

This wild vitality and indiscipline can appear as reckless irresponsibility, or simply as the behaviour of mischievous delinquents finally let off the leash. Bent on pleasure, regardless of consequences, Dylan and Caitlin and their crew threw out the rule book, and opened the floodgates to a tidal wave of misrule, of drunkenness, wantonness, gatecrashing and theft. Over the laughter, song and thrumming guitars can be heard the sound of splintering furniture, the shrieks and curses of injured guests, the crackle of flames and the crash of breaking glass.

*

It sometimes seemed that nothing was off-limits. Bohemians lit indoor bonfires, got uproariously drunk, fought each other. Jacob Kramer's hair caught light in the gas-jet at one of Roy and Mary Campbell's studio parties, causing panic. There was blood on the carpet after Philip Heseltine's model wife, 'Puma', viciously stabbed a party-goer in the leg. David Tennant gave a party at which a fracas developed; tatters and tufts were ripped from Allanah Harper's frock and hair. 'Only one fight,' complained Evelyn Waugh after one of Olivia Wyndham's infamous parties – 'It was not enough of an orgy.' Mark Gertler was one of the worst offenders. At one of Lady Ottoline's Thursdays he smashed a fellow-guest's glasses, kicked one of the Stracheys so hard that her foot bled, and bruised the arm of a young Belgian woman who was there. Clearing up after an evening of friendliness had got out of hand must have seemed at times like clearing up after a tornado.

Gertler's worst exploit was carried out in company with Koteliansky – 'Kot'. Monty Shearman, who admired Gertler, had given him the key to his rather *soigné* apartment in the Adelphi. One evening after dining with Kot and Beatrice and Gordon Campbell, Gertler suggested they go round to Shearman's. There they found the place decked with flowers, while decanters of wine and delicious food were laid out ready for Monty's return

with a large party from Diaghilev's ballet company. Gertler and Kot, 'for some extraordinary reason which has never been explained', went berserk. First they ate and drank everything in sight, then they started hurling the cushions and flowers around the room. Kot seized an Omega tray and smashed it over Gertler's head, where it remained decorating his shoulders like a ruff. Undaunted, he grabbed a bottle of eau de Cologne and started shaking it about everywhere. Then Kot rushed to the pianola and began to play it fortissimo, at which point a neighbour appeared and furiously intervened. Still drunk, and high on outrage, they left and went on to another party. A day or two later Gertler got a letter from Shearman politely asking for the return of his keys; the destruction was never mentioned.*

As in some sermonising morality tale, the dark side of that wonderful vitality was always threatening to engulf its victims. Unshackled from the demands of a nine-to-five existence, the daily life of the Bohemian often teetered on the brink of chaos, while parties and pubs tempted the artist to run headlong into irresponsibility. Thus late hours, noise, alcohol, and sometimes also drugs, took their toll both of work and health. Among those of the artistic community brought low by alcohol were Stephen Phillips, Dylan and Caitlin Thomas, Augustus John, Francis Macnamara, Roy Campbell, Nina Hamnett, David Tennant, Nancy Cunard, Sylvia Gough, Jean Rhys, Philip O'Connor, Constant Lambert, Constantine Fitzgibbon, and Malcolm Lowry.

Over-indulgence seemed all the more permissible because it had a heroic history. Back in Murger's Golden Age of Bohemia, or so it seemed, the carefree Parisian poet, carousing with his comrades, his inhibitions released by consumption of cognac, might find himself inspired to new heights:

> Quand le bourgeois dort,
> Il fait soif encor,
> Passons la nuit à boire!
> ★
> Boire est le vrai bien!
> Après, il n'est rien!

* In her memoirs Beatrice Campbell says that Kot was full of remorse afterwards. She also records that years later Monty Shearman approached Kot for help with arranging a posthumous exhibition of Gertler's paintings: 'Kot admired him very much for never mentioning the "incident" and not bearing any ill-will about the destruction of the Russian Ballet party.' One can't help wondering why Shearman was so tolerant. Was he simply a very forgiving person, or could it be that, as a mere collector, and not an artist, he felt somehow disqualified from judging a 'genius' of Gertler's stature?

> Rien, sinon boire encore,
> En attendant l'aurore . . .*

In the same way, experimentation with mind-altering substances had a lurid but fascinating pedigree among artists, the attraction increased by its notable success in *épatant le bourgeois*. The writings of Coleridge, de Quincey, and in due course Cocteau gave opium-eating a questionable mystique, while the reputations of Baudelaire, Théophile Gautier and their comrades of the Club des Haschichins glamorised the taking of hashish, making it seem an experience no self-respecting artist should miss.

Those windows through which one glimpsed the Infinite, those extra-ordinarily precise yet phantasmagoric perceptions were surely the proper preserve of the artist who seeks Beauty and Reality, not to say the Fourth Dimension. Mescaline could transfigure one's perceptions of the visual world:

To a painter a rubbish dump is potentially as beautiful as the Garden of Eden [wrote the surrealist artist Julian Trevelyan]. I have, under Mescaline, fallen in love with a sausage roll and with a piece of crumpled newspaper from out of the pig-bucket. I have also looked at pictures by Picasso, Van Gogh, Michelangelo, and others, and have rejected them all as 'ready-mades'.

Until a regulatory law was introduced in 1920, opiates were a popular home remedy easily obtainable from compliant chemists over the counter. During the First World War cocaine could even be bought at Harrods: 'A Useful Present for Friends at the Front.' Cannabis and mescaline were also available from pharmacies in the form of patent medicines. The problems associated with drug-taking occurred in a tiny minority of cases, and hardly anyone thought about after-effects or addiction. Augustus John described

* From the poem 'Les Rôdeurs de nuit', in *Chansons parisiennes* by Fernand Desnoyers, quoted and translated, in *The Bohemians – La Vie de Bohème in Paris 1830–1914* (1969) by Joanna Richardson:

> When the bourgeois sleeps
> We are thirsty, still;
> Let's drink the night through!
> *
> Drink is the real pleasure!
> There's nothing after!
> Nothing, except to drink again,
> While we wait for the dawn to rise . . .

how he and Iris Tree took spoonfuls of hashish mixed into jam at intervals through the course of an inspiring evening:

In the silence one seemed to hear the tick-tick of the clockwork of the Universe, and voices reached one as if from across the frozen wastes between the stars. Ping! A shifting of the slats of time and space! . . . Is it a new dimension we have entered? Can we be approaching ultimate Reality?

Augustus was an occasional user. One bad experience had made him cautious, and he concluded, 'I don't recommend *Cannabis Indica* to the careless amateur.'

Kathleen Hale should certainly have been more careful when she went to a party given by Philip Heseltine. He presented all his guests with tiny parcels of lavatory paper and instructed everyone to wash them down with a draught of beer; Kathleen was unaware that the parcel she was swallowing contained hashish. One by one the other guests passed out on the floor. Philip took Kathleen to bed with him but was perhaps too incapacitated to take advantage of the situation. She spent a horrendous night dreaming of 'colossal and malign elephants', and was never tempted to repeat the experience.

In 1919, under the pseudonym of Leda Burke, Bunny Garnett published a potboiler romance entitled *Dope Darling*. His hero Roy is mesmerised by the flapper, Claire:

She was always asked to all the parties given in the flashy Bohemian world in which she moved. No dance, gambling party, or secret doping orgy was complete without her. Under the effect of cocaine, which she took more and more recklessly, she became inspired with a wild frenzy, and danced like a Bacchante, drank off a bottle of champagne, and played a thousand wild antics.

Claire is recognisably Betty May, whom Bunny knew well. Betty herself admits that she was powerfully attracted by drugs from the outset: 'Compared with cocaine, all other pleasures seemed flat . . . it was wonderful. I shall never forget the incredible deliriums of pleasure and excitement which I got first of all when I began taking drugs.'

Betty became seriously hooked on cocaine. She made several suicide attempts, and had a terrifying withdrawal before she could free herself from addiction. *Dope Darling* is a banal tale, but one which nevertheless reveals an awareness of the dark side of drugs. Abuse of opium certainly contributed to the disintegration and early death of the painter Christopher Wood, while

others such as Mary Butts, Brenda Dean Paul, and Aleister Crowley were to varied extents victims of their drug habits. Nevertheless, despite their easy availability, only a minority did more than experiment.

<p style="text-align:center">*</p>

As the drop-outs of their time it is not surprising that Bohemians got their fair share of disapproval. Accusations of subversion, arrogance and élitism are automatically levelled at coteries, though as this is surely true of any social grouping which includes some and excludes others, we should all beware. Fascinatingly, those accusations come as often from within Bohemia as from without. For exponents of individualism, being labelled was anathema. Kathleen Hale was scornful of being called 'Bohemian' – 'I hate that description. It's so *silly*!' And yet she failed to come up with a different epithet to describe that group of which she herself was so indispensable a member.

Inevitably, as familiarity with the new social landscape increased, Bohemia found itself once again in sickened retreat from the scene, appalled at the abuse of its hard-won liberty. The 'tavern by the wayside' was, it seemed, being invaded by intellectual scavengers, parasites, 'tea-party tigers', each out for what they could get. How was it that these maggots, these charlatans could occupy the same ground, claim the same privileges, as the true artist? Dylan Thomas wrote indignantly to a friend in 1933:

The Arty Party

The type of party you describe – and you describe it very well indeed – is a menace to art, much as I dislike the phrase . . . Still do seedy things in their mother's pyjamas enthuse over some soon-to-be-forgotten lyrist, or some never-to-be-heard-of painter of nature in the raw and angular. Neuter men and lady tenors rub shoulders with 'the shams and shamans, the amateur hobo and homo of Bloomsbury W.C.1', while their hostess, clad in scarlet corduroy, drinks to their health in methylated spirits.

Certainly there were components of the Bohemian party which lent themselves to parody – and Dylan Thomas in an ill-fitting dressing-gown with bloodshot eyes popping out of his head after a week's drunken dissipation was himself no great advertisement for the poet's life.

Ethel Mannin, another *soi-disant* Bohemian whose commentaries are very much from the inside, displays similar distaste for the degeneracy of her own world in *Ragged Banners*. Mannin takes her idealistic hero Starridge on a progress through London's Bohemia in the company of his friend Lattimer.

Somewhere, their taxi pulls up outside a house where a party is in progress. Lured by the babble of voices and strains from a gramophone they make their way up to the top floor. Now Mannin's camera moves unsteadily round the room, documenting its occupants, coming to rest on a couple dancing like somnambulists, clasping between them a sheaf of lilies, moving on to record the young man in a blue suit who is suddenly revealed as a woman; now close up on a bearded man lounging behind him, heavily rouged and powdered. The men's shirts are vivid blue, green, and open-necked. Starridge is accosted by a tattered woman who asks him whether he is an imagist poet. Lattimer reappears. Starridge casts about desperately for escape:

'I want to go home.'

Lattimer laughed. 'This passion for going home – positively indecent. This party hasn't really started yet – it's not much past one yet, and it will go on till breakfast time.'

'I don't care if it goes on till doomsday, I've had enough.'

But Lattimer is adamant. He produces Liana, a blonde nymph dressed in chiffon and rosebuds – 'she moved in an aura of perfume and her eyes were a masterpiece of make-up'. Revolted, Starridge allows himself to be led by her between hermaphrodites and cigar-smoking women in monocles, to a corner where she drapes herself on a blue divan: 'Do tell me all about yourself.' Starridge sees that the only way to get out of Liana's clutches is by pretending to be queer; he runs away leaving her bleating with dismay.

'I shall never go to another party again as long as I live,' Starridge declared violently. 'Parties are the last word in futility and inanity. You meet all the people you don't want to know and none of those you do' . . .

It is probable that each advancing wave of social change contains within it the undertow of its own decadence – but what wonderful copy those blighted lives made, too.

<p style="text-align:center">*</p>

With hindsight it is easy to judge the dizzy immaturity of the Bohemians. Their dissentient stance on life can seem like a waste of energy, ineffective and ruinous to those who adopted it. And yet that very gypsy outlandishness and bravado which we associate with *la vie de Bohème* expresses a profound human imperative – the desire to live, to love and to create freely and

truthfully. Many among the artistic community paid the price for their own inner vitality and idealism:

> Wild men who caught and sang the sun in flight,
> And learn, too late, they grieved it on its way,
> Do not go gentle into that good night.

The creation of immortal poetry is not the only justification for living. The Bohemian experiment in 'making it new' embraced life as well as art. If we place a high value on social change, on liberty, on emancipation from tyrannous and unnecessary controls, then the Bohemian enterprise can be seen as worthwhile and important in itself. We have to recognise that we owe many of our present assumptions about life to the people who, sometimes in very small ways, but motivated by revolutionary ideals, hope and defiance of convention, stood up to the establishment a hundred years ago. Sobriety and caution are not virtues which feature largely in the annals of Bohemia, because they are not the ones which prompt people to treat life as an adventure, a journey into the unknown. True, many of them lost their way, succumbing to poverty and other pressures. But even for these, the strains of gypsy guitar music, the popping corks, the chopped jazz rhythms and cannonades of laughter that accompanied their descent into defeat may have made it seem more like victory. They did not go gentle into that good night. For they were with friends, and perhaps for a moment, as they danced, drank and loved, young and full of ideals, they believed they knew what life was for.

'To live one must always be intoxicated with love, with poetry, with hate, with laughter, with wine – it doesn't matter which . . .' wrote Roy Campbell. Intensity was all.

Today we can conduct relationships with people from any social class without fear of ostracism, while deploring oppressive, stratified societies. Our choice of friendships and love affairs are our own. The idea of chaperonage makes us laugh; women are independent. We recognise that children have potential that must not be squashed. We take it for granted that society is fluid, that informality will prevail. We do not expect to behave like marionettes at any social gathering. We are hatless, relaxed and on first-name terms with people we barely know. Red paint, ratatouille and yellow corduroy brighten our lives. Etiquette, manners and rules are observed empirically rather than imposed. There are fewer taboo subjects of discussion than ever before. We live in a society which most people's great-grandparents would hardly recognise.

History does not stand still, and some things have been lost; graciousness and sobriety perhaps, and the measured graduation from formality to intimacy in human relationships. Sex often precedes friendship rather than the other way round. Self-control is often an inadequate substitute for rules. New social neuroses have replaced the old.

But as the twenty-first century dawns it is worth looking back to the early decades of its predecessor and, while they are still just within the grasp of our senses, acknowledging the undoubted debt we owe to a pioneer generation. Even at the age of twenty-two, Arthur Ransome was able to recognise that his Bohemian life possessed a unique intensity:

Now, in youth, it is the best life there is, the most joyously, honestly youthful . . . My life will be the happier, turn out what it may, for these friendships, these pot-house nights, these evenings in the firelight of a studio, and these walks, two or three of us together talking from our hearts, along the Embankment in the Chelsea evening, with the lamps sparkling above us in the leaves of the trees, the river moving with the sweet noise of waters, the wings of youth on our feet, and all the world before us.

Epilogue

Bohemia didn't end with the Second World War, though many people said it did. With the formation of the Arts Council in 1946, and the foundation of the Welfare State, some of the struggle was removed, and with it the sacrifice. For those who had survived the times of hardship, and got through the war, their personal Bohemia seemed a bitter-sweet memory, like the passing of youth. On 15 October 1949 Liam O'Flaherty wrote to a friend:

I now eschew heavy potations and addict myself to Coca-Cola.

I see little of London these days. It's like a morgue, although it's picking up a little. Passing through there three weeks ago it seemed quite cheerful on the surface. The imperial glitter and the feeling of security is gone, however. The Fitzroy was crowded with frightful pansies, the Café Royal was inedible and all the old crowd gone . . . Stulick's Eiffel Tower is now run despicably by a Greek, Ma Lewis's place is still open, or so they say, but merely a barely perceptible chink.

O'Flaherty was fifty-three, and perhaps had reason to lament the disappearance of the world he had grown up in. Arthur Ransome believed that, on the whole, Bohemia was for the young. So where do old Bohemians go?

Too many of those beautiful Café Royal models were extinguished like candles, their fates as obscure as their nicknames. 'Dolores' was destitute when she was found dead in a basement aged forty. Lilian Shelley killed herself. Red-haired Eileen O'Henry was murdered by her jealous lover. Buck-toothed 'Bunny' was strangled. 'Puma' died from an overdose of barbiturates. The rigours of life for an artist could be very severe, and many succumbed. Christopher Wood, ravaged by self-doubt, poverty and an irreversible opium addiction, lay down under a train at the age of twenty-nine. For poor Nina Hamnett, it was a slippery slope. Her glory days long past, she sank into alcoholism and in 1956 fell from the window of her second-floor flat in Paddington, landing on the railings below. Many of her friends believed it was suicide.

None of Carrington's friends agreed with the coroner's verdict of accidental death, when, three weeks after Lytton Strachey's death, she shot herself. Carrington's escape from her inhibited, prudish family had been motivated

as much by the pursuit of love as the pursuit of art. A talented painter, love came first in her life; in a sense it was what her life was about, rewards, risks and all. When Lytton died, Carrington wrote, 'I write in an empty book. I cry in an empty room. And there can never be any comfort again.'

Mark Gertler struggled to find equilibrium after the bitter disappointment of his love affair with Carrington. But depression and ill-health stalked him. Dreadful, inexplicable headaches made it impossible for him to work, sometimes for days on end. For one whose entire *raison d'être* was painting this was a disaster – 'My work was my faith, my purpose.' After the failure of an exhibition in 1939 things went rapidly downhill. Gertler committed suicide. He had staked everything on his art, and there was nothing left to live for.

Too many passionate, creative spirits were sent spinning off course through their own reckless appetite for experience. Katherine Mansfield was only thirty-five, with everything still to live for, when she lost her battle with illness. The threat of encroaching death (from undiagnosed gonorrhoea and TB) lent a passionate desperation to her longing for everything that health had to offer:

. . . the earth and the wonders thereof – the sea – the sun. All that we mean when we speak of the external world. I want to enter into it, to be part of it, to live in it, to learn from it, to lose all that is superficial and acquired in me and to become a conscious, direct human being . . . I want to be all that I am capable of becoming so that I may be (and here I have stopped and waited and waited and it's no good – there's only one phrase will do) *a child of the sun.*

For Mary Butts too, death came sooner than it should have. After her extravagant youth, drug addiction and broken marriages she found stability for a while in a remote Cornish cottage, where she wrote, cooked, gardened and took up rug-making – 'a nerve-soothing but creative pastime'. When a friend asked her how she saw life after death, she replied gaily, 'Oh, we'll go on talking and laughing and walking together. We'll meet our friends and go to some heavenly pub. And we'll all be "copains".' But her fractured youth had taken its toll. Mary's drug use had aggravated her stomach, and she died of perforated ulcers at the age of forty-seven.

Laurens van der Post wrote of Roy Campbell: 'Born on fire, it was as if his whole being had irrevocably accepted that he could only live by burning himself out.' Campbell's powerful constitution alone preserved him from self-immolation during the many years he spent wandering Europe, years beset with poverty, illness, self-doubt and bouts of heavy drinking. Even

before his dramatic death in a car crash in Portugal at the age of fifty-six, Campbell was disintegrating. But Mary outlived her husband by twenty-two years. Her Catholicism gave her the strength to endure privation and old age (though even at eighty the relics of her beauty were still visible), while piously tending the flame of Roy's memory.

Dylan Thomas's intense appetite for life contributed to its brevity. He was thirty-nine when he died after a bout of hard drinking in New York. Soon after, the deification of the apostate began. His sister-in-law, Nicolette Devas, offered her contribution to the Dylan legend:

Dylan planted seeds in people, and encouraged or not, the seeds sprouted and sent tendrils through the body and nourished the bloodstream. With these germinating seeds the people were never quite the same again. Though it is trite to say 'Dylan lives after his death' his influence persists in this way, quite apart from the influence of his written work.

Dylan's legacy to his wife, Caitlin, was her lifelong obsession with their relationship, her writings about him, her violence and alcoholism, none of which was subdued by his death. On several occasions she attempted suicide. At last, in her sixties, Caitlin broke free of her dependency. Her energies were absorbed by 'open-air therapy': swimming, bicycling, horseback riding, badminton, and teaching her son to dance. Her final, cathartic memoir of Dylan, *Double Drink Story* (1998), was published four years after her death in 1994.

Another reprobate, Gaudier-Brzeska – the 'Savage Messiah' – achieved the status of unfulfilled genius after his death in the trenches at the age of twenty-three. We shall never know whether, had he lived, this belligerent, maniacally talented sculptor would have gone the way of several of his contemporaries, and crossed over to join the ranks of what he called the 'bloody bourgeois'. It seems unlikely.

But then, who would have imagined that Jacob Epstein, the 'Artist against the Establishment' as his biographer dubbed him, would have accepted a knighthood in 1954? Public acceptance came late, but not too late for the marginalised mistress, Kathleen Garman, to become Lady Epstein. 'It was wonderful to hear her on the telephone ordering all those things from Barker's, saying "This is Lady Epstein." I was so happy for her,' recalled their daughter.

It is perhaps more predictable to see Arthur Ransome becoming fat and forty, for in *Bohemia in London* he had already written, 'Bohemia is only a stage in a man's life, except in the case of fools and a very few others. It is

not a profession.' Thus at twenty-two he prophetically forestalled criticism of his own abandonment of the Bohemian cause. Photographs of Arthur Ransome in his old age resemble nothing so much as a friendly colonel. Bald, bespectacled, in tweeds and with a splendid white walrus moustache, he appeared every inch the old buffer. Comfortably off, he now joined the Garrick Club and spent happy evenings playing billiards there with his cronies. In summer he went to Lords to watch the cricket. An honorary doctorate conferred by the University of Leeds in 1952 put the stamp on his respectability.

And yet a few indicators remained to suggest Ransome's Bohemian youth. His second wife was Russian. The fiery Evgenia Shelepin had been Trotsky's secretary; they had met when Ransome was in Russia covering the Revolution as correspondent for the *Daily News*. His health too had been affected by the years of poverty and malnutrition. He was not as robust as he appeared, and in his seventies Ransome found it hard to come to terms with age and decrepitude. 'I'd always hoped to end respectably,' he told an old friend.

Ransome's contemporary, the painter C. R. W. Nevinson, renounced Futurism in his art, reverting to more conventional types of painting. But his touchy and pugnacious character found expression in his writings, and in his autobiography he dwelt as much on his personal enmities as on his quest for beauty in art.

Ethel Mannin didn't resent the passing of youth, but she felt displaced in the post-War world of the 1950s with its 'television and long-playing records'. In old age her pleasures were correspondingly elderly – good wine, good books, and her roses. Her robust impatience with humbug remained vigorous however. She continued to travel, espoused Buddhism, and signed up to a variety of liberal causes. Passion, she felt, was for the young, but 'the unending struggle against injustice and barbarism in the world' was perennial.

Viva Booth's marriage to the homosexual Willie King gave the 'Queen of Bohemia', as Osbert Sitwell called her, a secure financial base to entertain her huge circle of artist friends. The Kings moved to South Kensington and bought a Rolls-Royce, and Viva indulged her passion for collecting rare antiques. But above all Viva retained throughout a long life her inexhaustible appetite for people. She gamely took a lover half her age, and rallied round old friends like Nina Hamnett and Nancy Cunard who had fallen on hard times. She continued to be as powerful a magnet for eccentrics, misfits and Bohemians as ever she had been in her rackety youth.

Frances Partridge was a hundred years old on 17 March 2000. In her great old age poor eyesight made reading difficult, but her mind was still acute.

She could still remember being taken on a suffragettes' demonstration when she was nine, carrying a banner saying Votes For Women. She could recall Bedales, Cambridge, her dancing days in the twenties, the happy and sad times at Ham Spray. 'I sometimes think I have survived this long for no other reason than to be a kind of archive,' she mused. The irony of Frances's longevity was intensified by premature loss, for she outlived both her husband and only son. In the last thirty years Frances achieved national treasure status not so much by virtue of her survival, but through the publication of her diaries, through which her qualities of uncompromising truthfulness and integrity shine undimmed.

Cyril Connolly became a figurehead of the literary establishment, portly and prosperous. And yet throughout his life this ugly, irascible man retained a passionate belief in art, and above all in poetry. To his close friends it seemed that in Connolly the precocious, neurotic adolescent was still close to the surface. Too patrician for the garret, yet too poetic for the Home Counties, the snob and the Bohemian in Connolly were never quite reconciled. The blood still pulsed powerfully, though the arteries hardened around it. In his sixties, living in Eastbourne, and into his third marriage, he had a late-life affair, clinging perhaps to a dream of romantic fulfilment that the humdrum reality of family life could not satisfy.

Robert Graves would never have been content to live out his days in Eastbourne, any more than his expatriate contemporaries Gerald Brenan and Bunny Garnett – a triumvirate of Grand Old Men who, in the 1970s were to be found, still vigorous and energetic, clinging to their respective rocks and drinking the wine of Southern Europe.

Robert Graves succeeded in his ambition to live by his pen. On his island retreat in Mallorca the author of *I, Claudius* (1934) and *The White Goddess* (1948) became a 'Grand Old Man' par excellence, still, in his seventies, Apollo among a constellation of admiring muses. He never faltered in his belief that poets are 'a singular and heroic breed, set apart from other men'. His dominating personality, his energy and magnificent appearance lent him an unmistakable distinction, but for the last five years of his life the mind behind those penetrating eyes was sadly confused and bewildered.

From 1920 Gerald Brenan was a permanent exile in Spain, where he was revered. Years of energetic scholarship ensured his position as England's foremost Hispanist, though it is arguable whether he is not more remembered in this country for his role in Carrington's love life than for his literary achievements. But Brenan himself did not live in the past. He had an insatiable appetite for life. 'I want drama and excitement and problems to solve, come what may.' He was seventy-nine when his wife of thirty-eight

years died; within a few weeks he had a new, twenty-four-year-old girl-friend.

Bunny Garnett's marriage to Angelica foundered; she was twenty-five years his junior and felt the need to resolve many unanswered questions about her childhood and upbringing that now refused to lie dormant. Bunny lived alone in south-west France for the last decade of his life, gardening, writing, cooking, enjoying many friendships. 'Did he still have affairs?' one young admirer asked him. 'Not in the plural,' was his reply.

The Grandest Old Man of them all was Augustus John, but serenity eluded him at the end. Alcohol finally exacted its revenge. Michael Holroyd's unsparing biography lays bare John's gradual degradation as he sank into old age, incapable of letting go of life. He was a fighter, still outdrinking everyone else into his eighties, still feeling almost a duty to pounce on pretty women, still angry, still passionate, still Bohemian to the core. And yet in later years the establishment clasped him to its collective bosom and heaped him with honours. Dorelia suffered his insults and reproaches with quiet endurance, and tended him to the last. After Augustus's death she lived on at Fryern Court, looking after her increasingly uncontrollable garden. In 1969 she died in her sleep aged eighty-seven.

Harold Acton was a rather different kind of grandee. No ties of family or financial necessity constrained him from continuing to live the life of an unreconstructed aesthete to the end of his days. His beautiful Florentine home adorned with opulent antiques and fine paintings, Acton cultivated the garden of high culture for his numerous visitors (including the Queen Mother), who were delighted to find their host making no apology for living in the past:

In the constant flux of those fashions and systems which the impotent try to foist on us I have kept my independence: I have not attempted to force fresh flowers from the modish manure and twist myself into the latest trendy postures. We must be true to our vision of this world.

Defiance of convention took here the form of a retreat from unthinking modernity, and yet Acton remained all his life an original, who never lowered his sights from the high altar of Beauty.

It was Ottoline Morrell's steadfast worship at this same altar that was to make her, for some, an object of ridicule, while others remembered her as one of the most influential and inspiring women of her time. Ottoline confronted illness and bereavement with courage and determination, and soon after her death one young protégé wrote to Philip Morrell of 'her love

for all things true and beautiful . . . no one can ever know the immeasurable good she did'.

In her old age Rosalind Thornycroft's appearance did not betray how brightly her passions had burned in youth. It was hard to imagine the fragile, bird-like old lady in a tweed skirt and genteel silk blouse as a wild romantic and Bohemian, smouldering with Wagnerian desires. She and Godwin Baynes recovered from their shipwrecked marriage. Godwin became a leading light in Jungian psychoanalysis, and had three subsequent wives. Rosalind returned to England with the children, and found happiness in her marriage with another divorcé who also had three children. In her sixties her desire for ceremony and beauty found its truest fulfilment when she joined the Roman Catholic Church. 'She was an idealist first and last,' remembered her daughter.

But life's tragedies caught up with some of these idealists. Vanessa Bell's vitality and sense of fun were to take a blow from which they never recovered. She was fifty-eight when her son Julian was killed in the Spanish Civil War, aged twenty-nine. After that she became unsociable, reclusive even, escaping abroad when she could, finding respite only there or at Charleston with Duncan and her family. She painted the garden, and her grandchildren, and flowers. Her biographer concludes that, despite an apparent serenity, she was 'walled up in her own feelings, isolated by her reserve and left profoundly alone'.

Nicolette Devas tried hard to hold on to her independent identity, her Bohemianism. She felt the tug of the conventional world when she married Anthony Devas, but the John in her was never quite squashed. 'There was no family tradition of self-control. We had been reared among people who expressed their emotions in public without thought for the effect on others.' It took the Second World War to beat Nicolette's natural vitality into submission.

'This war is going to kill the fun in me. Never again shall I feel that lovely careless rapture. I feel my youth dying.' My frivolous grumbles proved to be true. From twenty-eight I leapt to forty.

Nicolette's memoir dwells passionately on the days of that lost youth, skimming over the post-war period in a few bleak chapters, as the heroes of her early life die one by one.

There is a similarly elegiac quality to the end of Robert Medley's memoirs, as he mourns the death of Rupert Doone, his lifelong partner. In the 1930s Robert had given unstinting support to Rupert in his great experimental

venture, the Group Theatre, which produced a number of plays by Auden and Isherwood. Their life and work together had, he felt, been revolutionary and important in its achievements. The Second World War drove a wedge between the intense phase of Medley's youth and the second half of his life, when he quietly immersed himself in painting and teaching, but despite this the lessons of his earlier experiences were never neglected. It had been 'a time when I came to recognise standards and principles in a life of art that I have lived by ever since'.

But others refused to be beaten by life. Stella Bowen and Ford Madox Ford separated. In 1939 he died, and with the threat of war Stella and their daughter returned to England and found a cottage on a remote part of the East Anglian coast. In it Stella reassembled objects from their travels – glass beads, a desk, paintings – which evoked her past life. But regret was not in her nature. Resilient and buoyant, she believed powerfully in the possibility of happiness. Even with the bombers flying overhead Stella looked to the future full of curiosity and optimism:

Meanwhile we continue to fight for our existence. And we are getting nicer all the time, so that even a poor stuck-up painter can feel sisterly towards football-fans and people who eat prunes and tapioca. Surely that is an improvement!

There are people in the world who will not make compromises with life. Their faces are turned like sunflowers towards the source of light, and even when battered and broken they refuse to give in to old age, sorrow, loss, defeat. Nancy Cunard was one. 'She was a good hater, and of course at the same time she loved things and people very deeply.' Nancy lived on, in pain and barely able to walk, skeletally thin, still drinking rough red wine and smoking Gauloises. Her ivory bracelets were crumbling, but she was honest, high-bred and angry to the end. Her peripatetic life ended in Paris in 1965.

Kathleen Hale was another. Though early poverty took its toll on her health, she was one of the survivors. If her marriage was a disappointment, her two little boys brought her fulfilment, as did her success with the children's stories about Orlando the Marmalade Cat, which she wrote and illustrated. When Kathleen was seventy-eight she went to Buckingham Palace dressed in second-hand chinoiserie and an astrakhan hat from a charity shop, decked with a Moroccan necklace hung with coins and glass beads, to accept an OBE from the Queen: Bohemia triumphant. She died in 2000 at the age of a hundred and two.

'Iris Tree was the most truly Bohemian person I have ever known' was

Daphne Fielding's verdict on her close friend. After her break-up with the handsome Austrian aristocrat who was her second husband, Iris found herself adrift with very little money. She travelled in Italy, Greece and Spain, and friends supported her. A small role playing herself in Fellini's *La Dolce Vita* gave her enough money to survive for a while. One rainy day in the fifties, Daphne bumped into her in a Venetian trattoria:

Suddenly she made her appearance, wearing a Galloway skirt of scarlet flannel, a black tabard and, for want of a better word to describe her headgear, a 'runcible hat' which appeared to be made of thick translucent indiarubber jelly set in a hat-shaped mould. At her heels, a black familiar, was Aguri [her Belgian sheepdog]. Both of them were dripping wet.

In this memoir of Iris, Daphne Fielding dwells on her friend's idealism, her insatiable desire for experiment and the starry-eyed romanticism which, even on her deathbed, never left her. Iris's last words – (she died in 1968) – were, 'It's here, it's here . . . Shining . . . Love . . . Love . . . Love . . .'

Betty May at the Fitzroy Tavern, by Nina Hamnett.

Betty May's ghosted memoirs, *Tiger Woman*, came out in 1929. Concluding, she wrote: 'My feeling about my life is in many ways one of great dissatisfaction.' The lows seemed to have outnumbered the highs, and

yet Betty's irrepressible liveliness led her to conclude that fate had played its part in bringing her sorrow, for how could she have behaved differently?

Against this hidden but all-powerful influence it seems to me impossible and foolish to rebel. It has brought me joy and it has brought me sadness. No doubt it will bring me both again, but I am sure that I am born for adventure, and in the future I shall be able to face these things as I have faced them in the past.

One can only hope that Betty's adventurous spirit sustained her through the hardship and dependency that seem to have dogged her into old age. Her beauty faded and time took its inevitable toll on her energies. There was a third marriage – she reappears briefly in the nineteen thirties as Betty Sedgwick, living in Hampstead – and a fourth, for she made it through World War Two, and surfaced again as Betty May Bailey. But the trail was going cold; she withdrew. Arthur Calder-Marshall tried, and failed, to find her. The friends of her youth died or lost touch. All but one: Bunny Garnett never forgot his early flame, the fascinating model for Claire in *Dope Darling*. He remained true to the best spirit of Bohemia and helped her when she fell on hard times. Reduced to a modest council house in Kent in the 1970s, Betty eked out her last years living on handouts from the state, a small stipend from her one-time lover, and memories.

Appendix A

Monetary Equivalents

In order to get some idea of what artists lived on in the period discussed in this book, the following figures, which give approximate equivalents of one old penny and one pound to today's money (2001 figures), may be useful:

	£0 0s 1d	£1
1900	0.25p	£61
1905	0.26p	£62
1910	0.25p	£61
1915	0.19p	£46.40p
1920	0.10p	£23.55p
1925	0.15p	£35.68p
1930	0.20p	£47.82p
1935	0.22p	£53.32p
1939	0.21p	£50.42p

Source: John J. McCusker, 'Comparing the Purchasing Power of Money in Great Britain from 1600 to Any Other Year Including the Present', Economic History Services, 2001, URL:
http:/www.eh.net/hmit/ppowerbp/

Appendix B

Dramatis Personae

The following notes do not aim to be encyclopaedic; there are omissions and failures of knowledge. They are intended as an aide-mémoire for the reader who may appreciate extra briefing on some of the extensive cast of characters who appear in this book. With this in mind, these deliberately abbreviated resumés emphasise their subjects' context in the world I have called Bohemia, as opposed to their achievements, artistic or otherwise.

Acton, Harold (1904–1994) Brought up in Italy and schooled at Eton, the author of *Memoirs of an Aesthete* (1948) frequented 'haut Bohemia' in the company of his Oxford contemporaries Evelyn Waugh and Peter Quennell. Acton's creed was culture, his predilections for the European and the exotic, for modernism and homosexuality; these marked him out as a nonconformist if not exactly a Bohemian.

Aldington, Richard (1892–1962) 'I [never] wholly shuffled off the bourgeois . . . I should say I was naturally the eremitical kind of bohemian.' Aldington's semi-autobiographical novel *Death of a Hero* (1929) satirised both worlds with equal acerbity. Aldington started as a poet; he was friends with Pound, F. M. Ford and D. H. Lawrence, and lived much of his later life in France.

Anrep, Boris (1883–1969) Anrep left his native Russia in 1908 to study art in Paris, and there fell in with Augustus John's circle, including his future wife, Helen Maitland. His mosaic on the main staircase of the National Gallery in London includes portraits of several illustrious contemporaries. Despite living in a ménage-à-trois with Helen and his mistress Maroussia, Anrep remained a sought-after figure in high society.

Anrep, Helen (1885–1965) After an unhappy affair with Henry Lamb, Helen married Boris Anrep in 1917; they had two children, but she left Boris in 1926 and found happiness with the art critic Roger Fry, through whom she became close friends with much of Bloomsbury. Warm-hearted and argumentative, she fitted the stereotype of the Bohemian with her romantic clothes and easy-going generosity.

Anrep, Igor (b. 1915) Younger child of Boris and Helen Anrep, Igor saw himself as an outsider from 'red-brick conventional people'. Brought up with his sister

Anastasia in Bloomsbury and among the John children at Alderney Manor, Igor was tutored by Isabel Fry, Gerald Brenan and Marjorie Strachey. As an adult he studied psychoanalysis and became a doctor.

Ashton, Frederick (1904–1988) Renowned British choreographer, Ashton's homosexuality was accepted in the group described by Cecil Beaton as 'the illuminati', of which he was a central figure. A regular at the Great Ormond Street gatherings of painters Cedric Morris and Lett Haines, his friendship with the ballerina Lydia Lopokova brought him into contact with Bloomsbury.

Bagnold, Enid (1889–1981) 'Tomboyish, dramatic, outdoor, beautiful,' Enid Bagnold was born into a military family, but in her youth Bohemia was her world. She studied art under Sickert; Gaudier-Brzeska sculpted her; Frank Harris seduced her. She was herself a successful playwright and author, best known for *National Velvet* (1935). Her wide social circle comprised writers, designers and actors.

Bax, Clifford (1886–1962) Brother of the composer Arnold Bax, Clifford studied art at the Slade and Heatherley's Art School. His close circle included Godwin Baynes and Edward Thomas. After travelling and living abroad Bax abandoned painting and became a prolific man of letters. The Bax brothers hosted cricket weekends at their country home, described in Clifford's memoir *Inland Far* (1925).

Baynes, Godwin (1882–1943) A vital central focus of the 'Neo-pagans', Baynes was a Cambridge rowing blue and a singer, proportioned like 'a hero of antiquity'. Before their marriage, he and Rosalind Thornycroft went on romantic holidays together; they set up a Bohemian household near Baynes's doctor's practice in London's East End. The marriage ended in divorce after both had been unfaithful.

Beaton, Cecil (1904–1980) Photographer and designer, Beaton was an habitué of 'haut Bohemia', from which many of his clients were to come. He was as familiar with the Sitwells and Cunards as he was with the Johns and Lady Diana Cooper. Though Beaton may have seemed snobbish, he admired purity above pretension, and the individual over the fashionable.

Bedford, Sybille (b. 1911) Daughter of an aristocratic German father and an English mother and brought up in cosmopolitan Europe, Sybille Bedford lived between Provence and the Bohemian fringes of literary London. She became a central figure in the Aldous Huxley circle at Sanary, described vividly in her autobiographical novel *Jigsaw* (1989), and in her biography of Huxley.

Bell, Clive (1881–1964) Born into a rich philistine family, Bell became a key figure in Bloomsbury, genial and worldly. As a critic, he was in the avant-garde of aesthetic theory. After the birth of their two sons his marriage to Vanessa Bell evolved into friendship, and he had several affairs, the most enduring being with Mary Hutchinson.

Bell, Julian (1908–1937) Elder son of Clive and Vanessa Bell, Julian was brought up with his younger brother in the relaxed atmosphere of Gordon Square and Charleston, while benefiting from an exceptionally close relationship with his mother Vanessa. A highly politically engaged poet and teacher, Julian was killed driving an ambulance in the Spanish Civil War.

Bell, Quentin (1910–1996) The younger of Vanessa and Clive Bell's two sons, Quentin grew up in a world where Post-Impressionism, pacifism and agnosticism were the norms: 'From an early age I knew that we were odd'. With a certain inevitability he grew up to become a writer, artist and academic, chronicler of Bloomsbury, and the acclaimed biographer of his aunt Virginia Woolf.

Bell, Vanessa (1879–1961) Virginia Woolf maintained that the basis of her sister Vanessa's life was 'an easy Bohemianism'. A painter, she held a lifelong contempt for conventionality; her son Quentin described his parents' marriage as 'elastic'. Vanessa had a liberating affair with Roger Fry, but the partnership that she formed with Duncan Grant lasted the rest of her life.

Bowen, Stella (1893–1947) The painter Stella Bowen left her native Australia in 1914 and lived for ten years in England and France with the writer Ford Madox Ford, with whom she helped set up the *Transatlantic Review* in 1924. Their relationship is described in her memoir *Drawn from Life* (1941). After bringing up their daughter Stella continued to paint, write and exhibit.

Brenan, Gerald (1894–1987) Through his youthful friendship with John Hope-Johnstone Brenan became close friends with Augustus John's family. His relationship with Carrington also brought him into contact with Bloomsbury. Brenan emigrated to Spain in 1919, where he became an admired Hispanist; his memoirs portray many Bohemian characters of his time. V. S. Pritchett described Brenan as 'one of the best talkers and letter-writers in England'.

Brett, the Hon. Dorothy (1883–1977) The painter Brett (known, like Carrington, by her surname) rejected her upper-class background to become a 'Slade crophead'. She often helped her poorer friends financially; these included Mark Gertler, Carrington, D. H. Lawrence, J. M. Murry, and Katherine Mansfield. After Mansfield's death she had an affair with Murry. Brett, who was deaf all her life, lived in Taos, New Mexico from 1924.

Brodsky, Horace (1885–1969) Australian, the writer and critic Horace Brodsky grew up in the USA. In 1908 he came to London where he became involved with Vorticism. He later wrote an intimate biography of his close friend Gaudier-Brzeska. Brodsky returned to New York in 1915 to edit *Rainbow*, a magazine of art and poetry, but finally settled in England in 1923.

Brooke, Rupert (1887–1915) 'The handsomest young man in England' achieved almost mythic status after his untimely death, but during his lifetime Brooke was subject to recurrent depressions and a deep confusion about his own

sexuality. The poet was the nucleus of the 'Neo-pagans' – a group of friends including the Olivier sisters, the Darwins, David Garnett, James Strachey and Geoffrey Keynes.

Butts, Mary (1890–1937) Admired by many for her flamboyance and magnetism, the writer Mary Butts lived a round of 'haut Bohemian' parties and lovers, both in Paris and London, experimenting with hair dye, modernist poetry and, unhappily, opium. Her friends included Aleister Crowley, Douglas Goldring and Jean Cocteau. She eventually moved to Cornwall and lived quietly, gardening and cooking for friends.

Calder-Marshall, Arthur (1909–1992) Calder-Marshall, a humorous, sceptical Christian, grew up in Sussex and came into early contact with Victor Neuburg, the influential poet who published Dylan Thomas; he also crossed paths with the 'Beast', Aleister Crowley. After Oxford Calder-Marshall taught, then became a professional writer known for his essays, novels, biographies and social commentaries.

Campbell, Mary (1899–1979) Eldest of the seven beautiful and rebellious Garman girls, Mary married Roy Campbell in 1921; following a turbulent lesbian affair with Vita Sackville-West, Mary opted for her husband and two daughters, with whom she moved to France and, later, Spain and Portugal. Her profound Catholicism gave Mary strength in the subsequent years of their stormy marriage and Roy's untimely death.

Campbell, Roy (1901–1957) When not in his native South Africa, France or Spain, Roy Campbell was one of Augustus John's favourite drinking companions. Active in the creation of his own legend – that of a pugilistic, womanising, poet-pirate, who drank deep of life, and alcohol – he later offended many by his pro-Fascist politics. He was killed while driving in Portugal.

Cannan, Gilbert (1884–1955) Cannan's novel *Mendel* (1916) is a thinly disguised portrait of his friend Mark Gertler, drawing upon the Bohemian milieu of the Slade School of Art, and Gertler's love affair with Carrington. Cannan himself was notoriously cited as co-respondent in J. M. Barrie's divorce; he later married Barrie's wife Mary. He suffered from schizophrenia and ended his life in a lunatic asylum.

Carline, Hilda (1889–1950) The Hampstead home of the painter Hilda Carline and her two painter brothers, Richard and Sydney, was a rendezvous for artists including Gertler, the Nash brothers, Anrep, Medley, Kathleen Hale and Dorothy Brett. Hilda's talent, obscured by the genius of her husband Stanley Spencer, was largely sublimated into gardening. The couple divorced in 1937.

Carrington, Dora (1893–1932) Prominent at the Slade School by her bobbed hair, naive air and asexual sobriquet, the painter Carrington's circle included Brett, the Nash brothers and the John family. Mark Gertler was obsessed with

her. In 1915 she fell in love with Lytton Strachey, to whom (despite her marriage to Ralph Partridge and other entanglements), she remained devoted. Heartbroken after his death, Carrington shot herself.

'Chiquita' Thinly disguised as 'Juanita' by Seymour Leslie in his novel *The Silent Queen* (1927), the gamine Chiquita was introduced to Augustus John as a model. She became pregnant by him, and was looked after by Dorelia at Alderney Manor before having the baby, Zoë. Leslie supported her financially until she married John's friend Michael Birkbeck.

Clarke Hall, Edna (1879–1979) Considered one of the most gifted artists of her generation at the Slade, two of Edna Waugh's closest friends there were Gwen John and Ida Nettleship, through whom she met Augustus John. He drew her and greatly admired her work, but her confining marriage at the age of nineteen to lawyer Willie Clarke Hall was a setback for her talents.

Colum, Mary (1886–1957) Released from her Catholic school into the heart of Bohemian Dublin, this 'lovely, saucy, bright student at University College' was much influenced by the Irish Revival writers Yeats and Synge. She was also deeply involved in women's suffrage. With her husband the poet Padraic Colum she helped found the *Irish Review* and became a friend of James Joyce.

Connolly, Cyril (1903–1974) Etonian and Oxford graduate, Connolly vacillated between literary respectability and dissolute Bohemianism; his one novel, *The Rock Pool* (1947), describes Bohemian life on the Côte d'Azur. An ardent traveller and hedonist, his close friends included Patrick Balfour, Noel Blakiston and Peter Quennell, though as editor of *Horizon* he knew most of the major writers of his day.

Cooper, Lady Diana (1892–1986) 'Dazzling and valiant', Lady Diana Manners was one of the 'Mayfair troika', consisting of Nancy Cunard, Iris Tree and herself. Her autobiography describes her marriage to the politician Duff Cooper, and her career as an actress and hostess to the cultured and aristocratic milieux of her day. Cecil Beaton admired her for her 'aristocratic grace' and 'gypsy bohemian traits'.

Crowley, Aleister (1875–1947) Poet and diabolist, Crowley, who liked to be known as 'the wickedest man alive', claimed to be the Beast from the Book of Revelation. In 1920 he founded Thelema, the centre of his cult at Cefalù, Sicily, where Betty May's husband Raoul Loveday died. Crowley wrote and travelled extensively, but was often to be found in Fitzrovian pubs.

Cunard, Nancy (1896–1965) Cecil Beaton's photograph of Nancy, cropped, bangled and kohl-eyed, remains a potent icon of the twenties. High-born but rebellious, she was equally at home in Mayfair and Bohemia. With Augustus John, Nancy 'discovered' the Eiffel Tower restaurant. A poet, she founded the Hours Press, and campaigned for racial equality; her long affair with a black man outraged her family.

Daintrey, Adrian (1902–1988) A solid middle-class background equipped Daintrey for his later career as *Punch*'s art critic. He studied painting at the Slade, and his circle included Augustus John, Matthew Smith, Nina Hamnett, and Alvaro Guevara. Recalling café life in Paris (a second home) he wrote, 'Art was a question of chat about one's complexes accompanied by an endless succession of drinks.'

Dennison, Christabel (1884–1925) A painter, Christabel was a marginal figure in the studios and bookshops of Bohemia, her potential blighted by an unhappy affair with the writer John Adams, by whom she had a child, adopted after birth. Christabel's writings give a picture of an educated, aware woman oppressed by domesticity and a masochistic love affair.

Devas, Nicolette (1911–1987) The daughter of poet and philosopher Francis Macnamara, Nicolette's autobiography lays claim to 'Two Flamboyant Fathers', the other being Augustus John, with whose children she was largely brought up. Her sister Caitlin married Dylan Thomas; she herself went to the Slade and married her more conventional fellow-student Anthony Devas. After her children were born she took up writing.

'Dolores' (1894–1934) Described by Epstein, who sculpted her several times, as a 'High Priestess of Beauty', this Café Royal model was notorious for her amours and much followed by the gutter press. Her chosen pseudonym was, according to some, appropriate to her indefinable air of tragedy; she had cancer and was found dead in a Paddington basement aged forty.

Doone, Rupert (1903–1966) Rupert Doone ran away from home to become a dancer. He later lived in Paris and became a friend of Cocteau's. This handsome prodigy became the lifelong partner of the painter Robert Medley after they met in 1925; together they founded the Group Theatre with W. H. Auden and Christopher Isherwood. Their relationship is described in Medley's autobiography *Drawn from the Life*.

Dowdall, Mary (1876–1939) 'The most charming and entertaining character in Liverpool', according to Augustus John, Mary Dowdall, nicknamed the Rani, was high-born (the daughter of Lord Borthwick) but, with her bare legs and gypsy manners, too unconventional for Liverpool society. She was a journalist and the author of several novels, and was to become epistolary confidante to Ida John.

Duncan, Isadora (1878–1927) 'When she appeared we all had the feeling that God . . . was present.' The American-born dancer and choreographer pioneered fluid, expressive movement, and championed free love and women's liberation. Isadora's life was blighted by the tragic deaths of her first husband and her two children. She herself was strangled when her scarf caught in the wheels of a car.

Earp, Thomas (1892–1958) A promising poet and writer, Tommy Earp's drinking companion Roy Campbell described him as 'the finest wit and the most exquisite literary critic alive'. Earp reputedly squandered his inheritance on riotous living, and his rubicund face with *en brosse* haircut was often to be seen alongside Augustus John or Wyndham Lewis in the Fitzroy Tavern or Eiffel Tower restaurant.

Ellis, Edith (1861–1916) An influential writer and lecturer, and wife of the sexologist Havelock Ellis, Edith was of the generation of 'new women' influenced by writers such as Olive Schreiner and Edward Carpenter. She was unstable, extravagant and vivacious, but her lesbianism meant that the marriage, for all its progressiveness, was not altogether successful.

Ellis, Havelock (1859–1939) A champion of Freud, Ellis's pioneer work on sexology had a liberating influence on succeeding generations. His passionate attachment to the feminist writer Olive Schreiner survived his problematic marriage to Edith Lees. In *My Life* (1940) Ellis reflected optimistically on the progress that he felt had been achieved against repression and unthinking tradition.

Epstein, Jacob (1880–1959) Epstein was born in New York, but settled in England in 1905. In pre-First World War London Epstein's controversial sculpture inspired reverence among the avant-garde; socially he was a Bohemian divinity equal only to Augustus John. Parallel with his first marriage, Epstein had a long-term affair with Kathleen Garman, who was to become his second wife. In 1954 he was knighted.

Epstein, Margaret (1870–1947) Margaret Dunlop divorced her husband to marry Epstein; they had one child. Ten years his senior, she 'looked like a Russian doll'. Their forty-one years together were dogged by Margaret's ill-health and Epstein's infidelity; in jealousy she shot and wounded Kathleen Garman. Nevertheless Margaret's intelligence and solicitude provided much-needed stability in the Epstein household.

Fedorovitch, Sophie (1893–1953) Born in Poland, the painter Fedorovitch came to England in 1920, then lived in great poverty in Paris. Her circle of friends included Iris Tree, Epstein, Augustus John, and Constant Lambert. In the 1930s she and Frederick Ashton started a fruitful collaboration as set designer/choreographer. She died in a gas poisoning accident.

Firbank, Ronald (1886–1926) Financially independent, Firbank indulged his taste for champagne at his regular haunt, the Café Royal. A lonely homosexual, his novels (written on piles of blue postcards) are witty aesthetic fantasies, influenced by the nineties, but influential in their turn on such writers as Evelyn Waugh and Ivy Compton-Burnett. Firbank died young from a disease of the lungs.

Fitzgibbon, Constantine (1919–1983) Born in America, brought up in England, and educated in France and Germany, Fitzgibbon was a true cosmopolitan, gifted, amusing and attractive. Theodora Rosling was the second of his four wives. Fitzgibbon was, like his close friend Dylan Thomas, a heavy drinker. His biography of Thomas is probably his best work, vividly evoking the Fitzrovian thirties.

Ford, Ford Madox (1873–1939) Described by a friend as 'an aristocratic Bohemian', the novelist and influential editor of the *English Review* was dominated by his turbulent emotional life. Ford eloped with his first wife, and his affair with the glamorous novelist Violet Hunt caused a public scandal. In 1922 he moved to France with the artist Stella Bowen. He later had an affair with Jean Rhys.

Fry, Roger (1866–1934) Organised by Fry, the Post-Impressionist exhibitions of 1910 and 1912 ensure his place in the history of modern art, as does his foundation of the innovatory Omega Workshops. *Vision and Design* (1920) influenced a generation. Fry's wife became incurably insane; in 1911 he formed a lasting attachment to Vanessa Bell. From 1926 he lived with Helen Anrep.

Garman, Kathleen (1901–1979) Fourth of the seven Garman sisters, Kathleen ran away to London in 1920; 'tall, self-possessed, remotely beautiful', she was spotted by Jacob Epstein in the Harlequin restaurant, and became his model and mistress. She had three children by him, and the relationship endured. After Margaret Epstein's death Kathleen married him and in 1954 became Lady Epstein.

Garnett, Angelica (b. 1918) Vanessa Bell's daughter by Duncan Grant, she was born at Charleston and raised as Clive Bell's child until she was told of her true parentage at eighteen. A versatile artist, Angelica became David Garnett's second wife in 1942; they had four daughters. *Deceived with Kindness* (1985) is a memoir of her upbringing in the heart of Bloomsbury.

Garnett, David (1892–1981) Birrell and Garnett's bookshop in Taviton Street was a favoured Bloomsbury rendezvous. 'Bunny' studied biology, but switched to writing and achieved success with his first novel *Lady into Fox* (1922). Explosive and passionate, he had affairs with Duncan Grant, Betty May, Carrington, Anna Wickham and many others. He married Angelica Bell after the death of his first wife, Ray Marshall.

Gaudier-Brzeska, Henri (1891–1915) Born in France, the sculptor Henri Gaudier moved to London in 1911 with his 'sister' Sophie Brzeska (this was a front for their relationship). He became involved with the Vorticists, and met Wyndham Lewis, Ford Madox Ford, Horace Brodsky and Ezra Pound. Mercurial and defiantly unconventional, his biographer dubbed him the 'savage Messiah'; he was killed during the First World War.

Gertler, Mark (1891–1939) Born into a poor East End Jewish family, Gertler attended the Slade School from 1908. Talented and charming, he was at the centre of pre-war Bohemian society. A passionate affair with Carrington left

Gertler disappointed. In 1930 he married the painter Marjorie Hodgkinson, but ill-health, depression, and the failure of an exhibition took their toll; he committed suicide in 1939.

Gill, Eric (1882–1940) Perhaps the foremost artist-craftsman of the twentieth century, the celebrated typographer Gill was as unconventional in his life as in his art. The communities he founded in Sussex and Wales appeared to be experiments in monasticism; in truth Gill was indulging in various bizarre sexual proclivities, including incest with his daughters. Gill's writings include polemics on religion, art and various social topics.

Glenavy, Beatrice (1881–1970) Beatrice Glenavy's fellow-Irishman William Orpen described her as having 'many gifts, much temperament and great ability'. Beatrice attended the Slade from 1910. Her friends included Katherine Mansfield, Middleton Murry, D. H. Lawrence, Mark Gertler and S. S. Koteliansky. She married the lawyer Gordon Campbell in 1912; her memoir *Today We Will Only Gossip* (1964) describes their social life in London and Dublin.

Godley, Kitty (b. 1927) Daughter of Jacob Epstein by his mistress Kathleen Garman, Kitty was mainly brought up by her Garman grandmother. She attended the Central School of Art, had a brief romance with Laurie Lee and in 1947 married Lucian Freud, by whom she had two daughters (his only legitimate children). She is now married to the economist Wynne Godley.

Goldring, Douglas (1887–1960) Goldring struggled all his life to survive by writing. His links with the literary world were first forged when he became sub-editor of the *English Review* under Ford Madox Ford. Goldring's friends included Ethel Mannin, Alec Waugh and Hugh Kingsmill. He married twice; he and his second, Swedish wife travelled widely and he became a respected minor travel writer.

Grant, Duncan (1885–1978) Largely brought up with his Strachey cousins, the painter Duncan Grant was from the first an intrinsic member of the inner Bloomsbury circle. His charm and talent made him irresistible to men and women alike, and he was beset by many romantic imbroglios. Vanessa Bell – who had a daughter, Angelica, by him in 1918 – remained his closest companion.

Graves, Robert (1895–1985) Graves's autobiography, *Goodbye to All That* (1929), recounts his war experiences and his struggle to be a poet. His marriage to the painter Nancy Nicholson broke down after he became involved with the American poet Laura Riding – the first of a series of 'muses'. Graves emigrated to Mallorca in 1929, remarried, and became a prolific and successful writer.

Gray, Stewart Roy Campbell and Epstein both recalled this semi-mythical character, a one-time lawyer in Edinburgh, who 'went bamboo', gave away his fortune, and headed a hunger march to London. He used his legal knowledge to open up uninhabited houses and provide 'squats' for homeless Bohemians.

Later he lived in Kathleen Hale's basement and appears to have converted to spiritualism.

Grigson, Geoffrey (1905–1985) Handsome and enthusiastic, a 'blend of sophistication and innocence', Grigson was founder of *New Verse* – the most influential poetry magazine of the thirties. As such his connections extended throughout literary London, and included Antonia White, Wyndham Lewis, Stephen Spender, and Dylan Thomas. He married three times.

Hale, Kathleen (1898–2000) Kathleen Hale describes her struggle to live independently and become an artist in her autobiography, *A Slender Reputation* (1994). Poverty and hunger were setbacks, but London's Bohemia provided many compensations, including becoming secretary to Augustus John. She later married and gained her 'reputation' as the writer and illustrator of the 'Orlando' books for children.

Hamar, Haraldur Known by his sobriquet 'Iceland', this penniless Café Royal 'character' was for many years a figure in the English Bohemian world. Iceland claimed to be a playwright, but his plays were never produced. His own walk-on role was in the lives of Augustus John, Nina Hamnett, C. R. W. Nevinson and the Sitwells.

Hamnett, Nina (1890–1956) The artist Nina Hamnett would often entertain friends with stories from her colourful past. Parisian friends included Modigliani, Cocteau and Stravinsky; in London she was intimate with Roger Fry, Sickert, Augustus John and Gaudier-Brzeska. Nina's brief marriage failed, and she reverted to promiscuity. Poverty and alcohol addiction eventually brought Nina low; she died after falling from her flat window.

Harper, Allanah (1904–1992) After a privileged upbringing, Allanah Harper was a central figure of 'haut' Bohemia, where she pursued a carefree life with such friends as Nancy Cunard, Cecil Beaton, Brian Howard and the Sitwells. She moved to France in 1929 and founded *Echanges*, a quarterly review which introduced English writers to a French readership.

Heseltine, Philip (aka Peter Warlock) (1894–1930) Composer and musicologist, Heseltine was at the centre of Café Royal society in the twenties, with his close friends Cecil Gray and Bernard van Dieren. He married the model Bobby Channing, known as 'Puma'; Viva King fell madly in love with him. Heseltine was eccentric, famous for his flamboyance, caustic wit and mood swings. He committed suicide aged thirty-six.

Hillier, Tristram (1905–1983) Good-looking and amusing, Hillier describes his art and impetuous love life in *Leda and the Goose* (1954). While studying at the Slade he became an habitué of the Fitzroy Tavern and the Eiffel Tower restaurant. Later he worked in Spain, Paris and the south of France, where he borrowed Vanessa Bell's cottage at Fontcreuse.

Hope-Johnstone, John (1883–1970) 'One of those delinquent upper-class Bohemians who leaven the English class-system', the romantically good-looking Hope-Johnstone was for a while tutor to Augustus John's children. In 1912 he set out with his young friend Gerald Brenan on a never-completed adventure walking to China. Learned and well read, he was also a master of arcana, from calligraphy to cookery.

Howard, Brian (1905–1958) Described by his Oxford contemporary Evelyn Waugh as 'mad, bad and dangerous to know', Brian Howard was a notorious dandy and aesthete who inspired the character of Ambrose Silk in Waugh's *Put Out More Flags* (1942). Nancy Cunard published Howard's poetry, but he never realised his potential as a writer. He committed suicide by a drugs overdose.

Hunt, Violet (1866–1942) As famous for her scandalous liaison with the married Ford Madox Ford as for her literary salon in pre-war London, Violet Hunt was also a prolific novelist. Violet's emphasis on propriety was at odds with Ford's more relaxed Bohemianism; but she was an important cultural catalyst. 'I have to live always in the boiling middle of things,' she wrote.

Hutchinson, Mary (1889–1977) A cousin of Lytton Strachey, married to the barrister St John Hutchinson, and close friend of T. S. Eliot and Aldous Huxley, the elegant and sophisticated Mary entertained artistic society in London and at her country home in Sussex. She often visited Charleston with Clive Bell; their affair lasted thirteen years. Mary's *Fugitive Pieces* was published by the Hogarth Press in 1927.

Huxley, Aldous (1894–1963) The author of *Brave New World* (1932) suffered from near-blindness. During the First World War Huxley often stayed at Garsington. His novels *Crome Yellow* (1921) and *Antic Hay* (1923) depict contemporary Bohemian society. In the 1920s and 30s Huxley and his wife, Maria, lived in Italy and the south of France, where D. H. Lawrence and Sybille Bedford became close friends.

Huxley, Juliette (1896–1994) Juliette Baillot came to Garsington in 1915 as Swiss governess to Ottoline Morell's young daughter Julian; she later left to educate the children of the Ranee of Sarawak (Brett's sister). In 1918 she married Julian Huxley, brother to the novelist. Her memoir, *Leaves of the Tulip Tree* (1986), gives a valuable portrait of Garsington and its guests and inhabitants.

John, Augustus (1878–1961) Born in Wales, John studied at the Slade 1894–1898. Spectacularly talented and attractive, he was King of the Café Royal at this period, but was equally fascinated by gypsy life. In 1901 he married Ida Nettleship, and soon after began a lifelong relationship with Dorothy McNeill, 'Dorelia'. Only five of John's innumerable children were legitimate. Despite alcoholism he continued painting to the end of his life.

John, Gwen (1876–1939) After Gwen's death Augustus John prophesied that 'fifty years from now I shall be known as the brother of Gwen John'. Having studied at the Slade, she settled in France, becoming Rodin's model and mistress. In 1913 Gwen became a Roman Catholic. She lived reclusively, painting and looking after her cats, and died mysteriously in Dieppe.

John, Ida (1877–1907) Ida Nettleship enrolled at the Slade in 1892; there her closest friends were Edna Clarke Hall and Gwen John, through whom she met her husband, Augustus. Sentimental and idealistic, Ida's romantic dreams of love were shattered by Augustus's infidelities, domestic cares, and frequent childbearing. She died of puerperal fever in Paris.

John, Romilly (1906–1986) 'I needed time to recover from my childhood,' wrote Augustus and Dorelia's son in *The Seventh Child* (1975). Romilly's full-time education ended when he was twelve; nevertheless he went to Cambridge and married while still an undergraduate. After a spell in the army and as a civil servant he decided to devote himself to literature.

King, Viva (1893–1978) Warm-hearted and permissive, Viva Booth was dubbed 'Queen of Bohemia' by Osbert Sitwell; her 'court' included Kathleen Hale, Nina Hamnett, Nancy Cunard, Nevinson, Wyndham Lewis, the Epsteins. She was briefly secretary to Augustus John, and had a tempestuous affair with Philip Heseltine. In 1926 she married the homosexual Willie King. Her Thurloe Square salon became a mecca for artistic society.

Koteliansky, S. S. (1882–1955) Koteliansky was a Ukrainian Jew who came to England in 1911 and remained. Despite his bad English he earned his living as a translator, and encouraged appreciation of such authors as Chekov and Gorky by persuading the Woolfs to publish them at the Hogarth Press. His close friends included Katherine Mansfield, D. H. Lawrence and Beatrice Campbell.

Kramer, Jacob (1892–1962) Born in the Ukraine, Kramer was brought up in Leeds. He gained assistance to attend the Slade School in 1912. A drinking companion of Roy Campbell and Augustus John, he joined Wyndham Lewis's Vorticist movement, and with him helped decorate the Eiffel Tower Restaurant. He later returned to Leeds, where he dominated its Bohemian sub-culture.

Kühlenthal, Christine (1895–1976) Though she was poised and accomplished, Christine's German parentage made her the victim of prejudice during the First World War. Her contemporaries at the Slade were Brett and Carrington. Christine's own painting talent was jeopardised by bad eyesight. She married the painter John Nash in 1918, but under the terms of a 'freedom pact' struggled to allow him emotional liberty.

Lamb, Henry (1883–1960) Henry Lamb abandoned his medical training to paint. Through his brother Walter he met the Bloomsbury Group, including Lytton Strachey (of whom he painted a memorable portrait). Stanley Spencer

was a close friend. His first marriage, to Euphemia Forrest, was unsuccessful; and despite their mutual passion, he failed to detach Dorelia McNeill from Augustus John. In 1928 he married Lady Pansy Pakenham.

Lambert, Constant (1905–1951) 'Very good-looking and a non-stop talker', this precocious composer and conductor was a Sitwell protégé and friend and collaborator of William Walton. Lambert's appetite for fast living and his unconventionality made him welcome in Fitzrovian society. His friend Anthony Powell based 'Hugh Moreland' on Lambert in *A Dance to the Music of Time* (1951–75). Alcohol hastened his early death.

Lanchester, Elsa (1902–1986) Dizzily charming, the red-haired actress who ran the Cave of Harmony nightclub in Charlotte Street with Harold Scott married Charles Laughton in 1929, and later became a renowned film star. Her best-known role is probably in *Bride of Frankenstein* (1935); she also starred in the film version of *The Constant Nymph*. Elsa became a US citizen in 1950.

Lawrence, D. H. (1885–1930) The working-class author of *Sons and Lovers* (1913) was introduced by Ford Madox Ford into literary and intellectual circles; his friends included the Huxleys, David Garnett, Lady Ottoline Morrell, Middleton Murry, Katherine Mansfield and Dorothy Brett. After his marriage to Frieda Weekley he spent much time abroad. Lawrence died in France of tuberculosis.

Lee, Laurie (1914–1997) Laurie Lee's account of his rural Gloucestershire boyhood, *Cider with Rosie* (1959), is his main claim to immortality. In the thirties Lee travelled in Europe; his passionate affair with Lorna Wishart (sister of Mary and Kathleen Garman), by whom he had a daughter, brought him into contact with Bohemian London. He eventually married Lorna's niece Kathy.

Lett-Haines, Arthur (1894–1978) For sixty years the partner of the painter Sir Cedric Morris, 'Lett' sacrificed his own talents to promoting those of Morris. The pair loved bizarre parties, and entertained frequently in Fitzrovia. Mischievous, bisexual, good-looking, he was depicted by Kathleen Hale (who had an affair with him) in her 'Orlando' books as the 'Katnapper', an irresistibly magnetic personality.

Lewis, Wyndham (1882–1957) A leading figure of the pre-war avant-garde, the founder of Vorticism trained at the Slade. Friends for a time with Augustus John and Ezra Pound, Lewis was notoriously energetic, talented and quarrelsome; his satire *The Apes of God* (1930) savages many of his contemporaries. He has been described as 'one of the loneliest figures in the intellectual world of the thirties'.

Lopokova, Lydia (1892–1981) Lopokova trained as a ballerina in Russia and came to London in 1918 with Diaghilev's Ballets Russes. Her gaiety and charm captivated Maynard Keynes and in 1925 they married; she became an incongruous, but festive, element in Bloomsbury celebrations thereafter. At their Sussex home, Tilton, she and Keynes were close neighbours of Charleston.

Macnamara, Caitlin (1913–1994) Voluptuous and impetuous, the daughter of Augustus John's drinking companion Francis Macnamara was largely brought up with John's children. Caitlin never succeeded in her ambition to be a dancer; in 1936 she met the poet Dylan Thomas, and their tempestuous marriage was undermined by poverty and alcohol addiction. After Dylan's death Caitlin lived abroad.

Macnamara, Francis (1884–1946) 'To know Francis was to know sorrow.' Poet and philosopher, scion of an ancient Irish family, Francis Macnamara became one of Augustus John's closest friends. Macnamara was serially unfaithful to his wife Yvonne Majolier, and to his second wife, Edie McNeill, sister of Dorelia. By Yvonne he had four children, including Nicolette Devas and Caitlin, who married Dylan Thomas.

Mannin, Ethel (1900–1984) Born into a humble background, Ethel Mannin became a journalist and prolific novelist, who wrote over a hundred books. In her memoir *Confessions and Impressions* (1930), 'angry with the humbug of conventional morality', she set out to shock the older generation. A confirmed pacifist and indefatigable traveller, her close friends included Douglas Goldring and the educationist A. S. Neill.

Mansfield, Katherine (1888–1923) The writer Katherine Mansfield came to London from her native New Zealand in 1903. A short-lived marriage was followed by the birth of a stillborn child by another man in 1909. In 1918 she married the literary editor John Middleton Murry. Their circle included D. H. Lawrence, Beatrice Campbell, Ottoline Morrell and Virginia Woolf. Undiagnosed gonorrhoea hastened Katherine's death from tuberculosis.

Marsh, Sir Edward (1872–1953) Much of London's Bohemia had reason to be grateful to Eddie Marsh, a rich and respected civil servant, and private secretary to Winston Churchill. A connoisseur and patron of modern painting, he bought work by Gertler, the Nash brothers, and Stanley Spencer. He also edited the five volumes of *Georgian Poetry* (1912–22), including poems by Brooke, D. H. Lawrence and Graves.

Marshall, Ray (1892–1940) The first wife of David Garnett, Ray bore him two sons, Richard and William. Ray was an illustrator, and her love of nature and timid, enigmatic qualities inspired David Garnett's best novel, *Lady into Fox* (1922). Her woodcuts adorn this and several of his other works including *A Rabbit in the Air* (1932). Ray died of cancer.

Maugham, W. Somerset (1874–1965) Though his books and plays were to bring him fame and fortune, Maugham drew on his impoverished Bohemian youth in his masterpiece, *Of Human Bondage* (1915), which depicts from first-hand the life of a young art student aspiring to the life of *Trilby* in Paris, and the hard-up struggles of Maugham's Bohemian contemporaries in London.

May, Betty Her luxuriant beauty and flamboyant clothes made Betty a proto-
type Bohemian. Born in London's East End, she modelled for Epstein, joined
the Parisian underworld, and became a cocaine addict. She and her third hus-
band, Raoul Loveday, got tragically entangled with Aleister Crowley's cult in
Sicily. 'I am sure that I am born for adventure,' she reflected in *Tiger Woman*
(1929).

McNeill, 'Dorelia' (1881–1969) Augustus John was enthralled by Dorothy
McNeill's Mona Lisa looks, rechristened her 'Dorelia', and immortalised her
unmistakable 'aesthetic' image in numerous portraits. Their relationship survived
her affair with Henry Lamb, and John's infidelities. She bore him four illegitimate
children and was serene mother-figure to Augustus's other offspring, and to many
of their rambling household of guests.

Medley, Robert (1905–1994) Medley studied at the Slade and in Paris; his
education and training brought him into contact with W. H. Auden (who was
his lover for a time), and also with Bloomsbury and Fitzrovia. His lifelong partner
was the dancer Rupert Doone. Together with Isherwood and Auden they
founded the Group Theatre. In 1983 Medley published his autobiography, *Drawn
from the Life*.

Mitchison, Naomi (1897–1999) Naomi Haldane grew up in a distinguished
academic family and, after her marriage to barrister Dick Mitchison, combined
writing with her socialist commitments. She was a political and social pioneer,
and a compulsive traveller, while bringing up her five children. The Mitchisons'
wide circle of friends included W. H. Auden, the Huxleys, the Stracheys and
E. M. Forster.

Morrell, Lady Ottoline (1873–1938) Married to the M.P. Philip Morrell, the
striking and unconventional Lady Ottoline held 'Thursday evenings' for a wide
circle of cultural celebrities; during the First World War her home at Garsington,
Oxfordshire was a sanctuary for conscientious objectors, artists and writers.
Ottoline's remarkable appearance and personality inspired portraits by Augustus
John and Duncan Grant, as well as fictional representations by D. H. Lawrence
and Aldous Huxley.

Nash, John (1893–1977) Younger brother of the more celebrated Paul, the
painter John Nash ('slight, witty and well-read') fell in love with Carrington
while at the Slade. They corresponded during his time as an official war artist,
and the relationship survived his 'open' marriage to Christine Kühlenthal, but
John's unrequited passion for Carrington remained an open wound until her
suicide in 1932.

Nash, Paul (1889–1946) Paul Nash trained at the Slade, worked briefly at the
Omega Workshops, and became an official war artist in 1917; the paintings he
did at that time established his reputation as an artist of visionary qualities.

Romantic and constitutionally unfaithful, he had a turbulent marriage with the exotic Bunty Odeh.

Nevinson, C. R. W. (1889–1946) Nevinson studied at the Slade from 1908–1912, where he joined the 'Slade Coster Gang', who dressed eccentrically and terrorised the Soho neighbourhood. Success as a war artist made him a celebrity. Nevinson was a famous party-giver, connected throughout the London art world. Touchy and imperious, he had 'many endearing qualities, but modesty was not among them'.

Nicholson, Nancy (1900–1977) An ostentatious feminist, the artist Nancy Nicholson smoked, rode a motorbike, and refused to take her husband Robert Graves's name. Their unsatisfactory marriage, beset by poverty and ill-health, ended after a crisis precipitated by Laura Riding. Though she and Graves did not divorce until 1949, Nancy transferred her allegiances and four children to the poet Geoffrey Taylor.

O'Connor, Philip (1916–1998) Introspective, prolific, alcoholic, the surrealist poet Philip O'Connor survived a disastrous upbringing. Laurie Lee was an early friend. O'Connor married six times and had nine children. *Memoirs of a Public Baby* (1948) describes his Bohemian existence in France and Fitzrovia, a hand-to-mouth life which brought him to the verge of a nervous breakdown.

Odle, Alan (1888–1948) 'A curious blend of Bohemian and gentleman', this habitué of the Café Royal was distinctive for his eccentric air of grandeur. Extravagant, contemptuous and unwashed, the artist Odle suffered from tuberculosis. In 1917 he met the writer Dorothy Richardson, who felt a maternal desire to care for him. They married when he was twenty-nine and she was forty-four.

O'Flaherty, Liam (1896–1984) 'He has the inflated ego of the romantic' – but also the romantic's imaginative vigour. Born on the Aran Islands, the writer O'Flaherty was encouraged to write by Edward Garnett. He married but separated, became involved in the Irish republican movement, and travelled widely. O'Flaherty published three volumes of memoirs.

Olivier, Noel (1892–1969) The youngest of the four Olivier girls, Noel was a childhood friend of David Garnett whose family were close neighbours in Surrey. Educated at Bedales, she was still a schoolgirl when she met Rupert Brooke, who fell in love with her. Noel trained as a doctor and married a colleague by whom she had five children.

Otter, Gwen Described by Ethel Mannin as 'one of the last of the dying race of Bohemians', Gwen Otter's legendary glory as a Chelsea salon hostess was on the wane by the turn of the century but, despite deafness and reduced means, she still continued to entertain a rich variety of artistic luminaries.

Partridge, Frances (b. 1900) Frances was educated at Bedales and Cambridge. Her job at Birrell and Garnett's bookshop in the twenties brought her into

contact with Bloomsbury. The Carrington/Strachey/Partridge *ménage à trois* was complicated by Frances's love affair with Ralph Partridge, whom she later married. Since Ralph's death in 1960 Frances has published a series of diaries which testify to her wide-ranging interests and friendships.

Paul, Brenda Dean (b. 1907 d.?) Brenda Dean Paul rose from studio Bohemia to become 'an acknowledged beauty of the party-world'. She trained as an actress and played the lead in Firbank's *The Princess Zoubaroff*; she also travelled widely. In the twenties Brenda became addicted to opiates, and was briefly imprisoned for illegal possession. Her memoir *My First Life* was published in 1935.

Powell, Anthony (1905–2000) The author and critic Anthony Powell's twelve-volume tour de force, *A Dance to the Music of Time* (1951–1975), is a close-up portrait of English society in the twentieth century; many of Powell's contemporaries are recognisable through the fiction. Powell lived and married within the upper classes, but had several close brushes with Bohemia, including an affair with Nina Hamnett.

Quennell, Peter (1905–1993) Born into the educated middle classes, after Oxford Quennell became a writer and editor whose charm and talent guaranteed him a place in 'haut' Bohemian society. A welcome guest of the Connollys, Dick Wyndham, the Sitwells and at Garsington, Quennell married five times. He wrote two volumes of autobiography.

Ransome, Arthur (1884–1967) '[Bohemia] is not a place but an attitude of mind,' wrote Arthur Ransome in *Bohemia in London* (1907). He made this observation at the age of twenty, when he set out to live for art in Chelsea. Many years later, a successful children's author, Ransome recalled the joys, poverty and friendships of his Bohemian life with intense nostalgia.

Raverat, Gwen (1885–1957) Gwen Raverat, the granddaughter of Charles Darwin, studied painting at the Slade School, but was to become principally a wood-engraver. In 1911 she married her fellow-student Jacques Raverat. Late in life she published *Period Piece – A Cambridge Childhood* (1952), which she illustrated herself – a surprise success.

Rhys, Jean (?1890–1979) Jean Rhys came to England from the West Indies in 1907; she later moved to Paris. Several of her novels reflect her experiences as a chorus girl as well as her masochistic relationships with various men, one being her patron and editor Ford Madox Ford. Recognition came late in life after the publication of *Wide Sargasso Sea* (1966).

Richardson, Dorothy (1873–1957) 'I lived for years on end on less than £1 a week'; despite this, Dorothy Richardson felt encouraged to write by such luminaries as H. G. Wells, with whom she had an affair and a miscarried pregnancy. She later married the artist Alan Odle. Some critics now regard her as a literary pioneer equal to Woolf and Joyce.

Riding, Laura (1901–1991) American poet and critic, the charismatic but inflexible Laura Riding became Robert Graves's 'muse' in 1926. The ensuing dramas caused the breakdown of his marriage to Nancy Nicholson. Their affair ended in 1939 after Graves met Beryl Hodge; Riding turned her attentions to another married man in America, while becoming increasingly venomous towards Graves.

Rosling, Theodora (1916–1991) The beautiful Theodora Rosling was brought up by her grandmother in Ireland and was convent educated. Her memoir *With Love* (1982) describes her emergence as an actress and model, and her Paris love affair with the photographer Peter Pulham; she later married Constantine Fitzgibbon, and became a well-known cookery writer under her married name.

Russell, Bertrand (1872–1970) Noted philosopher and campaigner, Russell came into contact with the world of the arts largely through his relationship with Ottoline Morrell and his friendship with D. H. Lawrence. His stature as a pacifist, a thinker and mathematician brought him a wide readership, and the school that he founded with his second wife, Dora, adopted progressive principles dear to the Bohemian heart.

Russell, Dora (1894–1986) Dora Black met Bertrand Russell in 1916; however her feminism and belief in sexual freedom deterred her from marrying him until 1921. Dora was a prominent birth-control campaigner and her progressive ideas on education were put into practice at Beacon Hill, the co-educational school she founded with her husband.

Sackville-West, Vita (1892–1962) The writer Vita Sackville-West portrayed her privileged background in *The Edwardians* (1930), which also gives glimpses of pre-war Bohemia. Vita's unorthodox marriage permitted both her and her husband, Harold Nicolson, many kinds of amorous manoeuvre. She had affairs with Violet Trefusis, Virginia Woolf and Mary Campbell among others. Woolf's *Orlando* (1928) was inspired by their relationship.

Sitwell, Edith (1887–1964) Cyril Connolly wrote: 'The Sitwells were not really happy people.' The poet Edith Sitwell was a conspicuous figure in the British art scene between the wars. Her indefatigable patronage of modernism (she encouraged Diaghilev's Ballets Russes, William Walton, Dylan Thomas, and T. S. Eliot among others), and her exotic appearance (which inspired many portraits) ensured her public renown.

Sitwell, Osbert (1892–1969) Like his sister Edith, Osbert Sitwell became an outspoken opponent of Georgian poetry and ardent advocate of modernism. His prominence provoked fictional caricatures by Huxley and Wyndham Lewis. Osbert's five-volume autobiography – *Left Hand! Right Hand!* (1945) and others – gives an illuminating portrait of his times and a riveting portrayal of the Sitwells' exasperating father, Sir George.

Smith, Eleanor (1902–1945) The aristocratic Eleanor Smith gave up a career as a gossip columnist to write novels about her passion: gypsies. A debutante friend of Evelyn Waugh's, she was alleged to have initiated the rage for treasure hunts that featured in many parties held by the Bright Young People in the twenties. Eleanor died suddenly at the age of forty-three.

Spender, Stephen (1909–1995) A key figure among the generation of politically engaged inter-wars poets that included Auden, MacNeice and Isherwood, Spender played out the role of 'mad Socialist poet' to great effect, and to the chagrin of his relatives. In his autobiography *World Within World* (1951) Spender describes the artistic groups in which he moved, including Bloomsbury and Garsington.

Strachey, Julia (1901–1979) Stylish, funny and acutely intelligent, Julia Strachey (niece of Lytton) was brought up by her great-aunt, Bertrand Russell's first wife Alys, and was educated at Bedales, where her best friend was Frances Marshall. Virginia Woolf described Julia as a 'gifted wastrel', whose writing talents were never fully realised. Both her husbands, Stephen Tomlin and Lawrence Gowing, were artists.

Strachey, Lytton (1880–1932) Eccentric in voice and appearance, ostentatiously homosexual, Strachey was at the core of the Bloomsbury Group. His iconoclastic biographical collection *Eminent Victorians* (1918) brought him overnight fame. In 1915 the painter Dora Carrington fell in love with Strachey and remained with him in a *ménage à trois* with her husband, Ralph Partridge, until his death from cancer.

Stulik, Rudolf (d. approx 1938?) The patron of the famous Eiffel Tower restaurant in Percy Street was a Viennese Jew who had acquired the restaurant in 1910. Adored by his clientèle, his personality was inseparable from the restaurant itself; outspoken and demonstrative, he was also over-generous, and in 1938 the restaurant was forced to close.

Taylor, Geoffrey (1900–1957) Geoffrey Phipps adopted his mother's name as a poetic pseudonym. Described by David Garnett as 'tall, dark, immature, adventurous and very nice', Taylor left his wife to join the four-way ménage of himself, Robert Graves, Nancy Nicholson and Laura Riding. After this catastrophic episode he settled down with Nancy and her four children by Graves.

Thomas, Dylan (1914–1953) Notoriously hard drinking and spendthrift, Dylan Thomas epitomised the feckless Bohemian of the thirties, but his poetic genius was undeniable. Born into a middle-class Swansea family, Dylan moved to London in 1934, and in 1937 married Caitlin Macnamara, whose memoirs record their tempestuous, alcoholic relationship, with its violence and numerous infidelities. Dylan died in New York.

Thornycroft, Rosalind (1891–1973) 'Cool and flower-like', the daughter of the eminent sculptor Sir Hamo Thornycroft was brought up on progressive

principles. Rosalind's first marriage, to Godwin Baynes, a key figure in the Neo-pagan group, ended in divorce. She sought exile with her children in Italy, where she had a brief affair with D. H. Lawrence; she remarried in 1926.

Todd, Ruthven (1914–1978) An 'unhealthy-looking grey oddity', this Fitzrovian 'character' clung to the rocks of fame: Miró, Robert Graves, Dylan Thomas, Nina Hamnett and Geoffrey Grigson were his cronies in the cafés of Paris and pubs of Soho. Ruthven (pronounced 'Riven') wrote more than fifty books of poetry and prose but was usually penniless. He died in Mallorca.

Tree, Iris (1897–1968) Daughter of the actor and impresario Sir Herbert Beerbohm Tree, Iris wrote poetry and bobbed her hair; 'haut' Bohemia was her world. Her close friends were Nancy Cunard and Diana Manners. Iris joined the roll-call of Augustus John's girlfriends; she married American interior designer Curtis Moffatt. This marriage, and her second one, ended in divorce.

Trevelyan, Julian (1910–1988) Trevelyan's parents, who were on the fringes of Bloomsbury, encouraged their son's interest in art and poetry; he grew up defiant and uncompromising: 'Painters must of necessity be anarchists, ruthless egotists.' Trevelyan exhibited at the Surrealist show in 1936; his circle included Roland Penrose, Eileen Agar and Stanley Spencer. His memoir *Indigo Days* was published in 1957.

Waugh, Evelyn (1903–1966) Novelist and chronicler of the inter-war generation, Waugh had a conventional upbringing and education; at Oxford and in the early twenties he directed his energies more to his social life and hard drinking than work. For a brief period he flirted with the Bohemian life of an art student, before becoming first a schoolmaster and then a writer.

Wells, H. G. (1866–1946) The reputation of this hugely successful novelist was tainted in the 'respectable' world by his espousal of left-wing, utopian and feminist causes. *Ann Veronica* (1909) caused a scandal by his portrayal of a 'New Woman' who runs away with the man she loves. Wells himself had many extramarital affairs with, among others, Rebecca West and Dorothy Richardson.

Wickham, Anna (1884–1947) Marriage and domesticity curtailed Anna Wickham's singing career; despite her husband's reluctance she achieved acclaim for her poetry. Bohemia became a second home; 'she preferred the hard-up to the well-off, the doomed and unknown to the rich and successful'. At the Crab Tree and the Café Royal her circle included Augustus John, Epstein, David Garnett and D. H. Lawrence.

Wood, Christopher (1901–1930) The painter Christopher Wood spent a significant proportion of his brief life in Paris and on the Continent with his lover, the Chilean socialite Tony de Gandarillas. Although his work was admired, Wood was trapped by poverty. Psychotic tendencies, drug abuse and disappointment in love combined to cause his suicide under a train in 1930.

Notes on Sources

In this book I have drawn on a multitude of sources – published and unpublished writings, periodicals and archives, social history, conversations, anecdotes and personal memories. The text gives dates of any specific works mentioned, but below is a résumé of other principal sources consulted in each chapter. For further reading please turn to page 325 for a select bibliography.

1. Paying the Price

There are two authoritative biographies of Robert Graves, Martin Seymour-Smith's *Robert Graves – His Life and Work*, and Miranda Seymour's *Robert Graves – Life on the Edge*. Both give full accounts of 'the Poets' Store'. *Scènes de la Vie de Bohème* by Henri Murger is the basis for Puccini's opera *La Bohème*, and was first written in 1845. Many would agree that W. Somerset Maugham's autobiographical novel *Of Human Bondage* is also his masterpiece. The Maugham family has inspired a number of works, not all of which agree about the death of Harry Maugham. The most recent is Bryan Connon's *Somerset Maugham and the Maugham Dynasty*.

Gerald Brenan's novel *Jack Robinson*, written under the pseudonym George Beaton, is not a very good book; but as an attempt to reconcile conflicting ideologies it is interesting.

For an authoritative and comprehensible history of prices and earnings I recommend John Burnett's *A History of the Cost of Living*. Ursula Bloom's lively and amusing account of her vicarage upbringing *Sixty Years of Home* brought the facts to life.

I highly recommend Michael Holroyd's funny, encyclopaedic and deeply sympathetic biography of *Augustus John*. John's own highly idiosyncratic memoirs *Chiaroscuro* and *Finishing Touches* proved useful too. Equally often I turned to Arthur Ransome's *Bohemia in London*, a most companionable resource.

Epstein's model Betty May put her name to a ghosted memoir entitled *Tiger Woman – My Story* which was to become another fascinating source book for Bohemia. Likewise, Nicolette Devas's memoir of her unconventional youth with the John family, *Two Flamboyant Fathers*, was full of revealing detail. *Through the Minefield* is a Rake's Progress through the thirties by Dylan Thomas's biographer and close friend Constantine Fitzgibbon.

Denise Hooker's biography *Nina Hamnett – Queen of Bohemia* presents its subject's

colourful life in all its diversity, and is much more readable than Nina's own maddeningly staccato memoirs, *Laughing Torso* and *Is She a Lady?* I found Arthur Calder-Marshall's memoir *The Magic of My Youth* and Geoffrey Grigson's *Recollections* useful, while Roy Campbell's pugnacious, sexy and wildly poetic personality emerged from *Broken Record* and *Light on a Dark Horse*.

Douglas Goldring is one of those minor authors whose writings are of more social than literary interest; particularly *The Nineteen Twenties*. Both Carrington's wonderful *Letters* with their charming illustrations, edited by David Garnett, and Gretchen Gerzina's sympathetic biography *Carrington* have been referred to extensively, as has Mark Gertler's *Selected Letters* edited by Noel Carrington, and John Woodeson's *Mark Gertler – Biography of a Painter*.

H. G. Wells's *Ann Veronica* is still, despite its rather ambiguous messages about feminine liberation, a wonderful read, with some brilliant characterisation. It caused scandal when it was published in 1909. The story of the forgotten Stephen Phillips is recounted in Clifford Bax's memoir *Some I Knew Well*.

Caitlin Thomas's angry, despairing voice makes itself heard throughout this book – *Leftover Life to Kill* came out soon after Dylan's death; *Double Drink Story – My Life with Dylan Thomas* was published posthumously.

2. All for Love

This chapter relied principally for background on three studies: Ronald Pearsall's riveting *The Worm in the Bud*, Peter Fryer's stimulating investigation of English prudery *Mrs Grundy*, and Leonore Davidoff's excellent analysis of nineteenth-century society *The Best Circles*. Here and elsewhere in the book Lynn Garafola's *Diaghilev's Ballets Russes* has also been enlightening.

It takes an effort today to comprehend how George du Maurier's bestseller *Trilby* so inspired its readers; it now seems impossibly dated. So too does *The Woman Who Did* by Grant Allen – a *succès de scandale* in its day.

Quentin Bell quotes Virginia Woolf's memoir of 'Old Bloomsbury' and its bawdy conversation in his biography *Virginia Woolf*. It was first read to the Memoir Club in 1922. Enid Bagnold's racy youth is described in her *Autobiography*; Isadora Duncan's romance with Gordon Craig is described in *My Life*.

Chloë Baynes pieced together her mother Rosalind Thornycroft's life from letters and memoirs; her book *Time Which Spaces Us Apart* was privately printed, but has provided this book with a rich resource.

One of the joys of research is finding memoirs with ever more whimsical titles. One of my favourites in every way is the flamboyant Viva King's *The Weeping and the Laughter*.

The published letters from Vanessa Bell quoted throughout come from a selection

edited by Regina Marler. A long conversation with Dr Igor Anrep provided the material about his parents' *ménage à trois*. Richard Garnett kindly passed me his father's sensational memoir about the Graves/Riding ménage in Hammersmith.

In *First Friends* Ronald Blythe has richly added to the texture of the period by publishing a memoir of Carrington and her friends Christine Kühlenthal and the Nash brothers. Robert Medley's reminiscences *Drawn from the Life* are frank and vivid.

Miranda Seymour's biography of Ottoline Morrell, *Life on the Grand Scale*, has been indispensable. 'Black Man and White Ladyship' is reprinted in *Nancy Cunard – Brave Poet, Indomitable Rebel* edited by Hugh Ford.

Gerald Brenan describes his relationships and sex life in *Personal Record*; Naomi Mitchison is equally frank in her invaluable memoir *You May Well Ask*; Fiona MacCarthy exposes Eric Gill's extraordinary proclivities in her landmark biography *Eric Gill*.

Though not a first-ranking author from a literary point of view, Ethel Mannin's novels, journalism and memoirs, above all *Confessions and Impressions*, and *Young in the Twenties*, leave a fascinating and valuable record of her times. Wyndham Lewis's memoir *Blasting and Bombardiering* is worth reading for descriptions like the Campbells' wedding.

The all-pervasive Lady Diana Cooper's upper-class upbringing comes into *The Rainbow Comes and Goes*. Adrian Daintrey considers male chastity in his memoir *I Must Say*, and Sean Hignett lays bare the life of Dorothy Brett in *Brett: From Bloomsbury to New Mexico*. For Constantine Fitzgibbon see Chapter 1. Alison Thomas has meticulously uncovered the lives of four lesser-known Slade artists, including Edna Clarke Hall, in *Portraits of Women – Gwen John and her Forgotten Contemporaries*.

The painter Tristram Hillier takes first prize for whimsical memoir titles: *Leda and the Goose*. Runner-up Peter Quennell wrote *The Marble Foot – An Autobiography*. Both had broken marriages. *My Life*, Havelock Ellis's autobiography, though less memorably titled, is painstakingly frank. A biography of Stephen Spender is currently due; I relied on his own intelligent and reflective autobiography, *World Within World*, for memories of his first marriage.

3. Children of Light

Jean-Jacques Rousseau's educational treatise *Emile* provided this chapter with important background, while understanding the progressive school movement in the nineteenth and twentieth centuries would not have been possible without Jonathan Gathorne-Hardy's comprehensive study *The Public School Phenomenon*. *Boys and Girls*, the history of the co-educational school Bedales, edited by Avril Hardie, was also very helpful.

For the section on the John family, see notes on Holroyd's biography (Chapter 1). Rupert Brooke's letter about the John children is printed in Pippa Harris's edition of the Brooke/Olivier correspondence, *Song of Love*. I have also referred to Romilly John's enjoyable memoir of his eccentric upbringing, *The Seventh Child*. Reading Margaret Kennedy's *The Constant Nymph* was sheer self-indulgence.

The first volume of David Garnett's autobiography, *The Golden Echo*, tells of his free Surrey childhood. A contrasting childhood is described by Ursula Bloom (see Chapter 1). Ford Madox Ford reflects on the Victorian rule of terror in Volume 5 of his refreshing and opinionated memoirs, *Memories and Impressions*.

Miranda Seymour was again (see Chapter 1) my source for Robert Graves; (for Dorothy Brett, see notes on Chapter 2). *Deceived with Kindness* by Angelica Garnett is a lucid and deeply felt account of my aunt's Bloomsbury childhood. I have also referred to Quentin Bell's version of events, for which I had access to his unpublished autobiography as well as his memoir *Elders and Betters*.

Philip O'Connor's provoking, almost deranged autobiography *Memoirs of a Public Baby* proved a goldmine. Much of my information on the Sitwells comes from John Pearson's fine biography *Façades*; though Volume 4 of Osbert Sitwell's autobiography, *Laughter in the Next Room*, was also a useful source.

Jacob Epstein's daughter Kitty Godley generously spent time telling me her memories of her mother Kathleen Garman, as well as giving me access to her cousin Anna Campbell Lyle's privately printed memoir of Roy Campbell, *Poetic Justice*, which describes her childhood in Provence. For Nicolette Devas's memoir, see notes on Chapter 1.

Death of a Hero by Richard Aldington is one of the most embittered novels to come out of the First World War; but it is also revealing about the pre-war social scene. C. R. W. Nevinson describes his awful schooling in his combative autobiography *Paint and Prejudice* – a marvellous source book for twentieth-century art. Evelyn Waugh's misery at Lancing comes into *A Little Learning*; Acton's prep school days are described in his *Memoirs of an Aesthete* – one of the books which made researching this one such fun. For Diana Cooper's education, see notes on Chapter 2.

Julia by Frances Partridge is a memorial to her fascinating and original friend Julia Strachey. Bertrand Russell's *Autobiography*, Volume II, describes the tribulations associated with setting up Beacon Hill School, and quotes correspondence between himself and A. S. Neill. Richard Garnett's hilarious account of his days at Beacon Hill are unpublished.

I owe the accuracy of my account of the Bells' education to much laborious research done by my mother, Anne Olivier Bell. Much other material about my grandmother and Charleston has been gleaned from Frances Spalding's excellent biographies *Vanessa Bell* and *Duncan Grant*, from unpublished sources, and from personal knowledge.

For Arthur Calder-Marshall, see notes on Chapter 1. Reading Gwen Raverat's *Period Piece – A Cambridge Childhood* for the fifth time, I am still as beguiled by it as I was the first.

4. Dwelling with Beauty

Cecil Beaton was one of the great aesthetes of the century; his *The Glass of Fashion* is a compelling book to which I turned frequently while writing this chapter and the next. *The New Interior Decoration* by Dorothy Todd and Raymond Mortimer also gave a fascinating perspective on the century's trends.

It was a happy surprise to come across *With Love*, the romantic memoirs of Theodora Fitzgibbon, a cookery writer whom I had long admired. Some London garrets are described by Arthur Ransome (see Chapter 1 above), by Kathleen Hale in *A Slender Reputation* – her dashing account of her youthful struggle to be an artist – and by Horace Brodsky in his memoir of his close friend *Henri Gaudier-Brzeska*.

By contrast, Lesley Lewis's *The Private Life of an English Country House* does much to shed light on the fascinating boredom of middle-class existence, while for more of the same I turned to contemporary arbiters of taste: Lady Colin Campbell's *Etiquette of Good Society* and Mrs H. J. Jennings's *Our Homes and How to Beautify Them* are both documents of their times. Another social document, but one that also makes terrific reading, is Vita Sackville-West's *The Edwardians*. *Homes Sweet Homes* by Osbert Lancaster, with its piquant illustrations, mocks the pretentiousness of the home-beautifiers.

For Carrington's early friendship with Christine Kühlenthal see Ronald Blythe's *First Friends* (Chapter 2, above). Another discovery was *Drawn from Life* by Stella Bowen, Ford Madox Ford's lover – Australian, but a naturalised Bohemian. Aldous Huxley's *Antic Hay* seems very dated today, but its very contemporary smartness gives it value as a record of 1920s society.

Daphne Fielding's memoir of Iris Tree, *The Rainbow Picnic*, is another valuable portrait by an affectionate friend. Mary Butts is a bit-player in several memoirs; she crossed paths with Robert Medley, Douglas Goldring and my father Quentin Bell. The American editor Christopher Wagstaff collated reminiscences and appreciation of this little-known writer in *A Sacred Quest*. Ethel Mannin's description of Gwen Otter's home comes in *Confessions and Impressions* (see Chapter 2).

For information on the Epsteins I read Stephen Gardiner's impressive biography *Artist Against the Establishment*, as well as Epstein's own *An Autobiography*. Vanessa Bell's pottery obsession and impressions of I Tatti appear in her published letters (see Chapter 2). For Harold Acton's reminiscences see Chapter 3. Robert Gathorne-Hardy edited two volumes of Ottoline Morrell's *Memoirs*, which give voice to their passionate and audacious author. For Ford Madox Ford's memoirs see Chapter 3.

I found Isabelle Anscombe's interesting and scholarly account of Roger Fry's enterprise, in *Omega and After*, invaluable. Sitwell tastes come into Osbert's autobiography (see Chapter 3).

Arthur Ransome's visit to Gypsy is described in *Bohemia in London*. Ethel Mannin deciphers the messages of two contrasting interiors in her novels *Ragged Banners* and *Sounding Brass*.

5. Glorious Apparel

Two books, both with the same title, helped my understanding of the gypsy world: Jean-Paul Clébert's highly scholarly *The Gypsies*, translated by Paul Duff, and Angus Fraser's more recent account. As mentioned above, I also found Cecil Beaton's *The Glass of Fashion* invaluable. Jan Marsh's insightful study *Back to the Land* informs this chapter and the next. For the Neo-pagans I turned to Paul Delany's account, *The Neo-Pagans*, but my mother Olivier Bell's inside knowledge of this group was even more precise and considered.

For the section on Augustus John, see above, Chapter 1. *The Silent Queen* by Seymour Leslie disclaims any resemblance of its fictional characters to real ones, but I am sceptical.

I found striking examples of the tyrannies of nineteenth-century clothing in Lady Colin Campbell's *Etiquette of Good Society*, in Viscountess Rhondda's *This Was My World*, in Gwen Raverat's *Period Piece* (see above Chapter 3), and in James Lees-Milne's *Another Self*. The boiled shirt dilemma appears in Wyndham Lewis's autobiography (see Chapter 2 above), in Gertler's letters (see Chapter 1 above), and in Ottoline Morrell's memoirs (see Chapter 4 above). Lesley Lewis (see above, Chapter 4) again demonstrates how suffocating middle-class life could be.

Vanessa Bell boasting about her shabby appearance is in the published edition of her letters (see Chapter 2 above). Constantine Fitzgibbon edited a fascinating selection of his friend Dylan Thomas's *Letters*. For Rosalind Thornycroft's 'advanced' upbringing see above, Chapter 2. I am again indebted to Nicolette Devas's memoirs (see above Chapter 1), this time for information on the John girls' lack of underwear.

Eric Gill's diatribe *Clothes* is as intemperate as one might expect from this unconventional genius. Edward Carpenter's polemic *Civilization: Its Cause and Cure* makes somewhat beatific reading: not recommended in large doses. There are two biographies of Philip Heseltine (aka Peter Warlock), one by his friend and contemporary Cecil Gray (himself an interesting semi-Bohemian character), and a recent one by Barry Smith. For Caitlin Thomas's and Betty May's memoirs, see Chapter 1.

Most of the information about the Chelsea Arts Ball was gleaned from the pages

of Tom Cross's diligent tribute *Artists and Bohemians – 100 years of the Chelsea Arts Club*. The best account of *The Dreadnought Hoax* comes from the horse's mouth – that of Adrian Stephen, who participated. For Arthur Ransome, see Chapter 1.

St John Adcock's combination of doggerel and caricature, *A Book of Bohemians*, is a rare oddity, produced in a limited edition on thick paper. For Huxley's *Antic Hay*, see Chapter 4. (And refer to *Beards* by Reginald Reynolds for a niche publication by Ethel Mannin's second husband!)

When Gilbert Cannan's *Mendel* came out in 1916 Carrington was furious – because she and Gertler are so recognisable in its pages. The fictional 'Oliver' and 'Logan' are the artist John Currie and his girlfriend Dolly Henry.

For Stephen Spender see Chapter 2. Max Beerbohm's Rede Lecture 1943 was a memory of *Lytton Strachey*, whom he first observed in his unconventional garb at the Savile Club. Osbert Sitwell's remarks on tweedy Bohemians are in his memoirs (see above Chapter 3).

For H. G. Wells's *Ann Veronica*, see Chapter 1 above. Brett's trousers come into Hignett's biography (see above, Chapter 2). The words of 'Augustus John' were by Harry Graham; the entire song is reprinted in Appendix 5 of Michael Holroyd's biography. Ethel Mannin's smoking habits come into *Young in the Twenties* (see Chapter 2). The Bohemian fashion parade comes from Sisley Huddleston's *Bohemian Literary and Social Life in Paris*, Angelica Garnett's *Deceived with Kindness*, Nina Hamnett's *Is She a Lady?* and Kathleen Hale's *A Slender Reputation*.

I have retold the Café Royal brawl story which I found in *Café Royal – Ninety Years of Bohemia* by Guy Deghy and Keith Waterhouse, a marvellous book which I wish I owned. Mary Colum's *Life and the Dream* belongs in the category 'unmemorable author – valuable social record', telling it from the Dublin angle. Roy Campbell's feud with Peter Quennell goes public in *Broken Record* (see Chapter 1 above).

The remarkable story of how Gerald Brenan ran away from home is told in his early memoir *A Life of One's Own*; Havelock Ellis reflects on progress in *My Life*.

6. Feast and Famine

A battered early edition of *Mrs Beeton's Book of Household Management* sits on my shelf – nearly 1,700 pages of Victorian domestic lore, referred to continually in the writing of this chapter and the next. The same applies to Caroline Davidson's *A Woman's Work is Never Done*. Naomi Mitchison's *You May Well Ask* answered many of the questions that I found myself posing regarding shopping, eating and cooking, while for readable scholarship and history John Burnett's *Plenty and Want* can hardly be bettered.

One of my favourite memoirs, *Today We Will Only Gossip* by the spirited Beatrice Campbell, lives up to its irresistible title; she recounts the dreadful tale of Katherine

Mansfield and the blocked sink. The emphasis on food makes Sybille Bedford's 'biographical novel' *Jigsaw* all the more enjoyable. For Lesley Lewis see Chapter 4. The chapter on 'Edwardian Glitter' in *Architect Errant* by Clough Williams-Ellis is particularly vivid. Harold Acton confirms his reputation as a sensualist in *Memoirs of an Aesthete* (see Chapter 3); his cook problem also makes comic reading.

For the finer points of cutlery I turned again to Lady Colin Campbell (see Chapter 4) and to that indomitable aristocrat Lady Troubridge's *The Book of Etiquette*.

Vanessa Bell's account of the Brandon camp is in the published edition of her letters. For Stella Bowen see Chapter 4 above. Both Roy Campbell's recipe for bouillabaisse and his story about Stuart Gray and the mouldy kipper appear in *Light on a Dark Horse*. The picture of food at Alderney Manor is a composite one gleaned from the Johns' many friends: Nicolette Devas, Kathleen Hale, Gerald Brenan, Igor Anrep and from Romilly John's memoir (see Chapter 3). Information about Ida John comes from Michael Holroyd's biography and from Alison Thomas (see above Chapter 2). In her letters (see above, Chapter 1) Carrington regularly describes meals; she also often refers to the servant problem.

For Rosalind Thornycroft see Chapter 2 above. I found good examples of artistic vegetarians in Clifford Bax's memoir *Inland Far* and Robert Medley's *Drawn from the Life* (see above Chapter 2).

Anthony Powell refers to Cyril Connolly's cook problem in the third volume of his memoirs, *Faces in My Time*. Life on Ditchling Common was vividly evoked in Fiona MacCarthy's riveting biography of *Eric Gill*. For Gertler, Ransome and Caitlin Thomas see Chapter 1. For Brett, see notes on Chapter 2.

Dodie Smith's *I Capture the Castle* is the kind of novel I would recommend to romantically inclined teenagers – but I enjoyed it almost as much. Osbert Sitwell is perhaps rather hard on Roger Fry in *Laughter in the Next Room*; other versions have Fry as an original and intrepid cook. Mrs J. G. Frazer's *First Aid to the Servantless* is pure delight; who *was* she writing for?

Read about the Eiffel Tower in almost any memoir of the tens, twenties or thirties. A good round-up of Soho bistros appears in Robert Machray's *The Night Side of London*. Nina Hamnett and the butter-throwing episode appears in *Laughing Torso* (see Chapter 1). For Kathleen Hale and Gaudier-Brzeska see Chapter 4.

George Moore's *A Modern Lover* was a book in advance of its time, banned by the circulating libraries as indecent; today this outspoken novelist is almost forgotten.

Richard Garnett drew my attention to *Christabel Who?* by Jane Spottiswoode. He pointed out, rightly, that Christabel exemplified an unromantic aspect of Bohemia that deserved investigating.

7. New Brooms

Mrs Beeton – see above, Chapter 6 – was essential here. I also found *A Very Great Profession*, Nicola Beauman's study of women's fiction from 1914–39, rational and stimulating – particularly Chapter 4 on domesticity. For Lesley Lewis and Mrs J. G. Frazer, see above, Chapters 4 and 6. For Ursula Bloom see above, Chapter 1.

Thorpe Athelney appears in Somerset Maugham's *Of Human Bondage*, see Chapter 1. Constantine Fitzgibbon's *Life* of Dylan Thomas was, from my point of view, the best of the bunch, being written by someone who knew the poet and his pubs at first hand. Andrew Motion's account of a blighted dynasty, *The Lamberts*, told me much about Constant's Fitzrovia. For Nicolette Devas, see Chapter 1. Ottoline Morrell's visit to Wissett comes into the second volume of her memoirs (see above, Chapter 4). For Tristram Hillier, see above, Chapter 2. For Gerald Brenan's *Jack Robinson*, see above Chapter 1.

Life for Life's Sake, Richard Aldington's autobiography, tells of a literary life on the Bohemian margins. Both *The Letters of Liam O'Flaherty* edited by A. A. Kelly and O'Flaherty's two books of memoirs, *Two Years* and *Shame the Devil*, illumine the life of this Irish writer who began life in the Aran Islands; his time in Fitzrovia and Chelsea was a prelude to worldwide wanderings. For Kathleen Hale see Chapter 4.

Ethel Mannin's remarks about servants come into *Young in the Twenties* (see Chapter 2); Vanessa Bell's letters to Duncan Grant and Roger Fry are in her published correspondence. Harold Acton describes his literary sessions with the servants in *Memoirs of an Aesthete* (see Chapter 3). Beatrice Campbell's household and her memories of Katherine Mansfield feature in *Today We Will Only Gossip* (see above, Chapter 6). *Below Stairs* by Margaret Powell is the sane and robust rejoinder of an intelligent working-class woman condemned to serve ignorant employers. John Higgens kindly told me his mother's side of the Charleston story. Naomi Mitchison's *You May Well Ask* (see Chapter 2) gave her angle on the servant issue.

Jeremy Lewis has done an excellent job of unravelling a most complex subject; his biography *Cyril Connolly* has a fascinating chapter entitled 'Living for Beauty'. Gerald Brenan's unkind letter about Carrington is quoted in Gretchen Gerzina's *Life*, and domesticity at Ham Spray features largely in Carrington's *Letters* (for both, see Chapter 1 above). For Stella Bowen see above, Chapter 4.

For Katherine Mansfield's correspondence I have referred to C. K. Stead's edition of her *Letters and Journals*. For Caitlin Thomas see Chapter 1. A minor classic, Jessica Mitford's memoir *Hons and Rebels* is full of the twenties and thirties Zeitgeist, and very funny too. For Christabel Dennison see above, Chapter 6.

Anna Wickham has a walk-on role in many memoirs of the time; my main source was David Garnett's biographical introduction to her *Selected Poems*.

8. The Open Road

Four books provided this chapter with particularly valuable background. Two are by Samuel Hynes: both his scholarly and perceptive *The Edwardian Turn of Mind*, and *A War Imagined*; I also recommend Paul Fussell's thought-provoking study *Abroad* and Alan A. Jackson's satisfyingly factual *The Middle Classes*.

Duncan Grant introduced me as a child to Kenneth Grahame's *The Wind in the Willows* – arguably a book more for his generation than mine. For John's gypsy life, see Chapter 1, above. For Bertrand Russell, see Chapter 2, above. Ethel Mannin's *All Experience* is imbued with its author's love of travel, and has a wonderful chapter on flying. Jessica Mitford describes her xenophobic father in *Hons and Rebels* (see above, Chapter 7).

I have referred to the account of the Violet Hunt scandal in *South Lodge* by Douglas Goldring; he knew Ford and Violet well. The relationship between Rosalind Thornycroft and D. H. Lawrence is described in *Time Which Spaces Us Apart* (see above, Chapter 2), which also contains Rosalind's strategy for dealing with fleas. David Garnett's autobiography *The Golden Echo* (see above, Chapter 3) recounts his pre-Revolutionary journey to Russia. For George du Maurier's *Trilby*, see Chapter 2, above. Peter Fryer's *Mrs Grundy* (see above Chapter 2) gives a good account of the activities of the Lord's Day Observance Society.

For Harold Acton see Chapter 3. Sisley Huddleston's *Bohemian Literary and Social Life in Paris* (referred to in Chapter 5, above) has a rather lofty approach to its subject, but is full of insider knowledge. The ephemeral *Fugitive Pieces* by Mary Hutchinson reveals a discerning and literary mind – sadly she did not write anything more substantial. Angelica Garnett comments on her mother's francophilia in *Deceived with Kindness* (see Chapter 3, above). For Stella Bowen see Chapter 4, above.

Two novels based on Côte d'Azur society in the twenties both drip with satire – but still ooze first-hand experience: *Mediterranean Blues* by Yvonne Kapp, and *The Rock Pool* by Cyril Connolly. For a biography of Connolly, see above, Chapter 7. David Gascoyne comments on literary expatriatism in his youthful *Paris Journal*. *Gone Abroad* by Douglas Goldring is a collection of the author's travel journalism. For O'Flaherty's *Letters*, see above, Chapter 7. Julian Trevelyan's autobiography *Indigo Days* has a buoyant, open-minded quality which makes one warm to the author.

Gerald Brenan's journey to the Balkans is in *A Life of One's Own* (see notes on Chapter 5). Paul Nash's walking tour in the Lake District appears in Ronald Blythe's *First Friends* (see above, Chapter 2); the section on the 'crazy walkers' was culled from Alison Thomas (see above Chapter 2) and from Michael Holroyd's biography of Augustus John. Romilly John gives a good description of his father as a driver in

The Seventh Child. Philip O'Connor's days as a tramp come into *Memoirs of a Public Baby* (see above, Chapter 3).

Five Women and a Caravan by Marion Russell is yet another social document disguised as a memoir; the description of Evelyn Waugh's caravan holiday comes into his published *Diaries*; my source for information on Brian Howard is the volume of tributes, *Portrait of a Failure* edited by Marie-Jacqueline Lancaster. Only insatiable researchers like me would ever read Eleanor Smith's *Flamenco*, which is, I fear, doomed to literary oblivion.

A Rabbit in the Air by David Garnett has certain qualities in common with *Zen and the Art of Motorcycle Maintenance* – a soul-stirring passion for mechanical gadgets. Sybille Bedford emerges from *Jigsaw* as a true cosmopolitan; see notes on Chapter 6.

9. Evenings of Friendliness

Yet again, Peter Fryer's *Mrs Grundy* was helpful in giving social background; so too was Alan Hodge's and Robert Graves's excellent resumé of the period (mostly garnered from newspaper sources), *The Long Weekend*. *London's Latin Quarter* by Kenneth Hare proved useful; so did Robert Machray's *The Night Side of London* (see notes on Chapter 6). For Deghy and Waterhouse's excellent book on the Café Royal, see notes on Chapter 5. Hugh David's thorough and amusing account of *The Fitzrovians* has not yet been supplanted, while *Bohemians – The Glamorous Outlaws* by Elizabeth Wilson is a thorough academic account of the phenomenon.

David Garnett's optimistic remarks about life in the twenties appear in Volume 2 of his memoirs, *The Familiar Faces*; for Arthur Ransome, see Chapter 1.

In *All Trivial Fond Records* and *Brought Up and Brought Out* Allanah Harper and Mary Clive (both upper-class girls with Bohemian aspirations) respectively recall their ghastly debutante days; upper-class social life is also meticulously portrayed in Vita Sackville-West's *The Edwardians* (see notes on Chapter 4). Iris Tree's clandestine life is described by Daphne Fielding in *The Rainbow Picnic* (see above Chapter 4); 'Iris of Memories' is reprinted in Hugh Ford's compilation of tributes, *Nancy Cunard – Brave Poet, Indomitable Rebel*.

For Stella Bowen, see notes on Chapter 4. C. R. W. Nevinson's recollections of the Armistice come into *Paint and Prejudice* (see notes on Chapter 3). Monty Shearman's famous party at the Adelphi is re-created from composite sources – Osbert Sitwell, Beatrice Campbell and Nina Hamnett. Sisley Huddleston (see Chapter 8, above) describes his friend Ezra Pound dancing the Charleston.

The five 'typical' parties were taken from Carrington's *Letters*; a combination of Romilly John's and Viva King's memoirs; *The Familiar Faces* by David Garnett (which has a whole chapter on parties of the period); Miranda Seymour's biography

of Robert Graves; and Marie-Jacqueline Lancaster's *Portrait of a Failure*, about Brian Howard.

Juliette Huxley's *Leaves of the Tulip Tree* gives a behind-the-scenes account of life at Garsington. Glimpses of Frederick Ashton's life come from Julie Kavanagh's biography *Secret Muses*; of Rudolph Vesey's parties from *Musical Chairs* by Cecil Gray. Other contributors to the party scene were Julian Trevelyan, Peter Quennell, Harold Acton, Kathleen Hale, Constant Lambert, Beatrice Campbell, Carrington and Vanessa Bell. Nina Hamnett's *Is She a Lady?* (see Chapter 1, above) is the source for the striptease story and the dope fiend story.

Osbert Sitwell describes the Golden Calf in his memoir *Great Morning*. Elsa Lanchester, founder of the Cave of Harmony, wrote a memoir entitled *Charles Laughton and I*. Michael Luke's *David Tennant and the Gargoyle Years* sheds light on David Tennant's Bohemian sanctum.

Nancy Cunard's 'Ode to the Eiffel Tower' was first published in her collection *Sublunary*; there are good descriptions of the restaurant and its proprietor Stulik in many memoirs of the time – I particularly liked Viva King's account in *The Weeping and the Laughter*, and Ruthven Todd's memories of Stulik in *Fitzrovia and the Road to the York Minster*, an exhibition catalogue for a show at the Parkin Gallery in 1973. For Betty May see Chapter 1, above. For Constantine Fitzgibbon's *Life of Dylan Thomas* see notes on Chapter 7; for his edition of Thomas's letters see Chapter 5. For Caitlin Thomas, see Chapter 1.

Beatrice Campbell tells the story of Gertler's misdeeds in *Today We Will Only Gossip* (see Chapter 6). Julian Trevelyan's experiences with mescaline are recounted in *Indigo Days* (see Chapter 8); Augustus John describes trying hashish in his memoir *Chiaroscuro*. David Garnett's melodrama *Dope Darling* (published under the pseudonym Leda Burke) is not the kind of book the author would have been proud to show his Bloomsbury friends; actually it's quite a racy little read.

Ragged Banners by Ethel Mannin is a novel about idealism, its hero an archetypal Bohemian poet. Three lines of poetry are quoted from 'Do Not Go Gentle into That Good Night' by Dylan Thomas. Roy Campbell's challenging declaration is to be found in the pages of *Broken Record*. The final quote comes from the last page of Arthur Ransome's *Bohemia in London*.

Epilogue

Liam O'Flaherty's lament for the Bohemia of his youth is published in A. A. Kelly's edition of O'Flaherty's *Letters* (see Chapter 7, above). Carrington mourns Lytton's death in the diary she wrote before killing herself, published in her *Letters* (see Chapter 1, above). Katherine Mansfield's plea for integrity is published in Claire Tomalin's revelatory biography *A Secret Life*. For Mary Butts see Chapter 4, above.

For a life of Roy Campbell, see Peter Alexander's *Critical Biography*. Nicolette Devas's obsequies on Dylan Thomas, and her own reflections on growing older, appear in *Two Flamboyant Fathers* (see notes on Chapter 1).

The biography of Arthur Ransome by Hugh Brogan describes his comfortable middle years and old age. Ethel Mannin's last autobiographical foray was *Sunset over Dartmoor*. For Viva King's memoirs see notes on Chapter 2; for Jeremy Lewis's biography of *Cyril Connolly* see Chapter 7; for lives of Robert Graves see notes on Chapter 1.

In *The Interior Castle* Gerald Brenan is well served by his biographer Jonathan Gathorne-Hardy, who knew him well. Michael Holroyd's biography of *Augustus John* painstakingly sees the old reprobate through to the end. Harold Acton's second volume of autobiography, *More Memoirs of an Aesthete*, is as cultured and readable as the first. For Ottoline Morrell I have referred yet again to Miranda Seymour's biography (see Chapter 2). Chloë Baynes has the last word on her mother, Rosalind Thornycroft, in *Time Which Spaces Us Apart* (see notes on Chapter 2).

Frances Spalding has done full justice to my grandmother *Vanessa Bell* in her fine biography. For Robert Medley, see Chapter 2. For Stella Bowen's memoirs see Chapter 4. For Nancy Cunard see Chapter 2. Kathleen Hale's memoirs *A Slender Reputation* contain a marvellous photograph of the septuagenarian in her Moroccan necklace. Daphne Fielding's haunting image of Iris Tree in her later years is in her biography *The Rainbow Picnic*. Betty May's last word on her life appears in the concluding paragraph of *Tiger Woman*, leaving one frustrated to know more.

Bibliography

In researching this book I have consulted over three hundred works of reference, novels, memoirs, printed letters and diaries, archive sources, unpublished works, periodicals and contemporary newspapers. A number are mentioned in the text and source notes, but it would be impossible to credit them all here. Below is an abbreviated list of works which I found indispensable to an understanding of the period and subject-matter.

History/Ideas/Society

Annan, Noël, 'The Intellectual Aristocracy', essay in *Studies in Social History*, (ed) J. H. Plumb, Longman's, Green & Co. 1955

Anscombe, Isabelle, *Omega and After – Bloomsbury and the Decorative Arts*, Thames & Hudson, London 1981

Beaton, Cecil, *The Glass of Fashion* (illustrated by the author),Weidenfeld & Nicolson, London 1954

Beauman, Nicola, *A Very Great Profession – The Woman's Novel 1914–39*, Virago Press, London 1983

Beerbohm, Sir Max, *Lytton Strachey – The Rede Lecture*, Cambridge University Press 1943

Bloom, Ursula, *Sixty Years of Home*, Hurst & Blackett 1960

Burnett, John, *A History of the Cost of Living*, Penguin 1969

Campbell, Lady Colin, *Etiquette of Good Society*, Cassell & Co. 1898

Carpenter, Edward, *Civilization: Its Cause and Cure*, Allen & Unwin, London 1889

Clébert, Jean-Paul, trans. Paul Duff, *The Gypsies*, Vista Books, London 1963

Cross, Tom, *Artists and Bohemians – 100 Years of the Chelsea Arts Club*, Quiller Press, London 1992

Davidson, Caroline, *A Woman's Work is Never Done*, Chatto & Windus, London 1982

Deghy, Guy and Waterhouse, Keith, *Café Royal – Ninety Years of Bohemia*, Hutchinson, London 1955

Frazer, Mrs J. G., *First Aid to the Servantless*, Cambridge 1913

Fryer, Peter, *Mrs Grundy – Studies in English Prudery*, Dennis Dobson, London 1963

Fussell, Paul, *Abroad – British Literary Travelling between the Wars*, Oxford University Press, Oxford, New York, 1980

Garafola, Lynn, *Diaghilev's Ballets Russes*, Oxford University Press, Oxford, New York 1989

Gathorne-Hardy, Jonathan, *The Public School Phenomenon*, Hodder & Stoughton 1977

Gill, Eric, *Clothes – An Essay upon the Significance of the Natural and Artificial Integuments Worn by Men and Women*, Jonathan Cape, London 1931

Goldring, Douglas, *The Nineteen Twenties – a General Survey and Some Personal Memories*, Nicholson & Watson, London 1945

Hare, Kenneth, *London's Latin Quarter* (illus. by Dorothea St John), George John Lane, The Bodley Head, London 1926

Hodge, Alan and Graves, Robert, *The Long Weekend: A Social History of Great Britain 1918–1939*, Faber & Faber, London 1940

Huddleston, Sisley, *Bohemian Literary and Social Life in Paris – Salons, Cafés, Studios*, Harrap & Co., London, Bombay, Sydney 1928

Hynes, Samuel, *The Edwardian Turn of Mind*, Princeton University Press, London 1968

Hynes, Samuel, *A War Imagined – The First World War and English Culture*, Bodley Head, London 1990

Jennings, Mrs H. J., *Our Homes and How to Beautify Them*, Harrison & Sons, London 1902

Lancaster, Osbert, *Homes Sweet Homes* (illus. by the author), John Murray, London 1948

Luke, Michael, *David Tennant and the Gargoyle Years*, Weidenfeld & Nicolson, London 1991

Machray, Robert, *The Night Side of London*, T. Werner Laurie Ltd., London 1902

Marsh, Jan, *Back to the Land – The Pastoral Impulse in England, from 1880 to 1914*, Quartet Books, London, Melbourne, New York 1982

Pearsall, Ronald, *The Worm in the Bud: The World of Victorian Sexuality*, Weidenfeld & Nicolson, London 1969

Richardson, Joanna, *The Bohemians – La Vie de Bohème in Paris 1830–1914*, Macmillan, London 1969

Robson, Philip, *Forbidden Drugs* (second edition), Oxford University Press 1999

Rousseau, Jean-Jacques, trans. Allan Bloom, *Emile*, Basic Books, New York 1979

Shone, Richard, *Bloomsbury Portraits – Vanessa Bell, Duncan Grant and Their Circle*, Phaidon Press Ltd, London 1976 and 1993

Todd, Dorothy and Mortimer, Raymond, *The New Interior Decoration – An Introduction to its Principles and International Survey of its Methods*, Batsford, London 1929

Troubridge, Laura, Lady, *The Book of Etiquette*, Associated Bookbuyers' Company, 1931

Wilson, Elizabeth, *Bohemians – The Glamorous Outcasts*, I. B. Tauris, London, New York 2000

Memoirs/Biographies/Letters/Diaries

Acton, Harold, *Memoirs of an Aesthete*, Methuen, London 1948

Aldington, Richard, *Life for Life's Sake – A Book of Reminiscences*, Cassell, London 1941

Bagnold, Enid, *Enid Bagnold's Autobiography*, Heinemann, London 1969

Bax, Clifford, *Inland Far – A Book of Thoughts and Impressions*, Heinemann, London 1925

Bax, Clifford, *Some I Knew Well*, Phoenix House Ltd., London 1951

Beaton, Cecil, *The Wandering Years – Diaries 1922–1939*, Weidenfeld & Nicolson, London 1961

Bedford, Sybille, *Jigsaw – An Unsentimental Education – A Biographical Novel*, Hamish Hamilton, London 1989

Bell, Anne Olivier (ed.), *The Diary of Virginia Woolf, Vols I–V*, Hogarth Press, London 1977 to 1984

Bell, Quentin, *Bloomsbury*, Weidenfeld & Nicolson London 1968

Bell, Quentin (and others), *Charleston Past and Present*, Hogarth Press, London 1987

Bell, Quentin and Nicholson, Virginia, *Charleston – A Bloomsbury House and Garden*, Frances Lincoln, London 1997

Bell, Quentin, *Elders and Betters*, John Murray, London 1995

Blythe, Ronald, *First Friends – Paul and Bunty, John and Christine – and Carrington*, Viking 1997

Bowen, Stella, *Drawn from Life – Reminiscences*, Collins, London 1941

Brenan, Gerald, *A Life of One's Own*, Hamish Hamilton, London 1962

Brenan, Gerald, *Personal Record 1920–1972*, Jonathan Cape, London 1974

Brodsky, Horace, *Henri Gaudier-Brzeska 1891–1915*, Faber & Faber, London 1933

Calder-Marshall, Arthur, *The Magic of My Youth*, Rupert Hart-Davis, London 1951

Campbell, Roy, *Broken Record – Reminiscences*, Boriswood, London 1934

Campbell, Roy, *Light on a Dark Horse – An Autobiography 1901–1935*, Hollis and Carter 1951

Campbell Lyle, Anna, *Poetic Justice – A Memoir of Roy Campbell* (privately printed), Typographeum, Francestown, New Hampshire 1986

Carrington, Noel (ed.), *Mark Gertler – Selected Letters*, Rupert Hart-Davis, London 1965

Clive, Mary, *Brought Up and Brought Out*, Cobden Sanderson, London 1938

Colum, Mary, *Life and the Dream*, Macmillan, London 1947

Connon, Bryan, *Somerset Maugham and the Maugham Dynasty*, Sinclair-Stevenson, London 1997

Cooper, Diana, *The Light of Common Day*, Rupert Hart-Davis, London 1959

Daintrey, Adrian, *I Must Say – Reminiscences*, 1963

Davie, Michael (ed.), *The Diaries of Evelyn Waugh*, Weidenfeld & Nicolson, London 1976

Delany, Paul, *The Neo-Pagans*, Macmillan, London 1987

Devas, Nicolette, *Two Flamboyant Fathers*, Collins, London 1966

Duncan, Isadora, *My Life*, Garden City Publishing Co. Ltd., New York 1927

Epstein, Jacob, *An Autobiography*, Hutton Press 1955

Faulks, Sebastian, *The Fatal Englishman – Three Short Lives*, Vintage 1996

Fielding, Daphne, *Emerald and Nancy*, Eyre & Spottiswoode, London 1968

Fielding, Daphne, *The Rainbow Picnic – A Portrait of Iris Tree*, Eyre Methuen, London 1974

Fitzgibbon, Constantine, *Selected Letters of Dylan Thomas*, J. M. Dent, London 1966

Fitzgibbon, Constantine, *The Life of Dylan Thomas*, J. M. Dent, London 1965

Fitzgibbon, Constantine, *Through the Minefield – An Autobiography*, Bodley Head, London, Sydney, Toronto 1967

Fitzgibbon, Theodora, *With Love*, Century Publishing, London 1982

Ford, Ford Madox (selected and introduced by Michael Killigrew), *Memories and Impressions Vol 5*, Bodley Head, London, Sydney, Toronto 1971

Ford, Hugh (ed), *Nancy Cunard – Brave Poet, Indomitable Rebel 1896–1965*, Chilton Book Co., Philadelphia, New York, London 1968

Garnett, Angelica, *Deceived with Kindness – A Bloomsbury Childhood*, Oxford University Press 1985

Garnett, David (ed.), *Carrington – Letters and Extracts from Her Diaries*, Jonathan Cape, London 1970

Garnett, David, *The Golden Echo*, Chatto & Windus 1953

Garnett, David, *The Familiar Faces*, Chatto & Windus, London 1962

Garnett, David, *A Rabbit in the Air*, Chatto & Windus, London 1932

Gathorne-Hardy, Robert (ed.), *Ottoline – The Early Memoirs of Lady Ottoline Morrell*, Faber & Faber, London 1963

Gathorne-Hardy, Robert (ed.), *Ottoline at Garsington – Memoirs of Lady Ottoline Morrell 1915–1918*, Faber & Faber, London 1974

Glenavy, Beatrice, *Today We Will Only Gossip*, Constable 1964

Goldring, Douglas, *South Lodge – Reminiscences of Violet Hunt, Ford Madox Ford and the English Review Circle*, Constable 1943

Graves, Robert, *Goodbye to All That*, Jonathan Cape, London 1929

Gray, Cecil, *Peter Warlock – A Memoir of Philip Heseltine*, Jonathan Cape, London 1934

Grigson, Geoffrey, *Recollections – Mainly of Artists and Writers*, Chatto & Windus, Hogarth Press, London 1984

Hale, Kathleen, *A Slender Reputation – An Autobiography*, Frederick Warne, London 1994

Hamnett, Nina, *Laughing Torso – Reminiscences of Nina Hamnett*, Constable, London 1932

Hamnett, Nina, *Is She a Lady? – A Problem in Autobiography*, Allan Wingate 1955

Harper, Allanah, *All Trivial Fond Records*, Harper & Bros., New York and London 1948

Harris, Pippa (ed.), *Song of Love – The Letters of Rupert Brooke and Noel Olivier 1909–1915*, Bloomsbury 1991

Hignett, Sean, *Brett: From Bloomsbury to New Mexico – A Biography*, Hodder & Stoughton, London, Sydney, Auckland, Toronto 1984

Hillier, Tristram, *Leda and the Goose – An Autobiography*, Longmans, Green & Co., London, New York & Toronto 1954

Holroyd, Michael, *Augustus John – A Biography*, Heinemann, London 1974/75

Hooker, Denise, *Nina Hamnett – Queen of Bohemia*, Constable, London 1986

Huxley, Juliette, *Leaves of the Tulip Tree – Autobiography of Juliette Huxley*, John Murray, London 1986

John, Augustus, *Chiaroscuro*, Jonathan Cape, London 1952

John, Augustus, edited and introduced by Daniel George, *Finishing Touches*, Jonathan Cape, London 1964

John, Romilly, *The Seventh Child*, Jonathan Cape, London 1975

Kavanagh, Julie, *Secret Muses – The Life of Frederick Ashton*, Faber & Faber, London 1996

King, Viva, *The Weeping and the Laughter*, Macdonald & Jane's, London 1976

Lancaster, Marie-Jacqueline (ed.), *Brian Howard – Portrait of a Failure*, Blond, 1968

Lewis, Jeremy, *Cyril Connolly – A Life*, Jonathan Cape, London 1997

Lewis, Lesley, *The Private Life of a Country House 1912–1939*, Alan Sutton 1992

Lewis, Wyndham, *Blasting and Bombardiering*, Calder & Boyars Ltd., London 1967

MacCarthy, Fiona, *Eric Gill*, Faber & Faber, London 1989

Mannin, Ethel, *All Experience*, The Beacon Library 1937

Mannin, Ethel, *Commonsense and the Child – A Plea for Freedom*, Jarrolds, London 1931

Mannin, Ethel, *Confessions and Impressions*, Jarrolds, London 1930

Mannin, Ethel, *Sunset Over Dartmoor*, Hutchinson 1977

Mannin, Ethel, *Young in the Twenties – A Chapter of Autobiography*, Hutchinson, London 1971

Marler, Regina (ed.), *Selected Letters of Vanessa Bell*, Pantheon Books, New York 1993

May, Betty, *Tiger Woman – My Story*, Duckworth 1929

Medley, Robert, *Drawn from the Life – A Memoir*, Faber & Faber, London 1983

Mitchison, Naomi, *You May Well Ask – A Memoir 1920–1940*, Victor Gollancz, London 1979

Mitford, Jessica, *Hons and Rebels*, Victor Gollancz, London 1960

Motion, Andrew, *The Lamberts – George, Constant and Kit*, Chatto & Windus, London 1986

Nevinson, C. R. W., *Paint and Prejudice*, Methuen, London 1937

O'Connor, Philip, *Memoirs of a Public Baby*, Faber & Faber, London 1948

O'Flaherty, Liam, *Two Years*, Jonathan Cape 1930

O'Flaherty, Liam, *Shame the Devil*, Wolfhound Press 1981

Partridge, Frances, *Julia – A Portrait of Julia Strachey by Herself and F.P.*, Victor Gollancz, London 1983

Paul, Brenda Dean, *My First Life – A Biography*, John Long Ltd., London 1935

Pearson, John, *Façades – Edith, Osbert and Sacheverell Sitwell*, Macmillan, London 1978

Powell, Anthony, *To Keep the Ball Rolling – The Memoirs of Anthony Powell*, Heinemann, London Vol II: *Messengers of Day* 1978 Vol III: *Faces in My Time* 1980

Quennell, Peter, *The Marble Foot – An Autobiography 1905–1938*, Collins, London 1976

Ransome, Arthur, *Bohemia in London*, Chapman & Hall, London 1907

Raverat, Gwen, *Period Piece – A Cambridge Childhood*, Faber & Faber, London 1952

Rhondda, Margaret Haig (Viscountess Rhondda), *This Was My World*, Macmillan, London 1933

Russell, Marion, *Five Women and a Caravan*, Eveleigh Nash, London 1911

Sampson, Anthony, *The Scholar Gypsy – The Quest for a Family Secret*, John Murray, London, 1997

Seymour, Miranda, *Ottoline Morrell – Life on the Grand Scale*, Hodder & Stoughton, London, Sydney, Auckland 1992

Seymour, Miranda, *Robert Graves – Life on the Edge*, Doubleday 1995

Sitwell, Osbert, *Laughter in the Next Room – An Autobiography*, Macmillan, London 1949

Spalding, Frances, *Vanessa Bell*, Weidenfeld & Nicolson 1983

Spalding, Frances, *Duncan Grant – A Biography*, Chatto & Windus, London 1997

Spender, Stephen, *World Within World – Autobiography of Stephen Spender*, Hamish Hamilton, London 1951

Spottiswoode, Jane, *Christabel Who?* Printed by Small Print, Llangollen, Wales 1998

Stead, C. K. (ed.), *The Letters and Journals of Katherine Mansfield*, Allen Lane 1977

Thomas, Alison, *Portraits of Women – Gwen John and her Forgotten Contemporaries*, Polity Press [Blackwells] 1994

Thomas, Caitlin, *Leftover Life to Kill*, Putnam, London 1957

Thomas, Caitlin, *Double Drink Story – My Life with Dylan Thomas*, Virago Press, London 1997

Thornycroft, Rosalind and Baynes, Chloë, *Time Which Spaces Us Apart*, Chloë Baynes, Batcombe Somerset 1991

Todd, Ruthven, *Fitzrovia and the Road to the York Minster – or Down Dean Street*, exhibition catalogue Michael Parkin Fine Art Ltd., London 1973

Tomalin, Claire, *Katherine Mansfield – A Secret Life*, Viking 1987

Trevelyan, Julian, *Indigo Days*, Macgibbon & Kee, London 1957

Wagstaff, Christopher (ed), *A Sacred Quest – The Life and Writings of Mary Butts*, McPherson & Co., Kingston, New York 1995

Waugh, Evelyn, *A Little Learning*, Chapman & Hall 1964

Williams-Ellis, Clough, *Architect Errant*, Constable, London 1971

Woodeson, John, *Mark Gertler – Biography of a Painter 1891–1939*, Sidgwick & Jackson, London 1972

Fiction/Verse

Adcock, St John, *A Book of Bohemians*, London 1925

Aldington, Richard, *Death of a Hero*, Chatto & Windus, London 1929

Allen, Grant, *The Woman Who Did*, John Lane, London 1895

Beaton, George (pseud. Gerald Brenan), *Jack Robinson – A Picaresque Novel*, Chatto & Windus 1933

Burke, Leda (pseud. David Garnett), *Dope Darling – A Story of Cocaine*, T. Werner Laurie 1919

Cannan, Gilbert, *Mendel – A Story of Youth*, T. Fisher Unwin, London 1916

Connolly, Cyril, *The Rock Pool*, Hamish Hamilton, London 1947

Cunard, Nancy, *Sublunary*, Hodder & Stoughton 1923

Du Maurier, George, *Trilby – A Novel*, Osgood, McIlvaine & Co., London 1895

Huxley, Aldous, *Antic Hay*, Chatto & Windus, London 1923

Huxley, Aldous, *Crome Yellow*, Chatto & Windus, London 1921

Kapp, Yvonne, *Mediterranean Blues*, John Lane 1933

Kennedy, Margaret, *The Constant Nymph*, Heinemann, London 1924

Leslie, Seymour, *The Silent Queen*, Jonathan Cape, London 1927

Mannin, Ethel, *Ragged Banners – A Novel with an Index*, Jarrolds, London 1931

Mannin, Ethel, *Sounding Brass*, Jarrolds, London 1925

Maugham, W. S., *Of Human Bondage – A Novel*, Heinemann, London 1937

Moore, George, *A Modern Lover*, Vizetelly & Co., London 1889

Murger, Henri, *Scènes de la Vie de Bohème*, 1845

Rhys, Jean, *The Left Bank and Other Stories*, Jonathan Cape, London 1927

Sackville-West, Vita, *The Edwardians*, Hogarth Press, London 1930

Smith, Dodie, *I Capture the Castle*, Heinemann, London 1949

Smith, Eleanor, *Flamenco*, Victor Gollancz, London 1931

Waugh, Evelyn, *Vile Bodies*, 1930

Wells, H. G., *Ann Veronica – A Modern Love Story*, T. Fisher Unwin, London 1909

Acknowledgements

I owe gratitude to a large number of people for helping to make this book possible. My special thanks are due to the following: my husband, William Nicholson, my mother, Anne Olivier Bell, Rupert Christiansen, Caroline Dawnay and Eleo Gordon. They know why.

A large number of people were kind enough to see me or answer my letters, including the late Lord Annan and Gabriele Annan, the late Dr Igor Anrep and Annabel Anrep, Sybille Bedford, Prosper Devas, Angelica Garnett, Henrietta Garnett, Richard and Jane Garnett, the late David Gascoyne and Judy Gascoyne, Luke Gertler, Victoria Glendinning, Kitty Godley, Chloë Green, Valerie Grove, the late Kathleen Hale, Lord and Lady Healey, Sir Nicholas and Lady Henderson, John and Diana Higgens, Brian Hinton, Michael Holroyd, Lord and Lady Hutchinson, Rebecca John, Francis King, Mrs Peggy Jean Lewis, Nigel Nicolson, Frances Partridge, Lord Skidelsky and Diana Syrat of Penguin Books.

I have had particular support and answers to awkward questions from the following: Juliet Annan, Russell Ash, Paul Beecham, James Beechey, Cressida Bell, Julian Bell, Dr Ronald Blythe, Martin Bryant, Richard Cohen, Caroline Cuthbert, Julie Duffy, Eleanor Gleadow, Jonathan Hugh-Jones, Tom Jeffery, Sarah Jelly, Josephine Jones, Jacqueline Korn, Sarah MacDougall, Mike Majerus, Jonathan and Olivia Mantle, Jamie Muir, Ghislaine Nankivell, Kathy Robbins, Felicity Rubinstein, Ruth Saunders, Richard Shone, Leda Sloat, Frances Spalding, Alastair Upton and Keith Waterhouse. Thanks too to Judy Goldhill, and Teddy Nicholson.

I am particularly grateful to Jeremy Crow and Elizabeth Haylett of the Society of Authors, and to the staff of the London Library and the British Library whose respective institutions are both national glories. Thanks are also due to Jo Digger, curator of the New Art Gallery, Walsall, Kath Begley of the Bank of England Library, Jennifer Booth and Adrian Glew at the Tate Gallery Archive, Mary Enright at the Poetry Library, Dr Ceridwen Lloyd-Morgan at the National Library of Wales, Hester Swift at the Law Society Library, Anne Walker at the Royal Pharmaceutical Society Library, Ella Wilkinson at the Royal Hibernian Academy Library, and the helpful staff of Lewes Public Library.

Special thanks to Elisabeth Agate for the picture research and to Douglas Matthews for the index.

*

In addition, the author gratefully acknowledges the permission of copyright holders to quote from the works of a number of authors, as follows: Jean Faulks, for permission to quote from the works of Ethel Mannin; A. P. Watt Ltd on behalf of the Literary Executors of the Estate of H. G. Wells, for use of excerpts from *Ann Veronica*; Chloë Green for permission to quote from *Time Which Spaces Us Apart*; the Estate of the late David Garnett and Richard Garnett for permission to quote from their unpublished writings; Mr Philip Denham-Cooke for use of excerpts from *Sixty Years of Home* by Ursula Bloom; the Trustees of the estate of Nicolette Devas for permission to quote from *Two Flamboyant Fathers*; J. M. Dent for permission to quote from *The Life of Dylan Thomas* and *Selected Letters of Dylan Thomas* by Constantine Fitzgibbon; to the Representative of Nancy Cunard's heirs for permission to quote excerpts from two poems first printed in *Sublunary*, 1923; to the Estate of the late Gerald Brenan for permission to quote from *A Life of One's Own* and *Jack Robinson*. Excerpts from the works of Liam O'Flaherty are reprinted by permission of Peters Fraser and Dunlop on behalf of Liam O'Flaherty; excerpts from the memoirs of Harold Acton © the Estate of Harold Acton; quotations from Nina Hamnett's works © Estate of Nina Hamnett; Arthur Ransome quotations © of the Arthur Ransome Literary Estate; excerpts from Betty May, *Tiger-Woman* reproduced by permission of Gerald Duckworth & Co. Ltd.; quotations from *Selected Letters of Vanessa Bell*, edited by Regina Marler, reprinted with permission, © 1962 Estate of Vanessa Bell, courtesy of Henrietta Garnett; quotations from *Christabel Who?* by kind permission of Jane Spottiswoode, who was the daughter of 'Christabel'; excerpts from *The Constant Nymph* reproduced with permission of Curtis Brown Group Ltd., London on behalf of the Estate of Margaret Kennedy, © Margaret Kennedy 1924; excerpts from *The Glass of Fashion* by Cecil Beaton (Weidenfeld & Nicolson 1954) by permission of the Author's Literary Trustees and Rupert Crew Limited; quotation from 'Liberty Hall' from Herbert Farjeon's *Nine Sharp and Earlier* (1938) by permission of the Farjeon Literary Estate; quotation from 'Do Not Go Gentle into that Good Night' by Dylan Thomas, courtesy of J. M. Dent.

Acknowledgements are also due to the following whose works have been quoted from: W. Somerset Maugham *Of Human Bondage*; Philip O'Connor *Memoirs of a Public Baby*; Geoffrey Grigson *Recollections – Mainly of Artists and Writers*; Caitlin Thomas *Double Drink Story*; Arthur Calder-Marshall *The Magic of My Youth*; Naomi Mitchison *You May Well Ask – A Memoir*; Douglas Goldring *The Nineteen Twenties*; *South Lodge – Reminiscences of Violet Hunt, Ford Madox Ford and the English Review Circle*; Gretchen Gerzina *Carrington*; Noel Carrington, ed. *Mark Gertler: Selected Letters*; George du Maurier *Trilby*; Quentin Bell *Virginia Woolf, Charleston Past and Present* and *Elders and Betters*; Enid Bagnold's *Autobiography*; Isadora Duncan *My Life*; Claire Harman, ed. *The Diaries of Sylvia Townsend Warner*; Miranda Seymour

Robert Graves: Life on the Edge; Michael Holroyd *Augustus John*; Ronald Blythe *First Friends*; Robert Medley *Drawn from the Life*; Roy Campbell *The Georgiad – A Satirical Fantasy in Verse, Light on a Dark Horse – An Autobiography* and *Broken Record – Reminiscences*; Victoria Glendinning *Vita: The Life of Vita Sackville-West*; Hugh Ford, ed. *Nancy Cunard – Brave Poet, Indomitable Rebel*; Wyndham Lewis *Blasting and Bombardiering*; Diana Cooper *The Rainbow Comes and Goes*; Adrian Daintrey *I Must Say*; Sean Hignett *Brett – From Bloomsbury to New Mexico*; David Garnett, ed. *Carrington – Letters and Extracts from Her Diaries*, pseud. Leda Burke *Dope Darling*; Tristram Hillier *Leda and the Goose*; Andrew Motion *The Lamberts*; Stephen Spender *World Within World*; Peter Quennell *The Marble Foot – An Autobiography*; Pippa Harris, ed. *Song of Love – The Letters of Rupert Brooke and Noel Olivier*; Jean-Jacques Rousseau, trans. Allan Bloom *Emile*; Daphne Fielding *The Rainbow Picnic – A Portrait of Iris Tree*; Ford Madox Ford *Memories and Impressions*; Rebecca John *Caspar John*; Anna Campbell Lyle *Poetic Justice – A Memoir of Roy Campbell*; Richard Aldington *Death of a Hero* and *Life for Life's Sake – A Book of Reminiscences*; C. R. W. Nevinson *Paint and Prejudice*; Evelyn Waugh *A Little Learning*; Frances Partridge *Julia*; Bertrand Russell *The Autobiography of Bertrand Russell*; Romilly John *The Seventh Child*; Kathleen Hale *A Slender Reputation*; Gwen Raverat *Period Piece – A Cambridge Childhood*; Theodora Fitzgibbon *With Love*; Horace Brodsky *Henri Gaudier-Brzeska 1891–1915*; Vita Sackville-West *The Edwardians*; Robert Gathorne-Hardy, ed. *Ottoline at Garsington – Memoirs of Lady Ottoline Morrell 1915–18*; Aldous Huxley *Antic Hay*; W. H. Hudson *Hampshire Days*; Augustus John *Chiaroscuro*; Seymour Leslie *The Silent Queen*; James Lees-Milne *Another Self*; Eric Gill *Clothes*; Diana Farr *Gilbert Cannan – A Georgian Prodigy*; St John Adcock *A Book of Bohemians*; Gilbert Cannan *Mendel*; Osbert Sitwell *Laughter in the Next Room* and *Great Morning*; Sisley Huddleston *Bohemian Literary and Social Life in Paris*; Angelica Garnett *Deceived with Kindness*; Mary Colum *Life and the Dream*; Havelock Ellis *My Life*; Virginia Woolf *A Room of One's Own* and *Moments of Being*; Beatrice Lady Glenavy *Today We Will Only Gossip*; Sybille Bedford *Jigsaw*; Michael Davie, ed. *The Diaries of Evelyn Waugh*; Clifford Bax *Inland Far*; Dodie Smith *I Capture the Castle*; Jean Rhys *The Left Bank and Other Stories*; Anne Olivier Bell, ed. *The Diaries of Virginia Woolf*; Margaret Powell *Below Stairs*; C. K. Stead, ed. *The Letters and Journals of Katherine Mansfield*; Jessica Mitford *Hons and Rebels*; Kenneth Grahame *The Wind in the Willows*; Mary Hutchinson *Fugitive Pieces*; Yvonne Kapp *Mediterranean Blues*; David Gascoyne *Paris Journal*; Cyril Connolly *The Rock Pool*; Jeremy Lewis *Cyril Connolly – A Life*; Marie-Jacqueline Lancaster, ed. *Brian Howard – Portrait of a Failure*; Eleanor Smith *Flamenco*; Evelyn Waugh *Vile Bodies*; Juliette Huxley *Leaves of the Tulip Tree*; Joanna Richardson *The Bohemians – La Vie de Bohème in Paris 1830–1914*; Julian Trevelyan *Indigo Days*; Claire Tomalin *Katherine Mansfield – A Secret Life*.

Index

Page numbers in *italic* indicate illustrations